MEDIAEVAL CRAFTSMEN

MEDIAEVAL CRAFTSMEN

John Harvey

Printed in Great Britain by
Jarrold Everyone Ltd Ltd, Barton Manor, be [illegible]
and bound by William Brendon and Son Ltd, Tiptree
for the publishers B. T. Batsford Ltd
4 Fitzhardinge street, London W1H 0AH
and 23 Cross Street, Brookvale, NSW, 2100, Australia

B. T. Batsford Ltd London & Sydney

First published 1975
© John Harvey 1975

ISBN 0 7134 2934 8

MAR 2 2 1976

Printed in Great Britain by
Bristol Typesetting Co. Ltd, Barton Manor, St Philips
and bound by William Brendon and Son Ltd, Tiptree, Essex
for the publishers B. T. Batsford Ltd
4 Fitzhardinge Street, London W1H 0AH
and 23 Cross Street, Brookvale, NSW, 2100 Australia

Contents

Illustration Sources

British Library

1 Add. MS. 18183, f. 48v
2 Add. MS. 19720, f. 165
3 Cotton MS. Augustus A.v., f. 161v
4 Harleian MS. 4425, f. 12v
5 Add. MS. 18852, f. 3v
6 Add. MS. 24098, f. 20v
7 Royal MS. 18D vii, f. 2
8 Add. MS. 18750, f. 3
14 Add. MS. 19720, f. 27
16 Egerton MS. 1894, f. 5v
17 Royal MS. 14E iii, f. 85v
19 Add. MS. 47682, f. 5v
22 Add. MS. 35313, f. 34
23 Royal MS. 15D iii, f. 15v
24 Harleian MS. 4431, f. 109
26 Harleian MS. 6205, f. 21
27 Royal MS. 15E iii, f. 102
29 Royal MS 17E iv, f. 87v
30 Add. MS. 42130, f. 193
31 Royal MS. 2B vii, f. 37v
32 Add. MS. 15692, f. 29v
40 Add. MS. 38122, f. 78v
41 BL facsimile MS. 169, f. 141
42 Royal MS. 10E iv, f. 99v
43 Royal MS. 2B vii, f. 5v
44 Royal MS. 15D iii, f. 12
45 Add. MS. 18850, f. 15v
47 Cotton MS. Aug. II, 1
79 Egerton MS. 1894, f. 8

80 Royal MS. 16G.v., f. 73v
83 Royal MS. 14E iii, f. 66v
84 Add. MS. 10292, f. 55v
106 Royal MS. 15E iii, f. 269
108 Add. MS. 15277, f. 15v
110 Add. MS. 24189, f. 16
116 Add. MS. 15277, f. 16
119 Sloane MS. 3983, f. 5
122 Royal MS. 16G.v., f. 11

British Museum 9, 11, 125, 134, 154, 155
Museum of the History of Science, Oxford 10
National Museum, Copenhagen 78
National Monuments Record 12, 13, 90, 109, 156, 157, 158
Mansell Collection 15, 21 (Bibl. Nationale, Paris MS. 247, f. 163)
Dean & Chapter of Westminster (Islip Roll) 25
The Lord Bishop of Bath & Wells 33 (Bishop Stillington's Register)
Jeffery W. Whitelaw 38
The late Edwin Smith 39, 51
Victoria & Albert Museum 46, 77, 81, 96, 98, 99, 100, 112, 114, 117,
 118, 124, 128, 129, 130, 131, 133, 149, 159
Giraudon 111
Kunsthistorisches Museum, Vienna 135
Hallam Ashley/Norwich City Museums 152, 153
The Warden & Fellows of Winchester College 107
Bayensche Landesamt fur Denkmalpfege, Munich 115
Kings Lynn Corporation 132
Trinity College, Dublin 18 (MS. E.1.40, f. 60)
Trinity College, Cambridge 28 (MS. 0.9.34, f. 52v), 121 (MS 0.9.34,
 f. 24)
Bodleian Library, Oxford 20 (MS Douce 353, f. 43v), 82 (MS Douce
 195, f. 149), 120 (MS. Bodl. 264, f. 84)
The remaining illustrations are from the Publisher's collection

Preface

Craftsmanship is the basis of society. From shaping the most primitive tool to the assembly of the latest computer, human activity has depended upon skill: the co-ordination of brain and hands. This process takes many forms, but these do not differ in kind. Each output of skill represents exactly the same faculty, an ability to learn an existing method of doing something. Although it is nowadays fashionable to talk of technology, this is nothing more than the discussion of crafts. Essentially such difference as there is remains only one of degree. Human history has seen many ' technological revolutions ', developments in method, craft by craft, or in whole groups of related crafts at once.

Such revolutions must be distinguished from evolution, for craftsmanship has no inborn capacity for mutation. The advances that take place are not the outcome of craft skill in itself but imposed upon it as the individual creative inventions of human beings. It is as well to insist upon this, for there has commonly been confusion between the two separate functions, as though new invention grew by some automatic means out of craftsmanship itself. This is not the case. The skill employed in carrying out the processes of each craft is specific and learned from a master or possibly from books; but it remains static unless change is brought about by fresh teaching. This is not to exclude the possibility that a given craftsman may invent an improvement in his particular skill; but this is an exercise of an entirely distinct faculty and forms no part of his ability as a craftsman.

The confusion between static craftsmanship and dynamic invention is not surprising. It stems from the fact that many of the world's great inventors have themselves been practical craftsmen. There is no mutual repugnance between the ability to do things and the power to design them. As we shall find in studying the contributions of craftsmen in the Middle Ages, new methods of working and new aesthetic factors were introduced, often from outside but sometimes from within the ranks of a given craft. It is necessary simply to beware of crediting the ordinary

craftsman with receiving, along with the skill taught him, any inescapable capacity leading towards progress, to development of the method employed.

The very word 'artefact' lends itself to another source of confusion, the basic ambiguity of our word 'art'. In Latin *ars* signifies two things: the mental ability required to produce a new invention, and also the acquired skill which makes its production materially possible. In this book the words 'art' and 'craft' will not be used as synonyms: *art* here means always creative activity and *artist* a creator, though in most cases a craftsman endowed with the power to originate over and above his particular skill. On the other hand, *craft* is used of any one particular skill, and its trained exponents are *craftsmen*. The resources of our language, wide as they are, are inadequate to distinguish between the two aspects of any production, at least in most cases. For example, only the context can show whether 'painter' means a creative artist or a craftsman who lays on pigments as protective or decorative coatings on other substances. In the latter sense it has become customary to speak of a 'housepainter' to make the necessary distinction.

In one instance, however, two separate words do exist side by side: *architect* and *builder*, and their products architecture and building. This is fitting, since Architecture is acknowledged as the Mistress Art. Building, with all its component skills such as masonry, carpentry, glazing, is a collective technique taught by the members of one generation to those of the next. It may be greatly modified in course of time by the discovery of new materials or the invention of improved methods, but these changes come from outside. Architecture, however, is not simply the control and supervision of buildings; its primary function is the creation of solutions to fresh problems posed by patrons who wish to have not standardised but specially designed works put up in answer to their requirements.

The same principle rules throughout the crafts, though the number of categories of creative designers is smaller than that of the crafts whose skills they inspire and control. In the Middle Ages the crafts became repeatedly subdivided and one branched out from another. Yet there were few categories of designer apart from the architect. The painter – that is the master painter who produced designs and drew cartoons with his own hands or by those of his pupils and assistants – came to control not merely paintings but what was made by glaziers of stained-glass windows, embroiderers and tapestry makers. The carver, a specialised offshoot of the master mason, did not merely cut figures to his own design in stone or wood, but designed work in the solid to be made in metal by founders and engravers of brasses and seals.

Although it is necessary to insist upon this sharp distinction between the functions of designer and of executant, it must be kept in mind that during the Middle Ages the designer had been trained as a craftsman.

The same man who, later, might be prominent as an architect, had used his hands in masonry or carpentry. Few of the masters responsible for designing buildings and works of art would have been unable to instruct the workmen in the correct methods of carrying out each process. It is in this respect that mediaeval designers differed from very many modern architects, whose capacities are based upon book-learning and draughts-manship on paper, but lack understanding of the physical properties of materials gained by handwork in them. This difference has led to much confusion and to widespread failure to understand the essential break between mediaeval and modern, a complete change in educational method and social outlook.

The change did not take place all at once, nor with equal force in all arts and crafts. It is seen at its worst in architecture of the last century-and-a-half, though its roots stretched back to the sixteenth century, when amateurs could first dictate the forms of buildings by reference to Vitruvius and to engraved copy-books. The living development of form which had been imposed upon the traditional crafts of the Gothic period, for the previous five hundred years, went out of fashion. The manual craftsmen had to take orders from men who knew nothing of the trans-lation of design into material substance. Other non-architectural crafts were affected far less: there is hardly any break in the practice of bell-founding during the whole of the last thousand years. It is as it always has been a practical method based upon very ancient experiments and improved by the experience of many generations. With architecture at one extreme and bell-founding at the other, a whole gamut of differ-entiation may be formed by the interpolation of other crafts and the corresponding methods of design.

The number of crafts practised during the Middle Ages, for our present purpose the five centuries from 1050 to 1550, was very large, and to deal with their practitioners in detail would require an encyclopaedia. The encyclopaedic treatment in fact exists in the volumes of the great Oxford *History of Technology* by the late C. Singer and others, though that is a study of methods and their development, and only to a very slight extent of the men responsible. For this country alone the subject has been covered in closer detail by two outstanding books, both due to the late L. F. Salzman: *English Industries of the Middle Ages* (1923) and *Building in England down to 1540*, completed by 1934 though not published until 1952. It is unlikely that any group of crafts has ever received such meticulous treatment, and *Building in England* must always remain the definitive study of materials, methods and words. It is per-haps not sufficiently realised that, besides other original material, Dr Salzman read through *every* ' Works ' account of his period in the Public Record Office and abstracted virtually all the relevant contents. The pub-lished book, in its enlarged edition of 1967, includes the full text of over 140 building contracts, almost all that are known to survive in this country.

The debt owed by this book to both of Salzman's will be obvious, but my gratitude must also be placed on record in respect of much personal help from Dr Salzman over a period of some thirty years. Many other books consulted will be found in the bibliography and notes, but the main basis of this study comes from record sources, published and in manuscript. While fuller details of the lives of many individual designers will be found in my earlier book *English Mediaeval Architects* (1954), some corrections and additional material in that field will be given here. As the function of the architect and his role in design have been described elsewhere (*The Mediaeval Architect*, 1972), more space is devoted to other aspects of building craftsmanship, to non-building crafts, and to an attempt at a comparative study of the building and non-building crafts side by side. Foreign material is admitted as well as British but the illustrations chosen are as far as possible of English origin.

All lengthy quotations from texts in mediaeval English have been modernised by re-spelling, but not otherwise. I should draw attention once more to my renunciation of the spelling 'Yevele' in favour of Yeveley as the surname of the great architect of the fourteenth century. The origin of his family was certainly Yeaveley in Derbyshire, not Yeovil, and the spelling adopted by the *Dictionary of National Biography* and later by me leads to historical and phonetic ambiguity. The usage Yeveley is not new: it was employed in the pioneer life printed in 1864 by John Gough Nichols. Many other mediaeval names appear in inconsistent spellings but the attempt is made to choose forms which are recommended by general usage or *correct* indication of origin.

The book owes much to my late father William Harvey who, though a professional architect, had also received training as a carpenter; and to the late T. D. Atkinson who worked for six months in a mason's shop in addition to a normal architectural education. Many craftsmen have contributed facts and comments of value, and I have to pay a tribute of affection to the memory of the late David Black, a great stonemason and the first master craftsman whose close acquaintance I made in childhood. It was also my good fortune to study the old timber structure of the York Guildhall in course of repair in 1940–42 under the fine carpenter and delightful personality Lemuel Powell – a work completed only to be at once destroyed by enemy action.

Help of various kinds came from others now gone from us: the late R. P. Howgrave-Graham, Harold A. James and Professor E. W. Tristram. I am deeply grateful to my friends Messrs Bernard J. Ashwell, Frank B. Benger and L. S. Colchester, Professors Kenneth J. Conant and Ralph H. C. Davis, Dr Eric A. Gee, Mr Cecil A. Hewett, Professor E. Martyn Jope, Messrs Dennis King, P. Laishley, L. R. Mildenhall, J. Moreton, P. Moreton, Arthur Oswald, Dr L. R. Shelby and Mr W. A. Wheeler. Dr R. B. Dobson has kindly read a draft of the text and has given me the benefit of his knowledge of mediaeval history and of

the development of the guilds, helping me to avoid numerous pitfalls. To my publishers I am grateful for much assistance, particularly in lending me a very large collection of relevant photographs; and especially to Sam Carr, who suggested the subject and has discussed the book at all stages; Douglas Sellick, who undertook extensive researches to find illustrations; and Mike Stephenson, who has taken charge of production. As always, my wife has promoted the work by doubling the parts of collaborator and critic.

John H. Harvey

Introduction

History, the study of what is on record about past human activity, shows two paradoxically conflicting trends going on at the same time. On the one hand language, the specifically human means of exchanging ideas, has tended towards simplification. Many tongues started with a complex structure and have become worn down in use. This was happening several thousand years ago in Chinese, and in English some five or six centuries back. Some early alphabets such as that of Sanskrit were devised upon extremely acute scientific distinctions of phonetics and proved unwieldy in practice. Others, notably that of the Greeks later adapted to become the Roman writing which we still use, erred in the opposite direction. An undue reduction to essentials made it impossible for writing to express the spoken word adequately. On the whole simplicity has won. The modified Roman alphabet of about 24 to 30 letters, and the almost uninflected and greatly simplified English speech dominate world communications.

Yet in another basic field of human activity the course of events has been contrary. Before the rise of cities, human communities were comparatively unspecialised. Simple domestic wants can be supplied by the family and a small self-supporting group is composed largely of individuals able to turn their hands to anything. The primary skills are extremely simple: cutting sticks, sharpening them, planting them in the ground, even tying them together with available natural fibres. But once the combination of families has grown to the point where a large area of land has been taken over and made into a town, complete self-support is impossible and exchange of goods and services is bound to follow. Inevitably this leads to specialisation based upon mere accident or upon inborn or acquired aptitudes. It is this living together in large towns in mutual dependence that is civilisation.

Civilisation has existed for a long time, but its recorded history cannot be pushed much beyond five thousand years. This is long enough to give a clear statistical picture of main trends, and to show that

development brings constantly increasing specialisation. The extreme pos-
sible number of human occupations is of course finite even though new
inventions bring with them the need for new skills. Many of these repre-
sent in new guise some older skill, duplicated for a time, but likely to
become obsolete. At any one time a given population comprises a specific
number of occupations, some requiring brain work, some trained skill
of different kinds, some mere physical labour.

Bearing in mind these three divisions of human activity as forming
the continuous background of all social events, we can see that it is in
the middle category that obvious differences abound. Both the intellectual
and the navvy have generalised aptitude and can switch from one job to
another with little difficulty. The man whose particular form of skill is
the outcome of vocational training is, contrariwise, bound to that one
method of earning his livelihood. We shall see that this underlies the
frequency of demarcation disputes throughout history. Every craft com-
posed of those with like skills forms a defensive – and sometimes an
offensive – alliance against any who may threaten their livelihood.
Similarly, if the methods of their craft are not very simple, they will
include processes that can be safeguarded by secrecy. This again is a
main component of craft history.

Behind these practical reasons for craft exclusiveness there is more than
meets the eye, and this takes us back to fundamental problems of the
relation between craft and religion. We shall see that there was, particu-
larly in the mediaeval period under discussion, a very close interpenetra-
tion of secular and religious interests. The interlocking of everyday life
with the practices of religion is a commonplace to the comparative
anthropologist; it is not just a Christian phenomenon nor one of any
single period, but worldwide in range. As A. M. Hocart wrote, particu-
larly of Ceylon but with a general application: ' what is uppermost in
(people's) minds is the part the castes take in ritual.' The barber, the
washerman ' are minor priests '. ' The smiths make statues of the gods,
temple jewelry, wedding necklaces. Carpenters make temple cars . . .
potters officiate as priests in temples of village goddesses . . . make
images, ex-votos, pots, which at weddings represent the gods.' This
corresponds to the traditional allocation to separate crafts of the produc-
tion of scenes in the pageant plays of the Middle Ages, such as those
of York, Wakefield or Coventry. As a genuine even if tenuous survival of
this way of thought we may mention the Lord Mayor's Show of the
City of London.

It was Hocart who also pointed out that occupations are inherited, as
in the Egyptian village where ' every occupation is hereditary '. In
mediaeval England, for long after the Norman Conquest, many estates
were held by serjeanty, the duty of performing some specific service to
the Sovereign. The purely honorary services, such as those performed
at coronations by the owners of the manors of Scrivelsby and Worksop,

have in some cases survived down to the present day. Many of the earlier serjeanties were thoroughly practical, but they too were undoubtedly ritual in origin. The idea of the sovereign as a high priest is familiar to us, notably from the transfer of powers to the Christian Pope at the downfall of the Western Roman Empire; but comparative anthropology also shows us the monarch as chief of agriculture (the Chinese Emperor ploughing the first furrow of the year) or as a chief craftsman (the legendary wheelwright from whom sprang the original royal house of Poland).

The performance of ritual, all over the world, is believed to promote good fortune, to ensure fertility, to confer power. This belief is not necessarily based upon any rational foundation, but even if it were no more than superstition it would remain as a vitally important fact in history. The association of craftsmen in the ritual of tribe or nation is of general occurrence and is in no way affected by the objective truth or otherwise of the underlying theory. Thus it is an irrelevance whether we accept that material crafts developed out of transcendent ritual, or adopt the materialistic hypothesis that the ritual grew out of antecedent material needs. In the latter case it is simply the effectiveness of craft skill that constitutes its power; in the former, the power is non-material, but breathes life into material operations.

We here reach the essential meaning of our word 'craft', underlying the plain sense of skill exercised in some particular way. Etymologically, the word is identical with the German *Kraft* meaning strength. The power resides in the skill and gives a particular meaning to the apophthegm 'Knowledge is power'. Craftsmen are then possessed of knowledge of a certain skill, and this confers upon them a power in which their significance resides. Craftsmen have always been held in honour, not merely in their own land but across national frontiers. This can be experienced even today in countries such as Morocco, where much of the economy is still directly based upon hand craftsmanship. Whereas a foreign tourist asking questions as an outsider would receive no useful information, any craftsman of the same or a related craft and able to show his special knowledge, is welcomed as a brother. This was a vital factor in former times. The passage of information on arts and crafts from one country to another was not hindered by an artificial barrier of secrecy between men of the same craft.

The social standing of skilled craftsmen in other lands, and in former times in Britain, was a great deal higher than might now be imagined. From the heroic age of Wales comes the famous passage in which the porter's refusal to open the gate is because 'there is revelry in Arthur's hall, and none may enter therein but the son of a king of a privileged country, or a craftsman bringing his craft.' That is indeed a literary statement of romantic tradition, but in the same historical period the crafts had their honoured places in the great hall of the High King of

B

Ireland. At Tara the two long mounds can still be seen, marking out the Teach Miodhchuarta or Banquet Hall, 700 feet long by a span of 90, built by King Cormac (AD 227–266). Every third year, until 563, the king and queen presided over an assembly of all degrees and occupations, divided into 42 groups. The English tables of official precedence, set out about a thousand years later, ranked an artificer (i.e. a craftsman) between a gentleman and a yeoman, and in the case of a rich artificer, next above a gentleman, but all these were to be seated, along with rectors, priests and merchants, at a table of esquires.

It is true that this honourable position granted to craftsmen appears to be contradicted by categorical statements that only the impractical and 'useless' arts were honourable. Thus Plutarch is quoted to the effect that 'the construction of engines and in general every trade that is exercised for its practical value is lowly and base.' But this is a partisan plea on behalf of the newly arrived class of literates. For skilled craftsmanship is immeasurably older and more pervasive than general literacy. In the Inca Empire writing was unknown, as it was among the Polynesians before the Europeans arrived. Yet the Incas and the Polynesian chiefs were in charge of highly sophisticated cultures. The useful invention of writing, by making itself necessary in the persons of its practitioners, long ago began to usurp a high position for them. The refusal of the Emperor Akbar to learn to read and write was a deliberate protest against the disproportionate weight given to literacy as against other attainments. As Hocart put it: 'The king's secretaries oust the king's serjeants . . . the man who uses his hands is brought under subjection by the man who wields the word or the pen. The secretariat begins as the servant and ends as the master.'

The attempt to reduce the handicrafts to a base and menial position is then just one aspect of a long struggle and need not be accepted as an assertion of gospel truth. Yet it received much of its force from the fact that it was the priesthood, from Ancient Egyptian times onward, that preserved and expounded sacred writings. The very word 'hieroglyph', priestly carving, has passed into language in commemoration of the fact. What began many centuries before Christ has been reinforced by the long reign, in education and in governmental positions, of the Christian clergy. Even now, when the bonds of revealed religion have notably slackened, the literature of art history is permeated by the attempt to show that art of all kinds was mainly due to the clerical order, providing designs and issuing instructions to a rabble of not merely illiterate but ignorant workers.

In our period this proposition is massively refuted by the record. The word 'Master' (Latin *magister*) as a mark of status among lay craftsmen goes back to an earlier period than its use by the academic master who had a university degree. In the Lombard Laws of AD 643 there is already mention of *magistri* in charge of building. Furthermore, the

practice of craft secrecy made it impossible for a cleric to design buildings or to carry out other craft skills, except in rare cases where a fully trained craftsman later took holy orders or entered a monastic order. This explanation can be shown to be individually true in the cases of several of the most renowned clerical artists, constantly brought forward in evidence as if they were the rule rather than the exception.

The Middle Ages were far more realistic over this issue than subsequent times. The literary evidence of Lydgate, himself a monk, shows no condescension towards craftsmen. Certainly knowledge was respected, but it included both what we should term science and the arts and crafts too:

> *Whom followed Cunning with his genealogy:*
> *That is to say, Grammar and Sophistry,*
> *Philosophy Natural, Logic, and Rhetoric,*
> *Arithmetic, Geometry with Astronomy,*
> *Canon and Civil (Law), melodious Music,*
> *Noble Theology and Corporal Physic,*
> *Moralization of Holy Scripture,*
> *Profound Poetry and Drawing of Picture.*

Elsewhere, in his detailed description of the artists and craftsmen who worked to rebuild Troy for King Priam, Lydgate admitted that he had not read Euclid and so was unable to describe adequately the technical details:

> *I can no terms to speak of geometry,*
> *Wherefore as now I must them set aside;*
> *For doubtless I read never Euclid*
> *That the master and the founder was*
> *Of all that work by square or compass,*
> *Or keep their measure by level or by line;*
> *I am too rude, clearly to define*
> *Or to describe this work in every part,*
> *For lack of terms belonging to that art.*

The Middle Ages need definition, and for the present purpose this must be arbitrary. The mediaeval period fills the gap of more than a thousand years between the collapse of the Western Roman Empire and the Renaissance. As far as this country is concerned the limiting dates are about AD 400 and 1500, but the early centuries are almost devoid of detailed record. For reasons of national history the end is best placed at 1540 with the dissolution of the last of the great monasteries under Henry VIII. Even later evidence is sometimes relevant to the crafts, in which tradition was paramount and innovations the rare exception. Although architecture changed markedly in appearance about the middle

of the sixteenth century, the methods of building craftsmanship remained much the same for two or three hundred years more.

What justification then is there for a discussion of mediaeval craftsmen set apart from those of other periods? The answer is that there was a spirit of the time, partly bound up with the forms of religion which ceased to rule after the reign of Henry VIII, and clearly different from the savagery of the Dark Age that had lasted from AD 400 to 900 or 1000. In craftsmanship itself much of the interest lies in the introduction of new inventions, new processes, and new aesthetic ideas after about 1100. A genuine renaissance of culture and science then took place and soon found visual expression in the Gothic style. It is with far more justification that the term renaissance, rebirth, is applied to this period than to that which revived the dead forms of the classical Latin language and of Roman art four centuries later. For the mediaeval period in our sense was precisely the time when knowledge derived from classical manuscript sources and lost to the West was brought back by means of retranslations from the Arabic. More or less at the same time, and through the same or parallel channels, other non-classical knowledge arrived: largely inventions made in China, but with other material from India, Persia and Middle Eastern states.

Repugnant as it may be to the nonsensical national vanity of modern times, the fact must be faced that civilisation is not conterminous with Western Christendom, and that most of the great inventions on which our culture is based were made in Asia. ' In skill and inventiveness . . . the Near East was superior to the West, and the Far East perhaps superior to both.' ' Islam . . ., from the ninth century till the fourteenth, was technologically far superior to western Europe.' Our Middle Ages were indebted for a vast proportion of their progress to the Saracens commonly regarded as the mortal enemy. It was not the Arabs who were the originators, but the great cultural symposium over which they, as conquerors, presided. A great deal was due later to the secondary cultural wave brought westwards through Asia Minor by the Seljuk Turks after their period of rule in Persia (AD 1037–1157). Chinese knowledge penetrated westwards by stages, helped on its way in the thirteenth century by the Mongol Empire holding sway from Peking to Azerbaijan and the Ukraine.

Among the great inventions which reached Europe from Islam were the Arabic numerals, paper, distilled alcohol and silk culture. The system of numbers was already in use for scientific purposes from about 1100, but it was only in 1201 that Leonardo Fibonacci of Pisa (*c.* 1170–1245) composed a treatise on the subject after living as a merchant in North Africa. Calculation and the keeping of accounts became enormously simplified, yet it took another three hundred years for the system to become really general. Paper, invented in China (it is essentially distinct from the Ancient Egyptian papyrus), reached the Arabs and was taken by

them to Spain. Manufacture was centralised at Játiva by the early twelfth century, and by 1150 the Arab geographer Idrisi recorded that the paper manufactured there is 'such as cannot be found anywhere in the civilised world, and is sent to the East and to the West'. Paper-making spread slowly over Europe, and the use of paper in England did not begin until about 1300. Alcohol (an Arabic word) was distilled at the medical school of Salerno in southern Italy *c.* 1100, and it was through Salerno that much of the medical and chemical knowledge of the Arabs filtered northwards. Silkworms had been brought to Spain by the tenth century and to Sicily and Italy by the twelfth. Machinery for working silk, invented piecemeal in China at dates from 100 BC onwards, was not available in Europe until about 1300.

That many notable inventions had been made in China has long been known, but only in the last twenty years have the full details been published through the researches of Professor Joseph Needham. The crossbow, used in China in the third century BC, did not reach Europe until the eleventh century AD; deep drilling for water became known in the West in the first half of the twelfth century, well over a thousand years after its employment in China. The time-lag in the case of the wheelbarrow, here by about 1200, was almost as long, while for the use of gates on canals and rivers it was even longer. True locks on canals, built in China in the first half of the ninth century AD, were unknown in Europe until after 1450. The ship's rudder, attached to a stern-post, was known in China in the eighth century and in the West before the end of the twelfth; but printing from blocks reached us only about 1400, more than six centuries late, and was overtaken in little more than a single generation by printing from movable metal type, invented in China or Korea only one hundred years before. On the other hand it took more than a thousand years for Chinese methods of producing a forced draught by water-driven engines, and of iron casting, to reach Europe by the thirteenth century.

Several other major inventions are of uncertain origin. The ship's compass falls into this category, though it was probably used by the ' Arabs ' before it reached the north-west in the twelfth century. In the thirteenth century some notable advances may have been the work of Roger Bacon (*c.* 1214–1292), the English Franciscan friar who was one of the greatest experimental scientists of the age. To him spectacles may well be due. They seem first to have been made about 1290, while Bacon was still alive, but simple convex lenses had been known in antiquity and globular bowls of glass, filled with water, had long been used by gem-cutters to enlarge their work. The slowness of development is strange, and still stranger the further delay, until the period around 1600, before the compound microscope and the telescope were produced.

A wide range of chemical experiments was in progress, mainly conducted by Muslims and Jews in Spain, and in Italy under Muslim

influences. Much of the evidence is embedded in the comments on the many ' stones ', artificial as well as natural, described in the *Lapidario* of King Alfonso x of Castile (1252–1284), the Learned. This was one of a series of scientific compilations drawn up at the king's behest and largely founded upon translations from books in Arabic. Further experiment in the interest of various craft processes may have resulted in the discovery or re-invention of gunpowder soon afterwards. So far as England is concerned, there is reason to think that information was received through royal clerks and envoys moving between Alfonso's court and that of his brother-in-law Edward I. We actually know of one English clerk, Geoffrey of Eversley, in the service of both kings in the years 1276–82: covering the very time when the translation was in progress, 1276–79, and the subsequent years when it was probably disseminated.

The translation of Arabic sources at the command of Alfonso x is essentially modern and strictly scientific. More famous than the treatise of Stones were the Books of Knowledge of Astronomy and the Alfonsine Tables of the movements of the heavenly bodies, for centuries the foundation of the almanac and of all calendrical calculations. The meridian of Toledo preceded that of Greenwich as a standard for the western world. Accurate timekeeping and the making of effectively regulated mechanical clocks stemmed from this scientific campaign in Castile. Astronomy, which then comprehended what we should term astrology, was not only the main subject studied, but provided a framework of reference for the rest. Thus the *Lapidario* classifies all known stones and mineral substances under the twelve signs of the zodiac and the 30 degrees in each sign; and every substance is qualified as hot or cold and wet or dry. Though artificial, the system provides an adequate framework of reference in the same way that Linnaeus's classification of plants, though artificial, brought order out of chaos. Furthermore, the factual matter concerning each substance was largely the result of direct observation and by no means limited to translation of a traditional source.

In at least one instance there is reason to think that the ' invention ' of an important craft process, that of yellow stain on glass, is due to experiments based on a section of the *Lapidario*. As far back as the eighth century AD glass vessels had been decorated in the Near East by means of a yellow stain induced by painting with silver salts and then firing. This process was completely unknown to western stained glass makers and painters until after 1300, but not later than 1310 it appears in new windows made for the nave of York Minster; by 1328 it was certainly used at Chartres Cathedral and perhaps as early as 1313 in Normandy. By 1350 the accounts for glazing St Stephen's Chapel at Westminster include silver foil and silver filings, undoubtedly used for this process. In the course of two generations remarkable progress had been made in a way that implies understanding of practical chemistry. For the recipe in the *Lapidario* does not directly refer to metallic silver, but to *Ecce,*

the name of stibnite or natural sulphide of antimony. The essential fact was that silver occurred as an impurity in the stibnite obtainable from a Spanish quarry and used in the thirteenth century to test the traditional method.

As a sample of the mingling of tradition and observation it is worth quoting the whole of the section of the treatise which deals with *Ecce* and enumerates its qualities:

Of the stone named Ecce.

Of the 18th degree of the sign of Capricorn is the stone which they call Ecce. This is found in Spain in a mountain which stands above the town called Arraca and this mountain is called Cebide; it is not very high. The substance is very black in colour, speckled with yellow spots. It is shining and light in weight, porous, easy to break, and by nature cold and dry. It has this virtue that to him who bears it upon him it gives great strength and overcomes fear, making him very bold in all feats of arms he undertakes. And if they grind it and knead it with honey and smear glass with it and fire it (in a kiln) it stains the glass a very beautiful golden colour. And it strengthens in such a way that it makes the material stronger than it was before and it cannot be melted so readily and does not break so easily. And if they mix it with wax and with resin it makes thereof a plaster very good for growing flesh over wounds and closing them again soon. And the two front stars of the three which are in the brightness of the tail of the Dolphin of the four which are in the quadrilateral in the body of the same hath power over this stone and from this it receives its force and virtue. And when they are in the ascendant this stone most fully exemplifies its workings.

It is customary to sneer at mediaeval alchemists as impractical visionaries, incapable of scientific experiment. Yet in cases like this there must have been repeated attempts to produce the required effect by substitution of other substances, until it was found that fine filings of metallic silver could be used. It must be remembered that the transmutation of metals was a principal aim of the alchemists, and there is no reason why they should not by practical experience have learned a great deal of applied chemistry.

To the same phase of experimentation belongs the invention of the weight-driven clock with mechanical escapement. In this case there seem to have been remote influences derived from China, but the deliberate search for an accurate time-keeping mechanism was due to the needs of the astronomers whose instruments, calculations and state of knowledge are fully described in the books compiled for Alfonso x. It is now becoming generally accepted that the English ' clocks ' made from 1283 to 1292 were truly mechanical: they included new *horologia* at Dunstable Priory, Exeter, St Paul's London, Norwich, Ely and Canterbury cathedrals, and Merton College, Oxford. Just before 1300 the earliest house-clocks may

have been made. It is probably significant that these developments took place within a few years after the completion of King Alfonso's books on astronomy and timekeeping, and during the life of Roger Bacon. To the same period belong the first mentions of the division of day-and-night into 24 hours: Pierre de Langtoft in his rhyming chronicle in French referred to King Alfred having led a holy life throughout the 24 hours; in the English version by Robert of Brunne it runs:

> Though all that he warred in woe and in strife,
> The four and twenty hours he spent in holy life.

By 1345 it was becoming customary to think of the hour as divided into 60 minutes, each of 60 seconds, hitherto purely a method for scientific calculation by astronomers.

The eastern origins of specialised craftsmanship are manifest from the vocabulary we still use. Cotton itself and the acton or haqueton padded with it, are Arabic; so are alchemy, algebra, alkali, almanac, camlet, mohair, nadir, zenith. In some cases, for example alchemy and also almanac, our word is ultimately derived from Greek or Latin but reached us in Arabic form. Important textiles named from places in the Arab world are damask (from Damascus), fustian (from Fostat or Old Cairo), gauze from Gaza, muslin from Mosul, tabby (a kind of silk taffeta), named from a quarter of Baghdad. Filtered through Arabic were also Persian words: azure, from *Lazhward*, lapis lazuli; gules, the heraldic red, from *gül*, a rose; taffeta; the game of chess, from *shah*, a king; and the piece rook, from the Persian *rukh*. Other words, strictly of Greek origin, were used for materials obtained by way of Muslim intermediaries for the most part: diaper, dimity, sarsenet (meaning the fine soft silk produced by the Saracens); and the pigments ochre and cinnabar or sinoper, from Sinope on the Black Sea.

It will be noted that words of scientific type have been included along with those denoting the products of craft skill. This is logical, since ' up to ... about 1500 and perhaps much later ... technology was the parent of science.' It is not possible to separate the man who discovered or adapted a chemical process for dyeing cloth or staining glass from him who applied it. The field of practical chemistry covered during the mediaeval period was described by F. Sherwood Taylor and Charles Singer in the *History of Technology* as embracing metals, alkalis, soap; acids; ceramics and glass; pigments, dyes and mordants; combustibles, incendiaries and explosives; drugs, foodstuffs and alcoholic liquors. We have seen that the distillation of alcohol reached Europe through southern Italy. Cider seems to have become a traditional drink first in northern Spain, and to have been taken thence by the Vikings to Normandy and so to England. The name, derived from eastern origins through Greek and Latin, appears in forms such as *sicera, sither*, in the twelfth century, the time of maximum contact with the Near East. In at least one case it was not the product but

the craftsman who bore the Moorish name: the cordwainer who made boots and shoes was a Cordovaner; he used to dress his leather with the Arabic plant sumach (*Rhus coriaria*); and the skins so dressed were ' Civile ', that is to say Seville.

As we shall see in dealing with the craft guilds, these organisations of the separate skills linked to religious observances and fraternities which had some of the character of secret societies, owed as much if not more to eastern as to classical precedents. It is highly significant that guilds of craftsmen began to appear in England in the reign of Henry I (1100–1135), the generation immediately following the First Crusade and the taking of Jerusalem. Not only in London but elsewhere there is evidence of this movement; the Cordwainers' Guild of Oxford was reconstituted in 1131. After the middle of the twelfth century the number of guilds steadily increased, and the system was in full flower before 1300.

It was not only in the East that cities became famous for particular products. Sometimes there is an obvious reason such as the suitability of the water supply for certain purposes, or accessibility to mines and sources of raw material; thus Toledo in Spain and Sheffield in England have long been noted for steel of the highest quality. By about 1300 it was possible to set down a list of over a hundred towns in England renowned in some way: a few of these still make sense, such as the baths of Bath, the ferry of Tilbury and the plains of Salisbury. Wales is no longer famous for its archers, nor Northampton for its bachelors, but the school of Oxford is still with us, as are the castle of Dover and the marvel of Stonehenge. Out of eleven places noted for kinds of fish, Grimsby is still distinguished for its cod. No less than eighteen towns were mentioned for types of textiles or clothing, as Doncaster for belts, Haverhill for gloves, Colchester for russet cloth, Tickhill for shoes. But it is in some of the more specialised crafts that the surprises come. Bridport already was, as it has since remained, famous for its hempen cables, and Corfe for its marble. One would not now go to Wilton for needles, to Leicester for razors or to Huntingdon for scissors. Coventry was the centre for soap, Carlisle for horn and Reading for tiles; the neighbouring Tilehurst, with a name going back to the twelfth century, explains this last industry.

Finally we may mention another characteristic shared by the eastern and western cities of the Middle Ages and retained by oriental and Moorish towns today: the localisation of crafts. In many places the street of the oldest buildings is the Shambles of the butchers, whose traditional trade does not need modernisation. In London there are still names which recall former agglomerations of the same kind: Bread Street, Fish Street, the Vintry, the ward of Cordwainer. Research has shown that this principle was all but universal: it existed in old Paris, in the cloth towns of Flanders, in the cities of Germany and Spain. We can visit Fez or Tetuan where the division into quarters and groups is still alive, and see

the dyers or the potters working close together, or the coppersmiths or ploughwrights. In such ancient centres it is possible to see at work the unity in diversity of mediaeval craftsmanship.

Chapter 1

The Crafts of the Middle Ages

The total number of different crafts practised is too large for detailed consideration to be given to all of them. In this book attention will be concentrated particularly on trades and occupations linked with the fine arts, with architecture, and with engineering. The many practitioners of even these skills provide a wide field for study. It is, however, first necessary to survey the whole field of skilled craftsmanship in the Middle Ages to get some idea of the complexity and sophistication of the scene. It is all too easy to see the period as simple and even crude and to picture mediaeval people as not far removed from savage tribesmen. Perhaps worse is the tendency to suppose that the men of former times had less individual personality than people of today. This completely false impression has been produced in part by the destruction of personal letters and other records which alone can throw a clear light on motives and intentions. In part too it has stemmed from a failure to compare like with like: every age has its rulers and its servants; its administrators and its clerks; its skilled craftsmen and its unskilled workmen.

Only by considering each category of society by itself, and by comparing it with like categories of other places and in other times, is it possible to reach any firm conclusions. To anticipate, it must be said that there is not a jot of evidence to suggest that human personality has changed in kind or quality in the course of recorded history. Nor do the changes in degree reflect any detectable development: they are 'horizontal' changes, cutting across the spectrum of human activity at any one time. Indeed, it might well be argued that, in so far as there has been a modern reaction against hero-worship or the cult of personality, to that extent there has even been a reduction in variation between one man and another. The outstanding in any category, as saints or sages, soldiers or statesmen, artists or technicians, are rare at all periods; the undistinguished is the norm. It is as idle to search for distinct personalities among the factory workers at the conveyor-belts of today as among the hundred thousand labourers on the Great Pyramid between four and five thousand years

ago. By lucky chance some record of a freak or eccentric among the multitudes may occasionally be preserved; that is all.

The men of the Middle Ages were at least as sensitive as ourselves over the risks inherent in the use of machinery. On each occasion when a fresh mechanism was invented there was a long protest against its use. This was, in the periods before the Industrial Revolution, not on the ground that the machine took away jobs, but because the work turned out was regarded as inferior. This was, for example, the case with the spinning-wheel, invented by the early thirteenth century and soon widely adopted. At Speyer in Germany the wheel was certainly used by 1280, but by 1298 the Drapers' Guild there forbade the use for warp threads of wheel-spun yarn. It was not easy to convince mediaeval men that a new invention could produce as sound work as the old methods; and since ideas of quality and durability reigned it was necessary to prove superiority over many years before there could be general adoption.

For the ' high ' Middle Ages, the late thirteenth and the fourteenth centuries, there are enough records to give some idea of the occupations which together made up a typical city. Although the figures are inexact and in any case were constantly changing, the number of different ways of earning a living varied around a hundred. In London a list of the different occupations was compiled by the Brewers, interested in possible lettings of their hall, in 1422. This showed 111 trades, but even so a few were omitted. The number of organised companies was less, amounting to some 80; about the same time we hear of the 67 misteries of York, again referring to organisations. There too the actual number of trades was larger: by careful analysis of the Poll Tax returns of 1381 Mr Neville Bartlett has produced a list totalling 116. Of these occupations some were professional and clerical, and by subtracting these we get a real total of a hundred, more or less.

The Poll Tax, which did include 20 clerks, was a lay subsidy and so did not name the clergy in holy or regular orders, who were set apart from the worldly scene. Undoubtedly some of them were, as writers and illuminators, in competition with lay scriveners and painters. The lay professions included, in the York of 1381, an attorney, two Men of Law, a bailiff, a broker, a chullour or pardoner, four gentlemen so described, three leeches and one *medicus*, three scriveners and three sergeants, probably the nearest thing to an official police force. The postal service was in the hands of a single messenger. He may have been a personage of considerable standing, as his predecessor Stephen le Messager, or *nuncius*, of Bootham, had left the very large sum of £20 (say £6,000?) to the mending of the public street about 1250. Transport occupied one carrier and two carters, 13 porters and three waterleaders who took water to those who still had no piped service.

As a general rule, mediaeval craftsmen with their own business were small capitalists in trade. That is to say, they both made the objects

within the competence of their craft skill and also sold them. Their premises were both workshop and shop in the modern sense of the word. None the less, and in spite of frequent attempts by authority to put down 'forestalling and regrating', there was already a large class of middlemen pure and simple, who lived by buying cheap and selling dear, without contributing any handiwork to the product. Mediaeval moralists inveighed against such men and preached the doctrine of the open market and the fair price. Produce, they said, should be brought in to market or sold in open shops and stalls on the main streets in broad daylight. In this way the buyer could form a proper judgement of what was offered (hence the legal maxim of *caveat emptor*) and pay a proper sum which was what the actual producer could afford to accept. Regratery, in its original sense no more than retail trade, came to have pejorative overtones and to imply unfair and excessive profit. This reflected the criminal law which strictly forbade engrossing, the buying up of foodstuffs of any sort to sell again wholesale; forestalling or speculation in future prices; and regrating which was buying to sell again in the same market or within four miles of it. These offences were still prosecuted with rigour long after the Middle Ages and indeed until they were reduced by an Act of 1773. It was not until 1844 that the whole of the old law was repealed in Britain, and in the United States of America much of the legislation against trusts and monopolies is still based upon the older principles of English law.

There was of necessity one major loophole: the need to import substantial quantities of foreign goods and to dispose of them to the consumer. Such importation and resale were the work of merchants who tended to be among the richest and most influential members of the community. It was they who, as merchant-venturers, took risks with their capital in sending ships to overseas ports to bring home the most profitable cargoes. There was also a need for some clearing house between the multitude of small weavers and home producers of textiles and those who wished to get a length of cloth: to fill the gap the trade of mercer came into being. Likewise the grocers (literally those who bought by 'gross' or wholesale) emerged to deal with the distribution to the public of pepper, spices and related provisions. As time went on there also grew up a category of miscellaneous shopkeepers, the chapmen, some of whom were itinerant. So in the population of York in 1381, even from an imperfect and minimised return, we find totals of 24 merchants, 36 mercers and 22 chapmen. It is also probable that some of the 32 drapers and 12 spicers were only middlemen, having no hand in any process upon the wares they sold.

The total number of persons identified by occupation in Mr Bartlett's lists was just over one thousand, and the middlemen accounted for nearly ten per cent of this. This includes 14 mariners – that is, master mariners – whose homes were in York and whose ships were, in effect, registered there; but Mr Bartlett's total of 96 men in trade omits a huckster

and a pedlar (in his miscellaneous category), and takes no account of drapers, spicers and others who are likely to have been traders rather than craftsmen. The professional and quasi-professional class amounted to nearly fifty. Consequently there were about 850 men actively engaged as their own masters in approximately one hundred crafts. Naturally the numbers varied enormously: there were 75 weavers and 73 tailors, 44 tanners, 44 cordwainers and 40 carpenters and joiners to only one clock-maker, one embroiderer, one maltster, one pursemaker, one plasterer, one hatter, one mattress maker and one arrowsmith.

We are, of course, discussing only the independent craftsmen of York. There were besides several categories of employees and of semi-skilled and unskilled workers. About these it is difficult to be precise. In the first place, the returns to this taxation suppressed a great many servants, whole-time employees who should have been taxed under the household of the master who employed them. Similarly there are few mentions of apprentices, though many master craftsmen had at least one apprentice and, by this date, commonly more than one. Another important factor was the presence of over 200 men described as labourers. Some of these had taken up the freedom of the city as labourers, and it is not clear exactly what services they offered to perform. It is safe to say that many were day-labourers, men who were hired for doing jobs and formed a pool of labour, perhaps largely unspecialised. Others may have been fully qualified but freelance craftsmen or men who had come down in the world.

What was the total population against which these figures must be set? It was probably larger than has generally been admitted. The tax of 1377 showed that York had not less than 7,250 inhabitants over 14, and from actuarial probability this implies a total of at least 11,000. It was pretty certainly more, for even the 1377 returns are under suspicion of having been lightly cooked, whereas those sent in four years later (showing only 4,000 persons over 15) must indeed have been done to a turn. Then we have one firm fact, coming from a few years later: that on Good Friday 1396 King Richard II distributed alms of 4d each to 12,040 *poor* persons at York. As this figure comes from an official book of accounts and agrees with the total sum, it must be accepted as indicating a population of York and its immediate neighbourhood of the order of 15,000 at least. From the 1381 subsidy it is possible to put the number of households at close to 2,000, nearly twice the number of independent men with identifiable occupations. Many of those listed have no occupation now legible and there are the 200 labourers to set on one side. Allowing for names and occupations now lost, the second city of England had a thousand crafts-men, each running his own business, in addition to professional men and traders.

It has already been said that these craftsmen were spread out, very unevenly, among about a hundred different trades. Not counting purely

mercantile and non-productive sections of the community, the main groups of crafts were: textile workers in 16 different trades, 250 identified individuals in all; leather workers (164 persons in 13 trades); victuallers concerned with food and drink (another 13 trades occupied by 136 men); the metalworkers (112 in 20 crafts); and the group of building trades and their subsidiaries, 14 in all (107 men). There were about 24 miscellaneous crafts besides, some of which have been mentioned. Among the rest were 13 barbers, 9 bowyers, 9 fletchers, 7 coopers, 6 millers and 5 horners. There were also 5 shipwrights, showing that York was a centre of shipbuilding as well as a maritime port, and three cartwrights provided for land transport. Some of the most interesting crafts were represented by very few practitioners, or only one. There were three gardeners, two bookbinders, one buckler maker, one clockmaker, and one mould maker. There was also one money maker, implying some slight activity at the York mint.

Unlike London, where many records have been lost in fires, York preserves the record of admissions to its freedom back to 1272, the first year of Edward I. Since the ' freedom ' was an integral part of the practice of many crafts, something must here be said of the system and its implications. From later Saxon times England had been divided into counties or shires, each responsible to the king through the sheriff (shire-reeve). This implied that cities and towns were treated just like the rural generality of the kingdom, and made few allowances for the pride of citizens, a class of growing wealth and local influence. London had always enjoyed special privileges and effective self-government, and after the Conquest it became the aim of all towns of substance to secure like privileges. Their claim was for liberty, freedom from direct servitude to the royal collectors of taxes; but by a paradox the historical result of civic liberties was often a greater degree of servitude for the citizens themselves. Municipal corporations tended to become closely knit oligarchies in the hands of a small group of the wealthiest merchants and traders; the ordinary little man, the typical master craftsman actually making the goods he sold with the help of one or two servants and an apprentice, was seldom to have much influence upon local affairs.

The gravest burden upon these small independent craftsmen, a burden which was to grow heavier as the centuries passed by, was the municipal taxation which they were forced to pay. First and foremost was the payment to take up the freedom, the right to practise their craft and sell their products. The charges varied greatly, from quite a small sum in the case of those who claimed the right by patrimony – as sons of their fathers who were freemen; ranging up through a larger fee demanded of those who had been apprenticed to freemen; to very heavy dues payable by foreigners. The word ' foreigner ' had the sense still applied by local dialect usage: everyone not a local inhabitant. People from other countries were aliens, and had to obtain denization from the Crown to

be allowed any privileges at all. On top of these payments due before a man could start up in business, there were far heavier impositions later on. A man of any substance was called upon to take up civic office: not merely the minor routine jobs such as constable served unpaid by the year throughout the country, but progressively more costly and time-consuming ' honours ' as members of the borough government: chamberlain, bailiff, sheriff, mayor. Apart from this, a man could easily be victimised by being fined heavily in the borough courts for relatively slight offences against the local regulations.

It was typical of the Middle Ages that, though all this was possible, there were also routes of escape. Outside the municipally organised system were free occupations, not tied to a borough. Such were the Tinmen of the Stannaries in Devon and Cornwall, the Free Miners of the Forest of Dean, the Minstrels with their own Court at Tutbury, and above all the Free Masons who held their own assemblies under the ' Constitutions '. These independent bodies, some of them national in scope, were very ancient. The tinners already possessed privileges in 1198 when William de Wrotham was appointed their warden, and in 1201 King John granted them official confirmation. By that time the produce of tin had risen to some 400 or 450 tons a year from 70 tons in 1156 and 350 tons in 1171. Like the masons, the tinners were all free men and could not be subjected to villeinage in the country nor tied to municipal regulations in a borough. It was said of the free miner that he ' paid taxes not as an Englishman but as a miner. His law was not the law of the realm, but that of his mine. He obeyed the king only when his orders were communicated through the warden of the mines, and even then so long only as he respected the mining law. His courts were the mine courts, his parliament the mine parliament.' In the same way Master Walter of Hereford, mason, was granted a ' free court ' of jurisdiction over the workmen at the building of Caernarvon Castle in 1305. This was not an isolated case, for thirty years earlier the masons' lodge of Strassburg Cathedral was one endowed with the privileges of ' freed masonry according to the English fashion', and had its rights confirmed by the Emperor Rudolf 1.

These crafts with a roving commission and independence from local authorities attracted many men, but they provided only a limited range of opportunities. Of much wider application was the freedom conferred by dwelling within an exempt jurisdiction or ' Liberty '. Most of these were religious in origin or owed their existence to the protection of some great church or monastery. They existed in or side by side with most cities and towns, and for centuries remained free from the interference of civic authorities, constables and tax-collectors. They had indeed to pay church rents and dues, but no admission fees were exacted and no offices had to be served under compulsion. No wonder that extensive liberties such as that of old St Thomas's Hospital in Southwark were hives of artistic

industry and included many aliens as well as English craftsmen. In York exactly the same thing applied within the Minster Close and certain parishes belonging to St Peter's Liberty; in the Liberty of St Mary's Abbey along Bootham and in Marygate; in Mint Yard belonging to the great Hospital of St Peter, later of St Leonard; and in some minor areas.

The craftsmen who did take up the freedom of a city by no means, therefore, comprised all the craftsmen of the district. Many others, no doubt including some of the most important for the aesthetic quality of their work, lived under the protection of the Church and were largely if not entirely independent of the townsfolk and the local authority. Unfortunately there are comparatively few detailed records of the inhabitants of these exempt areas until a relatively late date, and it is to the municipal records that we have to turn for much of our information on the crafts practised and the individuals who exercised their skills. The York register of freemen, in the years from 1272 to 1300, shows for example the admission of Abell the goldsmith in 1272, of William Skot, locksmith, in the following year, as also of James ' le nayler ', evidently a nailsmith. In 1275 is the first recorded carpenter, Mathew de Yekam and in 1277 a goldbeater, William de Popilton. The year 1283 saw Thomas de Brandesby, ' potter ', made free, and also Robert ' le Bellegeter ', i.e. the bellfounder. It is probable that both men were of the same trade, for bell-founding was a principal occupation of men called ' potter ', that is to say maker of metal pots. In 1294 and 1296 come the first two masons so described, William de Carleton and Walter de Skotton. In the latter year Henry le Plummer became a freeman, along with Richard Godwynn, ' nedeler '. What kind of needles Godwynn made is uncertain; perhaps of bone, for steel needles were not to reach England for another century. The first recorded York sawyer, Henry de Richemond, was made free in 1299, as well as an alien from Bruges, Roger le caldroner. A more difficult and highly specialised trade, that of wire-drawer, was exemplified in 1300 by Ralph de Notingham.

The first appearance in the freemen's register of several other crafts is of considerable interest. In 1309 there was a latoner or brassworker, Nicholas Musket; in 1313 the first riveter, Richard by name; in 1333 William Whitebrow a plasterer, and next year Gilbert de Ilkeley, gardener. The earliest of York's bookbinders, Adam de Oxenforth, arrived in 1343, probably straight from Oxford. In 1348 there was a pewterer, in 1349 a joiner and also a pinner (maker of pins); in 1350 a ' moldemaker ', Richard de Duffeld. The making of moulds, possibly for casting leaden ornaments, perforated grilles, pilgrims' badges and the like, was one of the most highly sophisticated trades of the time, and marked a significant step towards mechanical production (152–3). In the following year, 1351, Roger de Hornyngton was admitted as a gardener and Robert de Goldesburgh as a ' herberer ', presumably meaning a specialist

C

in pleasure gardens and arbours – the mediaeval equivalent of the landscape gardener. The description is not unique, for Roger le Herberur had been gardener to King Henry III and in 1275 was still being paid his wage of 2¼d a day at Westminster.

Some significant trades made their appearance after the Black Death in the middle of the fourteenth century. Edward III was making a serious attempt to put the country on its feet and took steps to encourage various skills. He also invited aliens to trade and to settle. By the Statute of York of 1335 merchant strangers were allowed to trade freely throughout English cities and boroughs. Later he brought in Flemish weavers and this may have indirectly encouraged new developments, for in 1366 three ' tapetters ', tapestry-weavers, became freemen of York and in 1380 eleven coverlet-weavers; all these men have English names, indeed most of them appear to have been of Yorkshire origin. Though not the earliest reference to tileries near York, the first tilemakers to be freemen, John le Sauscer and John de Heselbech, had arrived in 1352. In 1372 a carver, Richard de Harewod, took up the freedom, indicating a new specialisation emerging from the ranks of the masons and the carpenters. The new men commonly undertook sculpture both in stone and in wood.

The fact that there was one clockmaker in York in 1381 has already been mentioned. He was John Lovell, living in the parish of St Mary Castlegate with his wife Agnes. When he became a freeman in 1374, he had declared himself a goldsmith; this seems to imply that he made clocks of smaller size than the great cathedral clocks of the period which were made by blacksmiths. In 1376 had come Gelisius Browdester, probably a foreigner (in our modern sense) and an embroiderer. The year 1387 saw the first of two crafts to be enrolled: William de Colburn a millwright, and John Danyel a slater. More remarkable was the advent in 1391 of Richard de Welton, colourmaker, a forerunner of the paint and distemper industry. The fact that enough painting was going on in York for a separate business of colourman to be founded shows how important the city then was, and how sophisticated its life had become.

The York tax returns of 1381, supplemented by the remains of those for 1377, by the admissions to the freedom and by the wills of a good many citizens, for the first time enable us to get an impression that is not merely statistical. Personalities, even if mostly dim ones, can be discerned in their social capacities. Seen in a wider background of evidence for the wealth or poverty of given parishes and the distribution of trades, the bare facts become more revealing. The parish of St Martin in Coney Street (Coning, or the King's street) has always been one of the most wealthy and influential parts of York. Most of its houses were those along this main street, though there were side alleys and courtyards as well. Since the two poll taxes were compiled on different principles they cannot be used as precisely equivalent statements, but the 91 entries for the parish in 1377 agree well enough with the estimated number of not

less than 86 households in 1381. But whereas there were said to be 313 persons in the parish who paid the 1377 tax, only 203 are stated as the total for 1381. The surviving list of names of householders for the earlier subsidy shows that 72 of the 91 were married, and of the remainder ten were women. Some 40 lines of the 1381 return are illegible, implying the loss of 15 or more entries. Among the surviving descriptions are 50 wives, four widows, a sister, a daughter, a personal maid and a maidservant of the rector of St Martin's.

The list of 1377, besides being more or less complete for the parish, gives a far better picture of the number of servants employed, a total of 135. In what remains of the 1381 roll only 47 servants and one apprentice are mentioned, though their Christian names are recorded. The 135 servants of 1377 were employed by 61 of the 91 households, so that if the return is really complete we might say that two out of three homes were employers of labour while one-third of the families consisted only of a man and his wife and their children under the age of 14. Considering the 61 households with employees, 27 had only one, while in 34 there were two or more. In descending order of importance there was one establishment with 13 employees, that of Thomas de Malton, admitted to the freedom as a cook in 1335; this was clearly one of the principal inns of York. By 1381 Thomas was dead and his widow Cecilia was called 'Braciatrix', a brewer, then living with her sister Margaret and only three (recorded) maidservants, Joan, Agnes and Joan. Katherine de Barneby had eight servants and is evidently the same person as Katherine Lakensnyder, widow, of 1381, when she also paid tax for Margaret her personal maid, Emma her 'tapster', and four other female servants, Magota, Joan, Magota and Alice. Emma the tapster was the Emmota Page, servant to Katherine Lakensnyder, whose will was proved on 1 June 1390. Mrs Lakensnyder herself died in the summer of 1394. Here again the premises were an inn, though there is no information in the freemen's register as to the occupation of Arnald de Lakensnither, admitted in 1350, or that of his son Henry, who obtained the freedom by patrimony in 1381. The name appears to be Dutch or Flemish and to mean a cutter of cloth, so that the 'de', suggesting a placename, may be due to misunderstanding.

Two men had five employees each: John Mansell, a cook free of York in 1358 and living next door to Thomas de Malton; and Roger de Moreton senior, a wealthy mercer who had been admitted in 1351 and who died in 1390, survived by his wife Agnes. Mansell had died by 1381, when his widow Matilda was living with her daughter Alice and one servant Emma. There were four households employing four servants each, those of Thomas de Feriby, Thomas de Fetherstan, William de Easyngwald and John de Calthorn. Feriby was another mercer, free in 1360 and in 1381 described as a chapman. Fetherstan was probably the cook of that name who had migrated across the river to Micklegate by

1381 and who must have been the same as the Thomas de Fetherstan-
halle, cook, who had taken up the freedom in 1359. William de Esyng-
wald in the 1381 return was given as a labourer, but had been made
free in 1365 as a waterleader. With John de Calthorn we meet with a
genuine craftsman, free as an armourer in 1367 and described as such in
1381, living with his wife Margaret and four servants, Robert, John,
Agnes and Alice. He died in November 1398.

Among those with three servants, nine in all, were Richard de Sharowe
named as a hostiller (innkeeper) in 1381, and Thomas Pay, yet another
cook, free in 1366. Robert Talkan, who lived to the south of St Martin's
church, was an important merchant who became mayor of York in 1399
and M.P. for the city in 1402. Constantine del Dam, perhaps from
Damme in Flanders, was a spicer in 1381 but described himself as an
apothecary in his will of 1398. His establishment is noteworthy as the
only one in the parish where an apprentice is mentioned (in 1381).
Richard de Anlaby and Thomas de Horton were dyers. There is con-
clusive evidence that most employers of labour were either keeping inns
or were in trade rather than craftsmanship, in a wealthy district. It
remains to be seen what the position was in a parish known to have
been a centre of handicrafts.

Among those parishes that remain in the taxation of 1377 the one with
most artist craftsmen was St Helen Stonegate. The figures indicate the
same story as in St Martin's: there were 86 entries in 1377 with a total
of 211 persons recorded; but in 1381, with probably 95 or more house-
holds, only 183 were taxed. Again, the men with larger numbers of
servants were all of the mercantile class. Ralph de Horneby, with five,
and Simon de Clapham, with four, were drapers; John de Ripon, also
employing four servants, was a merchant; William de Levesham, with
three, was a spicer. The identifiable craftsmen included five glaziers and
glasswrights, only one an employer: John de Preston with a wife and
three servants. In 1381 his wife was named Cristiana and he had two
servants, Arlaund and William. Of two carpenters only one had a serv-
ant; so did the single joiner in the parish. A cutler, two goldsmiths, and
a smith had no servants. The single mason, John Sawnderson, had three
servants: he had been made free of the city in 1347. Our old friend Adam
of Oxford the bookbinder had a wife and two servants; in 1381 his wife
is named as Amy and their one maid as Cristiana. Adam's first wife Avice
had died in 1370; Amy or Amisia made her will in July 1387 and it was
proved on 26 August; Adam lived on until January 1390.

The carpenter with a servant was named Robert Downe in 1377 but
was clearly identical with the Robert de Dounom, wright, of 1381. He
had taken up the freedom in 1364 and had a wife with the unusual name
of Arnburga and a servant William. On 14 June 1377 Dounom and
Stephen de Barneby, carpenters, undertook a contract to carry out repairs
to the gaol of York, in the Castle (see Appendix 1); and by 1399 Robert

Downan was the master carpenter on the works of York Minster, remaining in office until 1404 or later. During that period his pay rose from 2s 6d a week to 3s. Presumably he was dead before 1415, when John Askham was master carpenter at the Minster. It may well be that Downam both designed and supervised the erection of the wooden vault of the choir and presbytery of which the present vault is a facsimile made after the fire of 1829.

It is unfortunate that so little remains of the lists of 1377, for they must have given a fairly complete picture of the numbers of employees. Considered along with the smaller numbers of servants recorded for 1381 they do, however, confirm the general view that the handicrafts of the Middle Ages were to a large extent in the hands of ' little masters ' with the consequent expectation that most young men who entered a trade could hope to have a shop of their own in due course. It is remarkable that in the one parish covering an exempt liberty for which there is a 1377 return, namely St Olave Marygate with St Giles, the number of employers of even one servant is very small indeed. This again supports the conclusion that such privileged areas formed a refuge for the poorer craftsmen who could not afford the high dues and other outgoings involved in work as freemen of the city. Only some 28 servants out of a recorded total of 243 persons taxed in St Olave's contrasts sharply with the 67 servants out of only 203 taxed in St Saviour's at the other end of York.

It remains to consider the classification of mediaeval crafts. The main divisions have already been mentioned, according to the various needs supplied, but across those lines there runs another grouping: was the work done concerned with the production of a raw material; with the making of parts or components; with finishing? Most of the crafts in the first category were performed outside cities: the work of miners, foresters, limeburners, and all the operations of agriculture and fisheries. The manufacture of parts and components and the carrying on of sectional processes which contributed towards some end product were exemplified in the work of dyers, fullers and shearmen in the cloth industry; of curriers, parchment makers, skinners and tanners in relation to leather goods; of arrowsmiths, bladesmiths, goldbeaters, nail makers, needlers and pinmakers, riveters, wiredrawers in the trades dealing with metal. Some jobs were essentially simple; others demanded long experience and knowledge of secret processes such as those employed by dyers and by bladesmiths. Then again there were crafts which contributed to the making of what we term fine art, others not.

Disregarding the question of durability – for all the victualling trades and some others were concerned with short-term consumption – we may say that an element of fine art and of creative design entered, or might enter, into the work of embroiderers and tapicers; of cooks and saucemakers; of glovers, pouch and pursemakers, and saddlers; of glaziers,

joiners, masons, painters, potters (both in clay and metal), carvers; of armourers, cutlers, girdlers, goldsmiths, latoners; and among the miscellaneous occupations, of bookbinders, cartwrights, chandlers, clock-makers, gardeners, hatters, moneyers, mould makers, scriveners and shipwrights. Together with the already largely mechanised skill of weaving, these last comprise most of the categories that constitute mediaeval craftsmanship. Obviously much work in these trades was devoid of aesthetic content, but within them we look for the choice products of the age. Some of the things made are gone for ever. We cannot taste the food prepared by mediaeval cooks nor relish the refinements of the saucemakers. Of the gardens we can form only a faint idea through descriptions and pictures, and reconstruct by the identification of plants.

We are led back to consider the intentions of the artists and craftsmen. Certainly their works were meant to please the eye; to perform some useful purpose; and except for articles of immediate consumption, to have a long life. These intentions were comprehended in a wider one: to work to the greater glory of God, and so far as it lay in man's power, to imitate the Creator in fashioning things and, looking on them, to see that they were good. It hardly needs to be said that the craftsmen also aimed at making a livelihood for themselves, perhaps a fortune; but it is the particular distinction of the men of the Middle Ages that they never lost sight of the ideal of the just price and fair play between buyer and seller. Through all their trade disputes and conflicts they never forgot that at any moment their souls might be required, and that a strict account was due.

Chapter 2

Crafts and Guilds

The religious outlook of mediaeval craftsmen was, of course, the outcome of the general temper of the period. It was the accepted norm to believe the teaching of the Church, though as time went on a great many details came to be questioned. This questioning of doctrine as promulgated from the pulpit and in the confessional was in part due to the objective way of thought of practical men. The hard facts of the world as it is, what we now think of as scientific facts, impinged on skilled technicians and inventors far more than upon the abstract thought of canons in their studies or monks in the cloister. Technology was the parent of science precisely because it was of necessity based upon trial-and-error and on direct and accurate observation. Through the five mediaeval centuries there was a gradual change of outlook, quite largely linked to the progress of deliberate design and invention in the realm of craftsmanship. But it would be a mistake to attribute to mediaeval craftsmen in general any spirit of disbelief.

Like men and women of all classes in their time they were relatively pious and given to observances of prayer and church services. Their wills show that they felt an attachment for their own parish church, to which they commonly bequeathed sums in excess of any dues which might be owed, and generally something to the cathedral of their diocese as well. After the coming of the friars in the first half of the thirteenth century it also became usual for the inhabitants of cities and towns where the friars had settled to leave a small sum to each of the orders there. It is not mere flippancy to say that these bequests were of the nature of premiums paid for a spiritual insurance policy. Men were taught to believe that the pains of the world to come could be alleviated by the prayers of those still alive, and by the performance of masses on behalf of named individuals. One outcome of this in the later Middle Ages was the founding of chantries specifically in the interest of the founder, along with his family and perhaps his close friends and associates. The building of chantry chapels and the enrichment of chantry altars in churches followed.

The ordinary man could not afford to pay for a perpetual chantry, and might have to content himself with a limited number of masses during the year following his death, or for several years. To secure perpetual benefits, however, another way lay open to him. For a comparatively small sum he, and his wife, could join one of the fraternities, and from its continuing membership in the future obtain the benefit of their prayers. For the man in the street membership of some fraternity was more or less essential. Its activities were not exclusively religious: it was also a social club and a benefit society. Looked at from a wider viewpoint of social anthropology and folklore, the mediaeval fraternity was the counterpart of the secret societies and initiatory cults found in all cultures and throughout history. The fact is that the fraternity of the Middle Ages was essentially a secret association although its existence was no secret; in this respect the fraternities are paralleled by modern Freemasonry.

Society was honeycombed with fraternities, local, national and even international in scope. Of the international bodies the *Feste du Pui* is the best known, a fraternity of merchants based on Le Puy in Auvergne in central France. Its meetings are known to have been convivial and musical, but it clearly exercised influence in a practical way. It is known, for instance, that Henry le Waleys who was mayor of Bordeaux in 1275 and five years later mayor of London, was a member. It seems obvious that his membership must have furthered his career in this world at any rate. Not all fraternities were exclusive: there were many popular Corpus Christi Guilds, and the Fraternity of all Christian souls in the chapel of the charnel of St Paul's churchyard in London was for the benefit of every man, woman and child who died a Christian. We may compare this with the even wider charity of the orthodox Muslim passing any graveyard – not Mohammedan ones alone – who prays for all those that sleep beneath the ground; and the appeal made by the Carthusians to everyone to pray for every human being at the hour of death.

It is common to refer to mediaeval associations as fraternities when they existed primarily for religious purposes, and to speak of societies of lay craftsmen as guilds. Though bodies of both types existed, the line of distinction between them is always blurred. It is impossible to dissociate the two aspects in many cases, where a particular fraternity was closely concerned with the interests of a trade or group of trades or crafts. One well documented instance of this was described by the late Maud Sellers in her study of the York Mercers and Merchant Adventurers. In 1356 land in Fossgate was acquired and in 1357 a fraternal guild for men and women was to be formed in honour of Christ and the Blessed Virgin Mary. The founders belonged to the woollen industry: mercers, drapers, hosiers and dyers; they obtained their licence from the Crown and as a fraternity held their regular services in the parish church of St Crux. Within a few years the fraternity was admitting members from other trades, such as butchers, spicers and potters, and for some fifty

years the body continued to be broad and inclusive, even welcoming members from other towns. Then a change set in and by 1420 all the miscellaneous tradesmen and outsiders had been eliminated and the lay aspects of the society had crystallised as the Community or Guild of Merchants of the Holy Trinity. These merchants were in fact the York mercers and their close associates, all being capitalist middlemen. Significantly, the mercers had by this time 'captured' the municipal government of York and the manufacturing crafts had been squeezed out of such influence as they had had. In 1430 the takeover of the original fraternity and hospital of St Mary at Fossbridge was confirmed to the merchants by royal charter from Henry VI.

The close connection between religion and societies of craftsmen was not limited to Britain or to western Europe. It also played an important part in those regions of the Near East penetrated by the Crusaders between 1097 and 1291. The type of association found in mediaeval England was not derived directly from Rome or from Byzantium, for in the classical and Byzantine system the crafts and trades (*collegia*) were organised by the state and controlled by governmental nominees. Furthermore, these trade corporations had predominantly secular functions. On the other hand, precisely the same interpenetration of religious and lay interests was characteristic of the groups which started as early as the eleventh century AD in north-western Persia (Azerbaijan) and spread through Asia Minor with the advance of the Seljuk Turks. These groups, which became concerned with trades and crafts and corporate life generally, were called *Futuwwa* or in Turkish *Fütüvvet*, and their leaders were *akhi* (*ahi*), at first religious mystics but later typical guildsmen.

In the fourteenth century the Moorish traveller Ibn Battuta enjoyed the hospitality of the guildhouses of these fraternities across Turkey and commented on the excellence of their rule of entertaining the stranger. This was, of course, paralleled in the West in the duty of hospitality enjoined by the Rule of St Benedict. In Turkey traces of this hospitable aspect of the work of the guilds still exist in the guest-rooms put at the disposal of strangers by village headmen in the remoter parts of Anatolia, and run at the expense of the community. The parochial facet of guild life also found expression with us in the multitude of guilds of religious and social type attached to parish churches, in cities and also up and down the country. In Ireland the subdivisions known in modern times as townlands correspond to the ancient system of the Baile Biataigh or Victualler's Town. In every Baile ('bally') there was a public hostel, and a similar system obtained in Saxon England. Walter Map, retelling in 1182 a ghost story of about a hundred years earlier, describes how a lost huntsman found a large building at the edge of a Forest on the March of Wales. Looking through the lighted windows, a dance of numbers of noble ladies (later found to be phantoms) was seen; but to us the main interest of the tale is that the building was said to be 'such as the English

have as drinking-houses, one in each parish, called *ghildhus*.' In 1257 the Bishop of Winchester took 12d new rent for a plot of land next the moor of Ropley, Hants, 60 feet square, granted to the men of Ropley to build a house to drink their guild (*ad potand, Gyldam suam*). The name of Gildersome in the West Riding of Yorkshire, five miles from Leeds, goes back to the twelfth-century *Gildehusum*, meaning the guildhouses.

The idea of the local or parochial guild is therefore a widespread one. It had a religious basis, was social and convivial, and laid stress on hospitality. The members regarded one another as brothers and sisters. The formation of these guilds was spontaneous, not imposed by any higher authority, and this freedom of association became the mark of the later guilds associated with particular crafts. One remarkable feature of the later guilds and trade companies, possibly derived from the open character of the early parish guilds, was that they did not consist exclusively of those who followed one particular craft. It is by no means a purely modern phenomenon that the London Companies include in most cases a very diverse membership.

In the smaller corporate towns of England the number of different companies was quite small, each company covering a grouping of various crafts. The system was not the same in all places, and sometimes quite incompatible crafts joined together in a single company. There was no general rule, no such thing as a typical exception. In the larger cities the numbers in most of the principal trades were sufficient to allow of a logical grouping, but guilds joined together and again split apart according to the pressure of temporary expediency or, probably, of personal relationships. Among the London Companies the union of the Barbers and Surgeons and that between the Painters and Stainers are well known, but there were many other amalgamations and absorptions. The Armourers, an organised body by 1322, took over the Braziers and in 1506 united with the Bladesmiths. The Blacksmiths joined with the Spurriers; the Girdlers (dating back to 1271 and with a charter of 1327) came to include the Pinners and the Wiredrawers; the Haberdashers took in the Cappers and the Hatters; the Weavers, after a period of bitter disputes, united with the Flemish Weavers, set up in 1366.

To us it may seem that the distinction between a painter and a stainer is not based on any real difference, but the two crafts had quite different origins. The painters coloured saddles and other objects made of wood, and became responsible for paintings and portraits on wooden panels. The stainers, on the other hand, began by colouring hangings of cloth for walls, and the artist's typical product on canvas derives from their trade. Although at a late date the building crafts might come together, this was only after a long period of serious rivalry. In general the masons who built of stone were opposed to the combination of the tilers and plasterers, who put up houses of their alternative materials, either with timber framing produced by the carpenters, or by using brick, a product of the

tile industry. It became necessary in the long run to join together for mutual protection. So the drapers came to terms with the weavers, the dyers, the fullers and the shearmen; the skinners with the curriers and whittawyers; the leathersellers with the glovers, pursers and pouchmakers; the cutlers with the sheathers.

The complications of getting a house built when the crafts were still separate are well shown by the arrangements that had to be made in 1408 to erect seven shops in Knightrider Street in London, on the north side of the garden of the great hospice of Old St Paul's, where Master Walter Cook, one of the canons, lived. Master Nicholas Waltham, carpenter, contracted to do all the carpentry except tilepins for £55; John Teffe, mason, undertook to make the underground latrines, walls, chimneys and foundations, for £20; John Smyth, tiler, was to tile the whole 'Rent' and to repair the tiling of other houses damaged by the works for £1 8s. 1d; Hore and Nicholas, two masons, working with their two mates for 2 weeks and 3 days, taking each with his mate 1s. 1d (i.e. for all four) were paid 17s. 6d for turning a vault (over the basement) and for rendering the high wall inside and out and for closing six seats of latrines; two daubers got £2 6s. 8d for daubing and another 10d for daubing six 'loupes' for the kitchens. In addition there was considerable expenditure on materials supplied at the clients' cost: 13s. 2d for 13,200 roofnails; £4 16s. 3d for 21,000 tiles; 5s. for 100 'rofetyl' (probably ridge tiles); and 1s. 8½d for 4 bushels 1 peck of tilepins. For floors there were 3,900 red Flanders tiles for 19s. 6d; 500 white tiles for 'coperons' (of fireplaces) cost 3s. 9d; seven 'clyketlokkez' with keys, for the pantry doors, came to 2s. 11d, and 2s. 4d was paid to Toche the smith for seven new clyketloks without keys, because the keys came from store.

Since the municipal authorities exerted themselves to keep control over the guilds, and insisted on authorising ordinances and regulations, we have numerous copies of such rules. Unwin quotes as typical those of the London Hatters, made in 1348: (1) wardens were to be sworn to rule the trade; (2) none but freemen were to make or sell; (3) apprentices were to be taken for not less than 7 years; (4) only freemen were to take apprentices; (5) the wardens were to search out defective work and take it before the Mayor and Aldermen; (6) none to be made free of the city or allowed to work unless attested by the wardens; (7) none to receive another's apprentice or servant unless he had been properly dismissed; (8) no apprentice or servant in debt to his previous master to be received; (9) no stranger to sell by retail, but only wholesale and to freemen.

The control exercised was particularly strict in resisting the entry of strangers – not only aliens from abroad, but 'foreigners' to the particular city or borough. In 1312 there was a petition to the City of London that no stranger should be admitted at all unless certified by the

merchants and craftsmen of his own trade, but this was not in fact absolutely enforced for some time. In 1364 a London regulation was made that admission was conditional on having served in a mistery for seven years and having paid a fee of £3 or more for the freedom. A fully qualified master craftsman in one of the building trades would at that time have earned, in regular employment, about 3s. to 3s. 4d a week plus some perquisites.

Each craft guild exercised considerable powers: usually the London companies had full control within London and for some miles round it but not elsewhere. Exceptionally, the Company of Goldsmiths was granted jurisdiction over the whole of England by its charter of 1327, and some other companies later obtained similar rights. The Pewterers, for instance, were granted rights of search over the whole country in 1468 after a campaign lasting 16 years. Within a short time the guild had been able to enrol 32 pewterers, braziers and bellfounders from different parts of England, paying fees that varied from 3s. 4d to £1. The right of search meant that officials of the guild or company carried out regular inspection of all that was done by their craft, confiscating and destroying work found to be below standard. They also investigated complaints by the public and gave evidence before the civic courts in relevant cases. The limits of jurisdiction, whether extending to the whole of the London area or to the whole country, did not normally cover areas of exempt privilege.

Certain ancient guilds enjoyed their own privileges and immunities, analogous to the free courts of the tinmen, miners, minstrels, masons and other itinerant craftsmen. Even though settled in London the Fishmongers held their regular Hallmoot courts, a separate jurisdiction within the trade exactly comparable to the capitulations formerly enjoyed by the subjects of western powers in the Turkish Empire, China, and elsewhere. Several other guilds had courts of this exempt type, notably the Weavers, who had been privileged by charter from Henry I early in the twelfth century. The exceptional importance of the craft of weaving was recognised not only by this charter to the London company, but also by privileges extended to the guilds of weavers at Huntingdon, Lincoln, Nottingham, Oxford, Winchester and York. The guild of Fullers at Winchester also had a privileged status. In general such privileges meant that disputes concerning any member of the guild would be tried in the guild's own court, and not in the ordinary local courts of the place.

During the mediaeval period there was a strong current of internal development within the guilds. As a general, perhaps over-simplified, picture it may be said that at an early date the main force in the larger cities was a Guild Merchant, a society of the wealthy traders of the place, irrespective of their individual trades. With the growth of the trade guilds, each at first representing one craft skill, the power of the Guild Merchant was reduced and eventually the institution disappeared. There followed

a period of divided control by the various crafts, for the most part in the hands of a substantial number of 'little masters', each a quite small capitalist. It was implicit at this time that everyone joining the guild had a reasonable expectation of achieving his own shop, training his own apprentices and employing one or more servants. But these servants might well be young men who had served their full term as apprentices and were employees only for a few years, until they had saved enough money to enable them to set up on their own.

This period of the craft guilds roughly corresponded to the thirteenth century and its character was what in modern terms would be miscalled 'democratic'. There was not as yet, even in London, any rigorous distinction into greater and lesser companies, with concentration of effective power entirely in the hands of the former. None the less, the privileges which had been obtained by such bodies as the Weavers and the Fishmongers did already confer on them a substantial preponderance. As time went on the guilds of middlemen came to play a bigger and bigger part, and there was steady increase of power among the greater companies, while the lesser guilds lost influence. Before this had happened the system of the London craft guilds had emerged as temporarily triumphant over the older oligarchical system under the leadership of Walter Hervey, bailiff in 1265, sheriff in 1268, and Mayor in 1272–73. Apart from its curiously revolutionary aspects, Hervey's system is remarkable as offering a radically different method of election to the normal one of topographical constituencies. In his view, representation should be through the crafts themselves, a distant preview of the concept of the corporative state; and until 1384 elections to the Common Council of London actually were, off and on, held on this principle, for example in 1312 and after 1351.

Walter Hervey became Mayor of London while Henry III was dying at Westminster, his last hours disturbed by the shouts of the popular party. Though this craft revolution lasted only for Hervey's year of office, its repercussions were felt for a long time. It is especially to this period, in which the craft guilds for a time obtained the ascendancy, that modern 'guild socialists' have looked back with nostalgia. William Morris and his followers, seeing the Middle Ages through rosy spectacles, did find some justification for their theories in the social, economic and political condition of England in the reign of Edward I (1272–1307). Given a qualitative rather than quantitative assessment, the work of that period was effectively better, and most of the workers who produced it better rewarded, than at other times. It is true that the craftsman of the thirteenth and fourteenth centuries enjoyed few luxuries; but he did enjoy the great benefits of a stable value of money and of an adequate supply of the essentials of life.

The core of the Middle Ages in England consisted of the years from the accession of Edward I in 1272 to the death of Richard II and of the

poet Chaucer in 1400. Life did not stand still, but within that century-and-a-quarter art and craftsmanship attained a peak of achievement at a level kept up until the fifteenth century had begun. From the political revolution of 1399 onwards the country suffered a grave decline which reached its nadir in the Wars of the Roses, with a slow recovery under Edward IV and a return to real prosperity after 1485. Even before 1400 there had been signs, at any rate in London, of a decisive change in the balance of municipal power. The Common Council, for some time elected by misteries, craft by craft on the principle enunciated a hundred years earlier by Hervey, finally returned to election by wards in 1384. From then onwards aldermen were eligible for re-election without any interval, and ten years later they became irremovable. All effective power passed from little masters of the handicrafts to wealthy capitalists of the distributive trades. This pattern became more marked after 1400 and, as we have seen, York had been captured by the Mercers by 1420. For the rest of the Middle Ages development tended always in the same direction.

In the guilds and companies the distinctive feature of this late mediaeval development was the livery. Livery, something delivered, came to mean specifically a distinctive dress handed out by a patron to his clients or by a guild or fraternity to its members. The idea started at the highest level with royal liveries to household servants, and the general fashion of livery was promoted by Edward III's grant of the livery of the Garter to his new order of knighthood. From the middle of the fourteenth century the tendency was towards internal differentiation, within each guild, producing two or more categories of members. The higher class of members received livery, the rest did not. Sometimes an intermediate class was formed by granting full livery of a gown and hood to the most influential members, a hood alone to those of the second class. In 1430 the London Grocers consisted of 55 members in the livery, 17 in hoods, and 42 'householders' not in the livery. Purely honorary liveries were given to outsiders, including women, but this did not imply real membership. Edward III set a fashion followed by many later sovereigns in taking up membership of the company of Merchant Tailors and Linen Armorers, and this contributed to the pride of the livery of all the companies.

As the fifteenth century wore on the distinction between the livery and the common membership of householders became increasingly definite, and the rank-and-file, not of the livery, steadily decreased in status. Below them, too, there were the servant employees and the apprentices in each craft. In the Pewterers there were at one time 41 of the livery paying quarterage, 15 householders, 32 covenant servants, and 94 apprentices. In 1485 the Goldsmiths had 56 in the livery and 73 young men out of the livery. The servant or journeyman in many trades no longer had any real expectation of being able to better his condition. Many of the apprentices, those with little or no financial resources, would never rise

to have a shop of their own, however modest. They were no longer even regarded as fully effective members of their own guild. This in turn gave rise to the formation of Journeymen's Guilds, parallel to the main company representing the craft. It should be stressed that the word ' journeyman ' never had any connection with travel or with the wanderyears of junior craftsmen; it meant purely and simply those who worked for daily wages. The development of these ' low level ' guilds inevitably gave rise to disputes and ill feeling between the two bodies, and was in direct opposition to the fundamental theory of the fraternities.

Even though class warfare was not yet recognised as a thesis, all men were no longer brothers, and much of the bitterness of trade disputes in later times can be traced back to this unhappy division between the privileged liverymen and the downtrodden generality of each craft. Many different factors, reacting with one another, had joined to bring this about. Going back to the early fourteenth century there was, in first place, the general trend towards a money economy. The older ideals and legal tenures based upon service were giving way before the convenience of fixed rents. This commutation of actual works into money equivalents, and the consequent mental attribution of values in financial terms to most relationships of life was certainly the fundamental change underlying all that came later. But within a generation or so of this new economy the international calamity of the Black Death of 1348-49 more than doubled its effect. The appalling death-roll of this epidemic of bubonic plague had two main effects. Spiritually and psychologically it attacked men's faith and set a premium upon the notion of ' eat, drink and be merry '. This could not be fulfilled without money, and the winning of higher wages became quite suddenly a primary goal. At the same time the material result of the plague, an intense shortage of labour, offered to the survivors the possibility of reaping maximum rewards.

In London and the Home Counties from 1350 onwards very many names of craftsmen are of northern origin. Place-names from Derbyshire and the surrounding area are much in evidence; it is as though some part of the country north of Trent had suffered a lower mortality and was able to furnish a reservoir of craftsmen to fill the gaps in the ranks. Several successive seasons of bad weather and poor harvests, culminating in the plague years when much of the harvest could not be carried for lack of hands, added to the severity of the crisis. The price of corn and foodstuffs shot up, so that there was for some time a marked spiral of inflation. This in turn sharpened the incentive to higher earnings, and to the chaotic free-for-all which ensued, the Statutes of Labourers were the only answer which the politicians of the time could devise. The attempt to fix wages at their former level failed, then as before and since; but in the fourteenth century the rigorous prosecution of workers who took ' excessive ' wages did have some effect. The lowest paid suffered most in the struggle, whereas men of exceptional skill were able

to plead that they were entitled to special rates above the average. The result was to increase differentials, one of the root causes of the change from unitary guilds to companies with an internal class structure.

The building crafts were particularly active in rebelling against the attempt to pin wages down. Building was one of the few necessarily large-scale industries and its influence was crucial. The story can be read between the lines of several Acts of Parliament, supplemented by moralistic comments from John Wycliffe and others. In an Act of 1360 (34 Edward III, c. 9) congregations and chapters of masons and carpenters were to be void and wholly annulled, and this was evidently directed against illegal conspiracies to raise wages. Wycliffe a few years later, in *The Grete Sentens of Curs*, declared that the curse of God and man would fall on all false conspirators and notably upon ' all new fraternities or guilds made of men . . . also men of subtle craft, as free masons and others ' who ' conspire together that no man of their craft shall take less on a day than they set.' The Act of 1425 (3 Henry VI, c. 1) condemned the breaking of the wage-rates laid down by the Statutes of Labourers ' by the yearly congregations and confederacies made by the masons in their chapters assembled '. In future those who held such assemblies would be guilty of felony and others who attended them would be liable to imprisonment and fines. No evidence has ever been found of prosecutions under the Act, which seems to have been a dead letter. Yet another Act of 1437 (15 Henry VI, c. 6) took a strong line against the rebellious attitude of the companies generally, for ' Masters, wardens and people of guilds, fraternities and other companies corporate ' have ' made among themselves many unlawful and unreasonable ordinances as well in prices of wares and other things for their own singular profit.'

We have digressed from the subject of the liverymen of the craft guilds, and something remains to be said of the livery itself. One might have expected that every company would have its own distinctive livery, but this was not the case. In any one year it was customary, at any rate in London, for all companies to wear the same colours, though distinguished by badges or cognisances worn on the sleeve. Both the gown and the hood were parti-coloured, and the colours worn in several years are on record: scarlet and green in 1414, scarlet and black in 1418, scarlet and deep blue in 1428, violet-in-grain and crimson in 1450. When the whole of the City Companies rode with the Mayor to Westminster and back to the City, as was the custom at the Midsummer Watch, the sight must have been impressive. In 1417 it was recorded that ' of old custom the crafts of the city have been used to ride with the mayor to the palace of Westminster and from thence to the city again, and that when they came in Cheap every craft, each by other holding, on horseback abode till the Mayor rode through them.'

When royalty entered the city the crafts played a great part in the reception. At the coming of Elizabeth of York in 1486, ' along the

streets from the Tower to Paul's stood in order all the crafts of London in their liveries and . . . well-singing children, some arrayed like angels and some like virgins, to sing sweet songs as her Grace passed by.' The greater companies held feasts to which large numbers of distinguished guests were invited, and when immense amounts of food and drink were consumed. The London Grocers, who had begun to build their Hall in 1428, held the first feast in it on 1 July 1431, 'at the which feast was the mayor and many a worshipful person more, beside the whole craft, at the which feast was drunken two pipes of wine and nine barrels of ale.' The Drapers in 1516 had 78 guests including John Leland the antiquary, and the total numbers were about 200. At the high table in hall were seated 30 of the principal persons, with 100 more at two side tables. In the ladies' chamber were 40 ladies seated at two tables, and in the chequer chamber were 20 maidens. The company was entertained by ten players and minstrels, and special food was provided for the high table and for the ladies. The Livery consumed four sirloins of beef, six sheep and a calf.

The companies vied with one another in their halls, which were among the most important civil buildings. This was not only the case in London, where most of the halls have fallen victim to repeated fires, but in provincial cities, notably York, where the hall of the Merchant Adventurers and St Anthony's Hall survive. The halls were not simply for official purposes and for occasional feasts; with their surrounding plots of land they contributed to the social amenities of the members. After the opening of the hall of the London Grocers in 1431, mentioned above, 'the garden was made new with the fair Erber (Arbour) and all the new vines with all the new rails.' The members were to 'suffer the grapes that come of the garden to hang still and ripe to the intent that every man of the livery may daily send after two or three clusters home to their houses.' It is evident from this that the superstition, that England cannot ripen grapes in the open air, had not yet taken root. With 55 members in the Livery, the vines must have produced during the season from 110 to 165 bunches every day; and this within a hundred yards of the present Bank of England.

The Goldsmiths, who bought their site in the parish of St John Zachary in 1357, spent £136 in 1364–65 on building a hall with kitchen, pantry, buttery and two chambers with two beds. In 1380 a new parlour and a cellar were added. Admittedly the Goldsmiths were among the wealthiest of the great London companies, but they were followed by many other guilds able to carry out works on as large a scale. Civic pomp was winning all along the line, but we must be thankful for the encouragement to the arts and crafts themselves given by the lavish outlay involved in the buildings, the gardens, the feasts, the livery, the ceremonial processions. Besides, it must not be forgotten that all of the greater companies, then and down the centuries, have maintained great

D

charitable institutions: schools, hospitals, almshouses. As Lydgate wrote in his *Measure is Treasure,* it is all a matter of proportion:

> Famous merchants, that far countries ride
> With all their great riches and winnings,
> And artificers that at home abide
> So far casting in many sundry things,
> And be expert in wonderful cunnings
> Of divers crafts to avoid all error;
> What may avail all your imaginings,
> Without proportions of weight and just measure?
>
> Reckon up physic with all their lectuaries,
> Grocers, mercers, with their great abundance;
> Expert surgeons, prudent apothecaries,
> And all their weights poised in balance.
> Masons, Carpenters of England and of France,
> Bakers, Brewers, Vintners with fresh liquor,
> All set at nought to reckon in substance
> If poise or weight do lack, or just measure.

Chapter 3

Training the Craftsman

By the middle of the fourteenth century it was a normal rule that entry to a craft guild should be by an apprenticeship of not less than seven years. In those traditional trades which still, in the middle of the twentieth century, preserve the system of apprenticeship, it is agreed that the term of seven years is desirable, even though it may have been shortened in order to fit in with modern methods of schooling. Both historical record, and the view of senior craftsmen of the old type, agree that the best age to begin apprenticeship is at about 13 or 14, so that the period of training may have been completed at 20 or 21. These age limits represent a norm which can be accepted for purposes of discussion. Before we can discuss the training of the craftsman in his special skill it is first necessary to consider what other education he may have received. In the absence of detailed information it is impossible to speak with complete certainty, yet much more is known than might be supposed.

It is essential firstly to discard the outworn fallacy that the Middle Ages was a period of illiteracy outside the ranks of the clergy. The number of schools *above primary level* was immense, and it is safe to assume a primary school held in practically every church porch. Obviously the position was not the same in 1100 as it was in 1500 or later, but there is good reason to suppose that among freemen living in towns the proportion of literates was high from the thirteenth century onwards. The qualifications are important, and highly relevant to this question of the schooling of craftsmen. Skilled craftsmen were almost always men free by condition. In many crafts this was insisted upon as a prerequisite, notably among the masons. In any case it was virtually impossible for anyone tied to the manor of his lord to perform essential work services as a villein and also be able to train or work as a skilled man at a craft. The literacy of craftsmen has, therefore, no real connection with the general percentage of literacy in the population.

Secondly there is the necessity of some education for anyone carrying on business in his own person. The picturesque fact that mediaeval

accounts for sums of money were recorded on notched tally-sticks, split into two corresponding halves, has tended to obscure the other fact, that a great many mediaeval accounts were kept in writing, at any rate from 1200 or so onwards. It is commonly supposed that every business man employed a clerk, being himself quite illiterate. This is far from providing a convincing picture. Only the richer traders would be able to afford to pay clerks to keep their accounts, and we have the paradox that whereas the man who could afford to keep a clerk was likely to have had some education himself, it was a matter of necessity for his poorer guild-brother. As the late Sir Hilary Jenkinson wrote in 1926: ' we are forced to the conclusion that in the later medieval period there was an extensive and widely recognised system of elementary business education, and that the numbers (continually increasing) of men who received it were such as we cannot suppose to have gone through the ordinary Church schools or to have received the tonsure of the Clerk.'

It is to be noted that such business education was an alternative to the possibility of attending the grammar and other Church schools in some capacity: e.g. as choristers. The evidence available is substantial, and working backwards from the end of our period we start with the view of Sir Thomas More in 1533 that readers of English formed rather more than half the population, while as far back as 1381 there were complaints against the number of copies of Wycliffe's gospel circulating among vernacular readers. Of more specifically statistical value is the record that in 1373, among the witnesses in a lawsuit, 11 of 14 laymen were ' *literati* '. The evidence of signatures and marks used in their stead is not altogether satisfactory, for the use of the signature, even by those undoubtedly literate, was slow to develop. It is, however, of some evidential value that among the witnesses to the will of Sir John Fastolf in 1466 one gentleman out of two was literate, two merchants were both literate, two husbandmen out of seven were literate, and one tailor and one mariner (out of two of each) were literate.

If we had more nominal rolls of mediaeval schools it would be possible to identify many pupils among the ranks of known craftsmen. Even though too little material of that kind is available, what there is does give food for thought. There is, from 1394, a complete register of boys admitted as scholars to William of Wykeham's College at Winchester, identifying those who proceeded to Oxford. Winchester College, though not completely unrepresentative, was founded specially to supply the ranks of the civil service with highly trained clerks, the intention being that as many as possible should proceed to New College at Oxford to complete their education. Yet the register shows that, of the first hundred scholars admitted in 1394–96, only 45 did go to Oxford. Five died at school; but the remaining fifty went out into the world quite highly educated by the standards of the period, with a substantial knowledge of Latin over and above the primary education they had received before entering Win-

chester. Nor is this exceptional: out of the first 100 scholars on the roll from 1400 to 1403, 44 went up to Oxford or entered a religious order; eleven died; but 45 went out into the world.

The Winchester register provides even more useful evidence at a later date. In 1472 the ages of scholars on admission began to be registered, and the dates of admission as scholars of New College are also on record. From 1472 to 1478 and continuously from 1484 (excepting 1489) there are thus statistics of age at entry and of school leaving age. Using only the years in which ages are recorded, as far as 1491, the roll yields 101 scholars who did proceed to Oxford, out of a total of admissions of 221. The proportion of the school that did not enter the tonsured life remained more than half. The age at entry in these years varied from 9 to 15, the figures being: at age 9, 3; at 10, 17; at 11, 35; at 12, 26; at 13, 14; at 14, 5; and at 15, one. The leaving age ranged from 14 to 19 among those who went to Oxford: at 14, 1; at 15, 13; at 16, 29; at 17, 36; at 18, 20; and at 19, two. The typical age of entry was evidently at 11, and that of leaving 17 in the case of university candidates.

Many boys, not going on to Oxford, must have left at an age which would still allow them to take up an apprenticeship, and we can hardly doubt that this must very often have happened. In a few individual cases the register actually states that scholars left to take up secular employment. Obviously the education received at Winchester was not wasted, and if even a sprinkling of its scholars became craftsmen it is safe to assume, *a fortiori*, that a considerably larger proportion of boys from the old town grammar schools did the same. In any case there is the converse problem of what boys were doing from 5 to 13 if they belonged to the families of craftsmen and did eventually become apprentices. To sum up, we must accept that during much of the mediaeval period there was a presumption in favour of literacy throughout the class of skilled craftsmen.

As we have seen, the easiest way to secure entry to the freedom of a city was by patrimony, as the son of a father who was himself free. Freedom by apprenticeship was a separate method of entry and involved payment of a higher fee, but this is not to say that those who entered by patrimony had not also served an apprenticeship. Even in the period before formal apprenticeship by legal indentures had become the rule, the training of a junior craftsman by his father, uncle or other elder relative must have been very common. Apprenticeship, under that name, is not recorded in England before the reign of Edward I, and in the first place related to students of law who became barristers. It took several generations for the system to become general, but as early as 1307 the fifteen-year-old son of a Northumberland freeman, his father being dead, entered into a contract with a local mason, William of Stamfordham, that he (John fitzAdam fitzJoseph) should be trained for nine years in manner of an apprentice and according to the custom of William's craft (*misterii*

sui). The long term, though unusual, is far from being unique. Salzman gave some examples of the fifteenth century which suggest that long terms included a period at school: in 1462 a boy of 14 was apprenticed to a haberdasher for 12 years, but out of this he was to spend two years at school, a year-and-a-half on grammar and half a year at writing. A goldsmith who took an apprentice for a term of ten years in 1494 was to put him to school for one year. There were also cases where goldsmiths were fined for failing to have apprentices taught to read and write, which clearly implies that there was a custom that they should receive such teaching if they needed it. Apprentices to York text-writers had to be at least 16, and served for not less than five years.

While apprenticeship was only one of several ways by which a craftsman might obtain the freedom of a borough, it was in many crafts the only way in which he could become a member of the relevant company, though it was left to the time of Queen Elizabeth I for an Act (1563) to be passed requiring every journeyman to have served an apprenticeship of seven years. There were, however, arrangements long before this for controlling apprenticeship, and London began to enforce the enrolment of apprentices by 1300. By the years 1309–1312, in which a total of 909 obtained the freedom of the city, 253 had been apprentices. There were certainly apprentices in Norwich by 1291 and in York by 1307 (for an indenture of 1371, see Appendix II). Different customs ruled in different crafts and at different dates in regard to the number of apprentices that a master might train. The rules were imposed by the guild, but had normally been approved by the municipal authorities.

By the time that the guilds had adopted the system of livery and become fully developed, it was usual for masters in the livery to be allowed to train two apprentices at once, while those out of the livery might only take one. Masters of the 'free' organisations such as that of the masons also took apprentices, quite independently of any rules which the Masons' Company of London (or any other local guild of masons) might make. In the case of the masons operating under the Constitutions, the rules were set out in the third, fourth, fifth and sixth Articles of Masonry:

3. that no master take no prentice for less term than seven year at the least, because why such as be within less term may not perfectly come to his art . . .
4. that no master . . . take no prentice for to be learned that is born of bond blood . . .
5. that no master give more to his prentice in time of his prenticehood . . . than he wot well he may deserve of the lord that he serveth nor not so much that the lord of the place that he is taught in may have some profit by his teaching.
6. that no master . . . take no prentice to teach that is imperfect,

that is to say having any maim for the which he may not truly work as him ought for to do.

The Articles, which form part of the 'Old Charges', go back to about 1360 and may represent something earlier that had originally been written in Latin.

The provision of the fifth Article, referring to the mason's client on whose work the apprentice would be employed, raises some interesting questions. In the case of a craftsman who had his own shop, both producing and selling finished articles, the terms of his responsibility to the apprentices he trained were entirely his own affair. If the pupil spoiled work and wasted materials the loss fell entirely on his master. Inferior work turned out by the apprentice would not be sold, and the searchers of the craft would in any case be likely to discover and confiscate it if there were any attempt to pass it off on the public. The case of independent masters who worked for clients at a rate of pay for themselves, their journeymen and their apprentices, was quite different. In law the master was entitled to any wages earned by his apprentice, but on the other hand had to maintain him in food and clothing and provide him with some pocket-money.

In 1331 the accounts for the building of St Stephen's Chapel in Westminster Palace show that John le Bakere, mason apprentice, was being paid 2d a day, while the master mason had 6s. a week, and the ordinary working masons 5½d a day. There was also a junior mason, John Colyn, 'polysshere' of marble, who took only 3d a day because he was young (*quia juvenis*). In 1364-65, when masons were working for the Infirmarer of Westminster Abbey, 13s. 4d was paid for 13 weeks worked by the fourth mason, being an apprentice, 'and previously he took nothing for one quarter because he was learning' (*quia fuit in addiscendo*). Employers were, then, prepared to pay for work done by apprentices and it was up to the master to see that the work done merited the amount paid. Some clients who engaged master masons on a permanent basis actually stipulated that they were to train apprentices, presumably to ensure a future supply of suitable craftsmen for their works.

Examples of this occur in the later fifteenth century. On 1 October 1471 Thomas Peyntour was appointed for life master mason to Ely Cathedral Priory. During his term of office (which certainly lasted until 1495 or later) he was to train three apprentices in his art of masonry one after another. They were to be assigned to him by the Prior and the Sacrist of the monastery, they having to find food and clothing, and the Priory to have any profits of the apprentices' labour. The contract of employment between the Prior and the Chapter of Durham with John Bell their special mason, on 1 April 1488, permitted him to have one apprentice of his own at a time, for whose work he would be paid by the sacrist 4 marks a year for the first three years, 6 marks for each of the

next three years, and 7 marks for the last year. Bell was also to teach, at any one time, ' one yong man their apprentice ', that is, an apprentice bound to the Priory, not to Bell himself. Bell ' well and trewly shall teche and informe, to hys cunning and power ', this succession of young men, for the rest of his life as part of his duties. This arrangement would eventually provide staff for a direct labour works department.

The duties of the master to his apprentice were strictly observed, and it seems always to have been a point of honour as well as of law to arrange for the completion of an apprentice's term in the event of the master's death or bankruptcy. Even during the Black Death of 1349 Maud, widow of John de Mymmes, an image-maker, bequeathed his apprentice for three years (probably his unexpired term) to Brother Thomas de Alsham of Bermondsey Priory. In 1449 Thomas Elkyns, mason of the Divinity Schools at Oxford, left to William his apprentice clothes and tools with ' moneys as mentioned in his indenture of apprenticeship ' (*sicut fit mentio in indentura suae apprenticietatis*). In some cases an apprentice was even sold to a new master: on 27 July 1386 a deed witnessed that John Shepeye, barber, had sold to Thomas Canoun, marbler, all his rights in Thomas, son of Hugh le Peyntour of Durham, whom he had taken as his apprentice for seven years by indentures dated 2 April.

The short interval of less than four months between apprenticeship and transfer, and the apparent incompatibility between the trades make this case a puzzling one. The boy Thomas's father, Hugh le Peyntour, was presumably an artist, and might well wish to article his son to a marbler to learn carving. It is not obvious why a boy with such a background would take up the trade of a barber, though it is not inconceivable that his intention was to learn the rudiments of anatomy. When the effigy of Richard Beauchamp, the great Earl of Warwick, was to be made in 1449 by John Massingham, carver, the contract associated with him Roger Webb, barber and warden of the London Company, who was almost certainly concerned as an anatomical adviser. Although a merely accidental change of mind may be the explanation of the curious transfer of Thomas Peyntour, it is not impossible a definite purpose lay behind it.

On the whole apprenticeship worked well in most crafts over a period of several centuries. Its essence was personal contact over a long time with opportunity for repetitive imitation of each process, and the learning by rote of recipes or other craft secrets. To trade secrets we must shortly return, but it is relevant here to remark on the distinction drawn between apprentices and pupils on the one hand, and servants and journeymen on the other. We may assume that there was a general validity for the attitude expressed in the ordinances of the London Bladesmiths in 1408: ' No one shall teach his journeyman the secrets of his trade as he would his apprentice.' Obviously the main processes of many trades were simple enough for an intelligent servant to become fully proficient without hav-

ing any secrets imparted to him; but in many other crafts there were essential secrets apart from the usual tricks of the trade. Inadequately trained men there certainly were: in 1497 at the rebuilding of the manor of Thorncroft in Leatherhead for Merton College, 'a lather not connyng (cunning) and was mad lywe (leave off) warke at noon', got 2d for his ineffectual pains.

As the guilds became more oligarchical, difficulties were increasingly placed in the way of young men who aspired to become masters. Unwin listed, from London records, the methods of repression: the master did not register his apprentice (who thus lost his legal standing); this was noted specifically at Canterbury also in 1490, when guild masters were not enrolling their apprentices in the books of the Common Chamber as they were called upon to do by law. Even if enrolled as apprentices, they might not be presented for the freedom by their masters. As early as 1347 the regulations of the Heaumers (helmet makers) laid down that if an apprentice were in debt to his master, the debt must be satisfied before he could leave or set up on his own. To avoid the undue increase of masters in the trade, an arbitrary fee of £3 or more was imposed. The companies began to insist upon a delay of three years between the end of apprenticeship and the start of work as an independent master; the period during which the ex-apprentice is styled an 'improver'. In many trades the apprentice had to prove means, and this effectively barred all the poorer aspirants. Finally, though it was less insisted upon in England than in Germany and other foreign countries, the apprentice had to make an expensive 'masterpiece' to prove his capacity.

The masterpiece was not always a mere subterfuge to defeat the young man's legitimate ambitions. In some cases the system amounted to a genuine examination. The Regensburg guild of stonemasons in 1514 laid down a series of six master-works that had to be done to show ability before graduation: to make a simple vault; to cut the pieces to form a stone doorway; to make a gateway; to cut a projecting cornice; to make appropriate foundation walls for a house and to repair a damaged wall or angle; to know the proper thickness of a wall from its height and make the correct foundation for it. Where it was not feasible to carry out an actual work it might be demonstrated by means of a model in clay. The earlier ordinances made at the Regensburg Congress of 1459 show that the German system of lodge masons involved six grades, five below the master-in-charge or workmaster (architect): apprentice, journeyman, *Parlier* (warden), *Kunstdiener* and master. The German *Kunstdiener* seems to have been a sort of post-graduate student who studied the secrets of proportion and design beyond those of stonecutting, and thus qualified as a workmaster or architect. In all countries there were master masons (and master carpenters) who designed buildings as well as those who were merely fully trained master craftsmen, but the German evidence seems to be unique in implying a further stage in formal training. Another

regulation is peculiar to Germany: a trainee mason who aspired to be a *Parlier*, the deputy of the master, had to wander for at least a year after completing his apprenticeship. Others might travel but were not obliged to do so.

The methods used by masters for training must have differed greatly, not merely from craft to craft, but according to the individual. One of the great advantages of pupilage and apprenticeship over the methods of academic education in schools and universities lies precisely in this individual approach. Schooling is commonly by lectures to groups of substantial size, and the obvious inadequacy of this has had to be tempered by the introduction of individual tutorial instruction. The apprentice enjoyed the benefit of an exclusive tutor for seven years on end. The result was that most skilled craftsmen attained an extremely high degree of accomplishment. Engravers who could write the Lord's Prayer and the Creed on a sixpence, and gem-cutters who, even before the period of optical lenses, could achieve true and equal angles on tiny stones, well exemplified the benefits of sound training.

Many procedures of the Middle Ages remain a mystery because of the lack of written textbooks of the crafts and the degree of secrecy maintained. These two factors are indeed reciprocal functions of the same phenomenon: it was to preserve secrecy that the full details of method were never set down. We depend mainly on accidental survivals of sketchbooks, drawings and diagrams on scraps of paper or parchment for such insight as we have into the precise means of mediaeval production. The trade guilds were extremely jealous of their respective processes and adopted every means to prevent leakage. We have seen that masters were prohibited from imparting the real secrets to their journeymen servants, and some crafts actually suffered from industrial espionage by aliens who came to England and learned a trade, or induced English masters to emigrate. In 1533 the Pewterers were said to have suffered from certain men who had gone abroad and taught their trade secrets to aliens. The result was an Act (25 Henry VIII, c. 9), by which no alien was to be received as an apprentice and any English pewterer going abroad or failing to return at once would not only lose his rights in the craft but himself be accounted an alien.

It may be objected that several mediaeval treatises upon artistic and other processes have survived. This is true in a limited sense only, for the famous treatise of Theophilus on *The Various Arts* precisely lacks those chapters of Book II which gave the recipes for making green, blue and red glass with copper, lead and salt. Lowe is certainly right in suggesting that there was deliberate suppression because ' these recipes were considered too valuable by early glassmakers to be allowed to circulate in written form.' There is besides evidence of a system of secrecy going back far into the pre-classical period. A cuneiform tablet of the seventeenth century BC found near Tall 'Umar on the Tigris, was written as an

elaborate cryptogram, unintelligible except to the initiate. The late C. J. Gadd and R. Campbell Thompson succeeded in deciphering the tablet, which they published in 1936. Some years afterwards the late H. Moore took their text and tested it with immediate success: the precise amounts of glass, lead, copper, saltpetre and lime recorded in the secret formula produced a perfect glaze for earthenware, in any case a result hard to achieve. What was far stranger was that this glaze exactly matched that of fragments of pottery found by the late Sir Leonard Woolley hundreds of miles away in another excavation at Atchana (Alalakh) and at first regarded as intrusive, since they so closely resembled Arab wares of three thousand years later. Then it was found that, after preservation of the secret for a thousand years, it became at least relatively well known to potters after the seventh century BC.

It is not only the rigid safeguarding of the recipe over a long period that is remarkable. The formula itself acquired sanctity, so that it was handed down, century after century. Instead of attempting to experiment, the inheritors of the process were well content to use it as it stood. This remained typical of the ancient pre-classical world and of the early East. Scientific curiosity came in with the classical Greeks but the results of their experimental knowledge again passed through long fossilisation, when the Greek and Latin manuscripts were simply copied and recopied. Many of the recipes, technical and medical, handed down from remote antiquity, again received scientific investigation when the manuscripts were translated into Arabic about the ninth century AD, along with the more seriously regarded works of philosophy, astronomy and mathematics.

The western world began to recover the lost works of Greece and Rome, mainly through retranslation from the Arabic versions, in the first half of the twelfth century. A little earlier the astrolabe (9–11), as a mathematical and astronomical instrument, had reached northern Europe with the method of its use. Walcher of Lorraine, Prior of Malvern, who came to England in 1091 and died in 1135, already had an astrolabe by 1092; in a treatise written between 1108 and 1112 Walcher was still making use of the clumsy Roman methods of calculation; but by 1120 he was employing degrees, minutes and seconds and had learned exact observations from Petrus Alphonsi, the physician of Henry I. This Petrus was an important link between the Arabic world and England. Born a Jew in 1062/63 and in 1106 baptised at Huesca in Spain, his godfather was King Alfonso I of Aragon (1104–1134). He was probably the interpreter of Arabic texts who collaborated with the Saxon Englishman Adelard of Bath, to produce the first re-translation into Latin of Euclid's *Elements* about 1115–20. Petrus has also been shown by Dr C. R. Dodwell to be highly significant in another way, providing a fairly definite date for the treatise of Theophilus on the Arts.

Although well known over a long period, the work of Theophilus has remained of very uncertain date, and most earlier students of the text re-

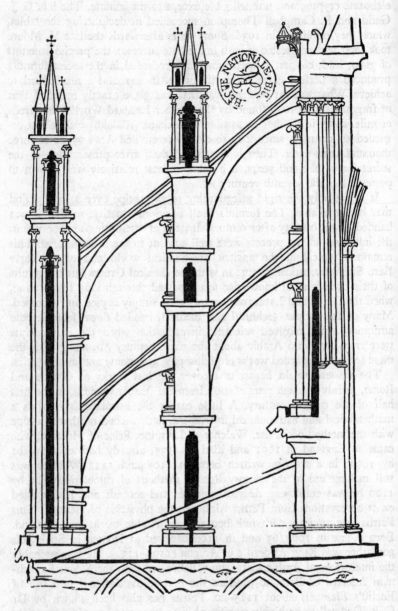

Flying buttresses of the choir of Rheims Cathedral, drawn by Villard de Honnecourt about 1240, from the designs (Album, 64).

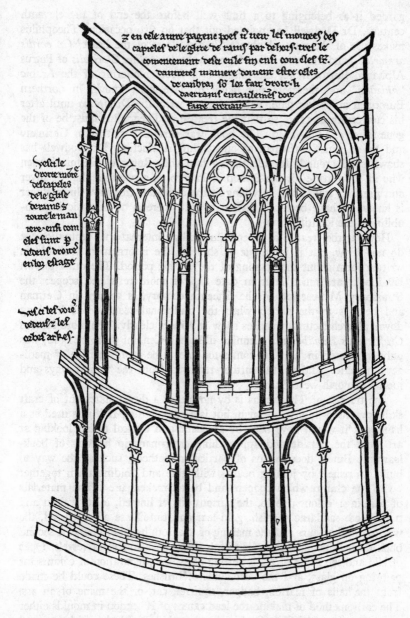

Interior of the choir chapels at Rheims, drawn by Villard about 1240 (Album, 60).

garded it as belonging to a time well before the end of the eleventh century. Dr Dodwell has pointed out that on two occasions Theophilus makes use of the unusual phrase ' in the closet of the heart ' (*in cordis armariolo*) and that this is first found in the *Disciplina Clericalis* of Petrus Alphonsi. Furthermore, the phrase is a direct rendering of the Arabic ' *khizāān* ' and therefore not likely to have been known in northern Europe at an earlier date. Petrus did not write the *Disciplina* until after his conversion in 1106, so that the treatise of Theophilus must be of the generation *c.* 1110–1140. The book was certainly written in Germany and by an artist craftsman of outstanding distinction. Dr Dodwell has shown solid grounds for identifying him with Roger of Helmarshausen who in 1100 made for the Bishop of Paderborn a portable altar of silver and precious stones still surviving in the cathedral treasury. Since Roger is known to have been still living in 1118 there is no intrinsic improbability in the identification.

How far the treatise of Theophilus had an international reputation we do not know, but it is unique as showing the information available in written form about the opening of the Gothic period. The other known handbooks are much later in date and of more restricted scope: the Strassburg Manuscript, of the fifteenth century, is written in German and belongs to the period when the traditional secrecy was breaking down, as architectural treatises show still more clearly. The more famous *Craftsman's Handbook* of Cennino d'Andrea Cennini (born *c.* 1382) was only completed in 1437. It comes too late to be representative of mediaeval practice, and is still further removed from the typical ways and means of north-west Europe.

The treatise of Theophilus is by no means a direct statement of craft skills practised by a single man, but is a compilation. If it was used as a handbook it would have been by monastic and clerical artists looking at art from the outside and approaching craftsmanship by way of book-learning. But it does tell us of particular methods, such as the way to build up panels by joining boards with glue and holding them together ' with the cramp which coopers and barrel-makers use '. The materials of painting: colours, gesso, the various oils of linseed, olive, walnut and poppyseed, sandarac varnish, gold-leaf and tinfoil are all discussed, the way to grind colours and the making of ink from hawthorn bark. A second book deals with glass including both sheet glass and glass vessels, types of kiln and the firing of glass, cutting glass, the preparation of colours for painting on glass, and the best kinds of brushes. These could be made from the tails of marten, badger, squirrel, cat, or the mane of an ass. The early method of making the lead cames of H section in moulds either of iron or of wood is described in detail, and also soldering with wax and tin.

The latter part of the treatise goes into great detail regarding metalwork, and this tends to support the identification with Roger of Helmars-

'Know well that this lion was drawn from the life', wrote Villard de Honnecourt about 1235 (Album, 47).

hausen. A workshop with windows in its south wall was to be built and then divided, half for the working of the base metals copper, tin and lead, a quarter for gold and a quarter for silversmithing. Furnace, bellows, anvils and hammers, pincers, drawplates for making wire, tools such as chisels and rasps, files, the tempering of iron are all dealt with; the refining of gold and of silver, the making of niello and brass, the purification of copper and how gold is separated from it and from silver, the gilding of bronze, the plating of silver with gold. Finally there are sections on die stamping, on the making of organs with the specification of sizes for bass, treble and alto pipes, bell-founding, the means of assessing the sizes for bells; and an appendix on staining and carving bone. In so far as *The Various Arts* represents an ideal handbook for teaching craft skills, it is really limited to the four crafts of painter, glazier, goldsmith and bell-founder. The much later work of Cennini covers a remarkably similar field, dealing with all aspects of painting, with illuminating, glass, and mosaic, and also with casting; but not with metalwork in a general way. Among the most interesting details added to our knowledge of mediaeval processes by Cennini is his discussion of sorts of tracing paper.

We come rather closer to the actual shop, and to the training given to pupils, in the unique album or encyclopaedia of design and practice compiled by Villard de Honnecourt. Though provided with some lengthy captions, this is not a written book but a graphic picture digest on the many arts grouped around the practice of architecture in the first half of the thirteenth century in northern France. The thorough studies of Professor H. R. Hahnloser, first published in 1935 and, greatly revised and enlarged, in 1972, have extracted all and more than could be hoped from the internal evidence. Villard, though not otherwise known to history, was a master mason of the highest rank, with knowledge of all the related crafts of carpentry, carving, the making of ' engines '; and of all kinds of fittings needed for buildings. He came from Honnecourt, a small village by the river Scheldt (Escaut), ten miles south of Cambrai and some forty from Amiens. He was certainly living in 1235 and must have been a fully trained master by say 1225. Probably soon after 1235 he went on a journey to Hungary and stayed there for some time, but had returned to France before the Tartar invasion of 1242. When at home he was evidently in charge of the building lodge of a great church, very likely that of St-Quentin; two subsequent masters of the lodge made entries in the book after his time, but during the thirteenth century.

What is relevant here is the abundance of material suitable to the training of young men in drawing and design, in the planning of churches, the construction of machines and devices, roof-trusses and floors. Of unique importance are the pages of figures ' extracted from geometry ', largely concerned with practical propositions of advanced stereotomy, the

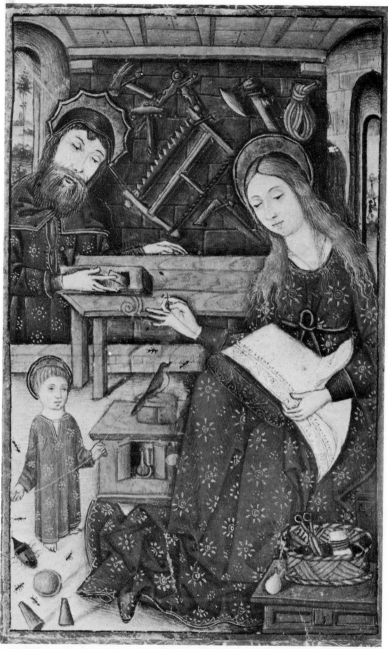

1. *St Joseph at work as a Joiner, the Virgin sewing and Jesus playing. Spanish, A.D. 1461. Note tools: plane, claw-hammer, gimlet, compasses, framesaw, hatchet, line, square.*

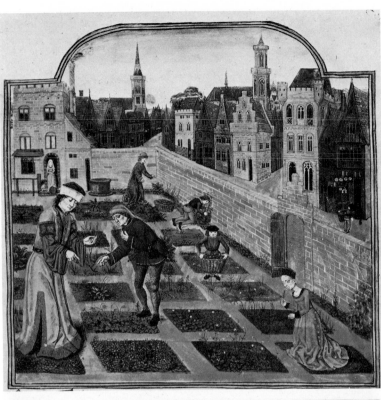

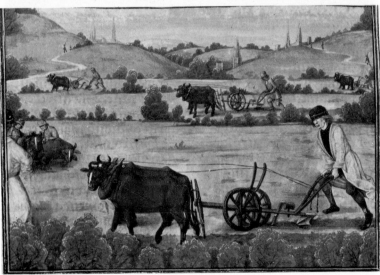

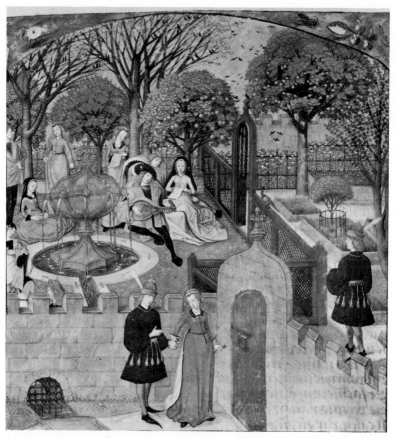

2. (above, left) *A town garden. French, late 15th century. Note square beds*

3. (below, left) *Ploughing in the countryside. French, early 16th century. Note wooden ploughs*

4. *Enclosed garden with fountain, trellis, trees and raised beds. Flemish, late 15th century*

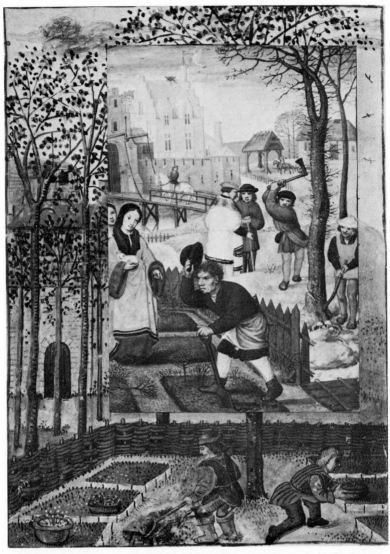

5. (Border) *Gardeners at work. Flemish, end of 15th century. Note raised beds with boarded edgings and pots placed on beds*

6. (Inset) *Gerhard Hoornbach: Gardening and Forestry. Flemish, A.D. 1500*

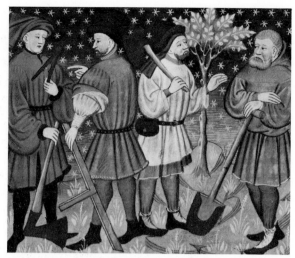

7, 8. Craftsmen: carpenter, mason, forester, gardener; and various trades, gardener and smith in centre, carpenter to right. French, mid-15th century

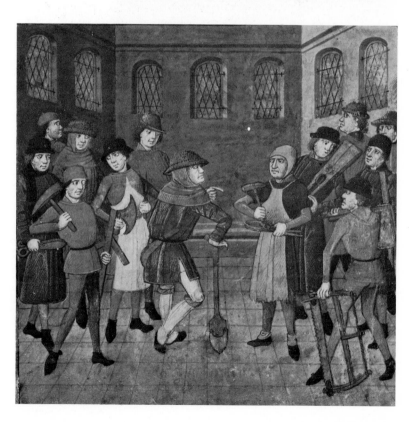

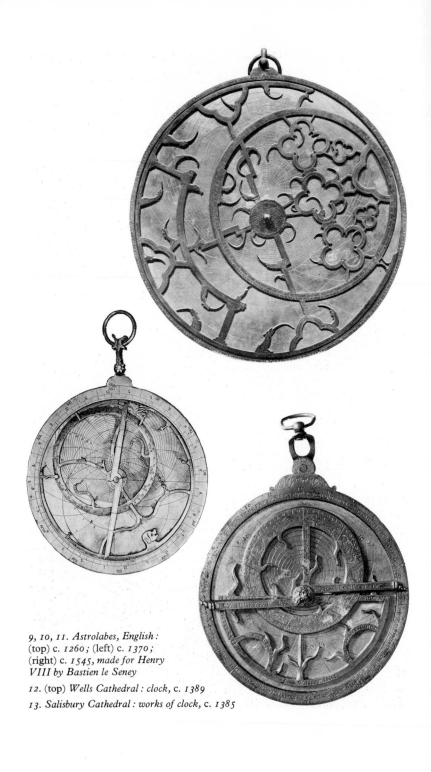

9, 10, 11. *Astrolabes, English:*
(top) c. *1260;* (left) c. *1370;*
(right) c. *1545, made for Henry
VIII by Bastien le Seney*

12. (top) *Wells Cathedral : clock, c. 1389*
13. *Salisbury Cathedral : works of clock, c. 1385*

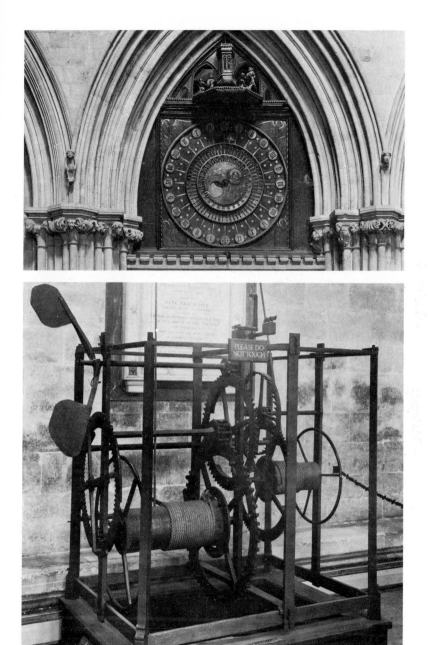

14. (top) *Building scene and garden. French, late 15th century. Note scaffold, hoist and windlass, sawyers, wheelbarrow, plumb-level carried by master mason; driving fence-posts, borders and square beds in garden*

15. *Jean Fouquet: Masons at work. French, c. 1470*

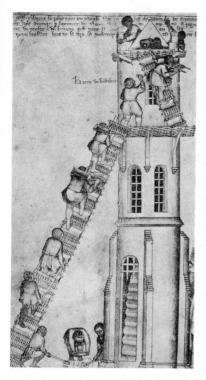

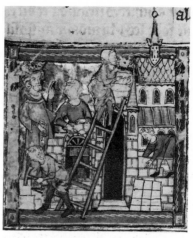

16. (above, left) *Building the Tower of Babel. English, 14th century. Note ladder and platforms of hurdles, and bracketed scaffold*

17. *Building. English, early 14th century. Note centering of arch*

18. (below) *Matthew Paris: Building craftsmen, c. 1250. Note plumb-level, hoist, plumb-line, auger, axes used by mason and carpenter*

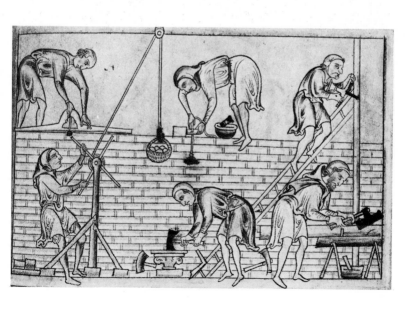

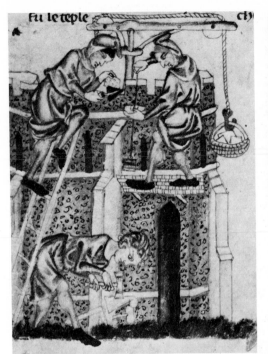
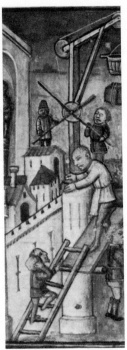
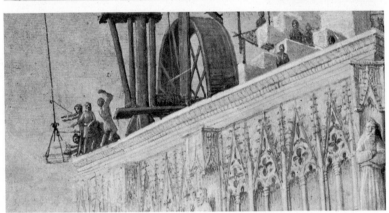

19. (top, left) *Building. English, 14th century. Note hoist, plumb-line, bracketed scaffold*

20. (top, right) *Building Troy. French, 15th century. Note jib-crane, bracketed scaffold*

21. *Jean Fouquet: Building the Temple. French, c. 1470. Note crane with great wheel*

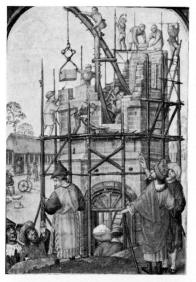
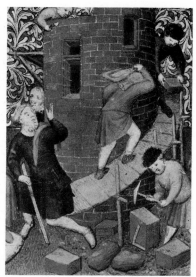
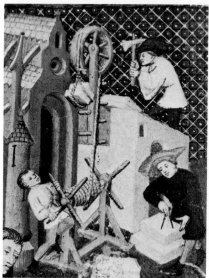

22. (top, left) *Building. Flemish, end of 15th century. Note putlog scaffold, X-lewis gripping stone, jib-crane with through-rungs, hand-wheel, centering of arch*

23. (top, right) *Building the Tower of Babel. French, early 15th century. Note helicoidal scaffold*

24. (lower, left) *Building. French, 15th century. Note hoist, peg-ladder, setting-out with compass*

25. (lower, right) *Westminster Abbey, west front. English, c. 1532. Note hoist with great wheel on unfinished tower*

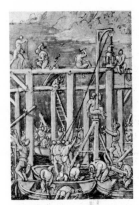

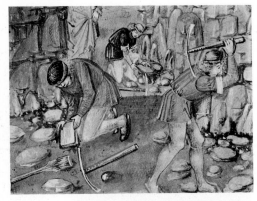

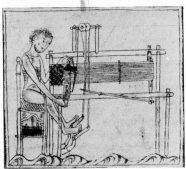

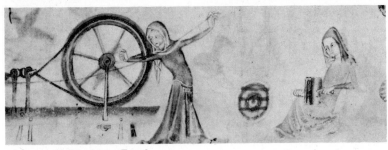

26. (top, left) *Pile-driver. French, 1519*

27. (top, right) *Quarrymen. Flemish, 1482*

28. (middle, left) *Vertical loom. English, c. 1250*

29. (middle, right) *Horizontal loom. French, late 15th century*

30. *Spinning wheel and carding wool. English, c. 1340*

31. (top, left) *Zerubbabel having an ephod made of golden rings. English, c. 1315. Note smith, and designer at drawing-board*

32. (top, right) *Euclid at drawing-table. Italian, 15th century*

33. *Penmanship. English, 1466*

34. (*previous page,* top, left) *Conisbrough Castle, Yorks. Keep,* c. *1180. Fireplace with Saracenic type of joggled flat arch*

35. (*previous page,* top, right) *Worcester Cathedral : cloister south walk,* c. *1430. Note shaping of boss, rib and web stones*

36. (*previous page,* bottom) *Launceston church, Cornwall, 1511-24. Detail in granite*

37. *Salisbury Cathedral : crossing,* c. *1237, distorted by building of tower above,* c. *1320-80 ; strainer-arch* (right) *by Robert Wayte,* c. *1415-23 ; vault* (top right) *by Henry Stevens, 1479*

38. *Hemel Hempstead church, Herts., c. 1150-75. Lead spire on timber framing, c. 1200*

cutting of voussoirs and the like, planning by proportional methods and mensuration of remote objects. This section of the book is of crucial importance since it demonstrates the highly sophisticated knowledge of mediaeval architects only a century after the first signs of Gothic. The freehand drawings are of scarcely less significance, since they include men and animals in some cases drawn, as Villard expressly states of a chained lion, from the life (p. 55). The direct observation of nature and the concern with actual facts rather than traditional fancies clearly demonstrate the great gulf between the academic and the technological approach of the time.

We may conclude this sketch of mediaeval training with a few quotations from the records of the London Carpenters Company, showing the dues paid for the various legal stages of a craftsman's career. On taking the freedom of the company the new master had to pay a substantial fee: £1 6s. 8d was received from Simon Clenchwarton in 1455 and from Thomas Mauncy in 1479; £2 from Humphrey Coke in 1504; £3 from James Nedeham ten years later. When Clenchwarton took on a ' covenaunt man ' or indentured servant he had to pay 1s.; Mauncy in 1488 had to pay 2s. for two ' prentes '; in 1493 he presented Thomas Felip ' jorneyman ', next year another, John Fortune; in 1499 1s. for an apprentice and another 1s. for Harrye Coterell; in 1504 another 1s. ' for presentyng of Julyan Smyth his prentes for viij yers '. In the following year the fee had gone up: for John Whythed, apprenticed for eight years, Humphrey Coke had to pay 2s., but it had again dropped to 1s. in 1507 when Coke presented Gylbard Watson as his apprentice for eight years, ' bygynyng at Candylmas ', as well as for Richard Penythorne, taken for nine years from Lammas. At midsummer 1512 Coke presented his apprentice William Collens, bound for seven years, and had to pay 3s.; at the same time he paid 3s. for John ' Wythehed ', evidently the boy taken on in 1505 and by now on the point of graduation. Finally Coke took William Symson for eight years, binding him at Christmas 1514 and paying 3s.

Simon Clenchwarton was the King's Master Carpenter from 1451 to 1461; Thomas Mauncy was his successor in that office from 1496 and had been chief carpenter of London Bridge from 1487; Humphrey Coke was one of the designers of Eton College and also of Corpus Christi College, Oxford, and became the King's Chief Carpenter in 1519. Coke was also chief carpenter of the Savoy Hospital, and for Cardinal Wolsey designed the roof of the great hall at Hampton Court; he died in 1531. It is a sad commentary upon education that not one of the named apprentices or journeymen who worked under these great masters left any mark upon the history of the carpenters' trade. They simply joined the mighty stream of craftsmen, thousands strong, who have plied their trades down the centuries.

E

Chapter 4

The Craftsman at Work

In the Middle Ages man's working life followed a fairly regular pattern, slow to change. The basic pattern tends to be similar in kind for a large part of the population, making allowance for the colouring of life by the differing accidents of social station, choice of work, and economic position. By definition the craftsman is quite distinct from the unskilled labourer on one side and from the thinker and the administrator on the other. In most cases he is a dweller in the town rather than in the countryside, and an indoor rather than an outdoor worker. To these generalisations there are, of course, many exceptions: mining, quarrying, the making of tiles and bricks mostly take place in the country, and largely in the open air; the practice of forestry and the conversion of timber are still more rural. Gardening, one of the most highly skilled crafts, was altogether carried on in the open during the mediaeval period apart from a very few revivals of the classical *specularia* or greenhouse, in continental Europe and not, as far as we know, in Britain.

The greatest difference between the typical working conditions of the Middle Ages and those of today is that mediaeval craftsmen produced their work in daylight. The means of illumination were limited, but occasional nightwork was lit by lamps, torches and candles; it was not primarily a lack of lighting that caused the avoidance of work after dark. It was held that the best work could only be performed by full daylight and that inferior work was to be prohibited by the most stringent sanctions. Insofar as craftsmen were also shopkeepers, selling their own products, there was also the objection that buyers could be more easily deceived as to quality by artificial light. In principle both the craftworker's and the shopkeeper's day was regulated by the seasonal interval from dawn to dusk. For convenience it was the custom in many trades to divide the year into a short winter and a long summer: in the fourteenth century London blacksmiths worked from 6 a.m. to 8 p.m. in November–January, and in the rest of the year from dawn until 9 p.m. Earlier than this we can deduce from regulations made between

1275 and 1296 that wages were closely geared to the hours worked: 3d a day (without food) from 11 November to 2 February, 5d a day from Easter to 29 September, and 4d in spring and autumn.

In 1495 an Act (11 Henry VII, c. 22) fixed the summer hours as from before 5 a.m. to between 7 and 8 p.m.; winter hours were from 'the springing of the day' until nightfall. These were overall times, but various breaks were allowed. The hours actually worked depended also upon customary half- and part-holidays, to which we shall return. At York Minster in 1370 the hours from Michaelmas to the first Sunday in Lent were to be from as early as the masons 'may see skilfully by daylight' and continued 'as long as they may see skilfully for to work'. In the summer they were to start at sunrise and work until no more than a mileway before sunset. As Chaucer tells us in his treatise on the Astrolabe, '3 milewey maken an houre'. The breaks were for dinner before noon, for a short time only, an hour for noon-meat, and drinking time in the afternoon, ten minutes ('tyme of half a mileway') in winter and twenty minutes in summer. Between St Helen's day, 21 May, and Lammas, 1 August, they were also allowed half an hour for sleep. All the times were to be struck on a bell provided for the purpose, and this was a general practice; at the Tower of London in 1532 a frame was made for a bell in the White Tower 'the whiche callith workemen to worke and fro worke'. (For the York Minster regulations in full see Appendix III.)

In the fifteenth century there is evidence from Beverley that enabled Salzman to work out a full timetable for the building trade. In winter work was from dawn to dusk, with breakfast from 9 to 9.30; dinner from 12 to 1, and a break for a quarter-hour at 3 p.m. In summer, from Easter until 15 August, there was work at 4–6 a.m., 6.15–8, from 8.30 to 11; then $1\frac{1}{2}$ hours off; then work at 12.30–3 and 3.30–7 p.m. Overtime work was not common in the Middle Ages proper, but was introduced to a substantial extent in the reign of Henry VIII. Then it seems mainly to have been due to the king's anxiety to get works finished, for example at Hampton Court Palace in 1531–33 and at Nonsuch in 1538. Freemasons might get as much as 1d an hour, and roughlayers 6d or 7d for 10 hours of overtime. The extra pay was welcome when the stable value of money had suddenly been attacked by the great inflation due to the swamping of Europe by the flow of silver brought by the Spaniards from America. The demolition of Chertsey Abbey in 1538, and the re-use of its materials for the royal palace at Oatlands, were achieved by 'Fre massons workyng howre tymys and drynkyng tymys for the hasty expedyscyon of certen wyndows and dors to Otelands' for 1d an hour.

Work at night was sometimes ordered because of urgency: a chamber was to be got ready at Windsor in 1243 for the visit of King Henry III: it was to be 'wainscoted by day and night'. Occasionally work was done

at night on the piers of London Bridge, doubtless between tides, and in 1446 there were payments for work in holidays and at night in building Eton College. The chamberlain's accounts of Norwich Cathedral Priory show that candles were bought for the carpenters in 1304–05 and in 1321–22; on the earlier occasion 8¾d bought 7 lb of candles. In the Regius MS. of the Constitutions of the Masons in verse, written about 1390, night work is forbidden except for studying:

(*Article XI*)
The eleventh article I tell thee
That he is both fair and free,
For he teacheth by his might
That no mason should work by night
But if it be in practising of wit,
If that he could amend it.

Several ordinances of the London guilds, including those of the Bowyers, the Hatters and the Pewterers passed during the fourteenth century, forbid night work altogether.

The question of holidays is complicated by the connection with church festivals and with week-ends. No work at all was done on Sundays or on any of the greater feasts. In any given place there might also be observance of certain local festivals and of the day of dedication of a cathedral or church. On Saturdays and on the eves of feasts it was customary to stop work by 4 p.m., but there is evidence of many half-holidays when men knocked off at 12 noon, and it seems to have been this habit, applied to Saturdays, which produced the later 'English week-end'. Men paid by the fortnight or by longer periods certainly received pay by complete weeks even though parts of some days had not been worked, but whole holidays with pay were a special perquisite of some craftsmen only. Masters in the royal service commonly took fees based upon a given sum per day for every day in the year, Sundays included, but in case they took other time off their pay might sometimes be docked. In 1310–11 Master Thomas of Westminster, painter, was paid 7½d a day for 365 days, less 26 days he took as vacation (*per quos vacavit*); he also had £2 for his robes. Three years before, when Master Thomas had been painting the ship *La Margarete de Westminster* inside and out for the voyage of Edward II to France to marry the princess Isabella, he had only had 6d a day, apparently on a daily basis.

In the accounts for Westminster Palace of 1329 there is a statement of the ancient custom. When workmen of any condition serve the king by the fortnight, three weeks, a month or longer, and two feast days occur in the period (Sundays always excepted), the king has the first day, i.e. he pays no wages for it, and the workmen shall receive pay in full for the next. The working out of this rule can be seen in some accounts (see Appendix IV). Because of the incidence of Sundays and the chang-

ing calendar of movable feasts, no two years were alike, but the total number of whole-day feasts kept was often over 40 and at the Tower of London in 1535–36 even went as high as 51. Freemasons were sometimes paid for more than half the total, but roughmasons and setters might get paid for as few as four or five whole holidays. The tendency in the royal works was to pay more generously as time went on. In 1360 the old custom was re-defined by William de Lambhith, Clerk of the works at Westminster and the Tower, in regard to men under his own control and those under Master William Herland the king's chief carpenter and Henry Yeveley, deviser of the masonry of the works: labourers were to take 4d a day in summer and 3d in winter, carpenters and masons 6d a day. The rule now specified clearly that pay was to be given for one feast day falling in a week, but not if a second fell within the same week; apparently the linking of the incidence of feasts to the period of payment, by the fortnight, month, etc., had been given up.

On private works conditions varied. York Minster, perhaps because it was of royal foundation, observed the principle that, if two feast days fell in one week, the mason lost only one day's pay; but they lost half a week's pay if there should be three feasts. The same rule applied at Westminster Abbey, another royal foundation. At Exeter Cathedral in 1380–81 the custom was not to work on feasts, and by a specific agreement the men received pay for one feast in two; in Easter week the workmen were paid 4½ days' wages. The London Bridge craftsmen were paid their full week even at Christmas, New Year, Easter and Whitsun. Half-holidays from 12 noon were the rule at York Minster in 1352 both for Saturdays and for the eves of feasts; apparently wages were paid notwithstanding. These easy-going methods were later reprehended by state intervention: the Statute of 1402 (4 Henry IV, c. 14) prohibited hiring by the week, and also specifically the payment of more than half a day's wage when artisans worked only until noon.

One complication concerned the use of Sunday as a market day. In the earlier part of the period this was very common, and in line with a widespread practice not limited to Christian countries. Thus the Turkish word for Sunday is *Pazar*, 'bazaar', and the Hungarian *Vasárnap*, 'market-day'; the Church gradually took objection to the holding of markets on Sundays, but a few such lasted even into the sixteenth century. In many trades it must have been a great convenience to use part of Sunday for marketing, both to sell and to buy, without interfering with the even tenor of the rest of the week's steady work. Hearing mass on Sunday was an obligation, but one which did not occupy a great part of the day. There seems always to have been considerable latitude between the devout who attended many masses and also special services on weekdays, and those who limited themselves to a Sunday mass. In Muslim countries, where prayer five times a day is obligatory, craftsmen and shopkeepers

regularly leave their work and troop into the nearest mosque. In Morocco 'mosque-wardens' armed with heavy silver-headed staves of office even patrol the streets and insist upon attendance.

Occasionally there is evidence that craftsmen went on pilgrimage. Special arrangements were permitted in regard to filling the places of such men, allowed leave of absence. The master carpenter of Chichester Cathedral joined the crusade of 1228–29, and nominated a young man to hold his post. The leading mason of Westminster Abbey, John Palterton, in charge of the works of the south walk of the cloister, set out on pilgrimage on 3 February 1355/56 and returned on 6 February 1356/57; from a week before he left until a month after his return, John East joined the staff. East was given the same pay as Palterton, 2s. a week, and his year's fee of £2 was equivalent to what Palterton received for fee and robes put together. In 1431 John Harry, a freemason working at Exeter Cathedral and taking 3s. a week, had leave to go on pilgrimage without pay, and on his return was made Master Mason. Pilgrimages of this kind by craftsmen must have been one of the principal means by which style and details passed from one country to another.

The fact that craft guilds and religious fraternities existed all over Europe ensured a great deal of social contact between craftsmen, across barriers of language. Even in that respect we must remember that knowledge of French was widespread among laymen of education, apart from the Latin taught throughout western Europe in the grammar schools. There must always have been interpreters in the Greek, Turkish and Arab cities most visited by craftsmen. On embassies there would be an official interpreter or dragoman, such as Danesh who accompanied Sir Geoffrey de Langley and his suite to the Ilkhan of Persia in 1292. On that famous journey one Robert the sculptor was of the party, at any rate as far as Trebizond. Whether in Byzantine Constantinople or in the remoter cities of Turkey and Persia, a skilled man would find himself welcome among brother craftsmen, and this could apply even in India or China if and when any westerners arrived. From the few records of such visits, for instance the travels of Marco Polo in China, it is evident that fresh skills were the best passport to a hospitable reception and to remunerative employment.

Craftsmen in England were liable to impressment for the works of the Crown. Purveyors were appointed and armed with writs giving them power to conscript artisans and labourers for an indefinite period and to imprison objectors. Generally men employed on works of the Church were exempt, and there was a favourable side to this arbitrary procedure. Men so pressed were likely to get higher wages from the king than from private employers, and were also entitled to travelling expenses. As early as 1233 expenses, or prest money, were allowed at the rate of 2d for 10 'long miles' to each of 16 carpenters sent from Reading to the works of Painscastle in Radnorshire, a distance of about 120 statute

(80 'long') miles. At times private employers of standing were able to obtain writs of impressment to enable them to get craftsmen for their works, but the numbers in these cases were low. For the king's works from the time of Edward III onwards, even hundreds of men were impressed from all over the country, e.g. for Windsor Castle.

Travelling expenses were, of course, paid for many journeys on official and private business, apart from those paid to pressed men. The cost of transporting craftsmen's tools is also of frequent occurrence in accounts. In 1306 Master John le Fleming, a carpenter working at York Place in Westminster for Edward I, was sent to 'Esthalle' to view the king's timber and received 6d for his own travelling expenses and 6d for his horse, a 'hakneye'. Five years later another of the king's carpenters, John de Waleden, drew 2s. for the carriage of tools ('*utensil*') of himself and his mates going to Newcastle-upon-Tyne to work on the castle; and in 1418 the chapter of Wells had to pay the expenses of their master carpenter going from Wells to Burnham to supervise the building of a barn, and 1s. 1d for the hire of a horse to carry the carpenters' tools to Burnham and back, including provender for the horse. Costs of transport of materials are a commonplace, but it is worth stressing that some products were carried great distances at an early date. Thus in the Pipe Roll of 1177–78 there is a sum of £27 6s. 11d allowed for carrying timber from York to London for the repairs of the Tower. Even whole buildings, usually timber-framed, were carried for long journeys, as when the hall of Llewelyn was taken down in 1316 by John de Mere and transported by sea from Conway to Caernarvon for re-erection. The work was done by contract for £14 3s. 4d. In 1463 the outer walls of Wolvesey Palace at Winchester were repaired with freestone from Beer in Devon cut into 'Crestez, Scues, Koynes and Vents', brought in a ship to St Denys by Southampton. The charge was by the 'doliate' or ton at 4s. 2d the ton for each of the $9\frac{1}{2}$ doliates, viz. £1 19s. 7d.

In some cases it is the payment of expenses for transport that is our only clue to the intervention of some major personality. In this way the record that 3s. 4d was spent on hiring a cart for carriage of painter's gear from Esher to Farnham in 1393 is the only evidence that Herebright the painter of London was an artist working for Bishop William of Wykeham. Since this was evidently the same man as Herebright of Cologne, citizen and painter of London, making an altar-piece for St Paul's Cathedral in 1398, we have here a proof of unique importance of the links between the Rhineland and church paintings of the highest rank in England. Herebright's work for Wykeham in turn opens up vistas of at least possible responsibility for the design of stained glass for New College, Oxford, and for Winchester College. To the question of the responsibility of painters for design of works executed in other materials we shall return.

From the transport of tools to the tools themselves is a natural transition. A major factor conditioning the crafts of the Middle Ages was the

availability of tools of various kinds. In spite of slight individual improvements, it has to be recognised that most instruments are very ancient and that they arrived in western Europe from sources further to the East. Scissors came in the sixth or seventh century; the mould-board plough not until the eleventh; joiners' planes can first be seen in drawings by the thirteenth; steel needles, brought by the Moors from the Islamic world, did not reach us until the fourteenth century and are first specifically evidenced at Nuremberg in 1370. Yet they had long been in use in centres such as Antioch and Damascus. The earliest metal needles were forged as closed hooks; the piercing of an eye through a solid head came later. Precision instruments such as the astrolabe, already mentioned, were made and used in the Near East and brought to Europe in the eleventh century, along with the way to use them.

In building there was a startling change from the rough surfacing typical of Romanesque times, produced with stone axes, to the fine and regular ashlar tooling made by driving the blade of a cold chisel, or bolster, across the surface with a maul or mallet. But as late as 1425 the tools belonging to the works of Scarborough Castle include three stone axes and a ' hamer ax ' as well as six ' irens ' (probably bolsters), two ' settyng chisells ' and, in the lodge, two trowels. In the Trasynghous or drawing office were two pairs of compasses made of iron, one pair a yard long, the other smaller; and four planes which would have been used for smoothing the thin panels used to make templates. Tools were frequently bequeathed by will: in 1332 Martin le Payntour of Lincoln left to Richard Mason two chisels and a ' hakhamer '; and in 1433 Edmund Warlowe, a London mason, left to his former apprentice Richard Mady all the instruments and necessaries called ' tool ' belonging to his office in the Priory of the Friars Preachers (the Blackfriars) of London. He was well to do, for he had a baselard (dagger) harnessed with silver, and a furred gown of violet and ' sangwaiyn '; and he was able to leave £1 to the friars.

A good many instruments were made by the craftsmen themselves out of bought materials. Drawing boards (31, 32) were formed from ' Estrich ' boards bought for the purpose at Westminster Palace in 1323, and in the following year Madam Joan la Vyntere (i.e. in the wine trade) was paid 10d for an empty barrel for making rules and squares for the masons. The point of buying an old wine barrel was that the staves would be so thoroughly seasoned as to be beyond further twisting and warping. In 1332 50 Estrich boards were bought for 10s., to make the ' trasura ' larger and to make more rules. On the other hand, two levels (' lyuelus ') were bought ready made from John Bate in 1383–84 for the works of Abingdon Abbey, but a total sum of 3s. 10d covered them as well as two boards and the working of them for moulds (templates). Other necessaries too were obtained from shops, notably measuring rods costing 3d for Master Michael of Canterbury at St Stephen's Chapel in 1292; a line

costing 1s. for measuring the wharf on the Thames in 1354–55; and in 1451–52 a string bought for ½d for measuring stones for the Shrewsbury Corporation works department. By 1515 there was a regular builders' merchant in Westminster, William Godwyn, who supplied 'packthred and whipcorde for the Breklayers and masons' for 1d, 200 6d nails for 11d, a 'grete Hamber for the masons hardhewers' costing 8d, with another 8d for two other 'lytill Hambers'. Chalk line, fine string impregnated with powdered chalk, for leaving a straight line marked by merely stretching it and plucking it at the centre, could be bought by 1435 and in *c.* 1543 a dozen knots of it for the carpenters at Whitehall cost 6d. In 1368 a sieve and a riddle were bought for 5d for sifting gravel and chalk for the Bishop of Winchester's work at Highclere in Hampshire, so that there must have been a highly developed trade in requisites. In London by 1292 it was even possible to hire tools and, as we shall see, scaffolding. When the ditches were being dug round the Tower of London, 8s. was the price of ten picks bought, but another two picks were hired for 15 days and rods were bought for measuring.

Standard measures and weights existed and copies of them could be bought. Although there was much variation on account of local custom in regard to various commodities – such as the use of a heaped or 'stricken' bushel – many of our imperial measures were already fixed. From early in the twelfth century the English foot was exactly the one still in use, going three to the yard and six to the fathom, 16½ to the usual rod, pole or perch. Every now and then the records give specific evidence of such equivalents, as when a wall at the Tower of London was measured in 1337 in the presence of Master William de Ramsey the chief mason and Master William de Hurley the chief carpenter, and found to be 2 royal perches in length, each of 16½ feet. At Pevensey Castle, the head of the Honor of Pevensey belonging to the Duchy of Lancaster, £1 18s. 6d was paid in 1391 for divers sealed measures and weights of the King's Standard bought at London and sent to Pevensey to regulate (the affairs of) the tenants of the Duke of Lancaster. By 1469 the hundredweight was already of 112 lb, since a total payment of £10 6s. 1d at 5s. per cwt bought 41 cwt 25 lb of lead. Many measures were customary, and whereas the doliate was at any rate likely to be of the order of the avoirdupois ton of 2240 lb, the fother or fodder was a reputed measure varying from one commodity to another, though generally fluctuating around a ton.

Stone was generally measured in 'tons tight', and this too in a rough and ready way corresponded to our ton. Though a little after the end of our period, an interesting account of 1594 may be quoted, since it shows that Beer stone, brought by sea to Thurrock in Essex, was reckoned at 18 foot square measure to the ton. Beer stone, by modern measurement, is reckoned at about 132 lb per cubic foot; multiplying by 18 gives 2376 lb to the reputed ton as against the true 2240. About 1543 coals were reckoned at 30 sacks to the load, but we simply do not know

either the size of the sack or the load in the reign of Henry VIII. On the other hand, when John Thurstone of London, plasterer, was paid 8s. per 'mount' for four mounts of plaster of Paris, the mount was specified as containing 30 hundredweight; and in 1548 a Decree in Chancery concerning 80 acres of land in Leatherhead, Surrey, specified that the acres were to be measured 'after 18 fote in the poole accordyng to the custom of the country there'. This long pole was the measure used in the royal forests and the whole of Surrey had once been forest.

Many surviving contracts specify precise amounts and sizes, and their terminology is often essentially the same as that of modern specifications. In 1373 the cloister of Boxley Abbey was to be according to the forms and measures, moulds and portraitures (i.e. detail drawings), of good and choice stone of uniform colour and free from cracks and vents. We have seen that the correctness of measurements might be certified by the architects – the master mason and master carpenter – actually checking in person. In other fields the craft guilds were made responsible for quality and for various types of certification. At Worcester regulations were made that all tiles should be marked with the maker's sign so that defects could be traced to the responsible party, and this was the general purpose of early trademarks. In Norwich marks were compulsory for the output of weavers, fullers, hatters, metalworkers, tilemakers, bakers and worsted-weavers. Coopers also placed their marks on barrels, and registers of some of their marks survive. This general pattern of the use of marks, as indicating responsibility for workmanship, gives the clue to correct interpretation of most (though not all) masons' marks on stone. Marks on timberwork, however, are usually position marks required for correct reassembly of frames, roof-trusses, etc., made and first assembled at a place remote from the building site.

The maintenance of quality was, as we have seen, one of the chief preoccupations of the guilds and of the municipal authorities. Although the actual processes used might be closely guarded trade secrets, they had to be open to inspection by the searchers of the craft, themselves members of the same company and under oath not to reveal secrets to any outsider, or even to mere journeymen of the same trade. One can imagine that quite frequent inspections were needed in some crafts. In tanning hides, for example, the regulations demanded that the hide must lie in the 'wooses' (ooze or liquor) for a whole year, and that the solution must be made of oak tan bark only. Lime was not to be added, and the liquid must not be artificially heated; this was to prevent any hastening of the process, for it was recognised that good leather required time to mature in the tan, and that speeding-up produced inferior goods. This has an important lesson for the present day, when supposedly 'scientific' means of simulating the effects of time are rife, and lead repeatedly to mistaken results.

Jerry building did occur in the Middle Ages though possibly less than

in more recent centuries. In 1317 a carpenter of Bytham in south Lincolnshire was sued for having built a house with willow instead of oak; and among similar complaints one may quote the case of 1479 where two Staffordshire stonemasons were sued for 20 marks on the ground that a tower built by them at Swynnerton had collapsed because it had been so negligently built. A timber house built by Thomas Sherman and William Becham fell down in 1543, and the London Carpenters' Company decreed that they must rebuild it on the ground of their defective workmanship, ' as well for ther own honystie as the honystie of the crafte '.

Concern for the reputation of a whole craft was on the fully professional theory based upon the instincts of gentlemen and men of honour. This gives valuable support to the thesis that skilled craftsmen and artisans, free by condition, were in fact of gentle blood. They were expected to behave as gentlemen, not as menial labourers. The masons claimed in their Constitutions that their craft of ' Geometry ' had originated in ' great lords' children freely begotten'; and even if this claim may appear excessive, it is at least in line with the traditional view still held in Spain, that every Castilian, whether rich or poor, is a *caballero* inspired by a sense of honour going beyond mere honesty. The professional code of the doctor was emphasised in the application made to the Corporation of London in 1422–23 by Gilbert Kymer, M.A., M.D., Rector of Medicine in the City. He appeared before the Mayor with the two Surveyors of the Faculty of Physic and the two Masters of the Craft of Surgery, and the draft rules proposed included provision that any sick man in need but too poor to pay for professional help might obtain it by applying to the Rector; and that when fees were charged they should be graduated according to the patient's means. With provisions for sick craftsmen we shall deal later.

The maintenance of quality was not simply a negative matter of imposing penalties. The brotherhood of each craft demanded a positive attitude of mutual help. The London painters' ordinances of 1491 required a member to promise that at the request of the Master of the Company he would help any brother craftsman to finish a piece of work. The eighth Article of the Masons provided that the master mason should prefer the perfect work of a ' cunning ' mason and ' do away the imperfect ' so that the employer might not be the loser; but the ninth Point, directed to the subordinate craftsmen, ordered that the man who was wiser and subtler than his fellow and who perceived that ' he should lose the stone that he worked upon for default of cunning, and can teach him and amend the stone, he shall inform him and help him that the more love may increase among them and that the work of the lord (employer) be not lost '. The herald-painters of the seventeenth century had a developed rota system by which all of them got a fair supply of work, and this may have originated much earlier.

Co-operation was not simply between employees on the same job; it

applied also through the various crafts to some of the activities of independent masters. In the early fourteenth century the cordwainers bought their leather by groups; the Horners' and Pewterers' Companies of London made joint bulk purchases of horn or tin, the Stationers as a body backed the printer to make him independent of the capitalist bookseller; a group of nine Curriers leased a workshop between them. The idea of brotherhood was not an empty word, but quite often a reality. Sometimes, though less often than in modern times, this fraternity among craftsmen took the form of united strike action over serious grievances. In 1332 the masons at work on the Palace of Westminster struck for two days in January because they had not been paid since Christmas; the Lord Treasurer had to give an undertaking that they should be well paid for the past and the future before they would go back to work.

In the field of wages and conditions, a great deal more is known of craftsmen in royal and ecclesiastical service than of those in trade generally, since very few records of the small independent masters have survived. A certain amount of information appears incidentally from enactments and regulations. There was a fundamental theory underlying the payment of wages of any kind in the Middle Ages: that within any given branch of trade the whole of the craftsmen of the same type and status should receive equal wages. This view, endorsed in the nineteenth century by Ruskin, ensured in principle that the better workmen would get more employment. The rule was not applied in any egalitarian way, for the claim of special qualifications was always recognised: the carvers of the stalls at St Stephen's Chapel in 1357 were paid at double the ordinary rate. Differentials were limited to the breaks between the less and the more specialised craftsmen, between juniors not yet fully trained and the master of his craft, and between the ordinary master and the designer who was a creative artist as well as a technician.

Overall pay was often made up in two or more parts: cash and allowances of food and clothing, or of other perquisites also. Legal wage rates were distinguished as with or without board, but other extras made a big difference to effective remuneration. In 1267 a great hall was built at the manor of Silkstead in Hampshire: John Wyther who built the hall had £6 2s. 1d in wages and he and his servants had their meals; 15s. 6d was paid for meat and bread: 8 quarters of wheat, 48 carcasses of bacon, 21 cheeses and 6 casks of cider; the mason who built the walls took 8s. 8d in cash, and the roofing was done by piecework for £2 13s. 4d. Sometimes not only board but also lodging was provided at the employers' costs: in 1278 houses as well as lodges for working were built for the men putting up Vale Royal Abbey, and it is said that the town of Roslyn in Scotland originated in the lodgings built for the masons who worked on the famous Chapel. In other cases existing buildings might be hired as dormitories. Meals were provided in the hall of large establishments, such as monasteries and colleges, for craftsmen of differ-

ent ranks: in 1391 the hallbook of New College, Oxford, shows that the architects, William Wynford the master mason and Hugh Herland the master carpenter, were entertained at the high table; with the Fellows of the College there dined a servant of Wynford and a servant of Herland, the College carpenter Hykenam (or Ickenham) with his son, William Brown the warden of the masons, and Thomas Glasyer the maker of the stained glass windows, and also John the Warden's cook; but with the household at the lowest table were the rent collector Roger, and Hykenam's apprentice.

The same arrangements appear in the records of noble private households. The Earl of Warwick, when in Normandy in 1431, had craftsmen and tradesmen of all sorts in for meals: two carpenters and two merchants of Paris to supper on 20 March; one of the King's Chaplains with his page on 9 April; two painters to dine on 22 April; Wild, a trumpeter, with his page and their two horses were entertained to supper and to stay the night on 22 May. When a new bakehouse was built for King's Hall in Cambridge in 1411–12 the master of the work, John Dodyngton, with his wife and his servant were entertained to a dinner costing 8d and were given wine at supper set down at 4d. Drinks for the men, both craftsmen and labourers, were distributed in the same way that they still are when the roof-tree of a house is raised; but more excuses for such liberality were found than the single occasion of ' topping out'. The carvers, masons and labourers at Merton College in April 1291 had 4d for drink on the instructions of the Warden, and again in May. When the great arch in the east gable of St Stephen's Chapel was turned in July 1333 the masons sought and obtained 6d as their ' arch-money' due by ancient custom. When a timber barn was raised on its stone footings at Ormesby, Norfolk, in 1434, the cost of bread, ale and cheese handed out came to 1s. 2d. Supper-money might be given for overtime workers: in 1515 at York Place, Westminster, the plumbers and others at work for Wolsey had 4d for ale ' whan they wrought after there houres to helpe up wt. lede to be laid uppon the rooff above the stare hede.'

Many jobs carried the free supply of clothes of some kind, not necessarily as livery. Mason setters often had gloves to protect their hands, but the masters, wardens and sometimes foremen were given ' robes', commonly a complete suit of outer clothing. This was general in the royal service, and common also at the greater churches. In 1311 the Sacrist of Norwich Cathedral paid £1 16s. for the robes of William and John the carvers, and 6s. 8d for an overtunic for Alexander the mason. Distinguished architects, artists, physicians and other professional men might have quite notable costumes: in the winter of 1398–99 Henry Yeveley, Richard II's master mason and chief architect, gave his receipt for a ray cloth and a white lamb's fur ' for my winter robe'; and at Easter the cloth and furs needed for the gown and hood of Master John Medilton. one of the king's physicians, were specified: 4 ells of russet

long cloth, 205 backs of ' gris ' or minever and 377 backs of ' Cristgris ', a sort of squirrel fur; another robe consisting of gown, cloak, tabard and hood required 14 ells of blue long cloth, 198 bellies of pure minever, 873 bellies of gross minever, 375 backs of ' Cristgris ', and 3 furrings of ' biss ' each of 7 ' tire ', tiers or rows.

Whereas the ordinary craftsman could look only to his guild or fraternity for benefits in sickness or old age, the higher ranks of professional men were given very handsome allowances. The master carpenter of Durham Cathedral, Master R. de N., ' who has spent his working life on our cathedral, now aged ', was granted by Prior Hugh (1258–78) 7 loaves weekly, with 7 gallons of ale, 3 messes of meat, 4 of fish; and 3 ells of russet or bluet cloth yearly. John Bell the younger, mason to the prior and chapter of Durham from 1488, whose pay while at work was 10 marks a year and 10s. in the winter, with a garment and a house rent free, was to have a pension of 4 marks a year if he could no longer work because of infirmity or great age. Henry V in 1421 granted to John Hoggekyns, master carpenter of the king's ships, 4d a day in consideration of his long service and that he was much shaken and deteriorated in body. Hoggekyns was presumably the naval architect responsible for designing the fleet that made Henry's victories possible, and the great ship that, sunk at her moorings in the Hamble River, still survives as a skeleton.

Richard Beke, chief mason of London Bridge and later of Canterbury Cathedral, was in 1435 guaranteed that if he became bedridden or blind his allowances of £1 a year for a house, 8s. for fuel, 10s. for clothes and two pairs of hose would continue, though his wages would drop from 4s. to 2s. a week. On the other hand, John Croxton in 1446 had to petition the City of London on the ground that he had for thirty years and more carried on all the works of the city and especially the building of the Guildhall ' and there in spendyd hys younge age ', as well as for six years on the Guildhall Chapel ' and purveyng for the ordenaunce and Counseille of the mooldes (templates) thereof ', but had only a little house, £1 a year and clothing; whereas he was owed arrears of £8 2s. 0d and asked for an extra £2 a year. It is some comfort to know that Croxton's petition was granted.

Chapter 5

Talking Shop

Since mediaeval crafts were very largely both urban and indoor occupations we have to try to form some idea of the kinds of houses, shops and workrooms in use from the eleventh to the sixteenth century. In what ways did they differ from their modern equivalents? Firstly it is necessary to distinguish between the private premises of independent traders, combining house and shop; the separate small shop – both workshop and stall – without living accommodation; and buildings erected specially for work done by substantial bodies of men for an employer. The house-with-shop might be independently built upon its own plot of freehold ground by the well-to-do burgher; or it might be leased as one of a terrace of 'rents' put up for a landlord, often a monastery or a chantry foundation. The small shops, perhaps mere stalls with only a few square feet of space, were commonly spread along the frontage of greater buildings, the inns or hospices of nobles and prelates. Buildings made for work of factory type were largely the masons' and carpenters' workshops at monasteries, royal palaces, and other great establishments.

The Customs of Cluny of about 1032, describing the plan of the great Burgundian abbey in the stage known as Cluny II, mention a cell where 'the goldsmiths or enamellers or master glaziers may exercise their crafts'. Similar accommodation is implied by the setting up at Coutances in Normandy, somewhere about 1080, of a cathedral staff including goldsmiths, blacksmiths, carpenters and a master mason. At York Minster in 1409 a new lodge was to be built and in it at least 12 masons were to work; at the same time at least 20 masons were to work in the old lodge. At the royal palaces and castles very much larger numbers had to be accommodated: in 1344 Windsor Castle had as many as 500 men for many weeks on end, and in one week there were 720. Obviously temporary sheds were the only possible way of providing workshops in such exceptional cases.

The king's master craftsmen at Westminster Palace and the Tower of London, on the other hand, had permanent houses and offices. The

chief mason had lodges, tracing-houses and other buildings; the chief
carpenter various 'mansions'; the smith a mansion, two gardens and a
house called 'Powderhous' in the Tower and another mansion on Tower
Wharf, as well as a plot of land in Westminster Palace, where the glazier
of the king's works also had a shed called the glazier's lodge 60 feet
long by 20 broad. The king's plumber too had mansions and lodges,
and the joiner had a house in the Tower 'of old belonging to the office'.
There were other houses, offices, lodges and 'traceries' at various royal
castles and residences as well. The cost of repairs was entered on the
official works accounts, and they were not a personal financial liability
of the master in whose custody they were placed.

Occasionally agreements survive, giving some information on crafts-
men's houses. In 1354 the Abbot of Westminster granted a lease for 40
years of a shop within the abbey to John Stafford, carpenter and his wife
Petronilla. It had a small curtilage and was the last at the north end of
a row of seven new shops next to the west gate. A rent of 10s. was to be
paid to the Sacrist and Stafford was to work for him at carpentry as
often as he might be needed, giving him priority before all except the
king and taking royal pay when at work, namely 3s. for a full week.
Stafford and his wife in this instance were made responsible for keeping
the roof safe from fire, water and other dangers, except fire conveyed
from elsewhere. Henry Yeveley, the great architect and master mason,
paid the high rent of £5 a year to St Paul's Cathedral for a plot and
a shop which he had in 1381 recently rebuilt, with a void plot and a
garden which he held in the great churchyard. The little garden was
elsewhere said to be next to the tracing-house or drawing office of the
Dean and Chapter. Yeveley's new shop was on the site of one formerly
in the possession of John Marberer, and Yeveley in his will made in
1400 mentioned these premises 'with all my marble and latten goods
and my tools therein'. This was probably the most important monu-
mental masons' shop in the country, producing high tombs, effigies,
brasses, and such major works as the Neville Screen carved for Durham
Cathedral of Caen stone between 1372 and 1380, and shipped to New-
castle-upon-Tyne.

In 1416–17 the Master and Guild of the Holy Trinity in Coventry
granted a lease of cottages in Bishop's Street there to David Oswestre
for 24 years at 6s. a year. It was a building lease, conditional on Oswestre
rebuilding within two years with fit timber and tiled roofs. Richard de
Abingdon, master at the building of the tower of St Mary the Virgin,
Oxford, in 1275, had been granted a house called 'St Mary's Entry'
rent free during the work, but was to be allowed to remain in it after-
wards at a rent of 12s. a year. William Wright, a Ripon carpenter, in
1379–80 paid 10s. rent for a house in Stanbriggate leased to him by the
Minster; but the costs of re-thatching in the same year were entered on
the fabric rolls. Some houses granted to master craftsmen were much

39. Ufford church, Suffolk. Font and telescopic cover. Late 15th century

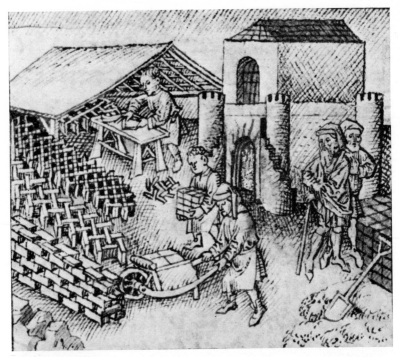

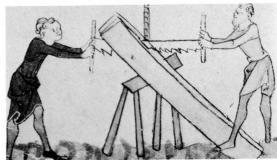

40. (top) *Brickmaking. Flemish, c. 1400*
41. (lower, left) *Potter. French, late 13th century*
42. (lower, right) *Sawyers. English, c. 1340*

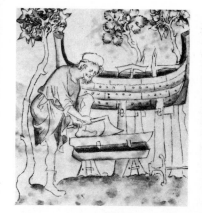

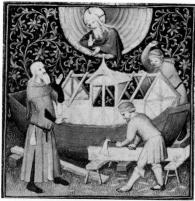

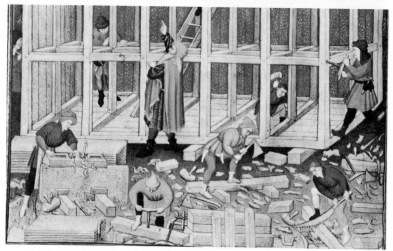

43. (top, left) *Building the Ark. English, c. 1315*

44. (top, right) *Petrus Gilberti : Building the Ark. French, early 15th century*

45. Building the Ark. French, early 15th century. Note carpenters' tools : jack-plane, mallet, chisel, auger, brace (foreground, right), cross-cut saw

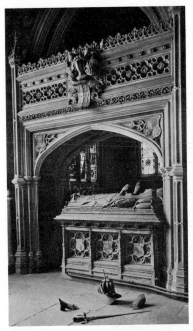

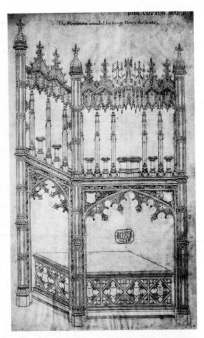

46. (top, left) *Great Brington church, Northants.: tomb of 1st Lord Spencer (died 1532)*

47. (top, right) *William Vertue (?): design for monument for Henry VI, c. 1503*

48. *Canterbury Cathedral: paving of Trinity Chapel, c. 1220*

49. (next page, top, left) *Thornbury Castle, Glos.: chimney, c. 1520*

50. (next page, top, right) *Oxburgh Hall, Norfolk: turret, c. 1480*

51. (next page, bottom) *Woodbridge church, Suffolk: south porch, flushwork parapet. Late 15th century*

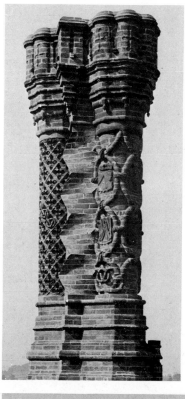

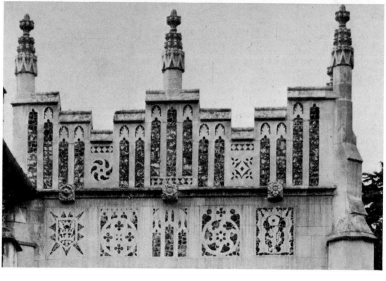

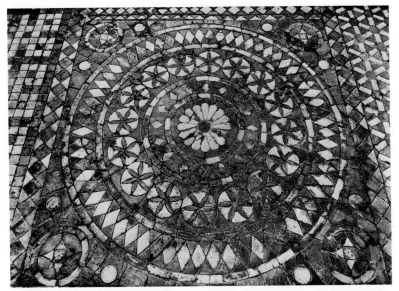

52. Byland Abbey, Yorks. South transept. Mosaic tile paving, early 13th century

53. Ely Cathedral : Prior Crauden's Chapel. Mosaic tile paving, c. 1325

54. (top, left), *55.*(top, right) *Ely Cathedral : Prior Crauden's Chapel. Tile paving,* c. *1325. Adam and Eve ; and Stag*

56. Gloucester Cathedral : floor tile, c. *1350*

57-60. Westminster Abbey: Chapter House, 1253-58. Floor tiles: rebeck and harp; gryphons; royal arms; rose window

61. (top) *Gloucester Cathedral : floor tiles, 15th century*

62. (left), *63. Great Malvern Priory : floor tiles, 1453-58. Rose window; 'Thenke mon'*
poem

64. (top) *Hampton Court Palace: Wolsey's plasterwork,* c. *1528*

65. (lower, left) *Little Moreton Hall, Cheshire: timber-framed doorway,* c. *1500*

66. *Sparsholt church, Berks.: screen with turned shafts, 13th century*

67. (next page) *Winchester Cathedral: choir stalls, 1308-10, by William Lyngwode of Blofield, Norfolk*

68. (top) *Ewelme church, Oxon. : St John's Chapel. Panelled roof, c. 1450*
69. (lower, left) *Barking church, Suffolk : nave roof, 14th century*
70. *Earl Stonham church, Suffolk : nave roof, early 16th century*

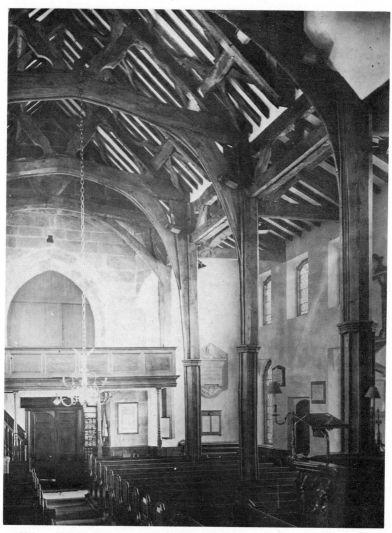

71. *Holmes Chapel, Cheshire : timbered north arcade*, c. *1500*

72-74. *Misericords : Cartmel Priory, Lancs., c. 1440 ; Enville church, Staffs., late 14th century ; Ludlow church, Salop, c. 1450*

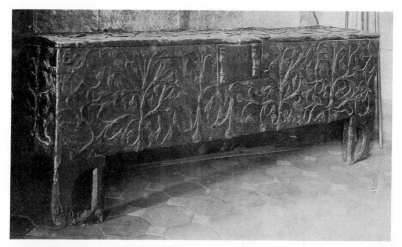

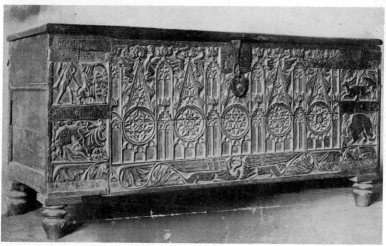

75. (top) *Malpas church, Cheshire : chest, 13th century*
76. *Wath church, Yorks. North Riding : chest, mid-14th century*

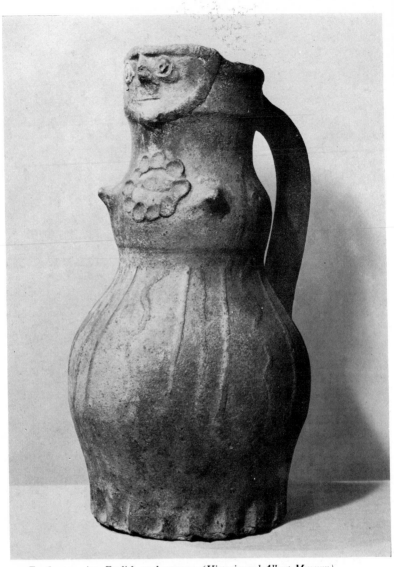

77. *Earthenware jug. English, 14th century. (Victoria and Albert Museum)*

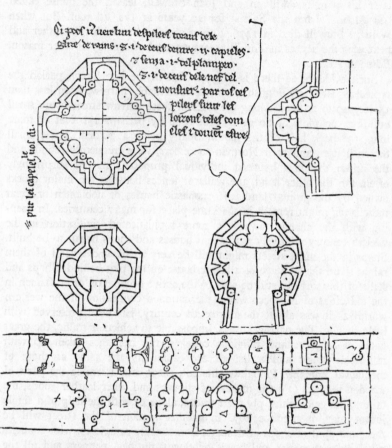

Technical jointing plans of piers and responds in Rheims Cathedral, drawn by Villard de Honnecourt about 1240. Below are his copies of the moulds (full-size sectional templates) for the details of the work, referring by masons' marks (used as conventional signs) to the relevant members on his copies of the working drawings to smaller scale (Album, 63).

F

more valuable: that in the Close at Exeter in which Master Thomas de Witney lived in 1316–24 cost £1 12s. 0d beyond the fees of £6 13s. 4d which Witney received. At Westminster Robert Stowell, who had become the Abbey's master mason in 1471, took a lease of two tenements in Tot-hill Street for 46 years from the Warden of the New Work; two years later his parents, William and Joan Stowell, leased the house called 'St Albans' from the Sacrist for 40 years at 13s. 4d rent. But when William Stowell died in 1476, Robert went to live with his mother and next year the houses in Tothill Street were taken over by another mason, Edmond Adam.

Such evidence as there is suggests that in the late Saxon period the typical street of an English town was remarkably narrow, from less than 15 feet up to 20 feet. Along the sides of these narrow streets were small buildings on plots of 20 or 25 feet wide by perhaps 150 feet or more long, the back half of the plot normally being a garden. These small Saxon houses, and their Norman successors, were frequently rebuilt and the minor divisions between individual properties moved surprisingly often. On the other hand, the walls or fences between the major blocks owned by the ground landlords, monastic houses or noblemen or great merchants, might remain in the same place for many centuries. In keep-ing with the change towards a more sophisticated civilisation in the twelfth century relatively permanent houses and shops began to be built. Shops in the main streets might still be very small, and several of them might share the frontage of a larger house on the plot behind. Shops and stalls of this sort can still be seen in the active occupation of craftsmen in the old cities of Morocco where the common civilisation of the western world, as it was about the thirteenth century, has been preserved with little change. The narrow streets, impassable to vehicular traffic, the great gates of hospices and religious colleges, the frontages taken up with minuscule shops and stalls, all are essentially the same as those of mediaeval England. Ploughwrights cut, shape and assemble the parts of wooden ploughs (3); the makers of slippers and other leather goods, the tailors, the goldsmiths, ply their trades, alone or with the help of a single journeyman or prentice boy. In another section of the street will be the more opulent shops of drapers, ironmongers or spicers, with counters piled up with plates and bowls of cloves, nutmeg, peppers and all the other accessories of cooking and pickling. Larger areas are given over to noisy trades such as that of coppersmith, open yards crossed by lines of drying cloth beside the vats of dyestuffs, (106) quarters filled with the kilns of potters and glass-blowers. (110) Here and there are cook-shops, bakers and confectioners, coffee-houses with gaming-tables for the affluent or unoccupied.

Contracts for building shops and houses in London show that from about 1300 it was usual to build a shop and two upper storeys of timber above a basement or cellar of masonry. One agreement of 1342, by which

Richard de Felstede, citizen and carpenter, was to build a tavern in Paternoster Row, gives the dimensions of the plot, 46 feet of frontage and only just over 29 feet in depth; and states that this area had formerly been occupied by five old shops, which can only have been 8 or 9 feet wide after allowing for the thickness of outer and party walls. In 1369 a great range of 20 shops and a gateway was to be built for the Dean and Chapter of St Paul's on a frontage of 258 feet, thus allowing a little over 12 feet of frontage for each shop. In 1405 a new ' great shop ' was to be 22 feet 4 inches long by 18 feet wide, again an investment of St Paul's Cathedral in property development. Meanwhile, in 1373, two ranges of shops built in Southwark for the Prior of Lewes were to have only one upper storey, and this applied also at Canterbury in 1497, where the size of four shops was to be 12 feet by 8 feet 6 inches each. The range of four houses occupied 84 feet by 20 feet and each house had, in addition to the shop, a small buttery, a hall and a kitchen, as well as the space upstairs. From these examples it can be deduced that provincial towns, and even Southwark, were for the most part built of two storeys only above ground, but that after 1300 London was being rebuilt as a city of three storeys and with accommodation on a larger scale.

It has already been stressed that most craftsmen, at any rate those who became independent masters, and in many trades all apprentices were of free condition. This did not mean that they were all freeholders of their shops and homes. Nevertheless, very many craftsmen were freeholders. In the latter part of the reign of Edward I, about 1300, Alexander le Mason of Tothill in Westminster, and his wife Emma, were in a position to dispose of their messuage by quitclaim as owners, and this is typical of a large category. Rather earlier, Alexander the Carpenter of Westminster, who worked as master at Westminster Palace from 1234 and after 1239 at the Abbey, was well enough off by 1260 to buy a ' suburban ' property at Knightsbridge, and died *c.* 1269. Some craftsmen were able to buy manors in the country, as did William de Burton, a London goldsmith, who at his death in 1368 owned Warbleton in Sussex. Substantial town property was owned by craftsmen such as William Lyndys, citizen and mason of Norwich, who had taken up the freedom in 1428. He died in 1469, desiring to be buried in the sanctuary of St John, Ber Street, and leaving for this privilege 3s. 4d to the high altar and 6s. 8d to the repairs of the church. To Norwich Cathedral he left 1s., to the nuns of Carrow 1s. 8d, to the Black Friars 3s. 4d. To the repairs of All Hallows, Ber Street, he left 6s. 8d and another 5 marks ' in cas the parysshyoners will makyn an Ele ' (aisle), but otherwise nothing. The Austin Friars were to have 2s. and one of his houses was to be sold to pay a priest for two years to say masses for his soul. His daughter was left 6s. 8d and six silver spoons; the ' mese (messuage) that I dwell in ' was to be sold and half the proceeds given to his widow Katherine, who was also to have all bedding and like effects and was to dwell for

life in 'my tweyne tenauntryes hanging on the same mese, with fre drawyng of watyr at the well and her plesur in the gardeyne at all tymes.' (2)

An earlier Norwich mason, Adam Godard, who died in 1394, was able to leave a tenement in the parish of All Saints in the Timbermarket to be sold and the proceeds divided into two equal parts: one for the support of his wife Matilda, the other to pay his debts and, as to the residue, to spend on behalf of his soul. Still earlier documents show that craftsmen were in the habit of leaving freehold properties to the Church, or in other cases perpetual rents out of property. Darley Abbey in Derbyshire received from Reginald of Derby, chaplain, a rent of 2s. out of half a toft in the parish of St Alkmund, Derby, which his father Robert the mason (*cementarius*) had given to the fabric fund for the perpetual observance of the anniversary of his death. Among the properties in York held by religious houses about 1220–25 was a parcel of land in the parish of St Andrew given in the time of King Henry I (1100–1135) to the priory of St Oswald by Peter the Mason, and worth the considerable sum of 5s. a year.

Many craftsmen had to be content with leasehold property, held under lay or clerical landlords. The surviving parts of a Husgable Roll for York, assessed about 1282, show various craftsmen paying tax for tofts held in their own name, others in respect of lands which they held on lease. Godfrey the Tailor (*Cissor*) paid 2d on his own property in Micklegate; William the Bellfounder (Belwryth), 3d for two tofts; John le Mason 1d; in Skeldergate, Michael the Shipwright paid 2d, as well as another 1d for a toft in Besingate (? Bishophill Senior). Also in Skeldergate was Stephen the Tiler (le Tyuler), possibly a tilemaker, paying 2d on his own plot; but he also paid 2d in Micklegate on a plot which he held as tenant of John Stybayn. Stybayn held other properties, including four tofts which he leased to Stephen the Cutler, who had to pay 4d. On the other side of the Ouse, near the Minster, Stephen Le Tyuler held two more tofts from the Vicars Choral, for which he paid them 2s. rent, as well as the 2d husgable due to the king; Everard the Carpenter held one toft from the Vicars at a rent of 2s. 6d, and was also assessed to pay 2d tax. John the son of John le Mason, however, held a toft as tenant of the heirs of Alan of Carlisle but rendered nothing to the king – presumably because the land was in the Archbishop's shire.

As distinct from the small shops of individual craftsmen, whether incorporated in a dwelling house or not, there were always some buildings that were essentially factories. Some were built as permanent sections of monasteries and other institutions. In the later Middle Ages there seem to have been considerable numbers of houses built for weavers in certain towns, with long ranges of windows giving light to large galleries in which looms were set up. Outside the building trades, it was probably only the weavers who needed space for many men working at the

same time. In most trades the guilds strictly limited the number of employees: in 1271 it was ordered that no London cordwainer was to have more than eight journeymen (*servientes*); the Bristol shoemakers in 1364 were not to employ more than a single 'covenant-hynd', who was to be paid 1s. 6d a week and eight pairs of shoes a year; but there was no limit to journeymen. We know from stylistic analysis that a number of painters must have worked for Thomas of Oxford (**107**) in the late fourteenth century, when he was producing the stained glass windows for New College, Oxford, and Winchester College; and there is a good deal of evidence implying shopwork by small bodies of employees in other trades. Ralph of Chichester, a master marbler, supplied ready-made details for the Eleanor Crosses in 1291–94, and at a later date alabaster-ers produced 'tables' or panels of carving almost on a mass-produced basis. (**96**)

It was, however, the masons' lodge that was through most of the period the main example of a large-scale workshop for the employment of many men. We have seen that at York there were even two lodges at once, for at least 20 and 12 masons respectively, and that elsewhere many more were brought together to carry out great works in haste. A lodge was either a permanent part of the buildings, for instance at the greater abbeys where some building was always in progress; or was built for the dura-tion of works. When the royal chapel of St Stephen in the Palace of Westminster was begun in 1292 under Master Michael of Canterbury, 15s. was spent on 50 oak poles to make a lodge for Master Michael and his masons, and Robert Le Hackre, a carpenter, was paid 5d a day for four days to build it. In 1310 another carpenter, Master Robert Osekin, was paid £8 for making two lodges (*loggeas*), one for the masons to work in and the other for the safe-keeping of the stones carved for St Stephen's Chapel. At Ely Cathedral in 1387 a lodge for the masons was made by John Heyden, carpenter, and his boy, paid a joint rate of 2s. 9d a week for 11 weeks; Walter Wrigth and his servant or mate helping the car-penter for seven weeks, at 3s. a week together, plus 21s. for their board; Robert Carpenter, who helped them for five weeks to complete the lodge, taking 1s. 6d a week and 7s. 6d in all for his board. The 'Trassour' or drawing office, apparently adjoining the lodge, had a paving of 200 (square) feet, scappled by Peter Mason for the piecework sum of 6s. 8d; and this paving was laid by John Leyer, who took two weeks and was paid 2s. 8d and 1s. 4d for his board. At Dunster Castle in Somerset in 1418 Richard Meryman, a mason, had £1 in part payment for making a 'logge'.

At York Place, Westminster, in 1515 a lodge was built for Wolsey's masons, with a door and a window; the door was provided with lock and key, and in the roofing 100 saplaths were used, 1000 roof nails and a load of 'lombe' (loam), presumably for daubing or making walls of cob type, or possibly for bedding tiles on the roof. By the sixteenth century the

royal palaces had not merely workshops, but a complex of storehouses, drawing offices, and space for administrative work. In 1548 the king's surveyor Lawrence Bradshaw, an architect who had trained as a carpenter, was allowed a clerk to assist him and £1 a year for 'money bagges, candelles to wryte by for the makinge of bokes and reconynge by night, and Inke, quylles and pyn dost', that is dusting powder or pounce, the old equivalent of blotting paper. At Eton College the large number of masons employed in 1448–49 had involved the building, in addition to the lodge, of a hostel consisting of a chamber 60 feet long by 18 feet wide, and fuel and the services of a cook were provided.

In one case we have very detailed information as to the contents of a lodge, that of York Minster in 1399, when a full inventory was taken. In the lodge in the churchyard were 69 stone-axes, a great 'kevell' (? hammer), 96 iron chisels, 24 mallets, 400 iron 'fourmers' (? punches), one iron compass, two drawing boards, four leaden 'chargeors' for moulds (presumably lead trays suitable for cutting into templates), a small hatchet, a handsaw, a shovel, a wheelbarrow, an iron rake, two buckets with ropes for the well there, a large 'kerr' (car or truck) with four wheels for carrying stone, timber and the like, two 'kerres' with wheels for carrying other stones outside the lodge, four iron wedges and an iron coal-rake. There were also tools for the mason setters, kept in the crypt, along with ten hand-barrows and two wheelbarrows, a great wheel for winding up stone and mortar with four great cables, and 160 hurdles (for making the platforms of scaffolds).

In the carpenters' shop were four great brass pulleys, a pair of pulleys with six sheaves, a small pulley, two iron 'dryvelles', probably augers, a large ladder and four small weak ladders. The plumbery had five fothers of lead in store, weighing scales and weights, 2 lb of tin, a brass plane, two soldering irons, a wood axe, a skimmer, a 'podyngiren', a tin iron with two hafts and one chisel, a pair of pincers, two new spoons or ladles and one old one, and two ladders of fir. In the glazier's shop were 1,603 quarries of white glass bought for the windows of the new choir, 700 of coloured glass bought for the same, some old coloured glass, 40 small panels of glass, 45 iron bars for windows, two pans for 'enelyng' (annealing), two soldering irons, a pair of clamps and a pair of tongs. Most of these tools and impedimenta are quite normal, but the reference to pulleys with six sheaves indicates the use of complex tackle for lifting great weights to the top of the building. Besides these stores there were in the bell-tower a wheel for winding up lead and mortar and a great cable and another cable.

Something must be said of the word 'lodge' and its probable derivation. The influence of modern speculative Freemasonry has cast a somewhat esoteric veil about the word, out of keeping with its real sense, which was thoroughly practical. The lodge might indeed be used for sittings of the masons' Court but this would not have conferred upon it any

atmosphere of sanctity. We have seen that one of two lodges built at Westminster in 1310 was simply a storehouse for worked stone; in 1438–39 a lodge was made for the King's Barge by the great mere at Kenilworth, framed of timber, wattled and daubed, and thatched with heather cut by John Borewell, labourer, and brought to the Castle by two women hired by agreement for 2s. 2d for the job. In this case lodge means a boathouse, and there is no doubt that the basic meaning of the word is shed. The French *loge*, also used for a hut or cottage, has the special meaning of a box at a theatre, and this is analogous to the sense of the Italian *loggia*, a gallery with one side open. The German *laube*, a booth, arbour or summerhouse, also a theatrical box, points the way back to an Old German original for the whole group of words. As early as *c.* 1195 an ingenious but mistaken derivation was suggested in the Chronicle of Lambert d'Ardres, where a description of a remarkable timber house built at Ardres by Louis the carpenter of Bourbourg near Dunkirk, concludes by mentioning that passages led from the house ' to the lodge, which gets its name for a good and sensible reason – for they were wont to sit there taking pleasure in conversation – derived from *logos*, meaning speech . . .' This strengthens the supposition that meetings were expected to take place in lodges, though the word is not really Greek in origin.

Even if the lodge were not so called from discussion taking place in it, many technical problems must have been aired within those lodges that were workshops, and this leads to the question of the jargon vocabulary used by craftsmen. In each craft there are many words employed that are not standard English, but ' terms of art'. Many of these words were Old English and of Teutonic extraction: though used in specialised senses, they form part of the stock of genuine English with roots in the Saxon period. In connection with the arts since the Conquest, largely dependent upon importations of men and processes from abroad, an important minority of terms is of alien origin. Perhaps more significant is the large proportion of names of crafts derived from or through the Old French: Alabasterer, Barber, Broderer, Butcher, Carpenter, Cordwainer, Currier, Cutler, Draper, Farrier, Fletcher, Founder, Fruiterer, Fuller, Galoche-maker, Gardener, Grocer, Jeweller, Joiner, Latoner, Lorimer, Marbler, Mason, Mercer, Merchant, Musician, Painter, Paviour, Pewterer, Plumber, Poulter, Scrivener, Surgeon, Tanner, Tapisser, Turner and Vintner. To these may be added several others that reached English direct from Latin: Apothecary, Armourer, Cook and Plasterer.

Among the important words that reached us through the medium of French are Ashlar, Brace, Ceiling, Joist, Mortise and Tenon, Sole (-piece or -plate), Truss and Verge (or ' Barge' as in Barge-board). Brick, closely analogous to the French *brique*, seems first to appear as a word in England in 1340 at Windsor (*brikis*), but had been used on the Continent in the thirteenth century. The root is Teutonic and many early

brick-makers in England were Dutch and Germans, and importation via the Low Countries must be assumed. The thing, as 'walltile', had long been known and made in England before it was called brick. Peg, slowly supplanting the older English word 'trenail', arrived from Holland or North Germany only in the fifteenth century. Our modern spelling of Quoin for a corner-stone is not found before the reign of Henry VIII, but its earlier forms such as *coyne* or *cune* go back to *c.* 1200. Among the really puzzling terms is Purlin, the longitudinal beam running from end to end of a roof, parallel to the wall-plates and ridge and giving intermediate support to the common rafters. In the spelling *polrene* it is found as far back as 1331 and this may indicate a derivation from 'pole' and 'run' i.e. the pole that runs from one end of the roof to the other. The sense is parallel to that of the Italian term for purlin, *corrente*.

A good many words now traditional are not very old. Their earliest occurrences at best go back to the time of Henry VIII. In this class are Batten, Dormer, Dovetail, Kerb-roof (for what is now usually called a Mansard roof), King-post, Notch, Strut, and Trimmer. An earlier word for the mansard- or kerb-roof is Gambrel, originally *cambrel*, found in the fifteenth century and related to 'camber', implying a curve or kink. The dovetail joint has a wide distribution and over most of Europe is known as a 'swallowtail', in Romance and Teutonic languages and in Hungarian and Slavonic; only the English dovetail and the Spanish 'kitetail' (*cola de milano*) stand out. In fact very few technical terms have any wide distribution across Europe, though Lath is closely related to the words used in French, Dutch, German and Danish. Floor is all but identical with the Dutch *vloer*, and Rib is the same in English and Dutch.

Some of the most important words are of unknown derivation, notably Mason, Ashlar as applied to dressed stone, Rubble, and perhaps Rafter. This last is supposed to be an Old Norse word for a raft or its logs, but the transfer specifically to the timbers of a sloping roof seems illogical, and is under suspicion when we find from Salzman's extensive collections that in the fifteenth century the word 'rester' or 'restour' was used for rafter. It is easier to suppose that the long-S was misread as an F. Rubble is apparently the same word as rubbish; in Latin forms the word can be traced back to the middle of the thirteenth century, but beyond that it seems to have no ancestry and no analogies.

Ashlar has two distinct meanings. In carpentry it means the short upright timbers at the foot of the rafters of a roof (ashlaring) or decorative uprights filling spaces in roof-trusses. In this sense the derivation from the Latin *axilla*, a little axle, appears sound enough, though not necessarily to be preferred to that from *hastella* (diminutive of *hasta*, a spear), in the sense of a small shaft. This derivation will not serve for dressed masonry, and the question is further complicated by the use of the Latin (*h*)*astellaria*, in various spellings (cf. the modern French *atelier*)

to mean a mason's workshop, at dates from early in the thirteenth century. The Spanish *silleria* for ashlar masonry, and *sillar* for a single ashlar stone (with the Portuguese equivalents *silharia* and *silhar*), are evidently closely related to the English in sound and sense, and seem to imply a derivation from the Latin *sella* (= *sedula*, from *sedes*, a seat). In this case ashlar would mean the stone that is cut with a true bed for setting.

Mason and Masonry are the most mysterious of all. The earliest versions found are *mazo*, *macio*, *masco*, going back to the first half of the twelfth century in Latin texts. Two possible etymologies offer themselves: one from *macia*, a mace, or some cognate word, meaning the maul or mallet used by masons to drive the cold chisel across the face of the stone. This seems to receive some confirmation from the word Hammermen used for the members of some of the combined guilds of the later Middle Ages, uniting in one fraternity all those trades that used different types of hammer. On the other hand there is in French inextricable confusion with the verb *maisoner*, to build houses, from the Latin *mansio*. Even if there is no real connection, the wide sense in which the ' mason ' group of words was used in the twelfth century shows that its meaning was that of builder.

The masons regarded their art as Geometry and by the middle of the fourteenth century had composed a mythological account of the craft, which they traced back to Euclid. Those free masons who were not members of local guilds in particular cities or towns, but held their free courts and moved from one employment to another across the country, were ruled by the Constitutions. These had the force of law for Masons and at their assemblies the history and the ' Old Charges ' were read out to the masters and subordinate masons present. Apart from general provisions as to the assemblies, there were in the oldest known version nine Articles directed to the masters, and nine Points directed to the other masons, including one addressed to such as might attain the rank of warden. A more elaborate version of the Articles and Points, fifteen of each, is contained in the versified manuscript known as the Regius poem.

In spite of the differences between the prose and verse Constitutions, they are consistent with one another and in the statements they make as to the organisation of the trade and the system of regular assemblies. These were official conferences, courts formally attended by the masters and men. It seems likely that there were conferences held yearly in each county, and meetings once in three years in larger regions. It is probable but not certain that there were also occasional congresses of a national type, such as those held in Germany in the fifteenth and sixteenth centuries, but these would have been attended by a limited number of the masters only, not by all the working masons of England. The Constitutions themselves give a fairly clear picture of what happened, starting with the warning of the master and fellows to attend:

When the master and the fellows before warned be come to such congregations, if need be the Sheriff of the country (i.e. county) or the Mayor of the city or Alderman of the town . . . shall be fellow and associate to the master . . . in help of him against rebels and upbearing the right of the realm.

At the first beginning, new men that never were charged before be charged in this manner, that they should never be thieves nor thieves' maintainers, and that they should truly fulfil their day's work and travail for their pay that they shall take of their lord, and true accounts give to their fellows in things that be to be accounted of them . . . And they shall be true to the King of England and to the realm . . .

After this the assembly was to act as a customary court, answering enquiry with presentments of masters and fellows who had broken any articles. Such cases were to be determined then and there, the assembly being a court of summary jurisdiction. Those presented for breaking the articles, and who refused to attend the court when summoned, were to forswear their masonry and no more use the craft. It is remarkable how closely this absolute penalty parallels that of the ancient Tribunal of the Waters held every week at Valencia Cathedral to regulate the irrigation of the Huerta or fertile plain: there the one sanction is the total cutting off of water from the farm or orchard of the guilty or rebellious suitor, so that he is for ever outlawed from his former livelihood. In the case of the masons' court it was the Sheriff of the county who, if he were found working at the craft after being forsworn, should take him into custody and all his goods into the king's hand.

Apart from the mythological history, the Old Charges put forward the proposition that the assemblies had been organised by King Athelstan (AD 924–939) to amend the state of the craft:

And so at such congregations they that be made masters should be examined of the articles after written . . .

The first Article is this: that every Master of this art should be wise and true to the lord that he serveth, spending his goods truly as he would his own were spent, and not give more pay to no mason than he wot he may deserve . . .

The second Article . . . that every master should be warned before to come to his congregation (unless excused for good cause) . . .

The third Article . . . that no master take no prentice for less term than seven year . . .

The fourth Article . . . that no master . . . take no prentice . . . that is born of bond blood . . .

The fifth Article . . . that no master give more to his prentice . . . than he wot well he may deserve . . .

The sixth Article . . . that no master . . . take no prentice that is imperfect . . .

The seventh Article . . . that no master . . . help or procure . . . any common nightwalker to rob . . .

The eighth Article . . . that if it befall that any mason that be perfect and cunning come for to seek work and find any imperfect and un-cunning working, the master . . . shall receive the perfect and do away the imperfect . . .

The ninth Article . . . that no master shall supplant another, for it is said in the art of masonry that no man should make end so well of work begun . . . as he began it for to end it . . .

The Points addressed to the ordinary mason instructed him to love God and Holy Church and All Hallows, and his master and his fellows as his own brethren; to fulfil the day's work truly; to conceal the counsel of his fellows; to do no prejudice to the art ' but sustain it in all honour in as much as he may '; to take his pay and accept the conditions of work set by the master; in case of any discord to obey the master or his warden; not to covet the wife or daughter of his master nor of his fellows, nor hold concubines; ' if it befall him for to be warden under his master that he be true mean between his master and his fellows and that he be busy in the absence of his master to the honour of his master and profit to the lord that he serveth '; if he be wiser than his fellow and can teach him, he shall inform and help him. The whole body was then sworn

To keep these statutes every one That be ordained by King Athel-stan . . .

Chapter 6

The Various Crafts

The multitude of different crafts already carried on in the Middle Ages may be subdivided into categories: based upon the types of material or process used, or upon the purposes served. Without counting the purely mercantile companies concerned with import and export, buying and selling, and a few exceptional misteries such as those engaged in transport (Porters, Watermen), it is possible to put most trades into one or other of the classes: Chemicals (Apothecaries, Colourmakers, Dyers, Soapmakers); Clay with the making of tiles, bricks and glass; Foodstuffs and Drinks; Leather and Horn; Metal; Stone; Textiles; and Wood along with Wickerwork. Purpose has been reduced to its simplest terms in the division into the Victualling Trades and others; but in spite of obvious overlaps there is also a fundamental distinction between the skills of Clothing, those of Building, and those of Ornament.

It has already been said that the word Art is here used to mean work involving creative imagination, while Craft denotes a particular skill taught by rote and unchanging from one generation to the next. It will be seen that there is a continuous progression from the simpler skills which subserve basic needs, such as baking or plain weaving; up to the highly complex craftsmanship, involving individual design, required to produce jewellery, painting of aesthetic quality, or works of architecture. The case of weaving is of particular interest, since it comprises both extremely simple and intensely complex variations. The original invention of the loom, and the plain cloth of warp and weft made upon it, are among the simplest of the great gifts to mankind; yet the development of pattern-weaving, from twill to damask, is of the utmost intricacy. It may seem that, in stonemasonry, the hewing of a cubical block is something that almost anyone could do (though this would be a fallacy); but the practice of the higher stereotomy which produced the fantastic vaults of the later Gothic period called for knowledge and ingenuity to an extreme degree, even to carry into execution a design already made by the architect.

In fact there is no clearcut frontier between the art that is fine and that which is applied. It might be held that even the most elaborately pattern-welded sword-blade was merely applied art; but that the fashioning of its hilt for show gave it a quality which transcended the functional and belonged to the sphere of aesthetics. Inevitably most artefacts partake of both qualities and they cannot in practice be separated. At a later stage something will be said of design, with special reference to building and to the associated arts of sculpture and painting. Here it is only necessary to stress the fact that attention is being concentrated in this book upon those crafts which gave scope to originality and invention: what may be called the artistic crafts.

Before proceeding to consider a number of crafts typical of the Middle Ages, something has to be said about the clerical artist. It has been usual to draw a picture of mediaeval life rigorously bisected by the division between clergy and laity. Virtually all real knowledge, enterprise, capacity for invention and artistic endowment have been assigned to the cleric, but without any substantial evidence being produced. The social intercourse between the clergy and lay master craftsmen, evidently considerable, has been underrated or totally neglected. Furthermore, the fact that mediaeval clients were often clerics, and that therefore many programmes of work were in response to their instructions, has been confused with the function of artistic design. Thus, in speaking of the origins in literature of many of the beasts carved by the sculptors, Miss M. D. Anderson writes: ' if we grant the improbability of a monk's acquiring the technical skill in masonry to carve these elaborate sculptures, we must also grant the improbability of a mason's acquiring sufficient literary knowledge to design them.'

The conclusion does not follow for two distinct reasons. Firstly, the use of ' design ' in this context as a synonym for ' choice of subject ' is misleading. Even if all such literary series of beasts, or other illustrations, were chosen by highly literate clerics, this determination of the subject matter does not constitute *design* at any period. The design of a carving is the original creative factor put out by the imaginative artist after he has been given a determined subject. Secondly, the evidence for substantial literacy among masons and other craftsmen, already adduced, considerably reduces the presupposition that literary subjects were chosen only by clerics. There is no reason why any reader should not be struck by the suitability for artistic purposes of beasts, monsters and other subjects taken out of books. More than this, we know from actual examples that certain pictures, for example in illuminated manuscripts, were adapted as the inspiration for fresh designs, in the same or in other media. A well known instance is the silver-gilt Swinburne Pyx, whose designs are closely influenced by a pattern-book of the East Anglian region that also underlay certain surviving manuscript illuminations. As far back as *c.* 1175 we know that Richard de Wolveston, chief engineer

and architect to the Bishop of Durham, carried with him in a wallet 'painted letters of very great beauty'. It is a fair surmise that he kept these by him as patterns.

Neither the acceptance of a detailed programme nor the use of patterns as suggestions for design need imply lack of originality on the part of the designer. These are the merest commonplaces of practice in the arts, and have no more and no less application to the Middle Ages than to any other period. The case of the clerical and monastic artist is different, in that mediaeval society was indeed far more strictly divided into the clerical and the secular than has been the case elsewhere. There was no counterpart to mediaeval clericalism in the Muslim world owing to the absolute denial of priesthood in Islam. Saracenic works of art, considered as a 'control' in the scientific sense, provide a valuable check upon European processes. The close parallels between western Christian and eastern Muslim arts and crafts between the eleventh and the sixteenth centuries show that there was no difference in kind between the artistic productions of the twin civilisations. The one obvious visual distinction is due to the difference of theological programme which tended to exclude the human figure from Islamic visual art. Even in that respect the cleavage is not total, and many Persian and Turkish miniatures exist to set beside comparable works executed in Christendom.

There were indeed clerical artists and in a few cases they can be shown to have been not only designers but actually executant craftsmen. The explanation of this is usually that a skilled craftsman subsequently entered a monastic order or took holy orders: his clerical status was not the source of his skill but an accident of circumstance superimposed upon it. Such cases were, of course, important for the progress of art in that they provided an exceptionally high degree of integration between manual dexterity, the craftsman's secrets of technology and design, and the book-learning of the time. The instances of whole families of goldsmiths traced in the records are conclusive as to the normal course of events. At the time of the Domesday survey in 1086 there was an Otto the Goldsmith who, beyond any serious doubt, was the ancestor of the family of FitzOtho, FitzOdo or FitzOtto, king's goldsmiths and masters of the Mint for two centuries from 1100 to 1300. One of them, Edward of Westminster (died 1264–65), took minor orders and held various livings on the presentation of Henry III; he was one of the most prominent of all clerical artists, yet it is certain that his capacity as an administrator of aesthetic taste and as an artist was not primarily due to his clergy but to his hereditary position and technical background.

Early in the twelfth century a lay goldsmith, Anketyl, worked for seven years at the Court of Denmark before returning to England and becoming a monk at St Albans. From 1124 he worked on the shrine of St Alban in company with a young layman, Salomon of Ely, of whom more later. Another St Albans goldsmith, who began the outer cover for

the shrine in 1170, also worked for the Danish Court, and was the king's goldsmith in England from 1169 to 1213. As a layman, he married and had two sons of whom one, Nicholas, followed his father's trade and in his turn went to Denmark, serving Waldemar II (1202–1241) for thirty years. He returned to England in 1237 and worked at the Mint, afterwards becoming a secular priest. In 1243 he was ordered to make three images for the shrine of St Thomas at Canterbury, and in 1253 he died. Meanwhile the Salomon of Ely who had worked on the shrine of St Alban in his youth had become a royal goldsmith with a yearly fee of £3 paid out of the issues of Cambridge Mill from 1157 to 1175; he founded a family of Ely goldsmiths which produced several distinguished churchmen and, in all probability, the famous Sacrist Alan of Walsingham. In the fifth generation from the first Salomon three brothers, sons of the third Salomon the Goldsmith of Ely (died 1298), all attained to high positions in the Church, two becoming archdeacons and one in succession Prior of Ely, Bishop of Norwich and Lord Chancellor of England before he died in 1325.

There must indeed have been far more interlocking between clergy and laity than is generally believed, both on account of blood relationship and also of friendship and sociability. The acquisition of craft skills was generally, if not universally, prior to entry into the priesthood. In the case of the monastic orders even more caution is demanded, because for several centuries many monks were not in holy orders but were lay brothers. Often such men entered an order late in life and after a long career in which they had exercised a trade. When the number of such allegedly monkish craftsmen is added to that of the choir monks and secular clergy who had been lay craftsmen first, we have accounted for most of the presumed clerical artists. Considerable numbers of illuminated manuscripts were made for or in connection with particular monasteries, but in many – perhaps most – cases the responsible artists were laymen in monastic employ. The priest, monk or friar as artist was certainly the exception rather than the rule and individual instances require to be justified by explicit evidence. In architecture there is abundant evidence that buildings were designed upon rules of proportional geometry kept secret by the masons, and never revealed to clerical patrons or to the lay public until a late date. The strict rule that no mason, master, warden or fellow, should teach anyone not of the craft how to set up an elevation from the plan (by means of the geometrical propositions) was repeated by the German Congress at Regensburg in 1459, but within a generation the rule had been broken by the printing of treatises including one by Matthew Roritzer, himself the master mason of Regensburg Cathedral. The reason for this sudden change of attitude in late fifteenth-century Germany is unknown; but there does not seem to have been any comparable relaxation elsewhere.

There was, then, a sharp distinction between the art of design in the

Middle Ages and in the modern period. It was only after 1500 – in England after about 1550 – that clients and amateurs could act as their own architects, reading Vitruvius, using patterns and copy-books, and simply issuing instructions to the skilled craftsmen. A great many arguments, attractive at first sight, founder upon this fundamental fact, the sudden breakdown of craft secrecy. Thus it is not enough to quote, as does M. Pierre du Colombier, examples of architects of the seventeenth and eighteenth centuries as non-craftsmen (*n'ont pas été des gens de métier*): Perrault, Inigo Jones, Wren, Vanbrugh. Such instances have no bearing whatever upon the conditions of a world in which a bishop (Conrad, Bishop of Utrecht, in 1099) could be stabbed to death by his master mason because he had learned a masonic craft secret from the master's son. Secrecy in craft methods had to be preserved, even against the patron for whom a master was working, to whom he was indebted for his livelihood.

It may be objected that where members of families of hereditary craftsmen became churchmen of distinction, the craft secrets passed with them out of the control of the trade. But on reflection we can see that this was not the case. The individual craftsman who took holy orders or became subject to a monastic rule did not for that reason become absolved from the strict secrecy which he had undertaken at an earlier date. It is true that a few such persons were capable of design and of producing works of craftsmanship: some of them are on record as having done so; but their ability would go no further and would die with them. We can be quite certain that, until after the onset of the Renaissance, the clerical order as such did not know any of the important secrets of artistic design or of craft processes. The exceptions lay in certain limited fields where written treatises were in existence, works such as that of Theophilus and those of the Strassburg painter or Cennini.

It is a striking fact that very few clerical practitioners are on record even for most of those arts that were described by Theophilus. Admitting that there were some clerical and monastic painters and goldsmiths, the great majority of both those trades consisted of laymen. Glassmakers and glasspainters, enamellers, braziers, organmakers, bellfounders, were normally always lay craftsmen; the makers of embroidered church vestments were often women, though commonly working under the direction of men in ordinary workshops of the period. It is common to picture monks, seated in their carrels, writing and illuminating manuscripts, and to suppose that most mediaeval books were so produced. Yet there was a substantial trade of lay scriveners in London and elsewhere, from whom even the religious houses bought most of their books. (33) The Augustinian canons of Bolton in Yorkshire bought a copy of the *Sentences* of Peter Lombard in 1305–06 and *Veritates Theologiae* in 1310–11; in 1313–14 they paid a York man for writing a chronicle. Early in the fifteenth century a great deal of writing was done for Winchester College, partly

by a local man, Peter the writer or Peter de Chesehull, i.e. Cheshill, the eastern suburb of Winchester, where the scholars had been taught before they moved into the College buildings in 1394. Peter charged 12s. for a Manual sent to Hamble church, and 10s. for another Manual bought from him; in 1415–16 he covered and bound a Portiphory sent to Isleworth, another church appropriated to the College, adding new leaves and notes (i.e. music) of the service for Corpus Christi. In 1418–19 he and his servant spent three days in the College mending books for 1s. 8d, and he had another 6s. 10d for illuminating capitals in a book of *Moralia* of St Gregory abbreviated, and for binding and covering. In 1400–01 a London writer, Roger Hussele, had been paid an instalment of £14 due to him on account of a total of £22 for three Antiphoners.

Even where it might have been expected that convenience and economy would have dictated the employment of local craftsmen, orders might be sent into foreign countries for expensive products. In 1282 Rochester Cathedral saw the erection of an enamelled tomb for Bishop Walter de Merton; the sum of £40 5s. 6d was paid to the maker, John, a burgess of Limoges, and he was actually brought to England to supervise the erection, a journey of some 400 miles each way. Organmakers, and makers of other musical instruments, were generally laymen. When new organs were made for Canterbury Cathedral in 1331–33 the main work was by William de Underdone, a carpenter who had been employed on the buildings, but there were also payments to Janyn le Organier who was very likely a Flemish expert brought over to advise or to tune the instrument. Underdone was paid 3s. a week, another carpenter named Elyas took 2s. 6d, and two other assistants 2s. 2d each. Later on they had their meals at the Prior's table, and their cash wages fell to 1s. 6d, 1s. 3d and 1s. respectively. Another account refers to a sum of 6s. as paid ‘to the masters making the organ’, which implies skilled men, but leaves it an open question whether these masters were Janyn and William de Underdone. A hundred years before the Bishop of Winchester had paid 3s. 11d for the expenses of the ‘master of the organ’ at Farnham in 1225, but this was not necessarily an organmaker. London wills of the early fifteenth century include those of Robert Somerton, harpmaker of the parish of St Audoen, in 1416; and in 1434 those of two lutemakers, John Thomas of St Benet Fink, and Lodowycus of St Edmund the King.

In other crafts the same tendency to send away for the best work and pay a high price for it can be traced. Though it is possible that the famous Gloucester candlestick (133) was made in England, it is much more likely that it was ordered from one of the centres of metal-casting in North Germany. Its date, certainly between 1104 and 1113, is very early for precision work of this kind. On the other hand, London had become a centre of goldsmiths' work and of the best casting before the end of the thirteenth century. William de Farringdon, one of the most notable of the London goldsmiths, king's goldsmith by 1285, was then

working on images given by Edward I to the shrine of St Thomas at Canterbury and on another image for Walsingham. In 1291–92 he made further images as royal gifts to Durham and to Beverley, but by this time he seems to have been aged or ill. He died in 1293, but in the meantime his servant Roger de Farringdon had secured the contract to make the new shrine for St John of Beverley, not finished until 1305. The shrine, of silver-gilt, was 5 feet long, 1½ feet wide and 2½ feet high, with niches and figures.

Goldsmiths were sometimes also bellfounders, as was Edward FitzOdo of Westminster, already mentioned, who cast bells for Westminster Abbey. But on the whole the trade of the bronze-founder or 'potter' was a distinct one (156–9). Bells of bronze were first cast in the eighth century and a century later were common in the churches of western Europe. What is possibly the earliest reference to a bellfounder in England is the mention in the Chronicle of Battle Abbey of Aedric 'who cast the bells' (*qui signa fundebat*) late in the eleventh century. By the middle of the twelfth century one Alwold was a *campanarius* or bellmaker of London, and may have recast a broken bell sent to town for the purpose by the Sacrist of Rochester. By 1250 there was a street of the bellfounders at Lübeck, and in England there were centres of the trade at Gloucester, Leicester and York as well as at London, and others, probably of less importance, at Bury St Edmunds, Canterbury, Exeter and Norwich. The London founders for a long time had a lion's share of orders, and in 1288, for example, John le Poter of London made a copper lavatory for Ramsey Abbey. Experiments were no doubt made, both as to the best proportions of alloy, and as to methods of tuning. By the opening of the fourteenth century Walter of Odington, monk of Evesham and musical theoretician, had devised a system for making each bell in a peal weigh 8/9ths of the next larger bell. It is very doubtful whether this was in advance of the practical knowledge of the founders, who must have worked out their own systems by experience and observation. In any case, surviving fragments of harmonic music of the period, and of a century earlier, show that musical composition was well ahead of the theorists.

In 1354–55 the works accounts show that, in order to make two bells for the King's chapel at Westminster, amounts of 1119 lb of copper and 1100 lb of tin were obtained. Were these quantities taken by themselves they would indicate an alloy roughly half-and-half by weight; but bell-metal varies between about 3 parts and 5 parts of copper to one part of tin. It may be, of course, that the large surplus of tin was in fact wanted for making solder or for other purposes. The complex interrelationships of the metal trades are well exemplified by some later accounts of Old St Paul's Cathedral for 1405. Thomas the plumber worked for 20 days on the belfry (*campanile*), taking 1s. a day, apparently laying lead, of which 5 fother 9 cwt had been bought from an armourer, Mathew Rede. At the same time four new bells were being cast by Master William

Foundour, who can be identified as the William Wodeward who flourished from 1385 to 1417 as a London founder, and who made cannon as well as bells and metal pots.

The removal and replacement of the royal effigies from Westminster Abbey during the war of 1939–45 provided a rare opportunity for the study of mediaeval methods of casting. Full advantage of this was taken by Dr H. J. Plenderleith and the late Herbert Maryon, who published a detailed account of their findings. The effigies, considered technically, fall into two main groups: those of Henry III and Eleanor of Castile, made in 1290–93, and those of Elizabeth of York, Henry VII and Lady Margaret Beaufort, cast in the early sixteenth century. Intermediate in character are the figures of Edward III (died 1377) and of Richard II and his queen Anne of Bohemia, made in 1395–99. Whereas ancient Roman bronze castings were as thin as 3/16ths of an inch, thickened where the metal was liable to strain, and the Tudor effigies by Pietro Torrigiano from Florence average under $\frac{1}{2}$ in. in thickness, the two thirteenth-century figures are immensely heavy, varying from 2 in. to 4 in. These were designed by William Torel, a London goldsmith, who modelled the originals in wax. There were two copies made of the queen's effigy, one for her monument in Lincoln Cathedral, destroyed in 1641. This raises problems of the method used for casting the replica, if the first statue was produced by the *cire-perdue* process, as has to be assumed. The casting was apparently done by or with the help of bell-founders, but the gilding was by means of an amalgam of gold and mercury, of which traces remained for analysis. The Edward III, cast nearly a century later, shows a considerable technical improvement and its thickness grades from $\frac{3}{4}$ in. down to $\frac{3}{8}$ in. in the head. The effigies of Richard II and Anne, made by the London coppersmiths Nicholas Broker and Godfrey Prest, present a curious contrast. That of the king is a highly competent piece of work, *averaging* only $\frac{3}{8}$ in. in thickness and very evenly cast. The figure of the queen, on the other hand, is about an inch thick, and a large part of the body had been recast by running in fresh metal; various plugs and patches showed the great difficulties experienced in bringing this job to a satisfactory conclusion. It is tempting to wonder whether one of the figures was cast by Broker and the other by Prest.

Life-size effigies were indeed a severe test of skill and there is nothing to suggest that difficulty was encountered in the normal casting of bells and pots. It is remarkable, in fact, how many bells have remained in sound condition for centuries. There are also many small bronze pieces of excellent quality (149–151) and a few that are really outstanding, such as the splendid jug now in the British Museum, bearing the arms and badge of Richard II, and recovered in 1896 from Ashanti in West Africa. Other finely decorated examples are known, as well as substantial numbers of plain jugs, pots and skillets. The quantities of such utensils made are demonstrated by the bequests in the will of Robert Tothe, a

citizen and potter (*ollarius*) of York, who made his will on 18 July 1404 and died in the next day or so, as it was proved on 21 July. He had at least eight servants, to whom he left: 200 lb of small brazen pots, two pots each of 16 lb and a ladle with each, worth 1s. 4d the pot and ladle together, a pot of 12 lb with ladle, worth 1s., a cwt of brazen pots and two half-hundred weights each with two ladles; another hundredweight of brazen pots was left to William de Neuton, 'belman', and yet another hundredweight to a servant. In addition to these products of his industry he left a best piece of silver with a foot and cover, a second piece of the same kind, six silver spoons with acorn heads, a best piece of silver with a cover but without a foot, and ' my best silvered belt with baslard ' and ' all instruments belonging to my craft'. A later bellfounder of London, Henry Jordan, who died in 1470, was sufficiently well off to leave landed estates to London Bridge and for the relief of poor founders.

The making of moulds for casting, by the wax process, and also other types of moulds for producing such things as leaden and pewter pilgrims' badges and pierced ventilating panels for windows, became a specialised craft in itself. (152, 153, 155) At York in 1335 one Gilbert le moldemaker took up the freedom as a porter, but in 1350 Richard de Duffeld entered as a ' moldemaker', as did Nicholas of Selby in 1361 and William Aton in 1410. Richard Batour, ' moldemaker', and Agnes his wife, were living in the parish of St Mary Castlegate in 1381. The making of moulds is closely related to the cutting of seals and the carving of wooden stamps for impressing patterns, such as those on glazed floor-tiles. (56-63) Of the men who carried on these processes very little is known, apart from the fact that most important seals were cut by goldsmiths, whose names are generally on record. By 1381 William Geyton was the King's Engraver in the Tower of London, and ten years later Peter Hilltoft had succeeded to the same office.

The art of working pewter was known in Roman times, but the proportions of tin and lead used were quite different from those of the mediaeval material. A fresh start was made late in the eleventh century, when pewter vessels were allowed by a synod held at Rouen in 1074 as a substitute for church plate; in 1076 the same decision was made for England at Winchester, then withdrawn, but later allowed. Much pewter was being made in France, Flanders and Germany by the later thirteenth century, and pewter caldrons were used to boil meat at the coronation of Edward I in 1274. Ordinances were issued by the London Pewterers in 1348, the year in which the first of the trade, William de Ordsale, took up the freedom at York. York became the second centre of the pewterer's craft and in 1416 adopted the London ordinances, which provided for two sorts of alloy. Round cruets, pots, candlesticks and the like were to be made of 26 lb of lead to 1 cwt of tin; but fine pewter, used for flat vessels, of 26 lb of copper to 1cwt of tin. The mixtures were adopted all over England and not merely at London and York. It was

the tougher ' fine pewter ' that seems to have been an exclusively English secret, called ' that fine tin which is little inferior to silver '. At some time before the middle of the sixteenth century the alloy had been improved by the discovery that bismuth (then called ' tin glass ') should be added in the proportion of rather over 3 lb to every 1000 lb of tin. In 1468 the London Company received a royal charter and was granted the right of search throughout the country.

Brass, an alloy of copper with zinc, was mainly used in the Middle Ages in sheet form and was known as laton or latten. Brassworkers, when specialised, were called latoners. Two latoners, Nicholas Musket and William de Morton, became free of York in 1309, Hugh Ras in 1314, Alan de Duffeld in 1322, and many subsequently. There were three of the craft in York in 1381 who paid the poll tax. In 1327 Adam Paytefyn, latoner, apparently not a freeman of the city, had been assessed at £1 as resident in the parish of Holy Trinity, Goodramgate. The whole subject is mysterious, for while monumental brasses cut out of sheet, are far more numerous here than in any other country, it is said that no sheet brass was actually made in England until the seventeenth century. Be this as it may, brassware was certainly sold by the reign of Henry VIII. In about 1543 William Selwyn of the parish of St Margaret Lothbury was paid 1s. 8d ' for wone smaylle Coke (cock) of brasse of hym boughte and by hym sett in the bottome of the grette sesterne wtin the grette kytchyn ' at Whitehall. The design of monumental brasses seems to have been an offshoot of the work of the master mason and carver, and will be mentioned later.

A good deal of mediaeval machinery and apparatus was concerned with the building trade, and with its offshoot, the practice of military engineering. Here it remains to say something of the highly specialised and rather small-scale machinery of the clock. As has been mentioned already, the first clockmakers in England seem to have been either blacksmiths or goldsmiths. The church clocks, which are the earliest to survive, both here and abroad, are certainly the work of blacksmiths, though undoubtedly of masters of the highest category (13). We do not now think of the blacksmith as a precision worker, but we must remember that the craft included trades which later became independent: locksmiths, nailers, pinners, riveters. The smaller kinds of hand-wrought iron nails, used largely for decorative purposes, were things of exquisite quality, even though produced by the thousand. House clocks were in any case presumably always made by goldsmiths or by specialists, and we have seen that the first York citizen to call himself a clockmaker had taken up the freedom as a goldsmith in 1374. This date is close to that of the three notable royal clocks of 1367–70, at Westminster Palace, Queenborough Castle, and the manor of King's Langley.

Until quite recently the whole subject of early clocks was shrouded in mystery, and not least the question of how soon the clepsydra or

water-clock, measuring time (in one of several systems) by drips, was superseded by the weight-driven clock fitted with a mechanical escapement. Though experts still differ among themselves, there is now a growing consensus of opinion that the escapement goes back to the thirteenth century and was applied to a clock not before 1277 but pretty certainly by 1283 in the *horologium* then made at Dunstable Priory. From the commentary of Robert the Englishman on the treatise on *The Sphere* of Sacrobosco, it seems certain that there were no mechanical clocks with escapement in 1271; and it is also doubtful whether the clock described in the *Libros del Saber Astronomia* of Alfonso x, of 1276–77, was mechanical. On the other hand, the Picard architect and engineer Villard de Honnecourt by 1235 already knew of a turning angel which would revolve once in the course of the day and night, which implies that practical technologists may have been very much in advance of the theoreticians of the time. What is certain is that it was in England that the first group of clocks, likely to have been fully mechanical, is found, starting with Dunstable and including those of at least five cathedrals in the next ten years. In several cases the documentary references imply repairs to existing clocks rather than the first construction. At present, Bartholomew the clock-maker at Old St Paul's in 1286 seems to head his profession, closely followed in 1288 by the Oxford bellfounder Roger de Ropford who repaired a clock at Merton College. These were presumably Englishmen, but the Windsor Castle clock of 1350–51 was built by three Lombard clockmakers. Colchester soon afterwards had two clockmakers, John Orlogeer free in 1358 and William Orlogeer ten years later. In 1362–63 Westminster Abbey paid £20 ' for repairs of the orologe constructed anew by the hands of Richard Merton '.

It was the second great wave of new clocks in northern Europe that inspired Froissart, best known as a historian, to write his romantic poem *Li Orloge amoreus* about 1370. Froissart well understood the nature of the driving train of wheels and particularly the importance of the *foliot*, the escapement which danced about ' playing the fool ', now to right, now to left, never resting: ' for by this is this wheel held back (*gardée*) and in true measure retarded.' Besides describing the wheels, the escapement and the chimes which sounded the hours, Froissart stressed the importance of the human element: ' And since the clock cannot go of itself, if it have no-one to keep it and take care of it, for this it must needs have a clock-maker who, late and soon, diligently tends it and regulates it, winds up its weights and sets them to their duty.'

It is such clockmakers and clockwinders that we meet in many of the surviving documents. The clock at Queenborough, made only about 1367–68, needed the attentions of John of Lincoln, ' hoelogiere ', by 1374, when he went down from London to mend the defects ' del clokke ', spending five days on going, staying there and returning, at the rate of 8d a day, for which he was duly paid 3s. 4d. By soon after this an alarm

clock was made at Nuremberg, and public clocks were spreading through-
out Europe. English towns, as well as cities, were getting their local
clockmakers: Clement at Lynn, who in 1402–03 was paid 16s. for keep-
ing 'la Clok' and also the water supply; Roger Clokmaker at Barnstaple
in Devon by 1424–25, when two men on horseback went from Exeter to
seek him out and bring him back to mend the cathedral clock. Their ex-
penses, and those of Roger's horse for four days, came to 5s. 3d. By 1445
it was Toker the clockmaker of Ashburton who was called in to make a
chime for the Exeter Cathedral clock.

By that date even separate churches in the same town were rivalling
one another in keeping clocks: at Shrewsbury in the town accounts of
1444–45 there was a payment of 3s. to the keeper of the 'hour-striker'
(*horicudii*) and 'le Chyme' of St Chad's for Michaelmas term, and 2s. to
the keeper of the hour-strike of St Alkmund's for the same quarter. A
more complex chiming mechanism was contracted for on 16 July 1525
by Thomas Loveday, 'burgeys and blaksmyth' of Gloucester, who
agreed with the Abbot to 'make newe and repayre a chyme goinge
uppon 8 belles wtin the seid monastry and uppon 2 ympnes (hymns) that
is to sey *Christe redemptor omnium* and *Chorus nove Jerusalem* well
tuynably and workemanly' and to maintain these chimes and the 'Clok'.
King Henry VIII himself by 1531 had what seems to have been an astro-
nomical clock or instrument erected in the gallery next the park – St
James's Park – at Whitehall Palace, as the works accounts refer to it as
'the Kyngs Extronyme'. Clockmakers were still, and remained until
1627, members of the London Blacksmiths Company; yet Randolph
Bull, clockmaker to Queen Elizabeth and King James I, c. 1593–1616,
described himself as a goldsmith. Whoever built the clocks, they built to
last: some of them have outlasted six centuries and their movements
have outlived some twenty generations.

Chapter 7

Building

It was its large scale that marked out building from the rest of the mediaeval crafts. While practically all other processes could be carried out by a master with only one or very few assistants, the construction of a castle or a monastery called for large numbers of men, skilled in different trades. It required also far more administrative ability than was needed for the profitable running of a small shop, and a capacity for foreseeing future needs months or even years ahead. This applied to the assembly and deployment of the men, logistics in the stricter sense; and to the placing of orders for stone, timber, lime, glass, lead and other materials at the correct times to yield adequate quantities when they were required by each stage of the process of erection. Furthermore, building and the associated skills of the shipwright and hydraulic and military engineers, involved the use of a great deal of plant and machinery. It was in the rapid development of such artificial aids to manpower that building exerted, from the eleventh century onwards, a revolutionary effect and led the way towards the inventions and industrial civilisation of the future.

It is unnecessary to credit the European Middle Ages with any exceptional power of invention. On the contrary, the types of machine employed were for the most part those of classical antiquity. These were in part derived from surviving Latin authors, including the architect Vitruvius and the military writer Vegetius; in part brought from Italy and, during the period of the Crusades, from the Near East. The arrival of Latin versions of Greek authorities, made through the intermediary of the Arabic translations, placed matters upon a more strictly scientific footing before the middle of the twelfth century. Between AD 1000 and 1200 we can see two major technological revolutions: the first, of the eleventh century, enabling really large structures to be built; the second, of the early twelfth, involved with precision, geometrical accuracy and with the movement of great weights by the help of machinery and tackle.

The fundamental invention of the wheel, apart from its use in trans-

port, was adapted to the operation of hoists, and as a water-wheel harnessed the main available source of power to work mills for various purposes. Water-mills for grinding corn were already of respectable antiquity in England, going back at any rate to the eighth century, but the principle was adapted to the crushing of mined ore, the fulling of cloth, and the hammering of iron, as well as to other processes as time went on. The water-mill was entirely dependent upon the natural supply of water, but required also, in most cases, the skilled direction of the water into a particular channel, and the pounding of the water behind a dam to provide a constant source of power. A good deal of early hydraulic engineering went on, even before the Norman Conquest, for the provision of water supply and for cleansing the drainage systems of monasteries and a few other large buildings. St Aethelwold, Bishop of Winchester in 963–984, brought to the Old Minster streams of sweet water stocked with fish by diverting the river Itchen into artificial channels flowing from north to south across the city of Winchester. These channels, the Brooks, still exist, and so does the underground overflow which drained the priory and, in later years, the College to the south and the Carmelite Friary to the south again. This overflow, the Lortbourne (now Lockburn), had to be cleaned out from time to time, and agreements were made as to the placing of iron gratings across it to prevent offal being carried down out of one property to the next. The supply of water to cities by means of pipes was a later development of the twelfth and thirteenth centuries. Paris had such a supply in lead pipes, from the reservoir of the abbey of St Laurent, by about 1190, but the first individual concession, to a convent, was not made until 1265. By that time such individual branches were already being made in Dublin, from the important supply brought to the city in 1244–54. London began to get a piped supply in 1237, but the Great Conduit in Cheap was not made until 1285.

Water-wheels had always been used in the Near East and from the Moorish Conquest, in Spain, to raise water up to reservoirs and to channels for irrigation. There is not much evidence for such use in Britain but quite elaborate machinery was constructed. In 1372 at the Bishop of Winchester's manor of Highclere in Hampshire there was a payment of £3 in wages to Robert Prewes for making an engine for raising water from the well, a very deep one, and for making a building over the well with a roof. Iron was bought, and a smith's wages paid, in connection with seven iron ties for the joints of the wheels and the band of one ' cogwhele ' for the water-well (total 1s. 4d); a spindle or shaft (*fusill*), 2 ties and two plates of iron for the engine (*ingenio*) cost 5s.; two arms (*brass*) for the engine cost 2s. 6d; and another 4d was spent on suet and grease to lubricate the ' craudles, cogges ', hinges and joints of the wheels.

The introduction of the water-powered mill from the Continent to Kent was in 762 under a charter of King Ethelbert. It moved north into East Anglia and Lincolnshire, but by the Domesday survey, in 1086,

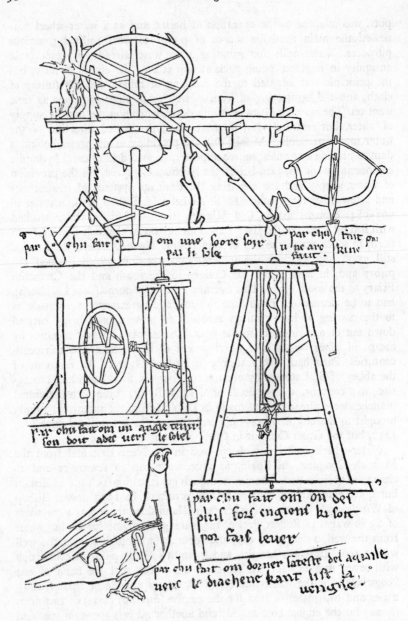

Honnecourt's machines: water-powered sawmill; improved crossbow, auto-
maton for turning an Angel so that it points to the sun; screw-jack for great loads;
Eagle with movable head, as gospel-lectern (Album, 44).

there were nearly 6,000 recorded mills in some 3,000 communities of England south of Trent and Severn. The use of water-mills for purposes other than grinding corn had begun in France by the eleventh century, the topographical evidence indicating direct derivation from Italy through Savoy. In the Grésivaudan, near Grenoble, there were oil-mills, hemp-mills and tanning-mills by *c.* 1040. Fulling-mills were in use in Dauphiné soon after and had reached Champagne by 1101. In north-eastern France the application of water power to miscellaneous purposes came a good deal later: there were malt-mills at Béthune by 1138 but paper-mills are not heard of before the thirteenth century; from Villard de Honne-court we know that there must have been saw-mills driven by water not later than 1235. [p. 98] There were mills for grinding pigments at Péronne, close to the border of Flanders, in 1376. In England the dates tend to be later, but not invariably so. There were already crushing-mills for ore and hammer-mills before the end of the eleventh century, fulling-mills by 1168, tanning-mills by 1217 and saw-mills by 1376; yet paint-mills were known by 1361. Probably the date of introduction was often much earlier than the first surviving record. By the middle of the thirteenth century there were fulling-mills established in places as remote as Appleby, Westmorland, and Dunster in the west of Somerset.

It is difficult to assess the extent of the influence of these water-powered mills upon the building industry. The evidence of accounts shows that sawing of timber was done mainly by hand (14, 42). Pairs of sawyers, who worked at a sawpit, were commonly employed, as at Whitby Abbey in 1394–95, when two sawyers for two days cost 2s. 6d. At the building of Goleigh Farm near Tisted in Hampshire in 1473–74, Henry Sawyer was paid 1s. per hundred for sawing 2,400 feet into boards, and a bonus of 11d on the job. Sawyers at Westminster Abbey in 1496–97 had 9s. 6d for sawing 950 'scafolk tymber'. It should be mentioned that there is no evidence whatever for the fatuous supposition that mediaeval boards were not sawn, but hewn or split and then adzed to shape: sawing was universal. A saw for sawing stone, 4 feet long, was in the stores at West-minster Palace in 1329 and in 1479 at Salisbury Cathedral 'an instru-ment called stoon sawe' was sharpened by filing. During Wolsey's works at York Place, Westminster, Rauff Robynett, smith, had 1s. 3d 'for makying of a fyle for the stone sawe'.

One would expect that water-powered saw-mills might have been applied to the sawing of stone, but there seems to be no definite evidence. In 1385–86 the Cellarer of Worcester Cathedral paid for work on a stone-mill (*petrini molendini*) at Bromsgrove, but this may mean simply that the building of a corn-mill was made of stone. The work involved a payment of 17s. to Thomas de Aston, mason, and his son John, and William Benet, mason, for two weeks; and then wages and board for Thomas Lyllyngstone, carpenter, working for seven weeks on the con-struction of the mill. It is likely that the spread of iron-mills had a good

deal to do with the increasing use of ironwork for building purposes in the thirteenth and fourteenth centuries, for they existed in France by the eleventh century and in both Austria and Denmark before the end of the twelfth. It is said that the first iron-mill in Champagne, set up in 1203, was owned by the Order of Templars. This may be significant in view of the order's close connections with the Near East and Mediterranean. As with so much else that concerns mediaeval processes, our lack of precise knowledge is due to the deliberate secrecy which protected inventions from the public. The point is explicitly made in regard to the devices used in the twisting-mills built at Bologna about 1272 by an exile from Lucca: that they were worked by undershot water-wheels is known, but nothing as to their machinery.

As an aside it may be remarked that the windmill is first heard of in western Europe about 1180, in Normandy, though there is rather vague evidence from later distribution to suggest that the invention came from the Islamic world through Morocco and Spain. It is an interesting commentary upon the evidential value of different kinds of record, that whereas there are several specific mentions of English windmills built between 1190 and 1200 no illustrations of windmills are known earlier than *c.* 1270. The time-lag between the arrival of such a remarkable invention, and its appearance in graphic art, is of the order of three-quarters of a century or well over two generations. Similarly we know that the pole-lathe had been in use long before the earliest drawing of it, also of the thirteenth century. It might be said on the other side that, whereas there is a detailed picture of a spinning-wheel in the Luttrell Psalter of *c.* 1340, (30) the first English reference to wheel spinsters (*filiatrices ad rotam*) is not until 1372. But there are references to the spinning-wheel in north-western Europe from the first half of the thirteenth century and it was certainly in use at Speyer (Spires) in the Rhineland by 1280 and at Abbeville in 1288. Besides, the reference of 1372 refers to Halifax in Yorkshire so that we may be sure that there had been a period of some length in which the wheel moved northwards after crossing the Channel.

The application of machinery was slow to develop but certain uses of wheel and pulley became essential to the construction of large churches, monasteries and castles. Although heavy transport was largely by water, loads of stone and heavy timbers had always to be carried over land for some distance, and carts and wains of strong construction were always in use. In some places, notably York, the sled on runners was used for local transport over short distances. As we have seen, the wheelbarrow did not appear in Europe until the thirteenth century. In this case the first mention in England, of 1257, is approximately contemporary with the earliest drawing, made by Matthew Paris in or about 1250. The record refers to the purchase of a wheelbarrow for the works at Winchester for 7d; by the late fourteenth century, when 'wheelberghes' were ob-

tained at Portchester Castle in 1396, the price had gone up to 10d, and this was still the cost at Ramsey Abbey in 1507–08, two 'whelebarowis' being bought for 1s. 8d.

We have seen that elaborate machinery might be made for water supply, though it is not clear whether this was a form of pump or a windlass with cables and buckets. Various applications of the hoist, employing a cable, pulleys and a windlass, capstan or treadwheel for motive power, soon became commonplace. The earliest drawings of the building of the Tower of Babel, show men carrying stones and other materials up ladders and inclined planes of scaffolding. (16, 23) By the beginning of the thirteenth century, if not earlier, this arduous method had been superseded by the early kind of hoist known as a hawk or falcon. In this a stout vertical shaft was mounted on the building itself and carried a pivoted horizontal beam with a pulley at each end. (19) This beam was the hawk proper, and the apparatus as a whole was called a *verna* in Latin and a *fauconneau* in French. The cable passed over both pulleys and the load could be swung, on the pivoted hawk, over the required point after it had been hauled up from the ground by work at the windlass. Not much later, certainly by the middle of the thirteenth century, the great treadwheel was introduced and both simplified the drive and made possible the hoisting of greater weights.

The surviving treadwheel in the tower of Salisbury Cathedral probably dates from the fourteenth century, but is of the same type as one shown in an illumination in the Maciejowski Old Testament of *c*. 1240. A great wheel in the tower at New College, Oxford was repaired in 1396, and timber had been bought for the great wheel at Abingdon Abbey for 12s. in 1375–76. In 1484–85 York Minster had both a great wheel in the new belfry and hoisting machines described as 'les fernes'. The hoist (*verna*) used at Westminster Palace in 1324 had been made in the White Hall of the Tower of London; its arms (*brachiis*) are mentioned, indicating that it may have been more complex than the normal hawk. Carriage to the water cost 4d, and transport by boat up river to Westminster another 4d. For this or another hoist at Westminster, in 1332, a great hempen cable was bought for winding stone up onto St Stephen's Chapel, 40 'teys' (*toises* or fathoms of 6 feet) long and weighing 120 'great' lb. Hempen cable of good quality and large size was expensive: two cables of hemp bought for the deep well at Highclere in 1380 cost £1 14s. 4d.

In the later Middle Ages the true crane came into use. Instead of the horizontal arm on top of the vertical post of the hawk, this was an adaptation of the oblique yard used on lateen sailed ships, forming a jib. (20, 22) Coulton noted that at Xanten in Germany a hoisting machine was called *asinus*, a donkey, and this may have been some type of jib-crane. Probably the first use of these real cranes was at seaports for loading and unloading of vessels, and this would explain the transfer from the lateen yard of the ship to the stationary crane on the dockside.

The earliest English use of the term found by Salzman was at Dover in 1347, though the reference was for the purchase of grease and tallow to lubricate an existing machine. In fact the accounts of Christ Church priory at Canterbury for 1309–10 include a sum of £1 spent on buying 200 (ells ?) of cord for the ' Crane '. Unlike the one at Dover and later cranes mentioned at seaports, this Canterbury crane was presumably used for building. In the accounts for building Bodmin Church in Cornwall in 1469–72 there were payments of 7s. 9d for making the crane and a bucket, and later 8s. 9d to John Wettor, carpenter, ' mendyng the crane and other labor '. Manuscript illuminations of the fifteenth and sixteenth century often show real cranes on the top of high buildings, sometimes provided with a great treadwheel in the open air (21, 25).

There is reason for thinking that some progress was made in the development of hoisting machines as a result of individual invention, perhaps sometimes by ships' captains or others concerned with navigation, but in at least one case by an architect. The chronicle of Gervase of Canterbury, in describing the steps taken by William of Sens in rebuilding the burnt choir of Canterbury Cathedral, states that in the first year, 1174–75, he made arrangements for buying stone overseas (i.e. from Caen in Normandy) and designed ingenious machinery (*tornamenta*) for loading and unloading the ships and for the transport of mortar and stones. The word ' *tornamenta* ' implies windlasses or types of derrick or crane, rather than screw-jacks, though the screw as a lifting device was known to Villard de Honnecourt (p. 98) and may have been in use soon after 1200. Wine-presses with screw-threads were in use in the twelfth century, and appear in drawings of Christ treading the wine-press at the same period. Before leaving the subject of machinery and devices, the various kinds of drawbridge must be mentioned. Of these the most ingenious was that provided with counterbalances sliding in grooves, so pivoted that the bridge itself rose to a vertical position in front of the gateway. The drawbridge outside the Middle Tower of the Tower of London, built for Edward I by Master Robert of Beverley about 1280, was of this kind. Another adaptation of the hoist, apparently an invention of the fifteenth century, was the telescopic font-cover, suspended over the font and so weighted that it could be pushed up or down without effort. The distribution of most of these covers in Norfolk and Suffolk – the most splendid example is at Ufford – suggests an individual and local origin (39).

One other device of great importance was the ram or pile-driver, essential for the foundations of buildings on soft soil and for the piers of bridges and retaining walls. (26) An invention of great antiquity, it became more sophisticated in the course of time. Ramming to provide a firm foundation is mentioned, after the collapse of a tower at Ramsey Abbey about 985, and various sorts of pile-driver were in use throughout the Middle Ages. In its simplest form the ram consisted of a heavy balk

of wood suspended vertically from sheer-legs and allowed to fall upon the head of the pile to be driven, then hauled up and dropped again. From the sizes of timbers to be provided by the Abbot of Bury for a ram to be used in making a wharf at Tilney in Norfolk in 1434 it is possible to get some idea of the simple pile-driver then employed. Two poles, that is for the sheer-legs, were to be of elm and each 34 feet long. A piece of elm for the ram was to be 2 feet wide, and there were two iron hoops for the ram and two iron plates for its collar besides two staples and two rings. Salzman quoted detailed accounts in connection with a pile-driver used on the king's works at Westminster in 1329, showing that the ram was suspended from a piece of sealskin specially tempered and greased. The ram was controlled by four iron hooks, each supported by an iron rod 1½ ' brasses ' (i.e. 9 feet) long. The construction of this pile-driver must have been complicated, since a man had to be paid 3d for instructing the master carpenter, John de Hurland, how to set up and operate the ram.

What is of outstanding interest in regard to this Westminster ram of 1329 is that it was not made on purpose but hired from Robert Suote, citizen of London, the carriage from London costing 2½d for the ram, a rope 120 feet long and weighing 24 lb, sealskin, hooks, rods, grease, and two ' trendell ' or wheels for a verne or hawk used to lift timber. The fact that plant could be hired as a straightforward matter of business shows that building construction must already have been highly organised. The same story is told by payments for scaffolding. During extensive works at the Tower of London in 1281–84, one Adam of St. Albans was paid for 200 nails bought for scaffolds and also for fat and soap for greasing the pulleys of the engines. Adam was clearly a builder's merchant in general business. We have seen that picks were hired in 1292. For works at York Place in 1306, on ceiling (possibly panelling) the great chamber for the sons of Edward 1, scaffolding was hired (*scaffaldo locato*) for 1s. 4d. In a different field but in connection with the same works at York Place, 2s. 6d was spent on buying 1000 turves (*turbis*) for repairing anew the king's arbour (or garden, *Herbaria*) there. A city in which scaffolding and pile-drivers could be had on hire, and garden turf bought ready to lay, was very far removed from primitive conditions.

Scaffolding, and the other falsework needed in the course of construction, play a far greater part in the skilled craftsmanship of buildings than is generally realised. There were at least three main types of scaffold used, of which one was that of vertical poles and square putlogs familiar until quite recent years. (22) A single staging of this type, and ladders of usual form, are seen in a miniature of the Tower of Babel in Aelfric's *Metrical Paraphrase* of the second quarter of the eleventh century (British Museum, Cotton Claudius B.iv). It is to this type of scaffolding that most of the documentary records refer, and only two main differences from modern usage call for comment. The first is that the verticals and

horizontals were lashed together with bast ropes, where wire rope has been used in modern times. Secondly, the platforms at each level were made, not of boards, but of wattled hurdles. In some mediaeval illustrations it can be seen that inclined planes were made of hurdles, and that wooden steps were fixed across at intervals, forming a shallow staircase. (16) This was perhaps a survival of early usage dating from a time before the general availability of hoisting apparatus, when everything had to be carried up to the top of the work.

Scaffolds were made of several kinds of wood, but not from pine or fir which were not then grown in this country. The commonest timber for poles was alder: in 1277–78 at the Tower of London 1,206 poles of alder were bought for a scaffold to support centering (*cintres*), and cost £12 15s. 6½d; 329 hurdles (*cleys*) were bought for £2 15s. 9d, and 19s. 9d was spent on rods (*virg*), very likely meaning putlogs, and spikes (*rostris*). In 1294 at St Stephen's Chapel, Westminster, 1000 withies (*hardis*) were bought for scaffolding, probably as a stronger lashing than bast rope. Two years later oak and alder timber was bought for the scaffold, as well as 43 hurdles. A later Westminster account of 1324 gives details of the poles used for scaffolding the north side of the Chapel: 61 pieces of ash 42 feet long and 400 pieces of alder 38 feet long, brought from the woods of Walter (Stapledon) Bishop of Exeter at Henley next Guildford. Stapledon was the king's Treasurer at the time. For the east end of the Chapel in 1331, there were 25 poles of alder averaging 18 feet long and 24 hurdles, with 500 ties (*scort*'), which may have been strips of bark. Next year, as work on the front grew higher, 100 alder poles were obtained, 12 great poles each 30 feet long for 'standards', 2 poles each 34 feet, 24 hurdles for making ways upon the scaffold, 6 alder poles for centres, and nails. The nails may have been used for fixing the hurdles to the horizontal poles and putlogs. Hurdles at Corfe Castle in 1376 cost 3d each, 10s. being paid for 40 of them.

The second type of scaffold was cantilevered from the wall, either supported on brackets as shown in some illustrations, (19, 20) or by carrying long poles right through the wall and laying the hurdles to form a counterbalanced staging inside and out. The third type was applicable only to the building of circular, or polygonal, towers, and consisted of a spiral platform circling the tower. This is shown in illustrations, (23) but has also been demonstrated as a feature of castle-building of the later thirteenth century by Dr Arnold J. Taylor. Dr Taylor regards this helicoidal scaffolding, and the analogous use of inclined planes as scaffolds on straight walls, as marks of the Savoyard origin of the building construction practised at Conway, Harlech and elsewhere for Edward I by his great military engineer, Master James of St George: exactly similar masonry, and sloping ranges of putlog holes, characterise the cylindrical keeps at Saillon (1261–62) and Saxon (1279–80) in the Valais, and the towers of Conway, built from 1283 onwards.

78. *Husum church, Sleswig. Hans Brüggemann, 'Riding George', c. 1520. (Danish National Museum, Copenhagen)*

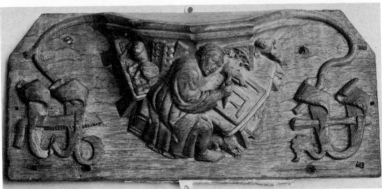

79. (top, left) *Carving a tomb canopy. English, c. 1375*

80. (top, right) *Irene, daughter of Cratinus, painting. French, early 15th century*

81. *King's Lynn, St Nicholas's church: misericord, c. 1415. (Victoria and Albert Museum)*

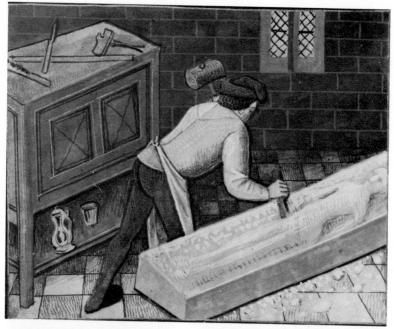

82. (top) *Pygmalion carving. French, c. 1470*

83, 84. *Carving tombs, early 14th century. Note that the inscription on left (English illumination) is in Lombardic; the French illumination on right uses the later Black Letter*

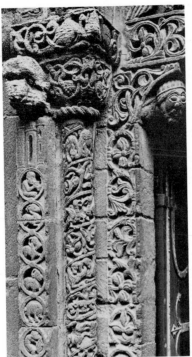

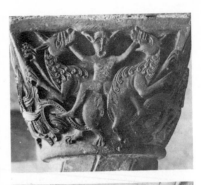

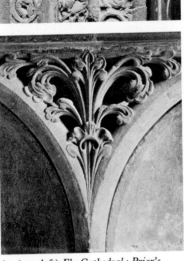

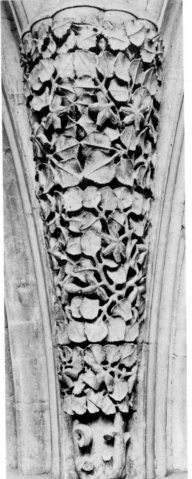

85. (top, left) *Ely Cathedral: Prior's doorway, c. 1140*

86. (top, right) *Canterbury Cathedral: capital in crypt, c. 1120*

87. (lower, left) *Wells Cathedral: north porch, c. 1215*

88. (lower, right) *Exeter Cathedral: corbel in presbytery, c. 1300, probably by William de Montacute*

89. (top) *Fownhope church, Herefordshire : tympanum, c. 1150*

90. *Norwich Cathedral : cloister north walk. Boss of Herod, Salome and the head of the Baptist, c. 1429, probably by William Reppys*

91. (top, left) *Exeter Cathedral : detail of Bishop's Throne, 1316, by Robert de Galmeton*

92. (top, right) *Newcastle-upon-Tyne : St Nicholas. Wooden boss, 15th century*

93. *King's Nympton church, Devon : screen, c. 1525*

94. Chester Cathedral: stall canopy, c. 1390

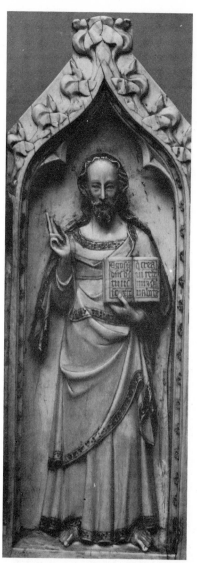

95. *(previous page,* top, left) *Wells Cathedral : alabaster tomb,* c. *1430*

96. *(previous page,* top, right) *St John before Herod : alabaster, 15th century. (Victoria and Albert Museum)*

97. *(previous page,* bottom) *Ludham church, Norfolk : screen, 1493*

98. *Leaf of ivory diptych. English, 14th century. (Victoria and Albert Museum)*

99. *(top), 100. Top and case of leather for 'The Luck of Edenhall' glass beaker. English, 15th century. (Victoria and Albert Museum)*

101. (previous page, top) *Winchester Cathedral : vault paintings in Guardian Angels Chapel, c. 1240, by William of Westminster*

102, 103. (previous page, bottom) *English linear design :* (left) *Hayles church, Glos., c. 1330;* (right) *Loddon church, Norfolk : screen, c. 1520*

104. (top) *East Dereham church, Norfolk : south transept roof, 15th century*

105. Ranworth church, Norfolk : coving of screen, c. 1450

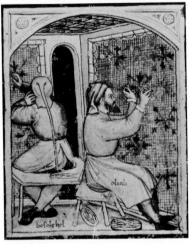

106. (top, left) *Dyers. Flemish, 1482*

107. (top, right) *Winchester College : east window of Chapel. Self-portrait of Thomas the glass-painter, 1393 (copy 1822)*

108. (lower, left) *Broderers at work. Italian, c. 1400*

109. (lower, right) *York : St Helen's church. Glaziers' arms, showing Grozing Irons and Closing Nails, c. 1675*

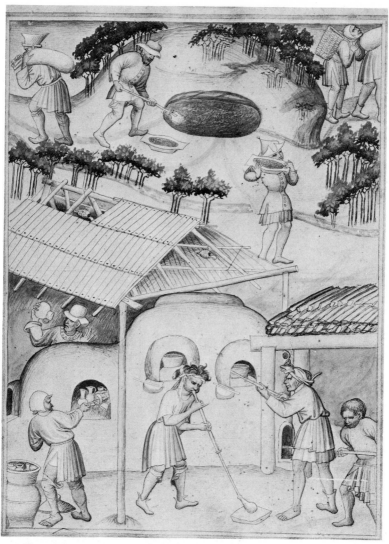

110. Glass-making and blowing. Flemish?, early 15th century

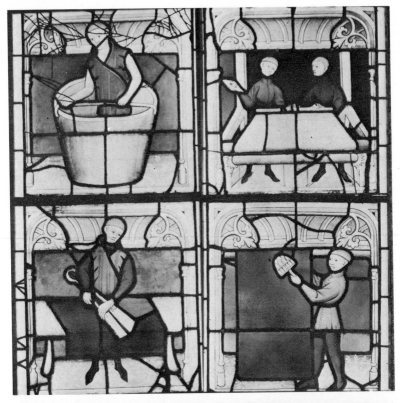

111. (top) Semur-en-Auxois, France : Notre-Dame. Window of the Drapers, c. 1460-65

112. Canterbury Cathedral : north transept. Detail of dress of Queen Elizabeth Woodville, c. 1482, probably by William Neve

113. Marsh Baldon church, Oxon. Glass, mid-14th century

114. Orphrey of embroidered chasuble, early 14th century. (Victoria and Albert Museum)

For works of a single storey, or for plastering rooms, trestle staging might be used. At Worcester Cathedral when the final, west, walk of the cloisters was to be built under Master John Chapman in 1435, Walter Carpenter was paid 2s. 11d for making 'skaffolds' and 'trestellys' around 'le Wyde' (i.e. the garth) for the building. At York Place in 1515 an agreement was made with John Thureston and Alexander Hatton, plasterers, that they should make and set up a scaffold in the great chamber for 15s. 4d as well as 4d 'gyven in Ernest'. Centering for windows and for vaults was a more highly specialised piece of craftsmanship, demanding great accuracy and careful adaptation from the full-size cartoons and templates for the arches (17). For this beech boards were generally used, as at the Tower of London in 1280–84 and at St Stephen's Chapel in 1324. Salzman found some instances of the use of elm and also of poplar for centres; smooth, non-splintering wood was desirable for the purpose. The carpenters who prepared centering were quite highly paid: in 1469 at Bodmin Church, 6d was paid to John Nicolyne for the 'synternys' of one window, and 6s 3½d went to John Lyde who worked on the 'synteris' generally.

Having obtained the necessary plant and scaffolding and set in train arrangements for the supply of materials, the craftsman was ready to start work. In the case of all major buildings and even most minor ones, a proper foundation was laid; for even the timber-framed house or cottage was set upon a dwarf wall of stone, flint or brick. The larger works, where great weight had to be carried, demanded special precautions: either the foundation trenches had to be taken down to solid rock, or the base of the foundation had to stand on driven piles, or a large mass or raft of rubble concrete had to be laid, on which the building could 'float'. The decision as to the appropriate foundation to use was one for the architect, that is to say the chief master mason in charge of the work. It was recognised that knowledge of the correct foundations for a wall of any given thickness and height was a distinguishing mark of the properly qualified man. The German regulations included the design of foundations as one of the essential masterworks required for qualification. At Hereford Cathedral in 1320 new work was to be built upon 'the ancient foundation which is thought to be firm and solid in the judgement of masons or architects regarded as skilled in their art (*judicio cementariorum seu architectorum qui in arte sua reputabantur periti*).' When Adam Mathie and John Meppushal, masons, undertook to repair Merton Hall (the 'School of Pythagoras') at Cambridge in 1374, one clause specified that the new buttresses were to be made 'according to the view and discretion of those skilled in the art of masonry (*secundum visum et discrecionem artificium seu peritorum in arte lathomie*).'

We get a good idea of the order and speed of operations from the accounts for the works of Kirby Muxloe Castle, published by the late Professor Hamilton Thompson. The start was on 22 October 1480 when

H

stone and timber began to be collected; in the following February and March old work on the site was demolished, and in July the foundations were dug and laid and a shed built for the masons. In August 1481 oak boards were prepared for the masons' templates, and by December worked stones were ready. Further demolition of old towers took place in March 1482, and in April the new towers and gatehouse were begun. Work went forward quicker on the towers than on the gatehouse: its foundations went in only in May, but by June floors and windows were going into some of the towers, and during September and October these were roofed and almost finished. In November lead was being cast for the roofs by John Smythson, plumber. In January 1483 centering was being made for the vault of the gatehouse, a suitable winter job for the carpenters; outdoors, sites were levelled for the new kitchen and bakehouse; by the end of February the gatehouse vault had been completed. In March foundations were laid for the new kitchen, and 100,000 bricks were burnt in a week by Anthony Yzebrond, a 'Docheman'. In April worked stones were brought to the site and in May lead pipes and gutters were being fixed. The works were suddenly brought to a premature conclusion by the execution of the patron, William, Lord Hastings, on 14 June. After a pause, some towers were roofed and floors laid between September and November, but the castle was left unfinished.

Apart from the tragic ending of this particular job, its timetable calls for comment. There was no real break during the winters: work of some kind continued, and an important brick vault was actually set in February 1483. This shows that the works were being pressed on at speed, for it was general to stop actual laying of stone or brick during the months liable to hard frost. In the statutes laid down by William of Wykeham for Winchester College it was decreed that building should only be done from 1 March until 28 October, apart from minor works and repairs which could not conveniently be deferred. This did not, of course, mean that indoor work could not be found under cover for the masons and carvers, cutting at the banker, or for carpenters, framing up centering for arches and vaults, or floors and roofs; but it was a wise precaution against defective results. Work unfinished at the start of winter was normally thatched as a protection. At St Stephen's Chapel, Westminster, 1,300 (bundles) of reed were bought on 12 December 1334 for covering over the walls of the chapel, the gable end and the adjacent oratories. The stones cut could not be left unprotected either, and on 19 February 1341 there was a payment of 10s. to William Gamel, a 'redere' (reed thatcher) of Bermondsey, for the task he had undertaken of repairing the 'great lodge' over the stones cut for the Chapel, he to find rods for binding the reed; but the price of reed and of clay (*lutum*) for daubing was to be paid from the king's accounts.

The lines of foundations had to be set out from the plan, pegs and string being used as at all dates. Early buildings tended to be very roughly

set out, without true right-angles, but from early in the twelfth century geometrical accuracy became the rule. This was doubtless due indirectly to the rediscovery of Euclidean geometry through Adelard of Bath about 1120, but more immediately from personal knowledge of practical methods, probably gained by masons and others who had served as military engineers on Crusade in the Near East. The simple method of obtaining an exact angle of 90° by erecting a triangle on the base-line with sides in the proportions of 3, 4 and 5, a procedure easily carried out with pegs and string, must then have been introduced, and was passed on from one generation to another.

Where there were old buildings on the site, demolition might demand the attention of specialists, as at Winchester Castle in 1221–22, when Gerard Le Mineur (very likely a military sapper and miner) was to throw down part of the wall and ' purge ' the foundation for the new tower, receiving £3 for the work. In cases where piles were needed, an old building of timber might be underpinned, as at Canons Farm, Ashill, in 1530, where the groundsill (horizontal timber plate) of the old stable had to be renewed, and the work also included ' prysing up of yt and settying stulpys of ock in the grownde to bere the grownsyll by cause the grownde was not sure '. All work on foundations, of vital importance to safety, was strictly subject to the supervision of the master mason. In a dispute of 1523 over the new chancel of Bishop's Hull Church in Somerset, Richard Brecher and John Hynde, rough masons, gave evidence that they had ' wrought upon the foundacion at the biddyng of John Denman fre mason, and at no wother man ys request '.

The digging of the trenches was a heavy work which might be done by employing a few men over a long period, or by flooding the site with a large labour force. The first method was used when foundations were dug and rammed for the Infirmary of Westminster Abbey in 1364–65: three labourers were at work for 40 days, while chalk, lime and ragstone were brought to the site. On the other hand, in 1370 at Highclere manor in Hampshire, 95 men were set to work for one day on digging foundations about the Hall (1 perch 1½ feet), and 40 perches and 14 feet for the chamber on the east of the Hall, the Low Chamber and on digging walling stone and making holes for posts. Two years later a stone wall was made at Highclere, two perches in length, 8 feet high and 3 feet thick. Stephen Godwin dug the foundations, 4 feet deep and 3 wide, at 6d a foot; and John le Hore and John atte Watere, two masons, built the wall with ' coynes ' drawn from the quarry and dressed, for £2 9s. od. A great deal of the other walls at Highclere was built with flints from the fields: in 1368 a man and his cart were employed for 15 days carting flints to repair the Hall, and in 1370 the price for collection and carriage was 2d the ' potte ': 1,580 pottes were used in the stone wall about the Hall and Chamber and for silling and underpinning (*pynnand*) along the chamber, as well as another instalment of

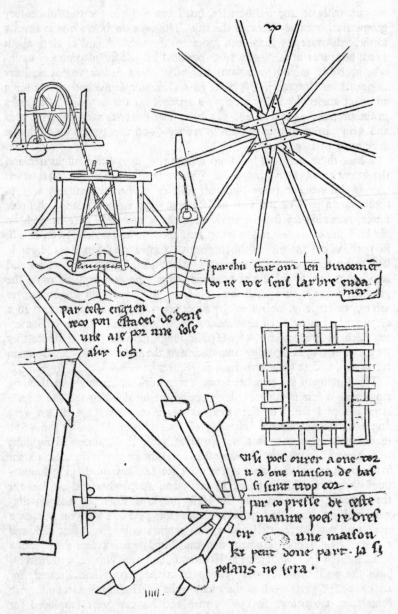

parchu fait om ten binoemēt
po ne voc fenl larbre enda g
mer

par celt engien
reco pon eltaoer de dent
une aie por une lole
alir loს ·

ulſi poel ourer a one toz
u a one maiſon de bas
ſi ſunt trop cor ·

par co prelle de celte
manime poeſ redreſ
en une maiſon
ki pent done part · ſa ſi
pelans ne tera ·

Honnecourt's machines: saw for levelling heads of underwater piles (plumb-rule); method of attaching the spokes of a wheel without cutting the axle; stay with levers for restoring a leaning framework to the upright; construction of a floor with timbers too short to span (Album, 45).

166 pottes. Another material used for foundations was chalk, as at the new Hall of York Place in Westminster built in 1306, when a whole ship-load of chalk cost only 4s.

Timber for pile foundations was a far more expensive commodity but might form a munificent gift to the works of a church or monastery. In 1239 Henry III ordered the keepers of the rich bishopric of Winchester, then in the king's hands after the death of Bishop Peter des Roches, to give piles of beech to the Franciscan Friars of Winchester to make the foundations of their church, and 10 marks in money. In 1277–78 Edward I had 500 beech trees felled in his park at Langley to make piles for setting beneath the mill on the west side of the Tower of London; the cost, with carriage by land and water, came to £21 4s. 7d. Before 1235 Villard de Honnecourt had invented, or noted, a clever device for sawing off the tops of such piles beneath water level: a sawblade operated by two long handles framed together and sliding in a fixed timber frame, was kept pressed against the pile to be sawn by means of a cable passed over a large wheel and heavily weighted with a stone. [p. 108] 'Difficult problems surmounted' might well have served as a motto for Villard, and for many other mediaeval architects and engineers. Throughout the work, but in the foundations first of all, they took steps to see that what they did would for centuries endure.

Chapter 8

Materials and Methods

The production of the raw materials used in building itself called for specialised craftsmanship. Some skills were direct and only a single process stood between the source of a material and its transport to the site. Such, for example, was quarrying, where the craft was that of getting blocks of stone of suitable size out of their natural bed and ready for carriage. Many quarrymen went further than this, and produced dressed ashlar stones or even mouldings cut to the pattern sent; but in doing this they were acting as stonemasons or marblers, not as quarrymen. On the other hand, before a blacksmith could start work, the ore had to be mined, and coal also, or else charcoal burned; and the process of smelting carried out together with processes to purify the iron or to produce steel. Several processes were involved in the making of pottery, tiles and bricks, forms of synthetic stone. It is not possible here to follow out each of these antecedent skills but something must be said of the materials.

Quarrymen and miners are two aspects of a single craft, for mines may be opencast and thus no more than quarries, (27) while some quarries are in fact underground and consist of adits and galleries. In general usage, mining is applied to the winning of metals and coal, and quarrying to building stone and chalk for lime-burning. We have seen that the first thing done by William of Sens at Canterbury Cathedral in 1174 was to arrange for supplies of stone from overseas. This may have been natural in view of his French origin, but it also reflects the actual shortage of freestone in Kent and the south-east of England. It was easier, and a great deal cheaper in transport, to cross the Channel, and one of the strangest turns of fortune's wheel has caused this solution to recur in the second half of the twentieth century: it is once again both cheaper and more satisfactory to get stone from Caen and other French quarries. This is not to say that there are not English freestones every bit as good as any in the world, notably that from Portland. But it is also true that, in addition to the economic and social factors which have led to a decline in the English stone trade, there was even in the Middle Ages an undue

dependence upon inferior sorts of stone, generally because they could be quarried close at hand and the high cost of transport be thus reduced.

The most successful quarries in the mediaeval period were those close to water transport, by coastal shipping (as from Purbeck and Portland) or by river (Barnack near Peterborough, Tadcaster in Yorkshire). Several different types of relationship grew up between major building sites and the quarrying industry. In the first place, some great monasteries, and the Crown, actually owned quarries and exploited them; others were leased from the owners. The quarrying would always have been done by local men with special knowledge, but they might be manorial tenants or paid employees rather than independent craftsmen. In other cases the building owner, or his architect, would have to negotiate with a completely independent quarry-owner and pay a price determined by supply and demand. Thirdly, the quarry might go into business by cutting and selling ready-made ashlar coursed in standard sizes; or it might dispose of its output wholly or in part to a middleman or stone merchant at some neighbouring centre. We may suspect that this was the status of William Puss who, for the works of Cambridge Castle in 1285-86, was selling Barnack freestone ready cut into quoins, stringcourses, jambs and other shapes, as well as ' sclatestone ' or stone roof tiles, sent out by water from Peterborough.

It was very generally worth while to get the stone hewn or partly finished at the quarry, to reduce the weight that had to be carried. In such cases written specifications, marked sticks showing the depth of courses or other dimensions, or drawings and templates, had to be sent in advance. At the start of the work on St Stephen's Chapel at Westminster in 1292, canvas was bought for making patterns (*exemplaria*) for stones to be brought from Caen; and again in 1324 Roger de Waltham was paid for 3 ells (11 feet 3 in.) of canvas for false moulds sent to Caen for stones there to be drawn according to the said moulds, at 3d the ell. The use of marked sticks is implied in 1332 when 200 ' hertlathis ' were bought for making false moulds to be sent to the quarry, as well as 100 ' bechlathis ' for making the said moulds. Not all the foreign stone came from Caen, for large quantities were brought from Boulogne and the neighbouring quarries of Herquelingues. In March 1294 a total of £17 14s. od was paid to Jakemon de Herkeling for four shiploads of Herkeling stone containing 1,062 feet of carved (*sculpta*) stone at 4d a foot. Since limestones such as Caen run out at about 18 feet to the ton the burden of all four ships amounted to some 60 tons: in other words, the ships averaged 15 tons apiece.

Jakemon was presumably a quarry-owner actually working a pit at Herquelingues, but not all stone was bought direct from the quarry. It was already easier in some cases to deal with a middleman, such as Richard de Bray, merchant of Caen, who in 1321 sold stone for the works of Westminster Palace. This applied to English dealers too, such as the

great architect and contractor Henry Yeveley, who in 1367 supplied 36 tons of Beer freestone for Rochester Castle for £18, 25 tons of Caen stone for £10, 2 'moncells' of plaster of Paris for £1, and later 13½ tons of Stapleton freestone, from Yorkshire, for £5 18s. od. In 1390–91, 5 loads of freestone were bought from John Prophete, 'stonman', costing 18s., for the works of the abbey of St Mary Grace's (Eastminster) near the Tower of London. Yeveley, and perhaps a few other masons with large shops, could sell ready-made components for churches. Westminster Abbey, for its church at Battersea, bought a window from Yeveley in 1379–80 for £5: this must have comprised a set of stones, sill, jambs, mullions, arch and tracery, ready for assembly. Similar methods, amounting to mass-production, were brought to a fine point a century later by William Orchard the noted Oxford mason.

While communications with overseas quarries were on a mostly impersonal level, one of the advantages of dealing with local or regional quarries in England was that personal contact could be maintained between the quarry and the staff at work on the building site. During the works at Winchester Castle which began in 1221, a certain stonecutter (*cissor*) was paid travelling expenses of 2s. for going to the quarry at Corfe. In an opposite direction, the quarryman might be brought to the site: in February 1291 Merton College entertained Baldok the quarrier to dinner for two days at a cost of 3d, evidently while he confabulated with the master mason in Oxford and took instructions as to the stone to be supplied. Robert Westerley, then second mason on the works of the nave at Westminster Abbey, was sent to the quarry with 'faussemolds' in 1423–24, and stayed there for four days. John Cole and Christopher Scune, successive master masons at the building of Louth spire from 1501 onwards, had to ride over to the quarries in the neighbourhood of Ancaster, some 40 miles from Louth, and transport had to be arranged over a complex system of waterways and roads. Some work was done on the stone at Coningsby, roughly half-way, where premises were hired for storing stone where it left the water and had to wait for wagons to bring it to Louth by road. The quarries of the Ancaster district had much earlier been exploited for the works of Edward III at Windsor Castle. In 1364 Thomas Plungeon of Ancaster was ordered to take quarrymen to dig stone in the quarries of Wilsford, Hesilburgh, Dembleby, Holywell and Careby.

As a rule the bulk of stone for building was bought by direct negotiation with quarrymen in the early part of our period, while later it became very general to buy through dealers, but there were many exceptions. By 1305 the stones needed for fireplaces in the king's chamber and in the chamber for his daughters at York Place were bought ready hewn: 30 'parpeis' or perpents of Reigate stone from Thomas de Leyt, with carriage to Westminster, cost 2s. 1d. Much later John Orgar, chief mason of London Bridge and a quarry owner at Boughton Monchelsea, supplied

Wolsey for his works at York Place with 150 feet of Kentish hardstone ready hewn at 8d the foot, in 1515. Portland stone, beginning to come into prominence in the fourteenth century, was bought for the Tower wharf in 1354–55 from Walter Bele, probably a London dealer; and in 1372–73 Westminster Abbey could simply pay £10 for 1000 feet of ashlar needed for the gate of ' Tottull '. But the Bishop of Winchester had to send to quarries in the Isle of Wight and arrange transport for the stone to Winchester Cathedral in 1371, while in the previous year for his buildings at Highclere he had sent for freestone to ' Whatel ', probably the Wheatley quarry near Oxford.

Although there is no distinction between quarries and mines, there was a difference between quarrymen and miners. The English quarryman was a local native who owned or leased quarry rights in a particular place, and was experienced in the extraction of that kind of stone. He might belong to some organisation such as the free marblers of Purbeck, but did not usually leave his native district except, in a few cases, to set up a shop in London. Miners, on the contrary, were often wanderers who were prospectors as well. In the later Middle Ages a good many were foreigners encouraged to settle in England and bring their special skills with them. In this way Michael Gosselyn and many other miners from Bohemia, Hungary and Austria were given safe-conduct into England to work in the king's mines in 1452, and there is no doubt that Central Europe was, at that period, the classical land with outstanding experience of ' advanced ' mining technology. Coal mining, probably originating in the need for fuel for forges, was already going on near Liège by 1190, and though forbidden by the statute of Arles in 1306, spread and prospered in those parts of north-west Europe with coal measures. Newcastle-upon-Tyne received a privilege in respect of its coal from King John at the opening of the thirteenth century, and this was confirmed by Henry III in 1234. By 1228 there was already a place just outside the walls of London known as Sea Coal Lane, near Ludgate, where the coal was used as firing for lime kilns; the lane actually had the alternative name of Lime-burners' Lane. By 1273 there were already grave complaints of the London smoke nuisance.

The burning of chalk or limestone to produce quicklime was one of the processes essential to mediaeval building. With the single exception of plaster of Paris, there was no other available matrix for mortar. In any district where royal works were in progress it was likely that a kiln would be started, and the product was sold and given away as well as used for the king's buildings. In 1240 Henry III ordered that the Friars Preachers (Dominicans) of Shrewsbury should have 20 quarters of lime from the king's kiln lately made under the Wrekin; in 1245 they were to have 50 horse-loads of lime from the works at Shrewsbury Castle, and their rivals the Grey Friars (Franciscans) were also given 50 loads. Among the expenses of the Bishop of Winchester at Highclere in 1370 was 10s. for

digging a pit for burning lime; 4s. 2d for making and burning 25 quarters of lime at 2d a quarter; £17 6s. 8d for 1040 quarters of lime made and burnt by Walter Helyar at 4d a quarter, and 50 quarters burnt by John Jolif for 6s. 8d, at the cheaper rate of 2d. A man hired with his horse and cart for 11½ days at 10d a day, to carry chalk and gravel, was probably bringing the former to the kiln.

The carriage of chalk from Greenhithe to York Place in 1515 cost 6d a ton for 20 tons, while the cost of the chalk itself was only 6s. 8d, at 4d a ton; carriage thus added 150 per cent to the cost of material quarried not 20 miles from Westminster. The payments were made to John Trowbridge of Limehouse, presumably in the business of lime-burning, the nearest mediaeval equivalent to the modern cement industry. Limehouse, 'lime-oasts' or kilns, had been the main centre of supply since the middle of the fourteenth century. We may note that the word cement, *cementum* or *cyment*, already existed in Saxon times, and later was used for special mortars which contained substances other than lime and sand. Wax, resin, pitch and eggs were all used for making cement according to different recipes, and it could also contain powdered tiles, bought in 1333 for making 'Cyment' for St Stephen's Chapel. Lime-burning might be the subject of a special contract, like other building processes. On 5 June 1495 the Prior of Christ Church, Canterbury, entered into an agreement with William Denny, limeburner, by which Denny was to burn lime at a kiln of the prior's beside St Sepulchre's. For the burning of every 112 quarters of lime, the Prior was to find 152 bushels of seacoal ('secole') by the heap; and every quarter of lime was to be 8 bushels by the heap. Denny was to dig chalk at his own pit, but the Prior was to provide carriage to the kiln, which Denny was to dig at his own cost – that is, after burning the lime, he was to dig it out of the kiln without extra charge. His payment was to be 3d a quarter, and every time the kiln was set the Prior was to provide a load of wood and pay for it and its carriage to the kiln. The value of such arrangements to the building owner was that they ensured the services of an expert, and did away with both administrative and technical problems.

Stone, coal, and lime are all inorganic materials and exist in a static condition from which they have to be extracted or, in the case of lime, transformed by burning. The case of the other great building material, timber, is entirely different. It is an organic substance, renewed by live growth from year to year, and perpetually renewable either by natural means or by human forestry. The problem of forestry is a very difficult one, for the evidence so far remains slight. It has long been held, though again without positive evidence, that the forests of mediaeval England were entirely natural and owed little or nothing to forestry as now understood. The essential question is whether tree seeds were sown, and young trees transplanted to form plantations. There is enough evidence to show that the totally negative view is not the whole truth. There were

enclosures of land called 'impyards', notably in the West Riding of Yorkshire, and these were in some cases undoubtedly nurseries of young trees, for at Methley in 1413 and later there were cases of theft of young oaks from the impyards. Furthermore, the word impyard survived long enough to be expressly equated with the term nursery garden.

As we shall see, there is evidence for deliberate flower gardening before the end of the eleventh century, and for the propagation of fruit trees from the twelfth onwards, so that there certainly existed a craft of gardening capable of producing timber trees. For the time being, this aspect of the matter must be left here, but it is worth noting that Chaucer, who during his career in the civil service held office both as Clerk of the King's Works and as Forester of North Petherton Park, showed in several of his poems a very wide acquaintance with timber trees and their uses. What is evident from many documentary references is that the master carpenters of the Middle Ages, and sometimes their clients, the abbots of monasteries or other landowners, had remarkable knowledge of individual trees in the forests, and were able to find timber suitable both in size and in type for special jobs. Soon after 1100 the Abbot of Abingdon, Faritius, sent six wains each drawn by twelve oxen to the borders of Wales beyond Shrewsbury to get beams and rafters for his new buildings. When the great octagon of Ely was begun in 1322, a message was sent to Master Thomas Page, a carpenter of Newport, Essex, and he not merely arranged the setting up of the 'ferne' or hoist, but sought out 20 oaks for timber growing in the woods belonging to Chicksands Priory in Bedfordshire, about 40 miles from Ely.

A certain amount of information is forthcoming on several aspects of the mediaeval use of timber: its felling, conversion, seasoning, and the kinds of tree used. Felling, (6) as shown by many records, took place at three main times: in January and February, in midsummer (May–July), and in October and November. Midwinter was avoided for obvious reasons, and also the times when sap was rising or falling. Summer felling accounted for about half the total, equalling the early and late seasons put together. Conversion into beams and planks of various scantlings was carried out, as already stated, mainly by sawing. The method of quartering the tree and getting planks by the method still known as 'quartering' must have been known by the middle of the fourteenth century, when quarterboard begins to be mentioned in accounts. It was from the same period that references to old or seasoned timber are first recorded. For structural carpentry timber was used at once, with no attempt at seasoning, but the advantages of seasoned timber for joinery were appreciated more and more towards the end of the Middle Ages. A letter dated 19 January 1356, asking the Archbishop of York to provide suitable timber for the wooden vault of the Minster nave, refers to the need for the timber to be cut in time to allow it to dry out during the summer months. What is of perhaps even greater interest is that the

letter goes on to remark that what is especially needed is bent trees rather than those of greater price which grow straight to a great height.

This distinction between bent and straight (oak) timber is essentially that between the two botanical species of English oak, *Quercus robur* (with pedunculate acorns and sessile leaves) and *Q. petraea* (with sessile acorns and pedunculate leaves). The 'Common Oak', *Q. robur*, is a wide-spreading tree with crooked branches, excellent for ship's timbers. What is called (but perhaps mistakenly) the 'Durmast' Oak, *Q. petraea*, produces tall straight timber suitable for long beams, principal rafters and most of the main timbers of framed buildings. The main use for oak timber in the Middle Ages was for building, and it was therefore the long straight timbers of *Q. petraea* that commanded a high price. By about 1800, in the heyday of the British Navy built of heart of oak, it was the curved and crooked timbers of *Q. robur* that were prized, and this species began to be planted to the exclusion of the sessile oak. It is likely that the relative commonness of the 'Common' Oak owes a great deal to a long period of deliberate planting. Nevertheless, mediaeval carvings show more specimens with the pedunculate acorns of *Q. robur*, and it may well be that the tall straight timber so greatly sought after by the carpenters was always rather rare.

In addition to oak there was considerable use of elm, for floor boards and for piles and timbering under water level. Beech was used for many purposes where a fine smooth finish was wanted, and notably for the thin boards from which masons' templates were cut. Alder, as we have seen, was in demand for scaffolding, and ash, lime, poplar and willow were employed. The walnut, a tree certainly in cultivation as early as 1403 in Essex, appears in accounts for its timber from the late fifteenth century, but was not in common use until much later. In the whole of Salzman's extensive researches he found only one mention of chestnut timber, for Dover Castle in 1278; and the whole of the legend of chestnut roofs must be dismissed. In virtually every case the wood of old roofs and house-frames can be positively identified as oak. Contrary to another widely spread superstition, softwood was used in the Middle Ages quite extensively, though it has generally failed to survive. In addition to imports of German oak timber, and Baltic oak boards, there was from the early years of the thirteenth century a very large amount of imported fir, expressly described as 'firre' or in Latin as '*de sapino*'.

The period was a thrifty one, and even fallen timber was used for building. In 1223 the sellers of windfallen wood in the royal Forest of Dean were ordered to provide 40 rafters from the windfalls for the repair of the Tower of London. It is astonishing that even the tortuous minds of mediaeval civil servants could have thought it worth while to transport these rafters for over 125 miles. Both royal and private estates naturally used their own timber, and the Bishop of Winchester brought timber from his wood at Wargrave in Berkshire for building his fourth

mill in Southwark in 1248. Master Henry the carpenter took wages of £7 4s. 4d for his work in the wood while felling was in progress at Hockday and for 8 weeks thereafter (from 4 May to the end of June in 1248). Master Henry also had 10s. for his summer robe and received £1 18s. 4d for his wages at Southwark for 10 weeks while the mill was built, and for some old timber.

Oak timber was considered far more valuable than other sorts, mainly because of its strength, but also on account of its durability. In view of it susceptibility to the ravages of the death-watch beetle, this latter quality may have been somewhat exaggerated, yet a great deal of very ancient oak timber has survived. The relative value placed on oak can be seen from an inventory taken in 1449 at the house in Lincoln Close then late of Canon Richard Yngoldesby, deceased. Two carpenters, John Baldok and Thomas Wright, called upon to put a price on two timbers called 'lez Balkez' said that one which was of Oak was worth 6s. 8d, but the other, of Ash, only 2s. In 1515 timber was bought for York Place from William Morer of Kingston-upon-Thames: 424 feet of 'Elmyn borde' cost 7s. 9d, priced at 1s. 10d a hundred with carriage; 704 feet of 'quarter borde' came to 15s. 2d, at 2s. 2d including carriage; 50 quarters cost 5s. Another 522 feet of elm board were charged at the slightly lower price of 1s. 9d a hundred including carriage from Kingston to Westminster. Morer was a prominent inhabitant of Kingston, one of the bridgewardens there in 1513–14 and 1519–20, and lived in a house beside Kingston Bridge which he rented from the wardens for 5s. a year until 1540 and thereafter at 10s. Out of this rent the bridgewardens paid to the churchwardens a quitrent of 1s. 6d. Morer from time to time sold timber, ropes and other necessaries for the repairs of the bridge and was regularly called 'Master'; he was still tenant of the house 'lying toard the grett bryg' to west of the tenement of Richard Thomas in 1547.

While stocks of materials were being brought to the building site, the architect – usually a master mason or master carpenter – was occupied with the detailed stages of design. The subject of architectural design has been dealt with elsewhere, and it remains only to emphasise the importance of this inventive aspect of mediaeval craftsmanship. Fresh problems of many kinds were liable to arise and had to be tackled by men who stood out from the common run. The search for men able to design, in the wider sense, is shown by the order of 1296 sent to 24 English towns, that they were to elect 'from among your wisest and ablest who know best, how to devise, order and array a new town . . .' Town planning was, in the thirteenth century, by no means a new thing, but under Edward I it was being treated as a general rather than a local question. Far from being taken for granted, the capacity of a craftsman to design creatively in a given new situation was specially sought and appreciated. When the Duke of Berri was staying at Mehun-sur-Yèvre

in 1390 he spent three weeks largely in giving directions to Master André Beauneveu, 'his master of the craftsmen in carving and painting', for the making of new figures (*imaiges*) and pictures. Froissart, who relates this, tells us that the duke was well advised for 'there was no better at that time than this Master André, nor his equal'. Not long before the chief architect to the French king, the master mason Raymond du Temple, had been described in verse by the poetess Christine de Pisan as 'a learned artist . . . who showed his knowledge in the designing (*en devisant*) of buildings'.

All designers, whether of buildings, sculpture, painting, jewellery, or machinery, have the special skill of drawing and of understanding drawings. The ability to 'read' a drawing is as much an acquired faculty as that of reading handwriting or print: to some it comes more easily than reading, but to very many it is more difficult. While sketches of lifelike character, in the manner of the strip-cartoon, may be made to tell their own story without words, as did many carved and painted scenes in mediaeval art, strictly technical drawing and its interpretation call for considerable experience. We have seen that Lydgate, in enumerating the varieties of knowledge, included 'drawing of picture', and this reminds us that the word 'picture' may mean no more than a drawing. In the Middle Ages this usage seems to have been more frequent, and 'painting' included what we should now call technical drawing and also 'perspective', even though the rules of scientific optical perspective had not then been applied. In the second year of the works on St Stephen's Chapel, 1293, there were payments under the heading of 'Pictura' (Painting) to five men, of whom one was Thomas the Master's son (*Thom. fil. Magistri*), paid 1s. 10½d for 5 days. The master was Michael of Canterbury, and this son was doubtless the Thomas of Canterbury who eventually succeeded his father as architect of the works *c.* 1321. In 1293, when the structural work had reached only a very early stage, painting in the sense of wall-painting on the finished building could not have been in progress, and what Thomas was doing was evidently architectural drawing. He and his colleagues were producing the working drawings for the job.

When the great east window of Exeter Cathedral was to be rebuilt in 1390, a skin of parchment was bought for 2d for the master mason, Robert Lesyngham, to paint (*pingend*) the new window. This 'painting' is not likely to have been a coloured sketch for the stained glass, but rather a drawing which could be shown to the dean and chapter for their approval. At Durham in 1381 a painter of Newcastle had been paid 1s. for making a painting of an eider duck, regarded as 'St Cuthbert's bird', as a pattern for the reredos (*pro exemplare pro le rerdos*); here again a drawing would have met the case, as at Woodstock Palace in 1496, when the carpenter John Brian petitioned Henry VII for payment for works, quoting the king's approval of the design in the words: 'your

Grace had a sight bi picture of the ruffe of your hall.' A few years later the Corporation of Shrewsbury paid Henry Blakemere 1s. for a painting of the plan of the town (*pictura proporcionis ville*) to show to the King's Council about 1505. In these cases coloured views which we should describe as ' paintings ' may perhaps have been meant, but when Thomas Karver of Lichfield in 1459 undertook to make 40 choir-stalls for the nuns' choir at Nuneaton Priory ' after the forme of a pyktur ' it is evident that only a technical drawing will meet the needs of the case.

There has been much controversy as to the use of drawings in the design and execution of mediaeval achitecture. The mere fact that surviving drawings in England are extremely rare has led to the sweeping conclusion that technical *working* drawings were not made. That this conclusion is unwarranted is proved by the considerable survival on the Continent of drawings on both small and large scales, on sheets of paper or skins of parchment. There is, too, the evidence of the elaborately inter-related and precisely shaped stones of the later Gothic vaults and traceries, which manifestly could not have been produced without a precisely geometrical setting-out, itself based on designs drawn to scale. Study of the continental drawings in the course of the past generation has fully confirmed the view that detailed drawings were usual – and indeed essential – for the execution of all major works from about the middle of the thirteenth century, if not before. Two problems remain: the absence of English counterparts to the many (over 2,000 according to Mr François Bucher) drawings in France, Germany, Austria and elsewhere; and the use of drawings for Romanesque and early Gothic buildings.

The survival of a very few fragmentary English drawings is sufficient answer to the first question: drawings such as those on the palimpsest leaves of the Pepysian sketchbook, going back to the fourteenth century and showing both small-scale detail and moulding profiles, must once have been numerous, but have been lost or deliberately destroyed. The evidence for strict craft secrecy in England makes deliberate destruction the more probable explanation. It was not intended that laymen should learn the technique of design by the study of working details. Furthermore, the discovery of two surviving plaster tracing-floors at York Minster and Wells Cathedral, has now confirmed the evidence drawn from both English and continental documents. It was on such floors that geometrical setting out took place, to full size. Templates and cartoons could then have been made on a basis of the actual geometry worked out on the floor. To the other question, as to the existence of earlier drawings, there is as yet no specific answer, but the precise profiles of mouldings had to be drawn upon the bed of each stone before it could be cut. The geometrical construction lines used for this drawing can be seen upon the beds of stones withdrawn during repairs or taken from demolished buildings. To this extent at least, technical drawing is

demonstrated at *all* periods: no building of any size, or of high quality, was ever produced by simply 'having a bash' without some drawing as a vital prerequisite. (p. 73).

At all times the design of mouldings and details lay with the master, and it was not until a late date that it became stereotyped or mass-produced. The singular pronouncement that 'the templates for much of the moulded work were of fixed design and the property of the guilds' is refuted by the self-evident fact that the mouldings differ almost infinitely among themselves and are not of 'fixed' design. So far as specific evidence of mediaeval 'copyright' exists, in continental documents of the late Gothic period, the drawings were normally the property of the master and might be taken away by him. They might at times be claimed by the lodge of a particular building as necessary to the continuation of the work, but nothing suggests that any guild produced or preserved designs or profiles in its corporate capacity. The famous drawing of mouldings of the porch of St Stephen's at Bristol, with its unique list of the names of the mouldings long ago commented by Robert Willis, was expressly recorded by William Worcestre in 1480 as 'the handiwork of Benet le Fremason'. It is immaterial whether this refers to the design, or to the red chalk drawing entered in Worcestre's notebook.

The delivery of templates to the working masons, recorded at Canterbury in 1175, was a standard procedure at all masonry works. As has been mentioned, thin boards of beech or of 'Estrichbord' (Baltic oak), were commonly used, but sheets of lead seem occasionally to have been substituted as iron and, still later, zinc were in the modern age since the sixteenth century. The Westminster Abbey accounts refer to lamp-black, glue, resin and tracing-line being bought for moulds in the second half of the fifteenth century. The lamp-black may have been to draw with, or may have served for transferring profiles on the principle of carbon-paper. Glue may have been used for joining together boards edge to edge, to produce a larger template, or to make models. Tracing-line, fine cord impregnated with chalk, or powdered ruddle or black, enabled centre-lines and other constructions to be marked easily. The resin (*Rosyne* in 1492–93 and *Rosina* in 1512–13) is less easy to explain, but it may have been used to give a 'tooth' to the surface of a planed board, on which fine lines could be lightly marked with a blind point or a metallic lead or silver pencil. At York Place in 1515 two wainscot boards were bought for 2s, one being sent on to Hampton Court; another 1s. 1d was paid 'for 13th Carves in the same', which presumably implies the carving of 13 separate mouldings or details at 1d each, on or out of one of the wainscots.

The work in hand had not only to be designed and begun, it also needed expert supervision. This was foreseen in some of the surviving contracts of employment. In 1308 Master John de Weldon, mason, was granted the oversight of defects of the tower and old fabric of St Paul's

Cathedral, with fees of £1 6s. 8d a year, and the survey of the New Work (the eastern Lady Chapel) also on its completion, when his fees would go up to £2. When working on the great tower he would also be paid 8d a day, and otherwise 6d. William Wynford in 1394 spent two days on the works of the Bishop of Winchester at Highclere ' to deliver stonework and to superintend the placing of it '. Consultants were sometimes brought in, and at Westminster Abbey in 1479–80 there was a record of 5s. spent on rewards and a ' repast (*recreacione*) made for the three masters of the masons to survey the old church and the new and for their counsel about the works of next year.' Agreement was not always reached at such consultations: in 1217 at Auxerre Cathedral the master, on being asked whether the tower was likely to fall, declared that there was nothing to fear, but one of his assistants (*quidam de discipulis ejus*) said that it was not safe to stay beneath for a single hour, to his master's rage.

Architects were brought for considerable distances to make inspections. In 1404–05 Walter Walton, who had been the personal assistant of Henry Yeveley, travelled by order of the Council of the Duchy of Lancaster to survey the great chamber at the manor of Little Hallingbury in Essex, and received 6s. 8d. In the next year a certain mason from the county of Huntingdon visited Ely Cathedral to survey the defects of the bell-tower and elsewhere, and likewise had 6s. 8d, while a boy or groom (*garcio*), sent to find the mason at his home, had 1s. In 1436–37 a breakfast costing 1s. 11d was provided for John Blomefeld, carpenter, William Rolles, mason, and Bartholomew ' Plumer ' for their labour in spending half a day scrutinising defects in the Belfry of St Paul's Cathedral. At East Bergholt in Suffolk the north aisle of the church was built with a bequest of £100 about 1442 by a freemason, R. Peperton, but a lawsuit ensued on the ground of the poor quality of the freestone: ' certeyn fremasons beyng expert & connyng in the seid crafte ' said that the stone was bad and would decay, and ought to be taken down. Other instances of survey or ' viewing ' are perhaps the record of visits preparatory to work, rather than the survey of defects. In 1516 the king's painter (at the time John Browne) had a reward of 6s. 8d from the churchwardens of St Lawrence, Reading, ' for seying the tabernacle '. A very costly tabernacle of St Vincent was brought by barge and set up in 1518, and later gilded. Similarly at Leverton in Lincolnshire in 1535 the sum of 4d was given ' to karver of Boston when he came to se ye fonte ' and 5s. ' to ye same for makyng a covering to the fonte.'

We have seen that payment for work done by measure was certified in the presence of the architects and provision was frequently made for work to be done to the satisfaction of the master or a consultant. In some instances there was a clash in the law courts and this has remained on record. Nicholas Tirry was sued, years after Wolsey's death, for

I

having failed to deliver stone for the works of York Place in 1529. Tirry was to have supplied 300 tons of foreign stone by Whitsun, from Caen, Bernay, and Liège; but only 53 tons had arrived in April and by May 136, after which deliveries ceased. Apart from the shortfall in quantity, 19 or 20 tons of the stone did not belong to any of these sorts but was hardstone that could not be well wrought. On 28 January 1536 evidence was given by John Aylmer of Southwark (*c.* 1471–1548), a well known freemason, then aged 64 and over, that he had himself measured the stone and had found that it was in fact only about 120 tons in all. Constant vigilance was necessary in mediaeval times just as it is now, and once again we find ourselves asking with Lydgate: 'What may avail all your imaginings, Without proportions of weight and just measure?'

Chapter 9

Craftsmen of Construction (1) Stone

Within the group of artistic crafts, concerned with building and its enrichment, fittings and furniture, and the aesthetic accessories of life, the leading part was played by the architects, designers of buildings. They were for the most part masons though this term might cover carpenters and engineers as well as stonemasons; before about 1300 the more distinguished masters at any rate were competent in all materials. So far as England is concerned, the trade of the wright or carpenter was far deeper rooted than that of the mason. Before the Conquest wooden building was the rule rather than the exception, and as late as 1344 there were 138 carpenters in the royal establishment against only 24 masons. This was largely due to the importance of timbered construction in military operations, the predecessors of the Royal Engineers being mostly recruited from those skilled in the making of wooden towers, bridges and engines of war.

It was the surpassing skill of the mason and the carpenter in the design and organisation of the many parts and processes that went to make up a complex whole that astonished contemporaries. It may still amaze us if we reflect upon the wide range of subjects dealt with in the surviving parts of Villard de Honnecourt's compilation. Langland in his remarkable passage on the wonders of animal instinct in *Piers Plowman* produced two versions of a striking compliment to the master builders that put them second only to the Creator:

I had wonder at when and where that the pie (magpie)
Learned (to) lay sticks that lay in her nest;
There is no wright, as I ween, should work her nest to (for) pay.
If any mason thereto made a mould,
With all their wise casts, wonder me thinketh!

This, dating from around 1380, shows a juster appreciation of the importance of the architect in society than is commonly to be found nowadays.

This commanding position of the master masons and carpenters exerted a strong psychological influence attracting good men to these trades. It was the equivalent of the proverbial fieldmarshal's baton in the private's knapsack: the apprentice could feel that he had a real chance of reaching the top, in terms of genuine ability rather than power or political influence. By the middle of the thirteenth century it was normal for all large building works to be under the control of a single man. In the words of the well known sermon of *c.* 1261 preached against idle prelates by the Dominican friar Nicolas de Biard: ' In these great buildings there is wont to be one chief master who only ordains by word and rarely or never sets hand to the work; yet he takes higher pay than the rest.' A few years earlier the accounts for Woodstock for 1256 contained a precisely parallel entry in real life: 7s. was paid to ' a certain mason being over all (*ultra omnes*) the workmen and directing (*regenti*) operations for 7 weeks.'

The methods used by the working masons to cut stone underwent one notable revolution before they settled down into the tradition which still holds the field. Not only Saxon, but early Norman masons cut ordinary ashlar stones with an axe, sometimes double-bladed. (17–19) Gervase of Canterbury pointed out that even the carving of the old work at Canterbury had been done with the axe (i.e. in 1096–1107), while in the new Gothic work started in 1174 the chisel was employed. Great caution is needed in making assumptions as to any given date of change. As Salzman remarked, a good deal of elaborate carving done even before the middle of the twelfth century must have been finished with a chisel; but on the other hand there is the specific evidence of records that axes were used by masons down to about 1500. The drawings in manuscripts are no safe guide, for over a very long period they generally indicate a mason by providing him with an axe. Tradition counted for a lot, both in the trade itself and in the graphic image left on the mind of the public and the contemporary artist. What can be said, however, is that the typical tools of the whole Gothic period were the hammer and chisel for both dressing and carving stone.

Not all masons did the same work, and they were divided into several classes. The roughmasons, who used picks or hammer-axes of mattock type, were concerned with the rough hewing of rubble in more or less cubical blocks but without sharp arrises or finely dressed faces. Normal stonecutters (*lapicida* in mediaeval Latin) received rather higher pay and produced the precisely shaped blocks of ashlar. Circular work, the convex stones for building up the drums of circular piers; or the concave voussoirs of arches, demanded the next higher grade of skill, both in correct setting-out and in cutting. Finally the freemason, who could carry out any process possible in freestone, and notably ' circular-circular ' work, such as that of the voussoirs for vaults where curvature went in two directions at once, was at the top of the tree (35, 37). Only masters noted

for design, or specialist carvers, got higher pay than the freemason.

The working mason was not concerned with the geometry of the shapes which he was to cut: these were determined for him by the moulds (templates) issued by the master (p. 73); but his skill in drawing had to extend to the transfer of the outline of any given template to the correct face of the stone. From this face the curve, chamfer or moulding had to be worked through the thickness of the stone to the opposite face or bed. At all stages, except for the simple work of the roughmason, it was a case of following the pattern and being sufficiently skilled in the use of compass and square to set out a precise copy of the master's drawing or template upon the stone. The laying of the stones involved not only the use of the trowel filled with mortar, and the capacity to mix good mortar, but the use of two more tools, the plumb and the level. The stability of the work, and not merely its appearance, depended upon the joints being (normally) horizontal, and the faces vertical. In principle, the plumb or lead weight on the end of a line as a test of verticality has been known and used from remote antiquity, though the precise forms and methods of use of the tool have varied at different periods (18, 19). The level, a long straightedge provided with a short plumb-line at right-angles, differed entirely from the quite modern type which depends on a spirit-bubble in glass correctly set into the straightedge. In the kind mostly depicted in mediaeval illuminations (14, 18), later known as the ' brick-layer's and carpenter's level ', the straightedge bore either a central vertical member, or an open ' bridge ', carrying a short plumb which hung in a groove and opening so that when it was seen to be ' on its marks ', the long edge of the instrument, at 90°, was level. Another type, used in antiquity and in mediaeval Italy, and more recently called the ' mason's and joiner's level ', is shaped like the letter A, with the plumb suspended from the apex over a mark in the centre of the cross-bar.

A great deal of gratuitous mystery has been wrapped around masons' marks, due to extraordinary neglect of the important enquiry made by the British Archaeological Association at Canterbury, on the occasion of the first annual meeting in 1844. This was at the threshold of modern archaeology and before so much of the evidence of tradition had been obliterated by the Gothic Revival. The Rev. J. H. Spry, D.D., one of the prebendaries, took the initiative and made enquiries in company with Henry Godwin, later to be the author of *The English Archaeologist's Handbook* (1867). The essence of their account follows:

'Dr Spry believing that these marks were quite arbitrary on the part of the workmen, and had no connexion either one with another, or with " free-masonry ", requested Mr Godwin to accompany him to the masons' yard attached to the cathedral; when there, he called one of the elder men, and told him to make his mark upon a piece of stone; the man having complied, and being asked why he made that particular

form, said " it was his father's mark, and his grandfather's mark, and that his grandfather had it from the lodge ". The editor (A. J. Dunkin) was told by one of the Canterbury masons, that when a stranger joins in work with other men, one whose mark is similar to his – the " foreigner " has to apply to his lodge for a fresh mark. On leaving that set of workmen, he may resume his former sign.'

Although this is by no means a full account of masons' marks, it confirms the general truth of the explanation reached inductively by Coulton after long study. The mark is individual, but may be hereditary; its use rests ultimately upon the authority of the lodge, even though no register of marks be set down. Its purpose is to show responsibility, as in the case of the personal marks used by other crafts and trades. As with heraldic coats, it is essential that the difference between one mark and another should be clear, to avoid any possible confusion; in case of need it must be the ' foreigner ' who temporarily substitutes a fresh mark for his own. Two difficulties commonly met with can be answered, the first positively, the second with strong probability. Why do some buildings lack visible marks altogether? The evidence from many demolished buildings suggests that in these buildings the marks were deliberately made on the bed of the stone, so as not to show on the face. The lightly scored marks which do appear on the face in many buildings were expected to be covered by coats of limewash or even rendering. The second problem concerns those buildings which have a substantial proportion of stones visibly marked, but many other stones unmarked. In at least some cases it is the plain ashlar that is unmarked, while stones requiring greater skill show marks. It is to this case that Coulton's central argument seems to apply: the unmarked stones were cut by men on the regular staff, known to the master; the marked stones were produced by foreigners taken on for the first time.

Except for the marks of a very few individual masons, added to their signatures, none can now indicate identifiable personality. The study of marks can, however, throw valuable light upon mediaeval craftsmanship. In a given building, where the stones are visibly marked, it is possible to obtain the number of mason-hewers employed and to work out their output. Where one or more – preferably several – marks of complex character or unusual form occur on a building of known date; and are also found at other buildings whose date is not known, but stylistically compatible, then an approximate date can be given to the second building, and an itinerary of men with known marks can be compiled. Such itineraries, with maps, were worked out by Coulton, T. D. Atkinson, and Professor Ralph Davis, and show the distances over which working masons might travel in search of a job. The late Rev. H. Poole was able to show that a mason with a very distinctive mark had worked in the fifteenth century over a period of some nine years or more at six churches

spread over an area in north-west Yorkshire, Lancashire and Westmorland. In five cases he was accompanied by several other 'marks' who worked with him.

Although the master in charge of works at small rural churches would probably cut some stones himself, there is no reason to suppose that in this last case the man with the distinctive mark was the master, at the head of a gang of itinerant masons. The probability is that in such instances, when one job was finished, several of the men would travel on in company to seek employment. There is no evidence in Britain of the custom which obtained in the Germanic region, of the master placing his own mark as a signature on the building. Such symbols are described as *Ehrenzeichen*, marks of honour, and are truly equivalent to a personal badge or monogram. The typical personal mark has in any case to be distinguished from: (1) position marks, commonly Roman numerals, used to indicate the course for which quarry-cut stones were intended – a notable example of this practice is the east end of the collegiate chancel of Lingfield Church in Surrey; (2) the size marks on Portland stone, denoting the contents in cubic feet: $III = 3$ cu. ft; $III- = 3\frac{1}{2}$ cu. ft; $V = 5$; $\overset{1}{V} = 5\frac{1}{2}$; $+ = 10$; $++ = 20$; $++++ = 40$ etc.

Besides the marks, many buildings contain graffiti which are either the work of craftsmen or have some relation to craftsmanship. An inscription in a hand of the late thirteenth century, scratched on a capital of the south nave arcade at Merstham Church in Surrey, reads: vj.ˢ ix.ᵈ prout xxvij pedum latitudine (6s. 9d – as for 27 feet in width); apparently a note by the accountant or controller of the works. At Sible Hedingham Church in Essex, both responds of the tower arch bear the word ' Stertover '. Several far-fetched suggestions have been made as to the meaning, but it is probably simply what it says: ' start-over ', i.e. the springing of the arch. In a few instances there are strictly technical drawings incised on the face of stonework: two of the thirteenth century are inside the Galilee porch of Ely Cathedral and are properly set out with square and compasses on a basis of construction lines. Most other drawings of this kind are sketch designs for tracery or detail rather than working drawings.

Besides their work on new buildings, masons carried out maintenance and repairs, which were not neglected in the Middle Ages. One man spent 13 days in 1432–33 at Winchester College cleaning the windows and buttresses on the north side of the Chapel. At Exeter Cathedral in 1350–51 a mason had been hired for the job of pointing up all the windows with ' free mortar ' (*libero mortareo*). At Old St Paul's in 1387–88 three masons were kept busy for 37 days, each getting 8½d a day, mending all the ' boteras ' of the Great Hall and other defects. At Worcester Cathedral, between 1386 and 1392 under the master mason John Clyve, a most remarkable work was done in restoring the Norman chapter-

house, almost ready to collapse from the thrust of its vault. Clyve's respect for the old masonry and vaulting which he retained and strengthened, shows that the allegedly ruthless capacity of mediaeval architects to destroy in order to build anew is by no means the whole truth.

One curious aspect of the life of mediaeval masons is their propensity to become involved in crimes of violence, either as victims or as aggressors. Lethaby long ago commented that 'mediaeval craftsmen were very quarrelsome' in quoting some London disputes involving masons. One of these cases involved a mason, John de Offington, who was said to have threatened the king's masons brought into the City in 1306 to do the queen's work – Walter of Hereford and others who were working on the church of the Greyfriars – frightening them off by saying that if they accepted less wages than the London men they would be beaten. In 1375 a mason called Helpeston was assaulted by a gang at Bulkeley in Cheshire, who mistakenly believed him to be William de Helpeston, the master mason employed by the Abbot of Vale Royal. When Master William Colchester was sent to York by Henry IV to take charge of the Minster works after the collapse of the old central tower, he and his assistant were seriously injured as a result of a local conspiracy. This was possibly resentment against the southern 'foreigners', but was probably aggravated by the unpopularity in York of the usurping king, who had recently had Archbishop Scrope summarily beheaded. In 1490 the Minster architect, William Hyndeley, and his assistant Christopher Horner, were for a time imprisoned on the charge of having murdered John Partrik, a tiler, in the course of a trades dispute between the masons and the tilers over demarcation of work. In 1442 a Gloucester mason, Henry Grene, was accused of having killed Stephen Baret of Gloucester, a 'kerver', in the churchyard of St Nicholas by stabbing him with a dagger.

Some disputes were undoubtedly symptoms of serious ill-feeling between separate crafts in rivalry with one another, as were the masons and the tilers of York; or between the local craftsmen and 'foreigns', whether from other parts of the country or from overseas. Fear of competition was embodied in the old rule at London, that strangers were not to be admitted to the freedom unless they had served in the same mystery for seven years and were certified by men of the trade. Even so, conditions might be imposed, and in 1488 Egbert Frese, a mason born in Friesland, was granted letters of denization for life provided he did not traffic in any goods or export or import any. By the early sixteenth century there were many alien masons, and particularly carvers, working in England, though matters had not reached the stage which they had at Canterbury in 1518, when the guild of shoemakers, curriers and cobblers had as members 'moo jornymen beyng aliants then jornymen beyng englesshemen'.

Masons were charitable to their own fellows and generous to the works

on which they were employed. Robert, the mason of St Albans Abbey in *c.* 1077–1119, gave 10s. to the abbey every year, and when he was on his deathbed restored to the monks most of the lands which had been granted to him for his long and notable service. John Bryan, a mason employed at the end of the fourteenth century for over 20 years on Canterbury Cathedral, left 20 marks to the fabric and was named as a 'friend' in the Register of Fraternity of Christ Church. Richard Beke, master mason of the Canterbury Cathedral works from 1435 to 1458, left £2 to the works and to the monks' refectory his silver cup with a cover. Reginald Ely, the architect of King's College Chapel, left property when he died in 1471 to found an almshouse in Cambridge for three poor men. Henry Redman, chief mason to Westminster Abbey and later to Henry VIII, was master at the building of the chancel of St Margaret's, Westminster, in 1516–1523 at pay of 3s. 4d per week, all of which he gave back to the fabric fund. John Clerk, who had been warden of the masons at Eton College, died in 1459 and left 16s. 4d to 'the felaship of free masons of London' toward their sustentation.

Outside the trade of masons, but doing closely similar work, were the marblers. In the strict geological sense there is no marble in England, but the word has always been applied to certain fossil limestones which will take a very high polish. There were several such marbles in the country, but it was pre-eminently that quarried and worked near Corfe in the Isle of Purbeck in Dorset that was in general use. Architectural members, particularly circular shafts turned on the lathe, and monuments with their effigies, were made of the Purbeck marble from the twelfth to the fifteenth century. The trade, always one of the most strictly enclosed and secretive of the crafts, is unusual in that it includes both quarrying and working of the marble. Though the rigidly self-perpetuating character of the Company of Marblers may not have been original, it was for centuries the practice to insist that every candidate must be the son of a freeman, besides fulfilling other conditions. The practical background to this exclusiveness lies in the very intractable nature of the material, not only hard but also easy to damage in the course of working. By the thirteenth century some Purbeck marblers had settled in London, and it is probable that 'marbler' normally meant either a member of the Purbeck Company, or a relative, in southern England. There were also northern marblers who worked the fossil stone from Frosterley in County Durham, such as Lambert who was in the service of the Bishop and in 1183 was granted 30 acres of land as a service tenancy, but if he ceased to work might keep it by paying a rent of 2s. When a new base for the shrine of St Cuthbert was to be made in York Minster in 1470 (much of it has been rediscovered and is in the Yorkshire Museum), the master mason Robert Spillesby travelled with his servant for 27 days to seek 'les merblers', their expenses coming to 37s. 4d.

The great age of Purbeck marble monuments and sculpture was almost over by 1300, and it may indeed be that the shrine base at St Albans Abbey, thought to date from *c*. 1308 but looking later, was the last really great work carried out in this material. Yet marblers were still to play a considerable part in tomb-making until the end of the Middle Ages. In 1273 William of Corfe made a tomb at Westminster for Henry the king's son; he was probably identical with William le Blund and brother of the Robert le Blund or Robert of Corfe who supplied marble for the Eleanor Crosses after 1290. Adam of Corfe settled in London and died there in 1331. As Adam the Marbler he undertook to pave four bays of the new Lady Chapel of St Paul's in 1313; he also supplied marble columns for St Stephen's Chapel at 6d the foot. Canterbury Cathedral in 1307–08 paid £2 10s. 9d for a marble window (*fenestra marmor*) and 54 feet of marble; and Exeter Cathedral bought marble from William Canon of Corfe between 1318 and 1325. Other members of the Canon family from Corfe were prominent as marblers and carvers later in the the fourteenth century. During the building of the new nave of Westminster Abbey, in 1393, John Mayhew and John Russe, the king's workers of the marble columns, were ordered to take in Dorset at reasonable wages the necessary marblers, workmen and servants of that art, and ships, wains and carts for carriage.

Ralph of Chichester, a marbler who in 1287 supplied Vale Royal Abbey with marble columns, bases, capitals and cornice mouldings, was perhaps trained in the working of Sussex marble, but his partner John Doget seems to have been identical with John of Corfe. Their work for Vale Royal was cut according to a pattern (*exemplar*) sent by Master Walter of Hereford. They also provided ready-worked marble details for the Eleanor Crosses between 1291 and 1294. On the other hand John Mapleton, a London marbler by 1390 and until he died in 1407, probably came from Mappleton in Derbyshire and was perhaps brought up on the local marbles there. About 1395 he bought premises in Fleet Street, and this yard, disposed of by his widow Agnes, may have become the shop of Walter Dytton, marbler, of the parish of St Dunstan, Fleet Street, when he died in October 1413. Dytton's father and mother were still living, but he was married to a wife Alice and was able to leave 13s. 4d to the church fabric and 6s. 8d to the fraternity of St Dunstan.

The traditional use of Purbeck marble for the graves of the priors died hard at Canterbury Cathedral. In 1449 Thomas Rouge, Marbler of London, was paid £10 6s. 8d for the gravestone of Prior John Elham; William Bonevyle of Corfe in 1467–68 supplied the marble stone for Thomas Goldstone late prior, for £4 10s.; in 1472–73 for a stone placed on the tomb of John Oxney he received £3 7s. 8d; and also £1 in part payment for a stone for the sarcophagus of the next prior, William Petham. John Bourde of Corfe Castle undertook in 1449 to make a ' Tombe of Marble accordingly to a portracture delivred him ', for Richard Beau-

champ, Earl of Warwick, the high tomb still in the Beauchamp Chapel there. The 'portraiture' or design was probably supplied by the London marbler, John Herd alias Essex. Another London marbler, Henry Lorymere, in 1488–89 had part payment amounting to £9 6s. 8d for making the tomb of the 13th Earl of Oxford at Earl's Colne in Essex; and in 1494 James Remus, a marbler of St Paul's churchyard, was to make a monument for Sir Brian Rowcliffe in the Temple Church. As late as 1525 'a marbell stone with carriage' for Bishop West's Chapel in Ely Cathedral cost £4 7s. 10d.

Another variety of masoncraft was the working of flint. The use of flint pebbles as rubble did not call for any special skill, and it was only in the latter part of the fifteenth century that the East Anglian fashion of using squared flints took hold. In the last century of the Gothic age some remarkable works in this intractable medium, set in carved flushwork panels of freestone, were built (51). They posed difficult problems for the designer, who made skilful use of the contrasting materials, but there is nothing to suggest that the work was done by a distinct branch of the trade. The cutting and laying of slates and stone tiles for roofs, however, produced the craft of the slater. Though slates and stone tiles (of different geological formation and much heavier weight) were in use from an early date, their distribution was for a long time local. Only later were they sent to London from the quarries to become an item of trade, obtainable from builders' merchants. In 1284–85 the accounts for Woodstock show that a perforator of slate was paid 3d for two days, drilling the suspension holes. In 1296 at Martinstowe (? Marstow, Herefordshire) labourers breaking stone at the quarries to get slates were paid $1\frac{1}{2}$d to 2d a day, and women got 1d a day for carrying the stones. Very large numbers of slates were won: 23,000 from a quarry at 'Birlond' and 10,000 at 'Hassal'. In 1343 even larger numbers were got for the works of Restormel Castle in Cornwall: 19,500 stone 'slat' were bought at 11d per 1000 between Golant and Fowey, and 80,000 were dug and drawn out of the quarry of Bodmalgan at a cost of 6d per 1000.

In London, however, it was possible by 1340 to buy 'sclatston' for roofing at Westminster, at 4s the 1000; 5,000 were bought and carried in five carts at a cost of 1s. 3d from Milk Street to Westminster. Probably the 'Schyngelston' bought from Bristol Castle in 1375-76 were larger, as they cost 12s. the 1000; 2,000 were bought, and two 'slateres', John Frygs and Henry his mate had £19 for roofing 15 houses in the Castle by contract. The 'grange', probably a large barn, at Winscombe in Somerset was retiled in 1393–94 with 6,000 stone tiles from Ilfracombe, bought at Redcliffe (Bristol) at 3s. 4d a thousand. At the rebuilding of Bodmin Church in 1469–70, 6,000 'helyng stones' cost 16s., and the 'helyeris that helid the Church', with the days they worked and their pay, are set down: Thomas Gylle, Ronold Mason, William Perish, John Roby, Thomas Hancok, John Deyowe, Thomas Hawys, a

servant of Thomas Gylle and a servant of Ronold Mason. They all, including the servants, seem to have been paid 5d a day, and the maximum period worked was 14½ days. Ronold Mason made a freewill gift of 3s. 4d to the works, and Thomas Hancok one of 2s.

Another separate craft was that of the paviour. The trade in England grew up late in the thirteenth century, as city after city decided to carry out street improvements and obtained grants of pavage to carry out the work. Although the first signs of the new movement appeared just before the end of Henry III's reign, when Shrewsbury obtained its first grant for the High Street, the paving of towns was essentially a national work undertaken under Edward I. In London each alderman was to appoint four scavengers to deal with the problems of street cleaning from 1280, there was a scale of wages for the London paviours fixed in 1301, and a surveyor of streets by 1390. The early grants of pavage were, perhaps rather surprisingly, mainly to towns in the north-western and midland counties: Nantwich 1277, Chester 1279, Northampton 1284, Coventry 1285, Cambridge 1289, Stafford 1295, Lichfield 1299, Newcastle-under-Lyme 1307, Liverpool 1329. The streets of Dublin were paved in 1322–29. The very late dates of pavage grants to some towns suggest that the work had in fact gone on independently at an earlier date: Southampton did not obtain a grant until 1384, Canterbury 1474, Bristol 1491. Southampton had a town paviour officially employed by 1482, and the Paviours of London had become a City Company by 1479.

We know little about the types of paving used but from continental miniatures it can be said that there were two different methods in use among paviours. The French and Flemish paviours sat on a four-legged stool and moved forwards as they laid cobbles; the Germans, on the other hand, used a one-legged stool and worked backwards as they laid the paving. There were at least two main kinds: cobbles, and flagstones, apart from indoor paving, of marble, patterned tiles or bricks. Whatever form was used, it had to be sound enough to enable regular street-cleaning to be effective. The paving of the streets was not an isolated phenomenon, but part of a general campaign to improve amenities. In 1298 Edward I ordered the bailiffs of St Mary's Abbey beside York to set their town of Bootham in order by repairing the pavement, removing pigsties, cleansing dunghills and repairing ruinous houses that extended to the public streets. Urban amelioration was the order of the day, and in view of the serious aesthetic nuisance of gaps left by demolished buildings along streets of the twentieth century, high praise is due to Edward I (who had just made York his capital during the progress of the Scottish wars) for including the repair of the frontages along with steps of a strictly hygienic character.

York itself seems first to have obtained a grant of pavage in 1319, for 10 years, then in 1329 for a further 5 years; in 1335 the Abbot of St Mary's had a grant for his borough of Bootham to last for 4 years. By

1378 the famous street of Pavement is first heard of under that name, though it had previously existed as Marketshire. In 1387 Richard de Bakewell, paver, was admitted to the freedom of York in consideration of the paving of Monkgate which he had carried out by contract. The city chamberlains' roll of 1396–97 allowed 7s. 3d. for the mending of the pavement in Petergate and Stonegate in that year; and in 1424 one of the conditions of a substantial lease of land was that the lessee should maintain and repair the paving of the whole street of Gillygate. It is likely that in most large towns the progress of paving was slow.

The paving of houses and churches was of a higher category than that done in the streets. It was usual to produce a truly level surface and to incorporate patterns. This was already the custom in Romanesque times, for St Bernard in his extreme polemic against artistic enrichments in monastic churches, written about 1124, exclaimed: ' How may we revere the images of the saints with which the very pavement, trodden by the feet, abounds?' He went on: ' And if these images are not sacred, why not omit the fine colours? Why adorn what will soon be made filthy?' The marble pavement of Canterbury Cathedral (48) – the old church of Prior Ernulf (1096–1107) – was famed for its glittering polish as well as the rest of the church for its glass windows and its paintings. Foreign marbles were brought back from pilgrimage for the paving at Durham, and we have seen that the new Lady Chapel of St Paul's was paved by Adam the Marbler in 1313. In spite of the vogue for patterned tiles, of which we shall soon hear more, marble and stone continued to be used until the end of the period. At the Duke of Buckingham's magnificent and palatial castle of Thornbury, in 1514, William Salte was paid for paving 3,260 feet with stone. In 1549–50 Mynnois the mason had 13s. for 32 days' work in paving the church and porches at Hawkhurst in Kent.

No division of the crafts can be completely logical. It might seem desirable to consider all carvers and sculptors together, yet while most arose as specialisations from the original builder some were offshoots of the goldsmith and the bronze-founder. Some carvers worked both in stone and in wood, mostly at a late date. Many carvers were a by-product of masonry, at times among the most highly paid of its practitioners. A few of them may have been foreign experts: John of St Omer in 1293 was paid 7s. 6d for cutting three capitals of Caen stone for St Stephen's Chapel. Others, the majority, were pretty certainly English: William de Montacute at Exeter Cathedral, carving capitals of freestone, bosses, a head and other details (88) in 1312–13, at the rate of 5d a day; in 1321–22 it was a London imager who made the statues for the Exeter reredos. In 1332 Master Richard of Reading carved statues for the gable of St Stephen's Chapel at Westminster. Thomas Chaucombe, ' *le ymaginarius* ' of London, dying in 1347, left his tools to his son William to carry on the business. Two years later another London imager, John de

Mymmes, died in the great pestilence, leaving tenements in the parish of St Mildred, Poultry.

Above all, the mediaeval mason was versatile. As a carver he might be called upon to adorn plain walling with statues, or like Michelangelo at a later date, be set to cut cannon balls. In 1303 Robert de Melbourn, a mason probably from Derbyshire, was at Rhuddlan and was cutting stone balls for the engines of war, still no doubt carpenter's work of the type of the trebuchet. But before the end of the century the account for works at the Tower of London for 1382–96 included the wages of a mason rounding stones for guns (*super rotundacione lapidum pro gunnis*). By that time the stores included four moulds of empty shapes for casting bullets (*pellott*) and another copper mould for the same; and three small cannons called ' handgunnes '. At the same time Thomas Wrek or Wreuk, a London mason who had been Henry Yeveley's partner in monumental works, was engaged by the City of London to make statues of the king and queen, Richard II and Anne of Bohemia, to set above the Stone Gate on London Bridge, cut in freestone, with three shields of arms and great tabernacles, all for £10. The painter's work on the statues, shields and tabernacles came to £13 6s. 8d, two laton sceptres, gilt, cost £1, and another shield 6s. 8d. All this exemplified the reconciliation between the king and his capital after the tense relations of 1392. The shields bore the arms of the king, the queen, and of St Edward the Confessor, last legitimate king of Saxon England, and one of Richard II's special patrons. In such a work symbolism triumphed through the skill of the mason as a dominant partner.

Craftsmen of Construction (2) Clay

The building of the Middle Ages was, at its highest levels, carried out in natural stone masonry, with splendidly wrought timber roofs, covered with stone tiles or with sheets of lead. These were materials available in most parts of Britain and over much of Europe. There was no obvious reason why substitutes should be sought. There were in fact no discoveries of new types of material though there was experimentation with stones from different quarries, wood of various species, and with diverse sorts of finish by limewashing, rendering or daubing. In northern Europe, though not in England, sheets of copper were used for roofing as well as lead, but on the whole there was little variation in the general type of materials used throughout north-western Europe. To this proposition there was one substantial exception: the extensive use in regions where there was little or no stone of a substitute material, brick.

The search for synthetics is no modern thing. At some very early date, in the Middle East, it was discovered that an artificial stone could be made by drying lumps of mud in the sun and that these could be rendered virtually indestructible by burning them in a kiln. We are not here concerned with the prehistory of ceramics, but with the fact that the manufacture of tiles and bricks was already an old process in classical times and was reintroduced as a principal source of building materials after 1100. Even before that date there had been intelligent appreciation of the utility of Roman tiles from the great ruins left by the Empire. The Saxon abbots of St Albans, from soon after 1000 began to collect tile from the Roman city of Verulamium nearby, as a stock of material for rebuilding, though this was undertaken only by their Norman successor Paul of Caen and his mason, Master Robert, after 1077. Nevertheless it was a long time before new bricks were made at all generally, though clay roofing tiles were to become normal in the greater cities in well under a century.

The parallel importance of stone and brick as materials was recognised by ancient tradition. This emerged in written form, seriously misunder-

stood, in the Constitutions of the English masons drawn up in the middle of the fourteenth century. One of the most striking pieces of evidence that the Constitutions must have existed earlier as a Latin original is the use of the word 'lacerus' to describe a material undoubtedly brick: i.e. *lateres*, bricks or tiles. The relevant passage, which tells the legend of the two pillars of masonry, runs as follows in modernised spelling:

'(The three brothers, Jabal, Jubal or Tubal, and Tubalcain) had knowledge that God would take vengeance for sin either by fire or water and they had great care how they might do to save the sciences that they had found and they took their counsel together and by all their wit they said that there were two manner of stone of such virtue that the one would never burn and that stone is called marble. And that other stone that will not sink in water, and that stone is named "lacerus". And so they devised to write all the science that they had found in these two stones if that God would take vengeance by fire that the marble should not burn; and if God sent vengeance by water that the other should not drown. And so they prayed their elder brother Jabal that he would make two pillars of these two stones . . . and that he would write in the two pillars all the sciences and crafts that all they had found. And so he did; and therefore we may say that he was the most cunning in science, for he first began and performed the end before Noah's flood. . . . all the world was drowned. And all men were dead therein save eight persons . . . And after this flood many years as the chronicler telleth, these two pillars were found, and as the *Polychronicon* saith that a great clerk that men call Pythagoras found that one and Hermes the philosopher found that other; and they taught forth the sciences that they found there written.'

Evidently the two materials should be transposed: it was marble that would not dissolve in water, and brick ('lacerus') that would not be consumed by burning – though the idea that it would perish in water clearly echoes the early use of unburnt brick. In the upshot, both materials survived, as we might expect, and as – oddly enough! – modern archaeology proves in regard to survival through the great historical flood in ancient Mesopotamia. In spite of the corrupt text and the inconsistencies of the story, it is of great interest in that it shows that mediaeval craftsmen believed that they were the inheritors of 'science', knowledge of the necessary skills of human society, and that these skills had been preserved through the Flood independently of the biblical account of Noah and his family, which did *not* deal with the body of knowledge beyond the individual capacity of Noah's family to remember. Secondly, masons of the fourteenth century and probably much earlier, thought of marble and brick as 'two manner of stone'.

To our way of thinking, ceramic products are arranged in a descending order: brick, roofing tile, ornamental floor and wall tiles, pottery vessels.

The invasion of the West by these products took place historically in inverse order, first by the importation of pottery vessels and by the process of potting (41), later the enriched tiles and the way to make them, then roofing tile as an incombustible substitute for thatch, and finally brick as a cheaper form of stone, easier to handle. In referring to pottery we must remember not only the fact that, as has already been mentioned, the word ' potter ' often referred to a founder who produced pots of cast metal, but also that the place of crockery was largely taken in the Middle Ages by vessels of wood, such as trenchers cut out of board, or lathe-turned cups and bowls. The relative scarcity of pottery fragments in the archaeological excavation of some early sites is thus easily explained.

The making of clay pots, jugs, bowls and plates was a country craft carried on at many places where there was suitable clay. It was rarely if ever the subject of urban organisation, and there do not seem to have been guilds of clay-potters. England did not make any really fine wares in the Middle Ages, and the noteworthy polychrome jugs of the late thirteenth century were imports from Bordeaux and Aquitaine. These did, however, inspire copies and versions made in England by potters who did not know the true secrets of the ware or the glaze and so could not attain to the quality of the original. Considering the isolation of the English potteries, not merely from the distant foreign sources of knowledge and inspiration, but from each other, a respectable amount of pleasant and useful crockery was produced (77). Before leaving the subject of pottery it should be mentioned that the great European centre of fine wares was in the part of Spain that had for long been ruled by the Moors, around Valencia (at Manises and Paterna), and the secrets of production were of eastern origin. By the sea route across the Mediterranean via Majorca the products of these Spanish kilns reached Italy, acquiring the name of Majolica from the intermediary rather than the place of origin. The processes, certainly of Near Eastern invention and of high antiquity, reached Moorish Spain not later than the eleventh century, before the Christian Reconquest. It is a matter of interest, though without direct bearing upon the wares produced in the West, that the surviving medi-aeval treatise on the manufacture of pottery was written in Persian at Tabriz in AD 1301 by Abu'l-Qāsim of Kashan, a member of a family of hereditary potters.

Moorish Spain was probably also the source of processes which en-abled glazed tiles to be made even before the Norman Conquest. A few have been discovered at places as widely separated as Winchester and York but it is as yet too early to speak confidently of their place of origin or the precise techniques employed. We are on firmer ground in regard to the later tile flooring, either of shaped pieces used as mosaics, or of stamped and inlaid tiles bearing patterns. Both of these processes origina-ted on the Continent, and did not reach England much before 1200. The shaped mosaic tiles probably arrived rather earlier than the inlaid tiles,

K

which may have been derived from Anjou and Poitou along with the Plantagenet dynasty at the accession of Henry II in 1154. The use of these mosaic tiles is particularly associated in England with the Cistercian abbeys of the northern counties, notably Fountains and Byland (52). At Fountains what remains of the mosaic paving comes from works on the presbytery carried out under Abbot John of Kent (1220–1247). The connection of mosaic floor-tiles with the Cistercians suggests a possible link with Spain through the important Cistercian monastery of Poblet, which contained also a royal residence of the kings of Aragon. The floor of the Poblet cloister included sections of *alicatado,* tiles of mosaic type.

Tiles with patterns impressed and then inlaid with white pipeclay include both square and patterned shapes, and sometimes form an elaborate carpet including large circular designs made up of concentric rings. In such patterns it is usual for the rings of larger tiles, bearing ornaments or the letters of inscriptions, to be separated by rows of narrower plain tiles. Very rarely, these tiles have been found to bear, underneath, numeral position marks showing the paviour the order of assembly. Such marks would probably be needed only when the tiles were sent away from the kiln for use elsewhere. The inlaid tile, whatever its place of origin, was in use in northern France from about 1200 and spread to the Low Countries and to England. Henry III had tile paving made at Westminster Palace in 1237, and in the same year ordered a kiln to be made in the courtyard of Clarendon Palace in Wiltshire, which by circumstantial evidence has been identified as the kiln excavated in 1937; this was finished by 1241 and had probably gone out of use by 1245. A second kiln at Clarendon was made in 1251 and this may have been where the pavement of the Queen's Chamber (documented to 1250–52) was made. These pavements and other improvements in the royal accommodation started in 1236, the year following the king's marriage to Eleanor of Provence. It has been suggested with good reason by Mrs Elizabeth Eames that this was cause and effect, and that the new fashion was due to the standards to which the queen had been accustomed before coming to England.

The production of inlaid tiles of the very highest quality passed to Chertsey Abbey, and it is not unlikely that this was the source of the splendid series in the Chapter House at Westminster, dating from 1253–58 (57–**60**). At Chertsey itself even finer patterned tiles illustrating the Tristan Romance were made and laid in the 1260s and some of the actual stamps used at the Chertsey kiln were later taken to Halesowen Abbey, a hundred miles away, before 1298. This is only one of a number of instances where the re-use of stamps can be proved. The cost of first-class artistic cartoons, and of expert carving of the wooden stamps, must have been relatively high, and there would have been every incentive to preservation. The stamps had to be cut so that the sides of the pattern sloped inwards (i.e. to the bottom of the impressed cavity) at an angle of about 20°, and stamping had to be done with a firm, regular pressure,

the cavities being between about $\frac{1}{10}$ and $\frac{1}{8}$ of an inch deep. These were then carefully filled with white clay and the surface scraped. The precision thus achieved is indeed remarkable. Less satisfactory in registration of the pattern, and much less durable, were the printed tiles made from about the middle of the fourteenth century, at first in the Chilterns. In this case the stamp was wetted in white 'slip', thinned pipe-clay, and printed on the surface as if it were an inked woodblock. Although good examples made by this means are hard to tell from the poorer qualities of inlaid tiles, they suffer rapidly from wear.

Regrettably little has emerged from the study of accounts as to the individuals who made these patterned tiles, but Salzman discovered several entries which are suggestive. In 1308 at Westminster Palace, Hugh le Peyntour and Peter the Pavier worked for 28 days on 'making and painting the pavement', and between 1274 and 1324 there were purchases of paving tiles at prices varying from 5s. to 10s. a thousand. Painted tiles for the bathroom of Richard II at Sheen cost 15s. for 2,000 in 1385, bought 'over the counter' from Katherine Lyghtfote, soon to become the second wife of the royal architect Henry Yeveley. The case (*fraill*) containing tiles of 'Naverne', possibly Navarre, cunningly painted and called 'pauyngtyle', bought in 1444, once again suggests a link with southern France and with Spain. Foreign tiles were mostly from Flanders and consisted of the plain black, green, yellow or white glazed tiles usually laid in chequer patterns. About 1500, and probably as a result of the close relations between England and Spain which led to the marriage of Catherine of Aragon to Prince Arthur in 1501, Spanish patterned tiles were used in and around Bristol, probably the port of arrival from Seville. A few of these have been found elsewhere, as at Haccombe Church in Devon and Meaux Abbey in the east of Yorkshire.

Tileworks, unlike potteries, were set up in and close to cities and towns, as well as at monasteries. The craft of the tilemaker has to be distinguished from that of the tiler, whose skill was that of laying tiles on the roof. The tilemaker was commonly a small capitalist and may have been fairly well off or even wealthy. Certainly Thomas le Tighelere or *Tegulator* of Farnham in Surrey, who flourished between 1289 and 1317 and in 1309 was one of Farnham's two first Members of Parliament, was a man of considerable standing as carpenter, miller and contractor. It is probable that he got his name from owning a tileworks in the area close to Farnham, well supplied with suitable clay. Accounts for works at Winchester College show that the patterned paving tiles for the Chapel and Vestry, a few of which survive, were made in 1396 by William Tye-lere at Otterbourne near Winchester, with clay brought from Farnham. This can only have been the white pipeclay, since the red clay is found at Otterbourne in abundance. Here again the name, or description, 'Tiler', clearly means a tilemaker.

A tileworks in central Paris gave its name to the later royal palace of

the Tuileries, and there was a tilery in the neighbourhood of Smithfield in London. There were two tileworks near York, one rented from the Archbishop, the other, close to the walls, from the Vicars Choral of the Minster. At Wye in Kent there were important tileworks belonging to Battle Abbey, and there were others at Canterbury, at Ramsey Abbey in Huntingdonshire, at Penn in Buckinghamshire, at Beverley in Yorkshire, and also at Hull, where the works belonged to the municipality. Newbury in Berkshire, which supplied tiles for Winchester College in 1412, was in 1320 the home of John *Tegulator* who held land at the south end of the town near the road to Andover. About 1400 the laying of tiles cost about 2s. a thousand; patterned tiles made at Otterbourne cost 10s. and plain Flanders tiles 6s. 8d a thousand.

York by 1218 had a fisherman called Thomas whose father was Robert *Tegulator*, and it is likely that there had been makers of rooftiles there even earlier. We know that the great Fire of London in 1136 caused a general replacement of thatch with clay tiles, and such tile roofs were made compulsory in 1212. At York two big fires caused enormous destruction in the next year after London, 1137, and it is likely that the example of the capital was followed. In the country as a whole thatch was very slow to disappear, and Norwich, for instance, did not make the laying of tile roofs compulsory until 1509. At York in 1309 William, son of Gilbert de Colyngham, ' teighler ', took up the freedom, as did several others under that description in the first half of the fourteenth century. The first to be called ' teghlemakers ', as we have seen, were John le Sauscer and John de Heselbech, both in 1352. By the fifteenth century several tilemakers of York made wills: John Sharpe who died in 1447, Nicholas Lililowe (1453) and Richard Bagot (1478); William Bryghtee, a tilemaker of Beverley, died in 1503.

Leaving until later the question of brick, we may notice a few references to the making and supply of roofing tiles, and the industry generally. In 1286 the earth thrown up from the ditches dug about the Tower of London was sold to divers tilers for making tiles; and in 1305 tileworks near London at Clerkenwell and ' Mungenegrene ' supplied the works at York Place, Westminster, with 30,000 tiles at prices of 3s. or 3s. 4d a thousand. One hundred hollow tiles, presumably ridge-tiles, cost 1s. 8d. Imported Flanders tiles, 3,300 in all, were bought in lots either at 6d a hundred or 4s. a thousand. In the following year Walter de Mallinge and his mate were laying tiles on the new hall at York Place by task for 18s. At Highclere in 1367 two men digging clay for tile-making in the Park were paid at 2s. a week, and the moulding, drying and burning of 19,000 plain tiles and 250 crests took six weeks. The tilehouse was thatched, and then three men were employed moulding and making another 17,000 tiles, 300 crests and ' huppetiels ' (hip-tiles); seven weeks went on drying and burning them and making 40 quarters of lime, as well as breaking chalk for the kiln. In 1370 a man was hired with his

horse and cart to carry brushwood to the tile kiln. The making and burn-
ing of 37,000 tiles cost £3 14s. at 2s. the thousand.

The normal procedure seems to have been to build a kiln and make
tiles close to the building site if possible, and in many districts including
the neighbourhood of London there was an ample supply of clay for the
digging. It was probably in order to set up an *ad hoc* campaign of tile-
burning of this kind that Abbot Litlyngton of Westminster, in Novem-
ber 1372, paid a boy 1s. for going to Uxbridge for Stephen Tiler (*tegu-
lator*). On the other hand, three years later, 20,000 plain tiles for roofing
the royal chapel at Havering atte Bower were bought from John Frost of
Woolwich for the high price of 5s. 10d a thousand. In the same year,
1375–76, Abingdon Abbey had the south side of the abbey church tiled
by John Sclatter of Abingdon for £6 8s. 9d the task, including the tiles,
laths, pegs, lime and nails. Probably in connection with this, William
Bodecote and three other carpenters were paid for spending four weeks at
the Abbey, getting £1 6s. 4d and their board. The transport of special
tiles over long distances is evidenced by an account of works at Port-
chester Castle in 1396, when 1,000 'reredostighel' were carried from
Billingsgate to the Pool ('le Poule') of London for 1s. 6d, and by sea
from the Pool to Portchester for 5s. In 1398–99 another 400 great
'pendanttigheles' were bought for Portchester and spent on the Rere-
dosses of the chimneys there; these tiles cost 3s. 4d the hundred and were
probably specially made of refractory clay to stand the heat.

The Hull tileworks mentioned above is first heard of in 1303, when a
rent of 13s. 4d was paid to the Crown and 54,350 tiles (apparently wall-
tile or bricks) were made; in the next year the output was 92,000. Dr
F. W. Brooks has worked out the whole story from the records, and shows
that the brickyard stopped work about 1435. This may have been due
to a drop in the price of bricks, for the detailed accounts show that the
cost of manufacture was only marginally under 4s. 9d a thousand, and the
bricks were sold at the standard price of 5s. There was thus hardly any
profit in the operation. Dr Brooks points out that Beverley, on the con-
trary, let out a tilery in 1391 to Richard Hamondson for a rent of 3,000
bricks a year, and got as much profit as Hull did out of making 60,000
bricks. The total output at Hull averaged about 92,000 bricks, and rose
as high as 140,000 in 1432. The York tilehouse outside the Walls had
about 1300 been the property of William le Tyuler, very likely the same
man as the William who was son of Gilbert de Colyngham. It descended
to Adam Tilier of York and to his son John le Tilier, a chaplain, who
gave the house to the Vicars Choral.

At Lynn in 1422–23 the Trinity Guild, building its new hall, spent
£10 11s. 10d on the cost and carriage of 'thactyle' and 'waltyle', but it
is not stated where these tiles and bricks were obtained. At Kingston-
upon-Thames, Surrey, in 1439, the offences presented at the view of
frankpledge included the assessment of a fine of 6d upon Robert Poynton

as a common maker of tiles who makes tiles containing a less measure than that ordained by ancient custom and not well burnt (*anelat*) as well as taking excessive prices against the statute. The reference to the ancient customary size is of interest, for excavations at Pachesham Manor near Leatherhead showed that plain roofing tiles of *c.* 1290 were of the same size as modern ones. The standard size was fixed by statute of 17 Edward IV, 1477, at 10½ in. long by 6¼ in. wide and ⅝ in. thick. The only substantial change made subsequently has been the substitution of turned-down nibs at the top of the tile for the old peg-holes, into which wooden pegs had to be twisted for hanging. The combination of archaeological evidence with that of the presentment at Kingston shows that the statute merely regularised what was already normal.

The question of size crops up in the accounts for the tilehouse of Ramsey Abbey. The stocklists have headings for Tiles of greater size and Tiles of lesser size, but it was only the smaller kind that was made in the years whose records survive, for example in 1391, 2,000 tiles as well as 18,000 not yet burnt; in 1439 a total of 50,400 made in the year. At that time there were also 540 crests made, of which 40 were used by the Abbey for repairs; 1,600 pavingtile made; 7,000 'Waltill' made; and 12,000 more roof tiles, small size, made but not burnt. In 1507–08 there are records of sales: 3,500 'Thackeltyle' of small size sold for £1 8s. at 8s. a thousand; 6,000 'Waltile' sold at 5s. and another 3,000 at 6s. 8d a thousand; another 14,000 roofing tiles at 6s. 8d the thousand. Among headings given, but for which no stock was held in 1439, there were also 'Cornertile' and 'Ovyntile'. In contrast to Ramsey, Worcester Cathedral Priory bought its tiles in 1504–05, paying 5s. a thousand to Thomas Robyns 'le Tyllemaker'.

Brick, under that name, hardly appears in the documents until after 1400 (**40**). What evidently were bricks, but described as tiles called 'Bakston', were bought at Sandwich for Dover Castle in 1372–73 at 7½d the hundred, to the number of 4,400. Prices varied a good deal. Worcester Cathedral in 1448–49 paid 1s. for 100 'Breke' to mend the well in the Almonry; but at Waltham in Hampshire in 1442 the Bishop of Winchester paid Richard Upham only £35 for making 210,000 'brekes' by indenture; this works out at only 3s. 4d the thousand. The same low price obtained at Canterbury in 1494–97, when 480,000 bricks were bought for the great central tower of the cathedral. By that time the advantages of arranging brickmaking by special contract were realised. In 1496 George Fascet, the prior of Westminster, entered into an agreement with two 'Brekmakers', James Powle of New Brentford, Middlesex, and Robert Slyngisby of Hertfordshire: before Michaelmas they were to make in the lordship of 'Belces' (Belsize), Middlesex, 400,000 bricks. 'The moulde of the same breke shalbe in lengthe ix ynches and a halfe and more'. The Prior was to find wood and straw and pay half the cost of carriage of the sand needed; the brickmakers were to receive

1s. 6d for every thousand bricks, and their two horses were to be at grass the whole time (from 12 April) at the Prior's expense, and the Prior was also to find them a house to lodge in and fuel to dress their meat.

Another contract of this type was entered into between the Warden and Fellows of New College, Oxford, and two brickmakers of St Giles without Cripplegate, London, Richard Whytby and Clement Peake, on 24 November 1534. They were to make in all 800,000 bricks, 500,000 at Stanton St John in three clamps or kilns, and the rest at Tingewick in three kilns; they were to be paid a total of £63 6s. 8d at the rate of 19d per thousand. (For the full text of this contract see Appendix v.) This compares quite closely with the price of 18d per thousand – by the long hundred of 120 – quoted by Nicholas Kirkeby in 1505 for making 120,000 bricks at Little Saxham, when the substantial inflation of the next thirty years is considered. These bricks for Little Saxham Hall were to be of large size, 10 in. by 5 in. by 2½ in. One great advantage of getting the bricks burnt close to the site was the saving on transport. In 1465–66 the Bishop of Worcester had to pay 9s. to one John Wythy for carriage of ' le breke ' by the river Severn to Tewkesbury for a chimney new made at the manor of Bredon annexed to the new chamber there, to be built by John Pylton, mason. About 1543 12,000 bricks carried by water from Limehouse in the parish of Stepney to the King's manor at Chelsea cost 10s., paid to John Barthellmew of Staines, Middlesex, bargeman.

The laying of tiles on roofs and on floors was straightforward and simple craftsmanship, though this was not necessarily so in the case of the exceptional mosaic floors made up of many shaped pieces, particularly when these included figures and complex forms, as at Prior Crauden's Chapel at Ely, of *c.* 1325 (53–55). Nowadays we think of bricklaying also as quite a straightforward operation, but in the late mediaeval period this was not the case. The methods of following a prearranged pattern must have been analogous to the setting of a loom for pattern-weaving. Firstly there was the formation of flush patterns by using dark vitrified headers, that is to say bricks laid with their ends to the surface, and chosen because over-burning had both darkened and glazed their fabric. They therefore showed up as black lines or dots upon the rich red surface of the wall. In order to produce patterns, bricks had to be counted in every course and headers laid accordingly to achieve the intended effect. Commonly the result is merely a trellis of diamond or lozenge shapes, but interesting variants occur.

Much more complex was the use of moulded and cut brick in many ways to get twisted and spiral effects on chimney stacks. (49). This was also combined with the use of terracotta panels moulded from relief sculpture in the early Tudor period. The moulding of panels of detail, heraldic shields, and bricks of shapes specially adapted to the building of intricately designed shafts, must have been a separate offshoot of the trade in clay products. What is so far uncertain is the responsibility for the

designs: were they detailed by the architect for the building, or were they bought as ready-made components from commercial brickworks at certain centres?

There is evidence for the construction of many brick buildings under the supervision, and apparently to the design, of men who had trained as stonemasons. In a few cases one and the same man was described as a mason or a freemason at one time, and as a bricklayer at another. Such were Christopher Dickinson, a freemason who was appointed the king's master mason at Windsor Castle in 1528 but later held office as master bricklayer at Whitehall and for the construction of the coastal castles of Deal, Sandown and Walmer; and Robert Newby, appointed bricklayer of Lincoln Cathedral in 1524, but referred to elsewhere as mason or stoneworker (*lathomo seu fabro lapidario*). It seems likely that until late in the fifteenth century the use of brick was regarded simply as a substitute for stone and that masons had full and complete charge of brick buildings. There seems then to have been an attempt on the part of some town guilds of tilers, as at York, to claim exclusive rights in the working of all materials of baked clay. As has been mentioned, matters came to a head with the murder of a York tiler, allegedly by two leading masons, in 1491. The background of the dispute has been explored by Dr R. M. Butler, who has shown that it concerned the building in brick of the Red Tower, part of the city defences, in 1490 by tilers and not by masons. The work was done on behalf of the Crown but at the command of the Mayor, who may have been advised by the influential brick and tilemaking interests of the district. Dr Butler has also compiled a list of the Common Masons of York, responsible for municipal works and for the defences in the late fifteenth and early sixteenth century. It is curious that two of the seven holders of this office in the period from 1448 to 1508 were not made free of the city as masons, but as tilers: Henry Willott, free in 1464 and Common Mason in 1477–78, and Robert Baynes, free in 1474 and in office 1499–1501 but dismissed in favour of Christopher Horner, one of the masons who had been accused of the murder of John Partrik or Pateryk ten years before.

One reason why it is improbable that bricklayers were normally architects is that, regarded as masons, they were setters rather than hewers. Their skill consisted merely in the construction of walls out of blocks of a standard shape, not of designing or cutting that shape or the works to be made. In 1442, for the works of Eton College, William Vesey or Weysy was directed to impress masons and layers (*positores*) called ' brikeleggers ', who were certainly men in a subordinate position. Vesey himself, possibly a Dutchman or German by origin, was a brickmaker and held a patent of 1437 to search for earth suitable for making *tegulae* called ' brike ' and to make them for use at Sheen and elsewhere on the king's works. In 1441 he was rewarded by being appointed one of the searchers of the trade of beer-brewing, itself mainly an occupation of

immigrants from the Netherlands. Like Thomas le Tighelere at an earlier date, Vesey became an important man and was M.P. for Lyme in 1449 and for Wareham in the next two years. In 1453 and 1454 he was Bailiff of the Water of Thames, and he had been able to found a chantry in the church of St Stephen's, Coleman Street.

At York the case is rather different. The guild was what later became known as the Bricklayers, Tilers and Plasterers, and these crafts seem to have been in close alliance even before they were amalgamated. They were concerned to keep for themselves as large a proportion as possible of the building done in York, and before the days of building in solid brick they were associated with the carpenters in roofing and filling in the panels of framed houses. Surviving work of the fifteenth century shows that the normal filling of framed houses in York was with wall-tile, used not as bricks, but laid on edge. The size was more or less standardised at $10\frac{1}{2}$ by $5\frac{1}{2}$ by $1\frac{1}{2}$ in., and as far back as 1389 the price had been fixed at not more than 5s. the thousand, reckoned by the long hundred (i.e. the thousand was 1,200). At the same time roofing tiles of standard size (*juxta formam . . . assignatam*) were to be sold at not more than 10s. for 1,200. The reason for the higher price of tiles may have been the need to stamp the peg-holes through the clay, but Salzman showed that very high prices for plain tiles had always been the custom in York. At various dates between 1327 and 1458 the price fluctuated around 10s., up to 11s. and down to 8s., but invariably contrasting with southern prices ranged round 5s. and sometimes dropping as low as 2s. 6d. In Salzman's view it was possible that the York tiles were exceptionally large, and this would agree with the existence at Ramsey of a category of larger roof tiles, more or less obsolete by the middle of the fifteenth century.

Associated with the York tilers were the plasterers, and something may here be said of plastering and daubing. Over a great part of England mediaeval houses were framed of timber, with the panels filled in with wattling or laths, covered with daub and plastered or rendered inside and out. In some cases hurdles were woven to the size of the panels and sprung into place in grooves; in others rods were sprung into the grooves and wattles woven through them. When new houses and shops in Burgate, Canterbury, were built for the Prior of Christ Church in 1278–79, 2,000 laths were bought at Wincheap market by W. the carpenter for 17s. 2d; as William carpenter he was given 11s. 3d for a robe; Robert the mason made the (ground floor) wall of the shops for £7 13s. 4d; loam and clay, with carriage, cost £1 3s. 10d, and the daubers were paid £2 12s. 8d. At York Place, Westminster, in 1305 Master Thomas le Plastrour sold plaster of Paris at 10s. the ' moncell ' and next year Stephen le Plastrour and Elias de Malton were mending the king's little chamber next the Arbour (*erbarium*) with plaster of Paris, the two men getting 1s. between them for a day's work. In 1340 at Westminster, white plaster of Paris for repairing and mending walls sold at 1s. 3d the bushel, but

black plaster fetched only 1s. – it is not clear whether this was really black, or simply a coarse product that was not pure white. In the Bishop's Palace by old St Paul's in 1387–88 a plasterer and his boy worked for 25½ days in the hall and chambers at the joint wage of 1s. a day.

At York plasterers were freemen as early as 1333, the first on record being William Whitebrow, whose surname was probably a jocular one. In 1381 the only one in the poll tax returns was Roger Plasterer of St Saviour's, with his wife Joan and Joan their maidservant. By 1434 two plasterers are mentioned, living on the Micklegate side and close to the Ouse, John Appylton (free 1419) who occupied two tenements in North Street, and William Coupland (died 1435) with one in Skeldergate. Apart from house plastering and daubing, it must be remembered that a great many larger buildings were roughcast with mortar. In 1443 the church at North Curry in Somerset was daubed with lime and sand by William Helier of Taunton; in 1456–57 all the stone walls within the garden new built at the north end of the long chamber of Wolvesey Palace, Winchester, were covered with ' le Roughcastynge '; and in 1500–01 the steeple of Ashburton church in Devon was ' rowcaste '.

This section upon the workers in earth and clay may fitly close with the poignant *memento mori* inlaid on a tile by one of the tilemakers who worked for Malvern Priory between 1453 and 1458 (63). At that time the doctrine of good works and almsdeeds as vital to the soul's salvation was earnestly believed, and the visitor was urged not to defer what he might do today:

Think, man, thy life may not ever endure,
What thou dost thyself, of that thou art sure;
But that thou keepest unto thy executor's cure,
An ever it avail thee, it is but aventure.

Chapter 11

Craftsmen of Construction (3) Timber

It has been customary to deal with mediaeval carpentry as if it were almost exclusively a rural peasant craft of vernacular type, devoid of sophistication and to be considered typologically. If this were ever true, it was only in the Dark Ages, when the darkness is due to sheer lack of information. As soon as we begin to get evidence, the skill of woodworking can be seen as highly developed and decidedly eclectic. Master carpenters travelled widely, in search of timber if for no other reason. Their minds at least, and probably their sketch-books too, were filled with useful details which they saw had been adopted by others. Some of them, in the royal service or in that of nobles and prelates, were associated with the master masons and must have discussed with them all kinds of constructional problems. In the course of providing scaffolds and falsework for the greater churches, castles and palaces they had to use the architect's drawings – whether on parchment, paper, tracing floor or board – to obtain precise templates of the centering required for arches, vaults and windows (17). As has been said already, many of them were military engineers and in the nature of things are likely to have been kept informed, by the king and his generals, of any relevant ideas discussed by soldiers or derived from Vegetius and Vitruvius, regardless of the possibility that some carpenters read these works for themselves in monastic and other libraries.

The contrast drawn in the *History of Technology* between a northern European tradition of carpentry carried out with the axe, the adze and the knife, and Mediterranean joinery using the saw, chisel and plane, is unduly simplified. As we have seen, mediaeval carpenters had their timber sawn for them and no longer had to rely on the adze. Even the plane, a tool known in antiquity but lost to the North during the Dark Age, had come in again by the twelfth century, perhaps by way of Spain (1). The chisel had to be used to cut the carpenter's joints already typical in the twelfth century, even though they became more sophisticated a little later, as Mr Cecil Hewett has shown by his studies in recent years. There were,

of course, carpenters of varying grades, and Chaucer described three of them in the Canterbury Tales: the 'fair burgeys' of the Prologue; John of Oxford in the Miller's Tale, and the Reeve, a country wright. We can hardly doubt that a good many of the first class were highly literate men and extremely well informed.

Considering how little is really known of the population of England in the generation following the Norman Conquest, we are well supplied with information on outstanding carpenters. Under Edward the Confessor, one Teinfrith was the king's 'churchwright' and was doubtless master carpenter for the abbey church at Westminster; he was rewarded with a grant of land at Shepperton in Middlesex. At the time of the Domesday Survey in 1086 several engineers and carpenters held lands and were almost certainly masters prominent in the royal service: Waldin in Lincolnshire, Radbell 'artifex' at Norwich; Landric, who held Chetel's manor in Acaster Selby near York and may well have been the architect of the original timber castles at York; Rayner at Marston in Herefordshire, and Durand the carpenter, who had lands in Dorset and whose descendants held by the serjeanty of finding a carpenter for the great tower of Corfe Castle. Not much later Wimund de Leveland was keeper of the Palace of Westminster and, as Sir Charles Clay's researches have shown, was probably the king's chief engineer, as his son Geoffrey certainly was to Henry I in 1130. Wimund is then the probable designer of the extraordinary great hall of William Rufus at Westminster, built in 1097–99 and for the next 150 years the largest room in north-west Europe.

In the second half of the twelfth century it would be possible to trace, from the Pipe Rolls, the careers of many engineers and carpenters in the royal service. They were men of standing who drew high fees and had great responsibilities. Not much is recorded of their activities, but some of them were in charge at various castles and are named as receiving fees and robes and carrying out building works or making engines of war. In 1180–81, when substantial buildings were put up for Henry II in Winchester Castle, for which Stephen the mason and his fellows were paid £22, Robert the carpenter had 4 marks (£2 13s. 4d) for the framing (*ad framaturam*) of the same. In 1173–74 the sum of £2 15s. 3d was spent on a palfrey and a pack-horse for Richard fitzWiching the carpenter, sent to the king at Huntingdon, with harness for the horses. This was in connection with the making of military engines under Yvo the engineer, but Richard had in his own right had livery of cloth (*pannos*) to the value of £1 in 1169–70.

In a few cases we get glimpses of both the working and the private life of notable carpenters, especially in the reign of Henry III, when the Liberate Rolls record the king's keen interest in the doings of his servants and their families. Master Gerard the carpenter, who flourished in 1241–51, was given a robe or 15s. for it, and 7½d a day, later raised to

1s. He travelled widely as a military engineer, buying 20 cartloads of lead at Boston Fair in 1244 for the engines at Newcastle-upon-Tyne, choosing six good timber trees for beams for the engines in the Forest of Carlisle, arranging to fell them and transport the timber to Newcastle. He was given 4 marks to buy a horse for his journeys, repaired the crossbows at Bamburgh and Newcastle, and then moved to Nottingham, whither his tools were sent. In 1245 he had charge of repairs to Winchester Castle and was made keeper of the castle at a fee of £2 per annum. In the following year Henry III paid £2 10s. for the maintenance of Gerard's two sons for a year, and in 1247 the king made a present of £2 to Gerard's wife Denise. It needs to be added that King Henry was a model of domesticity and that he showered largesse upon his servants' wives and daughters from sheer kindness of heart.

At Winchester, besides the royal craftsmen at the Castle, there were important works at the Cathedral and at Hyde Abbey. The latter, between c. 1240 and 1265 had as master mason Henry of Hyde, who sometimes appears with Randolf the mason, Michael Sclattar and Gilbert the Smith; rather later, about 1266, Nicholas the Carpenter is mentioned. The Abbot of Hyde in 1278 granted to John le Engynnur of Bishopstone in north Wiltshire the keeping of lands in Chisledon on which John was to build houses; the presumption is that he had served the abbey in a technical capacity for which this grant was a reward. The standing of carpenters is attested by an inquiry held at Lichfield about 1358 as to defects of houses there. Two of the witnesses were carpenters, Thomas Chebsey and John Wis, both 40 years old and upwards and of free condition. Later sidelights on the craft are given by the bequest of 3s. 4d to the London Company (*Societati*) of Carpenters in the will of William Strete, carpenter, who died in 1419; and by the clothing mentioned by Richard Sponeway of St Peter upon Cornhill, who died in 1426. Besides leaving substantial sums of money he referred to ' my best robe of violet with fur ', ' my green robe ', and ' my blue robe '. Yet these men were not of the highest condition and cannot have been by any means as well off as the great king's carpenters to Edward III and Richard II, William Hurley (died 1345) and Hugh Herland (c. 1330–1405).

The work of carpenters as foresters has already been described. The timber was sent, either to the carpenter's yard if he had one of sufficient size, or to a level field chosen as a ' framing-place '. At Westminster Palace there was space to frame up the timber vaulting for St Stephen's Chapel, prepared long before the walls were ready for its erection. In 1326 Robert de Holebech, carpenter, was marking the timbers of the vault and taking the timber apart (*disiungenti*) to put it in store. The vastly greater roof of Westminster Hall had to be framed in the open near Farnham, and on 1 June 1395 orders were given to send 300 strong wains to the Frame by Farnham to carry the timber wrought for the roof to Ham (in Kingston-upon-Thames), each wain taking five loads in the

four weeks following Trinity Sunday, 6 June. From Ham the prepared timber was taken by water to Westminster. The same methods were used on a small scale in 1428–29 when new doors were made for the hall of Wethersfield Manor in Essex. John Walforde felled the timber by agreement for 1s. 7d; John Heerd carried it from the park to the manorhouse for 1s. 2d. It then cost 10d to move it from the manor to 'le Framyngplace', where John Langford made the doors for a lump sum of 10s. About 1543 the framing of timber galleries for Whitehall Palace was done at Enfield. John Russell (*c.* 1500–1566), 'carpenter for the king's grete works' had 1s. a day for 7 days for travelling expenses of his horse and himself, in riding to Enfield to oversee the carpenters working there for the speedy finishing of the frame of the gallery. William Peires of Enfield, carter, had 8d for carriage of a load of timber from Helgrove beside the park there to the frame in making within the said park; and John Tayler, William Upchurche, John Wright and Thomas Wilde, with other men of their company of carts, received £7 2s. 4d for the carriage of 61 loads of framed timber from Enfield to Westminster for the gallery, which was on the waterside of the palace, at 2s. 4d the load.

Framed buildings had to be raised upon the dwarf walls prepared to receive them, and a crane or sheerlegs with cable and tackle was necessary to haul the frame up to the vertical. It was propped up by raking shores fitted into oblique slots cut near the top of the main posts: these slots can often be seen, though they were commonly filled in after erection. Raising frames was a traditional occasion for celebration by the craftsmen and labourers concerned. In 1434 a barn was built at Ormesby in Norfolk; timber costing £1 2s. 10d was bought and carried from Norwich for 8s. 8d. The carpenter William Berry then framed the barn in carpenter's work for a lump sum of £3 13s. 4d while a stonemason with his servant built the 'fotyng' getting 6s. 3d for 7½ days work by the two men. Then at 'le Reyseng' of the barn, 1s. 2d was spent on bread, ale and cheese. Not only farm buildings and small houses were made of timber, but also some very large mansions and in cities the equivalent of office-blocks. In 1436 John Carpenter of London was paid £20, part of his contract price of £66 13s. 4d for everything belonging to the art of carpentry in the new inn for the Bishop of Worcester on the south side of the Strand, to contain eight 'mansions' in all.

These larger buildings were often much more than mere works of craftsmanship, being excellently designed by masters who were among the first architects of their day. It is likely that the John Carpenter who worked for the Bishop of Worcester was John Goldyng, citizen and carpenter of London and the King's Chief Carpenter from 1426 until his death in 1451. This is made even more probable by the fact that 'John Carpenter of London' produced woodwork for Fromond's Chantry Chapel at Winchester College in 1439, since the glass for the windows

was certainly painted by John Prudde the King's Glazier. Goldyng in his official capacity presumably designed the original roof of Eton College Chapel, replaced by a copy in 1699 and finally destroyed in 1957. Another important example of architectural carpentry of the same period was the old Canterbury Guildhall, framed ' of hert ok ' in 1438–39 by three carpenters of Woodchurch, Richard Wodeman, John Tuttewyf and Piers Colyn for £43 6s. 8d. With its three great beams of 18 in. by 12 in., ' in the best wise enbowid (moulded) workmanly forth ', it survived in its original condition until its wanton destruction in 1950.

Apart from the subdivision of mediaeval building according to the different crafts involved, more than one carpenter might be employed at once on separate sections of the same group of buildings, to secure speedier completion. When new buildings were erected at Goleigh Farm near Tisted in Hampshire in 1473–74, the Hall and chambers were built by Hugh the carpenter and his servant, working for 9 weeks and another 8 days, taking £2 18s. wages and their board; but William Yong, carpenter, was employed on the new kitchen, getting a fee of £1 5s. Another 9s. was spent on the wages and board of carpenters, tilers and other labourers hired for building the new kitchen, as part of the task of carpentry. Conversely, the same carpenter might work for two different clients, especially in the case of a church, where the rector was responsible for the building and repairs of the chancel, but the parishioners for the nave. An interesting instance is the church of Norton Subcourse in Norfolk, some ten miles south-west of Great Yarmouth. Fortunately the parties to the contracts for the church roofs had them enrolled in the borough court rolls of Yarmouth, which have survived. The chancel roof was made in 1319 by William de Gunton and Roger de Gunton of Yarmouth; by the end of the job William had died, but his widow Margaret with her son John de Gunton, and Roger de Gunton, then undertook to make the nave roof to the same pattern for a committee of parishioners by Michaelmas 1320. (For the contracts see Appendix VI.)

Difficulties of the same kind regarding extras demanded by the client occurred in the Middle Ages as in modern times. In *c.* 1539 William Woodlyffe, mercer of the City of London, wished to have a house built at Wormley, Hertfordshire, apparently for his farm tenant William Curle. Woodlyffe entered into a contract with John Harresone of ' Wallton ', Essex (possibly Saffron Walden), carpenter, to set up a house of two storeys, 24 feet long by 15 feet wide; he paid £2 on account and Harresone bought 10 loads of timber. Woodlyffe then changed his mind and wished the house to be made larger, agreeing to pay for the extra. Harresone had timber sawn, costing £4, and framed and reared the house to the value of £5 at least, bought 200 ' planche borde ' for 5s. and paid out to Leonard Killer 1s. and to Richard Pawmer, bricklayer, 16s. 8d and to his labourer 10s. ' for laying of breike in the walls of the seid howse '. He also paid William Curle, Woodlyffe's tenant, 2s. 4d for more

timber, and asked Curle to provide carriage. It was for £5 costs in respect of this carriage that Curle sued Harresone before the Sheriffs of the City of London. We do not know the whole of the story, any more than we do the details of an earlier case of 1450, in which the churchwardens of Capel, Surrey, had sued John Walfray of London, carpenter, for £2 which he owed them, successfully. Walfray was outlawed for failing to pay, but in January 1453 was pardoned his outlawry. Walfray had presumably failed to carry out some or all of a job he had undertaken. Besides the records of such civil lawsuits we also find references to more serious difficulties involving carpenters. In 1479 Robert Person of Barnard Castle, carpenter, sought sanctuary at Durham Cathedral, and one of the witnesses that he had taken sanctuary was the priory carpenter Thomas Ryhope. Person's trouble was that on 30 June 1476 at 'Haldworth' (Holdsworth) in Halifax, Yorkshire, he had shot an arrow in self-defence and, hitting Thomas Ferrour in the throat, had wounded him mortally so that he died nine days later.

Carpenters and wrights were always the most numerous among the craftsmen of the building and associated trades. At York in 1381, out of a total of 107 men in these crafts assessed to the poll tax, 36 were set down as wrights, as well as three fusters (woodworkers), 4 joiners, 2 turners and 7 sawyers, a total of 52 in the business of woodworking. A good many of them were probably in a small way, but some must have been extremely prosperous. At least 27 carpenters and three joiners were sufficiently well off to leave wills in the period from 1328 to 1549. Richard de Briggs, who died in 1328 in the Close, wished to be buried in the Minster if the keepers of the fabric would permit and left to the fabric a conditional bequest of 100 'thakebord'. He was survived by his wife Margaret and son John, as well as a sister Emma. Among his legatees were Joan a maidservant and one William Briggs, chaplain, presumably a relative, who was to have three silver spoons and a cup, and was also to choose from among 'my tools' (*instrumenta*) a hatchet, a wimble and a 'grophirne'. The wimble was a gimlet or borer with a screw-point and the gropeiron was a gouge. In the fifteenth-century poem, *The Debate of the Carpenter's Tools*, the former spoke up for itself:

Yes, yes, said the wimble,
I am as round as a thimble;
My master's work I will remember,
I shall creep fast into the timber.

William Cotyngham, a York carpenter who died in 1457 and who had relatives living near Cottingham in the East Riding, presumably his birthplace, was a man in a very comfortable position. His own will and that of his wife Joan, who died two years later, include many bequests to relatives, to friends, to servants and to the poor. Cotyngham left to the Minster fabric £1, and his wife 6s. 8d. Among the specified legacies

115. Altötting, Bavaria : 'Das goldene Rösslin'. French (Paris), c. 1403

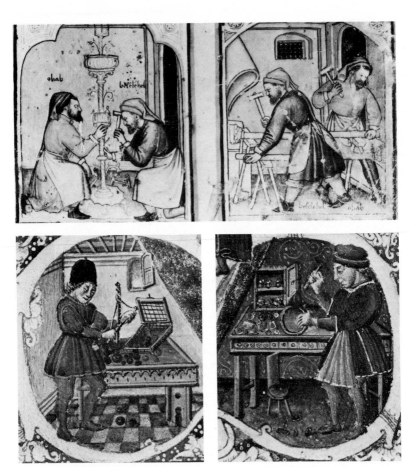

116. (top) *Goldsmiths at work. Italian, c. 1400*
117. (left), *118. Lapidaries at work. Central Italian, c. 1465*

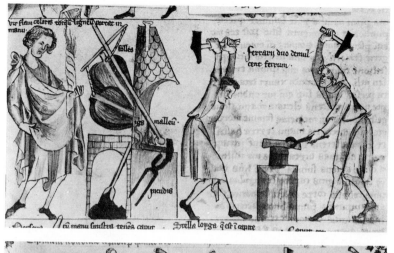

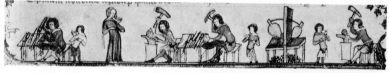

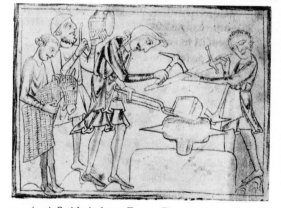

119. (top) *Smiths in forge. Franco-Flemish, 14th century*

120 (middle) *Smiths and Armourers. Franco-Flemish, c. 1340*

121. (left) *Swordsmith and Heaumer. English, c. 1250*

122. Armourers. French, early 15th century

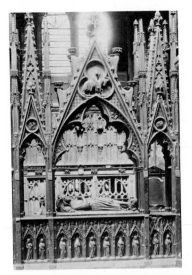

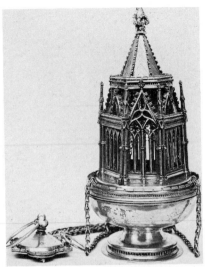

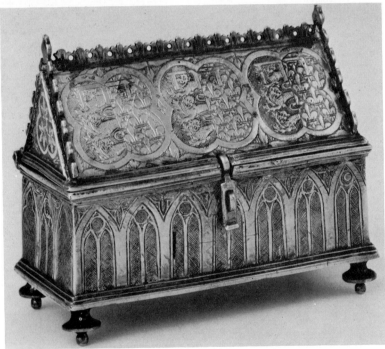

123. (top, left) *Westminster Abbey : tomb of Edmund Crouchback,* c. *1296, by Michael of Canterbury*

124. (top, right) *Ramsey Abbey : silver-gilt censer,* c. *1375. (Victoria and Albert Museum)*

125. Silver reliquary. English, c. *1308. (British Museum)*

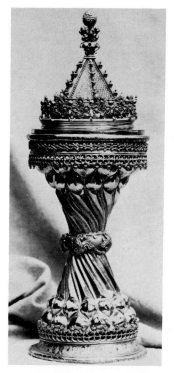

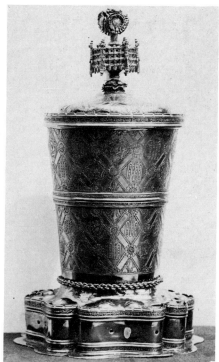

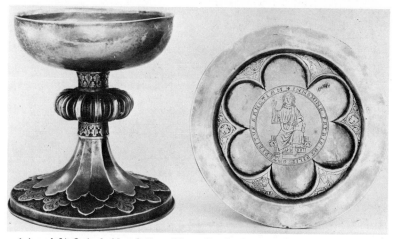

126. (top, left) *Oxford : New College. Silver-gilt salt. English, 1493*

127. (top, right) *Cambridge : Christ's College. Silver-gilt cup. English, 1507*

128, 129. *Dolgelly Chalice and Paten. 13th century, by Nicholas of Hereford. (Victoria and Albert Museum)*

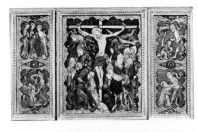

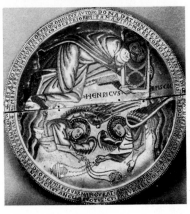

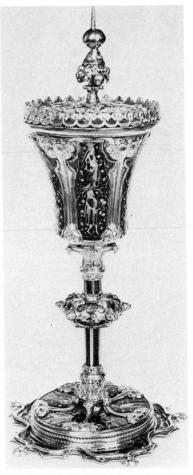

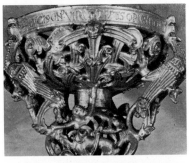

130. (top left) *Triptych, silver-gilt and enamel. English, c. 1340. (Victoria and Albert Museum)*

131. (2nd top, left) *The Valence Casket, gilt bronze and enamel. English, c. 1250. (Victoria and Albert Museum)*

132. (right) *Lynn Cup, silver-gilt and enamel. English, c. 1340*

133. (3rd top, left) *Gloucester Candlestick, gilt bell-metal. English, c. 1110. (Victoria and Albert Museum)*

134. *Enamel plaques of Bishop Henry of Blois, c. 1160. (British Museum)*

*135. Lorenz
Helmschmied of
Augsburg : Armour
of Archduke
Sigismund of Tyrol,
c. 1480. (Vienna,
Waffen Sammlung)*

136. (top) *Rowlstone church, Herefordshire : candle bracket, 15th century*
137. (left) *Canterbury Cathedral : choir. Iron gate, c. 1310*
138. *Haddiscoe church, Norfolk : south door. Ironwork, late 12th century*

139. *Winchester Cathedral. Iron screen, mid-12th century*

140. (top, left) *Leighton Buzzard church, Beds.: west door. Ironwork, probably by Thomas de Leighton, c. 1290*

141. (top, right) *Windsor Castle: St George's Chapel. Ironwork of door, c. 1245*

142. *Westminster Abbey: tomb of Queen Eleanor of Castile. Iron grille by Thomas de Leighton, 1294*

146. (lower, left) *Westminster Abbey: Henry VII's Chapel. Bronze gate, c. 1515*

147. (lower, right) *Ely Cathedral: Bishop West's Chapel. Iron gate, c. 1525*

143-145. (top) *Windsor Castle: St George's Chapel. Iron lock-plate, ring-plate and grille for tomb of King Edward IV, by John Tresilian, 1477-83*

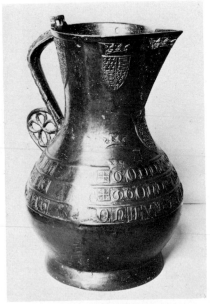

148. (top, left) *Walton-on-the-Hill church, Surrey: lead font, 12th century*

149. (top, right) *Bronze flagon. English, c. 1350. (Victoria and Albert Museum)*

150. (lower, left) *Stoke Lyne church, Oxon. Bronze closing ring, c. 1200?*

151. (lower, right) *Gloucester: St Nicholas's church. Bronze knocker, 14th century*

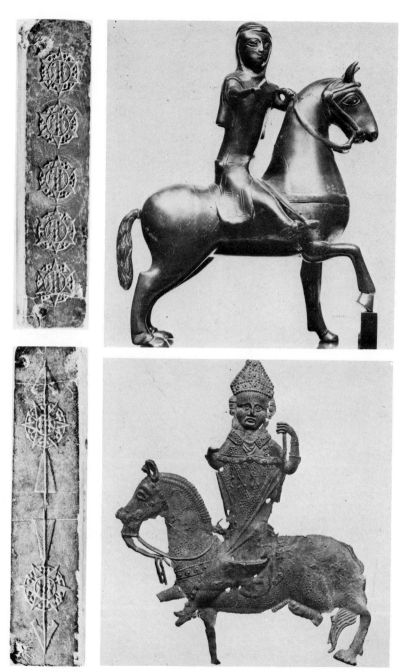

152, 153. (left) *Stone moulds for casting badges.* (Norwich, St Peter Hungate Museum)
154. (top, right) *Bronze equestrian figure, 14th century.* (British Museum)
155. Pilgrim's lead badge of Becket, 14th century. (British Museum)

156, 157. York Minster: nave, north aisle. Bell-founding (above) and bell-turning, from the Tunnoc window, c. 1330

158. York Minster : Tunnoc window. Votive picture of Richard Tunnoc (died 1330)

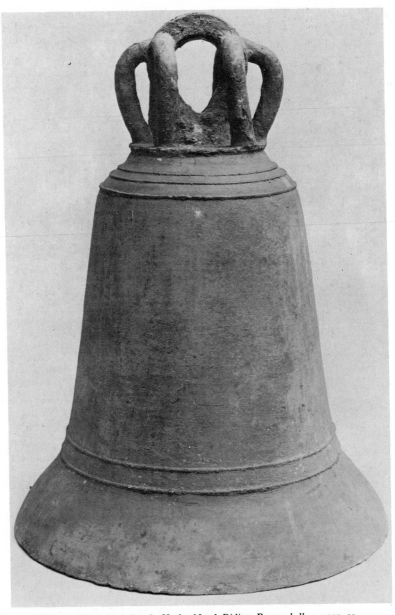

159. Skelton-in-Cleveland church, Yorks. North Riding. Bronze bell, c. 1230-50. (Victoria and Albert Museum)

were a best robe, a second best robe, a robe formerly the livery of Master William Duffeld, a dagger harnessed with 'lokitts', chape and a silver rose, a chest 'standing next the chimney in my parlour', a candlestick with two little feet (*pediculis*) called in English 'flowres', a best silver spoon and a 'karlel' (Carlisle) axe. Cotyngham wished to be buried between his sons William and John, who had predeceased him, in the churchyard of St Michael le Belfrey, but his executor, and later his widow's, was their surviving son Thomas Cotyngham, chaplain, a vicar in the cathedral choir. A later York carpenter who died in 1484, Thomas Denton of the parish of Holy Trinity, Goodramgate, left his house in Goodramgate to his wife Matilda and also named quite a selection of his tools as bequests: two broad axes, two squares, a 'blokker', a 'knotter', and four different sorts of gimlet or auger: a 'mortas wombill' (mortice wimble), a 'bandwombill', a 'magwombill' and a 'pynwombill'. The mortice wimble would have been a large auger for drilling a series of holes to start the sinking of a mortice, which could then easily be trimmed out and squared with a chisel; the pin wimble would be of the standard diameter to make holes for the wooden pegs or pins which held the joints of framing.

In early times humble houses built of timber and daub were generally thatched, with straw, with reed, heather or any other available material. Though often done by amateurs, really good thatching was and is a skill in itself, now practised by a few surviving thatchers, who mostly work with the relatively durable Norfolk reed. But besides the risk of fire inherent in such roof coverings, they do not last many years without needing extensive repair or relaying. For timber houses of higher standing an alternative was to cover with oak shingles, wooden tiles, which are evidenced from the eighth century in England and were fairly popular from the twelfth to the fourteenth. By the end of the thirteenth century it had been discovered that roofs of stone or clay tile were cheaper as well as safer, and shingling was almost given up except for some church spires, where the wooden covering has the advantage of being much lighter than lead, and not liable to creep downwards. Though no ancient shingles remain, a few spires have maintained a continuous tradition of reshingling down to the present day. In connection with the curious superstition, already referred to, that wood was not sawn in the Middle Ages, it is important to note that shingles, normally cleft with the grain for durability, were in 1295 being made from blocks (*gobones*) of wood sawn for the purpose. In 1394–95 the belfry of Old St Paul's was relaid with 4,000 old shingles and 10,500 new 'schyngel' bought at 18s. the thousand including carriage to the site.

The woodworkers included not only carpenters and those of other trades already mentioned. Setting aside the bowyers and fletchers who made bows and arrows principally of wood, and the coopers who specialised in barrels, there were also the saddlers, whose products in early times

consisted to a much greater extent of the 'tree' than they do now. Mills, including their machinery and cogwheels, seem usually to have been made by carpenters, though the word 'millwright' had appeared by 1481. The design of such machinery was probably in the carpenters' hands, but it called for the co-operation of a blacksmith. In 1335–36 four bands (*ligatur*) of iron, costing 1s. each, were bought for the wheel called 'Kogwell' of the windmill at Ashwell, Hertfordshire. Similar collaboration was of course essential for the trade of the wheelwright or cartwright and the later coach-builder. One of the more important inventions, or improvements, of the Middle Ages was the 'dished' wheel, whose spokes meet the hub as a flat cone, giving strength against the sideways thrusts frequent on poorly surfaced roads. This had certainly come into being by the fifteenth century but neither the time nor the place of the development is known.

In 1381 York had, beyond the 52 woodworkers already mentioned, 9 bowyers, 9 fletchers, 7 coopers and 23 saddlers, and there were 3 cartwrights and 5 shipwrights. Although the usual way to travel was on horseback, or by mule, carts and wagons were coming into use for passenger transport, especially for women and children. There were regular carriers from Oxford to London, Winchester and Newcastle-upon-Tyne by 1395, and in 1397 £400 (!) was spent on a chariot for Richard II's young queen, Isabella. Three years later John Norman, wheeler of London, was being paid for repairs to the queen's chariots. These state carriages must already have been works of fine art, for in 1403 a chariot made for Henry IV's daughter Philippa, later Queen of Denmark, was painted at a cost of £5 by Thomas Kent, and John Gadyer, goldsmith, provided certain pommels for the chariot, price £10. On a humbler plane, William Worcestre noted his aunt's account of how Agnes Botoner, daughter of his great-uncle Adam Botoner, had been saved from the great plague of Coventry in 1386, in which her father died, by being taken at the age of four to Bristol by a 'loder' (carrier), John Randolf of Lawfords Gate, Bristol, whom she afterwards married.

With the immense subject of shipbuilding we cannot deal, but it is worth noting that new ideas in the construction of ships were coming to the fore in the tenth century, probably derived from the Moors in Spain, perhaps through the Spanish resident at the Danish court in Dublin. The arrival of the true rudder in the North was not until the thirteenth century. As we have seen, it came from China, where it had been known for three hundred years, perhaps by way of Byzantium. The design of the larger ships, like that of major buildings, must always have involved drawings: many centuries of tradition lay behind the phrase put by Marryat into *The King's Own* (1830): 'The dimensions of every separate piece of timber I knew by the sheer-draught which lay before me.' Occasionally carpenters carried out work as boatbuilders. In 1284 Robert de Colebrook, a well known London carpenter who later became chief

carpenter at the Palace of Westminster, was paid 10s. 4d for timber and boards for a small boat for the king's son the lord Alphonso, and for painting it. William Brid, a carpenter of Mortlake, was paid £3 8s. 7d in 1392–93 for mending a boat for the passage of the king with his household and harness across the Thames at Sheen.

The boundary between carpentry and joinery is a vague one. In strict principle, the mark of joinery is the use of the plane, and one might add that the joiner uses glue. But the types of fitting, such as doors, and of furniture, such as chests and cupboards, overlap and merge, and there was a long period in which carpenters produced minor works in a style not far removed from that of the newer trade. Joinery existed in Italy by the eighth century and it was two or three centuries before it was known in north-western Europe. The first mentions of joiners in England seem to be in the middle of the thirteenth century, and their introduction, like that of patterned tile floors, may be due to Henry III's attempts to provide his queen with the luxuries to which she was accustomed. At the Tower of London in 1274 Salamon le Jongnur was paid 13s. 4d for two boards of fir with trestles and other ' harness ', apparently drawing boards for architectural design at the beginning of the great works of Edward I. Earlier joiners had already made beds and other items of furniture, but such things as choir stalls were generally made by carpenters and their design was in some cases due to the master mason. This point is proved by Honnecourt's album, and reinforced by the inclusion of a design for a bench-end among the strictly architectural designs of the Rheims palimpsest of *c.* 1240–50. As late as 1454 a carpenter, J. Roune, was paid for making sedilia and ' les dextes ' in the choir of Hambledon Church in Hampshire, getting £1 6s. 8d.

The early joiners made saddle-bows but at any rate in London emerged as a completely independent craft in 1307. William Lee, the King's Joiner, died in 1483, leaving to ' my feleschipp of Joynours of London ij lidgers Colour stones to remayne to the Feleschip of Joynours of London for ever ' – joiners who lacked them were to be allowed to borrow them for 14 days on giving pledges for their safe return. He also left 6s. 8d to the common box of the company. A ' colour stone ' was a flat slab (or ' ledger ') on which colours could be ground, and as we shall see was normal equipment for painters. Lee's bequest looks like evidence for the production by London joiners of a substantial amount of painted furniture and panelling. This again was a technique adopted in England by Henry III, though in this instance some years before his marriage. Linenfold, or what were at the time called ' drapery ' panels, had come in by the reign of Henry VIII, and were made mechanically by a moulding plane used from end to end of the board; the top and bottom were then finished off with a chisel.

Both carpenters and joiners made chests (**75, 76**) and the line of demarcation must have been an extremely difficult one. On the whole it

seems to have caused less contention in practice than that between masons and tilers. John Wydmere, a London joiner who became King's Joiner in the Tower in 1394, had £4 in 1413 for riding with his men to Langley to provide a bier on which the body of Richard II was carried to Westminster for the honourable reburial decreed by Henry V. Next year Wydmere had 13s. 4d for making a chest to stand in the Receipt of the Exchequer to contain truces, etc. On the other hand it was a carpenter to the Bishop of Winchester, William Boveyate who in 1471–72 made 16 beds of which 8 were 'Trokilbeddez', for Waltham, Hampshire. Another carpenter, John Curteys, made a chest for vestments at St Andrew's Church, Canterbury in 1485 for 7s. Some of these church chests were regarded as valuable items: in 1431 a chest of spruce (or of Prussia?; *unam cistam Prucie*) bound with iron was conditionally bequeathed to the vicar and parishioners of Acaster Malbis near York if they were prepared to pray every Sunday for the soul of the testator, Richard Bryan, citizen of York; if not, then the York Friars Minors (Franciscans) were to have it. Two years later John de Wyghton, chaplain, referred to his chest of the better sort (*j cistam meliorem*) standing in the chantry of St John the Baptist in St Martin's, Micklegate, York.

Not only were the joiners in competition with the carpenters, but also with the wood-turners (**66, 67**). The use of the lathe for turning marble shafts has already been mentioned, but in wood there was a brisk trade in furniture, notably stools made of turned components. Throughout the Middle Ages the turners remained a separate trade, though not a large one. In 1542 at Whitehall Palace there were payments for 'the wod & Tornyng of viij pyllorse for ij Tornyng Chayerse now in makyng to be sett up in the low gallery.' Another minor skill was that of wickerwork and basket-making. It was strictly one of the woodworking trades, since the withies used for it were species of willow-tree and were grown for the purpose over a very long period. As we have seen, woven hurdles were used extensively as platforms on scaffolds, for filling the panels in framed structures and for all sorts of temporary purposes such as penning sheep. Baskets were made for carriage, including the moving of bricks and mortar, and wicker furniture has a long history. One Westminster basket-maker, John Banbury, who died in 1561, is of considerable interest as the father of Henry Banbury (1540–1610), the first English nurseryman who can be connected with a nursery garden in a definite place, Tothill Street. It was probably John Banbury who really started the nursery, for fruit trees as well as for osiers, since he directed his son to 'plante and grafte for the behalfe of his mother and he to have the third parte for his labor'. A good deal of furniture and household goods was left to Henry Banbury, and the lease of a house to John's wife Elizabeth.

We saw that some carving was done by stonemasons, but on the whole it was woodcarving that offered greater scope. Chip-carving in geometrical patterns, as often seen on early chests, is a carpenter's technique, executed

with knife or chisel (**76**). It suggests in some cases that drawings made as designs for tracery were used as a basis for carvings. Effigies and statues in wood preceded final works in bronze. Thus about 1507 James Hales 'le imaginator' made the wooden pattern for a bronze or copper effigy for the Earl of Derby at Burscough Priory, Ormskirk, Lancashire. That a long tradition of effigies carried at royal, and some noble, funerals led up to this was shown by the late R. P. Howgrave-Graham in regard to the so-called 'Ragged Regiment' at Westminster Abbey. The early practice was to take a death-mask, and this practice was still followed at the death of Edward III, of whom a wooden effigy was made by Stephen Hadley. To this the mask was fixed. Later, the surviving bronze effigy was made with this funeral effigy as a model. At most later royal funerals the effigy was entirely carved in wood, the face being a portrait but presumably based upon a death-mask in most cases. For the earlier effigies of Henry III and Eleanor of Castile, made as we have seen in 1290–93, preliminary models, probably carved in wood, have to be supposed.

Carving of exquisite quality was already being made in the thirteenth century, and some of the work on the stalls of Winchester Cathedral, (**67**) made by William Lyngwode, a carpenter brought from Blofield in Norfolk in 1308, can hardly be surpassed at any date. The slightly later woodwork in Exeter Cathedral, including the Bishop's Throne of 1316–17, made by Robert de Galmeton, carpenter, for £4, was produced under the supervision and probably to the design, of Master Thomas Witney, architect of Winchester Cathedral and then at Exeter (**91**). The Ely stalls of 1336–48 must have been designed by William Hurley, the king's master carpenter who was called regularly to Ely to supervise the new works, as they are in an advanced version of the new London style. Several carpenters and probably specialist carvers also will have worked on such extensive jobs. In 1395–96 the new choir-stalls for Bicester Priory were made by Robert Dryffeld as a task for the price of £20, and he was also paid an extra of £1 13s. 4d for 30 finials, which must have been carved work.

At the making of the great new roof for Westminster Hall the first four of the angels which appear to support the hammer-posts were carved by Robert Brusyngdon for £1 6s. 8d each. He was a specialist sculptor, and the rest were carved at decreasing prices, some by Brusyngdon, others by William Canon, Peter Davyn and Hubert de Villers. From this time onwards specialists were almost always called in, and generally received fairly high pay. It is not clear how many of the 'kervers' had town shops, and some were itinerant craftsmen along with the masons and carpenters, or were retained by the great churches in regular employment over substantial periods. At Norwich Cathedral in 1427–28 William Reppys, gravour, was paid £2 for carving six bosses of the cloister vault (**90**). At Canterbury in 1436 a carpenter called William Jon was paid 5s. for making the sign called 'le Crowne' in the Mercery, but two years later,

when an image had to be made for the sign of the ' Sonne ' there, it was commissioned from the famous sculptor John Massingham, who received 13s. 4d.

Undoubtedly there was much copying and emulation, in stalls and carved work as in large-scale architecture. It is a commonplace in contracts of all kinds to find the specification: ' as good as the work at . . . or better ', and sometimes definite buildings and details were named. Melrose Abbey even sent to Bruges in 1441 to Cornelius de Aeltre, a master of the art of carpentry, to make new stalls for the abbey, taking those of the Abbey of Dunes as a model, though with variations, and the seating in the choir of Thosan by Bruges as model for the seats. Scotland suffered from a shortage of good craftsmen of her own, and Melrose had as architect the Frenchman Jean Moreau of Paris, who was also in charge of the works of St Andrews and Glasgow Cathedrals, Paisley Abbey, Nithsdale and Galloway. England, on the contrary, seems to have had considerable numbers of highly skilled men until a late date, though towards the end of the fifteenth century there was an influx of Flemings and some Germans. There is no reason to suspect foreign influence in the names of most recorded carvers: Matthew the mason of Alnwick Abbey who in 1450 carved a stone lion to place above the gateway of the Castle; or Geoffrey Kerver of Worcester who in 1463 was making both the carpenter's work and ' lez kervyng ' of the new library at All Saints, Bristol, with ' lez deskes ' there, by contract for £13 6s. 8d.

With the great English trade in carved panels or ' tables ' of alabaster we cannot deal here except to note that this was a major artistic export, with English masters sending both the material and the finished products abroad (95, 96). Thomas Prentis, alabasterman of Chellaston, was in 1414 selling alabaster to Alexandre de Berneval, the master mason of Rouen; and in 1442 the Prior of Modbury in south Devon had licence to ship from Poole an alabaster tablet bought in England to the abbey of St Pierre-sur-Dive in Normandy. Finally, there seems to be no likelihood of anything foreign about the two ' gravors ' of Wymondham, Norfolk, William Bale and Thomas Sterlyng, who in 1519 undertook to make the image of a ' riding George ' to stand in the parochial nave of the great abbey church. This sculpture is lost, but the splendid character of such pieces at exactly that time is still displayed by its counterpart carved for the church at Husum in Sleswig, about 1520, by the German Hans Brüggemann (78). Right to the very end of the mediaeval period there were carvers able to reach the supreme heights attained by Gothic art.

Chapter 12

Craftsmen of Enrichment
(1) Painting

It is impossible to draw any hard and fast line between the construction and the enrichment of mediaeval buildings. Their art and craftsmanship were united and produced a single whole incorporating structural and aesthetic elements. Once the mason or carpenter had cut mouldings or even plain chamfers, on the structural members of a fabric, an aesthetic factor had been deliberately introduced. The subsequent development of such details was an artistic progress due to individual creative powers. Their execution belonged to the rank and file craftsmen. Yet we must remember that there was no irrevocable distinction between officers and other ranks: the apprentice of today might, in ten years' time, be an architect or a sculptor, painter or goldsmith of distinction.

Carvers, both of stone and of wood, have already been discussed. From simple mouldings to enrichments, from such details to figure sculpture, is an endless chain without sharp breaks. The appearance of a building, its light and shade, its punctuation, depended upon these additions to mere structure. Yet at some point, however hard to define, the work passes over from the *ars mechanica*, workmanship, to *portratura*, portrayal or visual art. The distinction was evidently present in the minds of the mediaeval masters, and even stress is laid upon both sides in their works; in an explicit way in the encyclopaedic treatment of Villard de Honnecourt. Honnecourt, from the inclusion in his album of highly technical matter concerned with stereotomy and other aspects of masonry, carpentry and engineering, was beyond any doubt trained as a mason. He had progressed to the top of his profession and, like another Vitruvius, took very nearly all knowledge for his province. In one direction he was concerned with surveying and mensuration, with water-powered mills and machinery, with clocks and automata, with plant and 'engines' for lifting. He was also absorbed in the strictly architectural problems of plan, proportion, elevation, and details such as window tracery and floors. The design of bays, abutment, the practical fitting together of parts, were all within his scope.

On the other hand, Villard was absorbed in draughtmanship as a technique, the means of setting down natural detail from leaves through insects, birds and animals to the human figure. Grotesques as well as real creatures sprang from his pencil, but he was above all determined to portray the scenes from ecclesiastical iconography essential to the work of a figure sculptor (more especially) or a painter. In all these fields Villard showed himself a highly accomplished artist and a master fit to take control of whatever works were required. For the period centred around 1235 we have then this completely satisfactory evidence that, in the north of France, one single man could be not simply an architect but a good deal more. On a building designed and supervised by such a master, the sculptor, the painter, the artist in stained glass or floor tiles would play a secondary role. The creative design would stem from the central figure.

The question: how far can Villard be accepted as typical for other places and times within the Middle Ages of north-west Europe, is central to our assessment of mediaeval craftsmanship. In an age when the specialisation of separate crafts was carried to lengths almost beyond those of modern trade unionism, it would seem that only the overriding grip of a master like Villard would be able to produce artistic unity. More than this, if we consider specifically a great building designed as a unity, with its masonry, carpentry, sculpture, painting, stained glass and contained works of art, it is difficult not to conclude that it *could* only have been produced by the dictatorship of a single mind. To what extent is there further evidence in favour of this view, beyond the album of Honnecourt?

We have noticed in passing several scraps of evidence tending in the same direction. André Beauneveu in 1390 was a master of craftsmen both in carving and painting; Henry Yeveley, officially a deviser of buildings and so by definition an architect, was also responsible as a London tradesman for shopwork on monuments of marble and latten; as far back as the twelfth century Richard de Wolveston, an engineer and architect, had been wont to carry with him illuminated letters which he may have produced himself. William Hyndeley, master mason of York Minster, died in 1505 leaving not only mason's tools but also his tools pertaining to ' les gravyng in plaite '. Here is what might be called in law ' evidence of a system '. Were chief master masons, the principal architects of the time, directly responsible for the design of effigies and of monumental brasses? The answer seems to be affirmative. Robert de Patrington, a York mason who took up the freedom in 1353, was on 5 January 1369 appointed master mason of the Minster at a fee of £10 a year and the house in which his predecessor in office, William de Hoton junior, had dwelt. Patrington's architectural status is certain. In addition he was paid £40 by Archbishop Thoresby for making six marble stones for the tombs of earlier archbishops in 1369–73, and a later reference shows that these stones bore figures of achbishops, possibly brasses. In 1381 Patrington undertook to

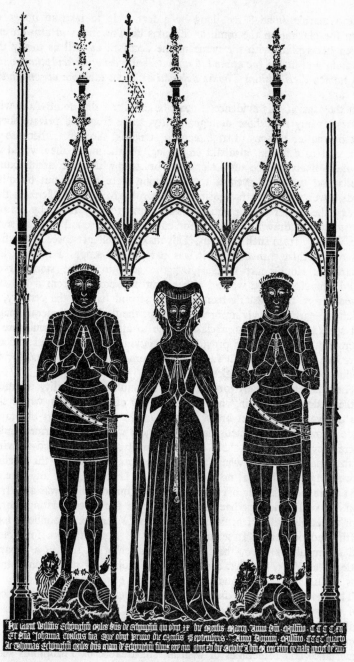

Etchingham, Sussex: Brass to Sir William Echyngham (d. 1412); his wife Joan
(d. 1404); and their son Sir Thomas Echyngham, who died 15 October 1444.

make a marble stone 8 feet long by 4 feet wide to take an image of latten for placing on the tomb of Thomas de Thweng, and also an engraved brass plate with the name of the deceased as well as to lay the said stone and image (*ac etiam latonum decenter ornatum sculptum continens nomen dicti domini Thome defuncti et dictos lapidem et ymaginem collocare*).

In the face of this evidence it must be admitted that tomb-slabs with brasses, at any rate those of high quality, came from the private shops kept by master masons of architectural standing. Architects, because of their skill in drawing, also did engraving. Furthermore, they would be the most likely source of designs for brasses, with their architectural details and canopies, even if the engraving were carried out by other hands. Over twenty years ago it was shown by Miss C. K. Jenkins that at least the earlier monumental brasses were probably made by masons accustomed to drawing cartoons for effigies in the round, and in some cases directly from such cartoons. This makes excellent sense. In the first half of the thirteenth century it was part of the scope of masters like Villard de Honnecourt to design figure sculpture. The stone-carvers would, therefore, have worked either from a sketch or from a full-size cartoon from the master's hand. By the second half of the century, to which the earliest surviving brasses belong, the desire for funeral images had spread downwards to a class unable to afford life-size sculpture in the round. The flat brass provided a satisfying substitute; and it could moreover be made, without further ado, from a cartoon intended for the production of standard effigies.

There is some support for the mason's overall responsibility for much of the trade in brasses in what little we know of the latoners, whose skill was the working of sheet brass. In view of the large numbers of brasses made it might be expected that the latoners would have formed guilds where they worked, but there is hardly any trace of organised activities on their part. At York, where ten latoners were admitted to the freedom between 1309 and 1361, no more appear as far as 1450 at any rate. In 1381 there were three latoners recorded, only one of whom was a married man. No will of any mediaeval latoner can be found, contrasting sharply with the many wills of armourers, blacksmiths, braziers, founders, locksmiths and pewterers. It seems likely that, after the fashion for brasses had set in about 1300, there was some attempt to set up a separate trade, as at York, but that a substantial monopoly of monumental business, including brasses, remained in the hands of the masons.

The position was quite different in the case of painting. Whatever control the master mason may have had over the decorative schemes for walls and windows, he did not as a general rule provide cartoons with his own hand. From an early date individual painters appear as men of importance and sometimes of wealth. The treatise of Theophilus shows that in northern Europe the painter had already broken free from the

strict secrecy of the architectural crafts. Unlike masonry and carpentry, the practice of painting in at any rate some of its branches, notably the illumination of manuscripts, was entirely compatible with clerical or monastic status. Not that a majority of painters were ever clergy: it is now accepted that most of the great illuminators, at any rate after 1300, were professional laymen. But there was wide scope for anyone to take part in an artistic practice in any case split into several different trades. We have seen that joiners carried out painting; painting of furniture seems to have been general, and the early trade of painters was associated with the making of saddles and other things shaped out of fine-grained wood and coloured. Quite independently the stainers developed from the colouring of cloth or canvas. The illuminator or limner, concerned with detailed pictures in manuscripts and, later, with portraits of persons and fine draughtsmanship, was also a distinct craftsman in his own right. These different branches of the same function carried on business independently.

The specialised skill of painting on glass was different again, and was carried on by men described as glasswrights, glaziers or in French *verrours* (**107**). Just how far internal specialisation was carried is, of course, uncertain. We do not know whether there were, within the trade, career distinctions between the glazier-painter and the glazier who simply made up windows by joining together the pieces of stained and painted glass with lead cames, solder and some form of mastic to keep the joints weatherproof. If so, the division would be analogous to that between mason-hewers and mason-layers, recorded in many mediaeval accounts. There is abundant stylistic evidence that different hands worked at the actual brushwork of painting the lights of a single large window. The late J. A. Knowles suggested that this would have been beyond the resources of a single glazier's shop, and implies the farming out of work among a number of independent glaziers whose shops were close together (as in the street of Stonegate at York). What little evidence there is does favour the small size of the normal glazier's shop. In the returns of the York poll tax of 1381 six 'glasenwrights' are named, five of them in the parish of St Helen, Stonegate, and one in the adjacent parish of St Wilfrid. Of these two were apparently unmarried, three paid tax for themselves and their wives only, and one, John de Preston, paid for his wife Cristiana and for two servants, Arlaund and William. The two bachelors had taken up the freedom only in 1372 and 1376, one of the married men in 1379; John de Preston as far back as 1362.

While there is no doubt that work with the brush was done by men bearing the trade designations of painter, limner, stainer and glazier, the responsibility for design and for the preparation of cartoons remains less clear. There is a strong suspicion that glaziers depended upon others for the designs of the windows they executed and that they were thus in the same position as broderers and tapicers. The development of style in glass-

painting followed and 'lagged somewhat behind that in the other arts' as Woodforde put it. That the windows of King's College Chapel were copied from the designs of artists other than the glasspainters is well-known, and there is no reason to think that this was untypical. On the contrary, the character of design of the fourteenth-century windows painted by Thomas of Oxford and his assistants for New College, Oxford, and for Winchester College agrees well with the supposition that the creative artist may have been of German origin and quite possibly Herebright of Cologne known to have been a citizen of London, to have worked for William of Wykeham (the client for whom the glass of the colleges was prepared), and to have painted an important reredos for Old St Paul's. That glass-painters worked from existing patterns is proved by the inventory of stores at Westminster Palace in 1444. At the glaziers' shed there were 25 shields painted on paper with divers arms of the lord king for patterns in the office of the glaziers working there, 12 patterns made up as models for windows, and plant which included two 'portreyyngtables' of wainscot, two tables of poplar, and 12 leaden 'payntyngdyssches'.

The tables for portraying would be large boards for setting out cartoons at full size, a process intermediate between the design and the painting upon pieces of glass. The dishes for colours are seen in contemporary illuminations, (80) but it is interesting to know that they were made of lead. Presumably they would stand a lot of hard use without serious damage. We cannot here pursue in detail the materials and media of painting, but among the media oil had a prominent place from much earlier than has been supposed. The unfounded legend that the Van Eycks invented painting in oil about 1400 dies hard. Far too much stress has been laid upon painting in egg tempera, but the documents show that wax (beeswax) was used a great deal. This is shown by the bequests to Gilbert of Newcastle, servant of John Alban, painter of York, in 1361, of two large chests for wax and a small chest for wax. Gilbert also received £2 and the best stone for grinding colour, with a grinder; a second servant William had another stone and grinder. These bequests were in fact made by John Alban's widow Alice, who died within a few weeks of her husband, but Alban's own will left, besides a good deal of property, 5 lb of wax.

At Westminster the king's painters had their own shops and there is a mention in 1541 of 'a stock locke and a stapul for a dore where the paynters make ther collours within the palaice'. The lock was needed because of the great value of pigments and gold leaf so lavishly used. The best colours were either rare and valuable in themselves, or had to be brought from foreign parts over long distances, or were difficult to prepare. Thus accounts show that the cost of painting a statue was much greater than that of carving it; it was the materials, not the labour of painting, which were so expensive. Master Hugh of St Albans,

Edward III's master painter for the wall paintings of St Stephen's Chapel from 1350, was paid 16s. on 14 November 1352 for 2 lb of 'cynopre' from Montpellier, which he may well have brought back personally after a visit to the south of France, as he worked for the King and the Black Prince in connection with their voyages to Gascony. Sinoper was originally a choice red earth from Sinope on the Black Sea, but became used for the brightest and most valuable red pigments including cinnabar (apparently not really the same word) or vermilion. Red colours and the laying on of them at Caister Castle in Norfolk in 1434–35 cost £4 18s. paid to Robert Grey, painter. Purchases of 1350 for the painting of St Stephen's Chapel had included £2 13s. 5d for 'vermilon, viridgrece', red lead and white, oil, varnish and other colours. Paintings on canvas were being made for the prior's lodging at Worcester Cathedral in 1424–25, when £3 0s. 4d was spent on linen cloths and towels and canvas for the paintings of the chambers of the prior. At Thetford in 1528–29 the Cluniac Priory repainted the Angel Inn, and the bill is itemised: 34 lb of 'rede hokyr' cost 2s. 5d, shreds (of parchment) for making size, 4d; 'wyte lede' 4d; painter's oil, 10d; a pound of 'wergisse' (verdigris) 1s. 4d; the painter had 6s. 8d, and Thomas Belt, for painting the sign, 1s. 8d. Evidently Belt was a skilled painter who could paint the angel on the sign, getting a quarter as much as the unnamed housepainter who repainted the whole building.

The high cost of paints is brought out by Henry III's orders for painting at his chapel in Windsor Castle in 1248, when 10 marks was to be spent on colours by Brother William the Painter, monk of Westminster, and again £5; and in the following year Master William was to have 2 marks (£1 6s. 8d) for painting, and £2 to buy paints. This William, one of the most noteworthy examples of the monastic artist, had been given by the king in 1240 the office of painter to the priory of St Swithun (i.e. the cathedral) at Winchester. There is a strong presumption that the surviving paintings in the Chapel of the Guardian Angels are part of the work due to him (**101**). He was not responsible for contemporary work at Winchester Castle, for in 1241 16s. was allowed for the robe of Nigel the chaplain, painter of the King's Hall of Winchester; and, though William seems to have been the painter mostly employed at Windsor from 1248 to 1260, he was not the painter of the surviving heads of kings there: in September 1241 it was Thomas the painter of Chertsey who was to have 10 marks, making the figures (or portraits) of the king (*ymagines regis*) at Windsor. Later in the reign, in 1265, a painter at Woodstock and his servant were to paint an image of the lord King in his Chapel there and other heads, for the low price of 2s. 9d in all.

Wages as low as this can be understood by reference to the fabric rolls of Exeter Cathedral: in 1280 Master Richard de Malmesbyry, painter, was hired for 2s. 1d a week, at a time when a skilled carpenter took 2s. 3d in summer and 1s. 10½d in winter. A master painter worth bringing from

a distance, for a horse was hired at Barnstaple to bring his utensils, could not command higher pay than any other skilled craftsman. In 1283 the London painters, hitherto largely concerned with the painting of saddle-bows, became sufficiently organised to obtain a grant of ordinances. Pay did not improve very rapidly, for in 1306 at York Place, Westminster, the sum of 10d was all that was allowed to William the painter for colouring the great chamber and covering the columns of the chimneypiece, taking two days. All the same it was possible for painters with their own shops as well as official work to become wealthy in the fourteenth century. Master Hugh of St Albans, whom we have met already, was able to pay £20, a figure equivalent to well over £2,000 now, for an Italian painting of six pieces (panels) of Lombardy, which he left to his wife Agnes. Master Hugh's acquisition of this painting goes far to explain the fact, which has puzzled art historians, that 'northern adaptations of Italian spatial forms . . . appeared in England (in 1350–60 at St Stephen's Chapel) before they did in Franco-Flemish painting.' Other links in the chain of influence were the artists, including Master Thomas a painter, working at the Palace of the Popes at Avignon in 1333 alongside Italian painters. Hugh of St Albans, besides his valuable painting, left a great deal of property, silver and bronze vessels and furniture to his wife, and £40 in cash. His successor Gilbert Prynce, who died early in 1396, left in cash bequests alone nearly £350 (well over £35,000 in 1973). His clerk and assistant Thomas Litlyngton was appointed executor and left £20, and Litlyngton's wife Joan was to have £2. Prynce's establishment included also a cook Gynes (£2), serving craftsmen not named, two apprentices John Hawkys and William Duton, and a servant Joan Pentecost (£5). Thomas Litlyngton was the chief painter in the king's service from February 1396 until 1402. Either he or his old master Gilbert Prynce is likely to have painted the Wilton Diptych, a personal possession of Richard II almost certainly dating from 1394–97.

Painter, or its Latin equivalent *pictor*, was at times used of sculptors, and the probability is that some men both carved and painted figures. This was apparently the case with Master Simon de Wells who worked for Wells Cathedral and for Henry III, who in 1257 sent for him to come to Westminster; Simon was also named as Simon le Peyntour or Pictor. In 1308 Master Adam le Ymager, '*depictor*', made, painted and gilded images of St Mary and St Stephen in the chapel next the Receipt in Westminster Palace. At other times it is impossible to be certain just what work is covered. Robert Ocle, who had taken up the freedom of Norwich as a painter in 1407–08, was paid sums of £3 6s. 8d and 6s. 8d in 1413–17 by Mettingham College in Suffolk, for making a ' table ' and painting it for the high altar of their church. By table we are to understand a reredos, but the work of making it might include merely joinery and enriched framing, or fully carved figure works. The extremely rich character of painted decoration is emphasised by the contract of 1380

between John of Gaunt and two painters, citizens of London, to paint the tomb of his duchess Blanche in St Paul's Cathedral. Richard Burgate and Robert Davy were not only to paint all the images of the tomb, but also all the ' aysshelers ' or plain alabaster of the monument, which had been made between 1374 and 1378 by our old friends Henry Yeveley and Thomas Wrek.

From surviving examples we know that much artistic painting was being done, in addition to the lavish laying on of gold and colour on carvings and enrichments. At all times the payments to the craftsmen were modest, though those on the materials may seem extravagant. At Cratfield in Suffolk in 1494 Thomas Bollre was paid £7 for painting the tabernacle of Our Lady, and this seems to have been only part of a total of £42 spent on making this shrine. In 1496 Robert Garard of Kessingland, Suffolk, left £8 ' and more if more be needed ' to the painting of the tabernacle and image of St Edmund the King in the chancel there. A roodloft carved for Banwell Church in Somerset in 1520–25 cost about £40, and on top of that £6 to Robert Hoptyn paid ' for gylting in the Rodelofte and for stenyng (staining) of the clothe afore the Rodelofte '. At Canterbury Cathedral in 1530 an angel was painted, with the arms of Thomas Goldwell and with the crest with inscription of Thomas Wulcy (i.e. Wolsey) for 6s. 8d. At Hampton Court Palace about 1535 Henry VIII paid £451 to John Hethe and Harry Blankston of London, ' gylders and paynters ', for ' payntyng, gyltyng and garnesshyng of the vought (vault) in the Kynges New Chappell.' The reason why painting of this sort cost such immense sums can be appreciated from the details given when similar work was done in Whitehall Palace *c.* 1543. A total of £10 14s. 6d went to Robert Burrell of London, painter, ' for the paynting and gilding of parte thinsid (of the inside) of the long open gallerie within the privey garden with a frete and flowres of divers collors, with the kings armes and the quenes crowned, my lord prince's badge cognisauncis and many small cognisaunces and tables of antique work, wrought with fyne gold and byce, fine sinoperlack, smalt and vedeter, mascot varmalon and other fyne collors in oyle primed ', reckoned at 49½ square yards at 4s. 4d the yard.

In contrast to works of luxury for the king and wealthy patrons we must bear in mind the great amount of simple decoration which called for an abundance of trained craftsmen. Plain limewashing, or redwashing with ochre, was never out of fashion. In 1240 orders were given to whitewash the whole of the Tower of London, inside and out, and the White Tower still takes its name from this traditional treatment, often repeated. In 1423, when the stone vaults of the aisles in the presbytery of York Minster had been put up, 1s. 3d was paid for pigs' bristles for whitening them. Westminster Abbey, newly transformed into a cathedral, in 1546 had the chancel of Eckington Church in Worcestershire repaired. The roof required 1000 tiles, 400 laths and 1000 lathnails, and 7 barrels of lime

were bought and 18s. 10d paid for 'whitlymyng' the chancel and for glazing all the windows, presumably with plain glass.

It has already been suggested that designs for stained glass windows were made by painters rather than by the glaziers, and it is reasonable to consider glass-painting as another medium of painting rather than as an entirely separate art. Seen from the viewpoint of the architect, the painting of the inside of a building, and particularly of a church, included both work on the solid walls and also upon the transparent windows. Whether the painted figures or scenes on the glass contrasted with plain walls, or were rivalled by elaborate wall-paintings as at St Stephen's Chapel, the whole had to contribute to unity of composition. Horizontal ranges of figures or panels formed a counterpoint to the vertical trend of columns or vaulting shafts, and of the window mullions themselves. Emphasising the fact that these problems of composition are quite independent of the specific or iconographical content of the paintings, we may quote from the detailed directions set out for the glazing in the church of the Observant Grey Friars at Greenwich, consecrated in 1494:

'Saint Edmond King of Norfolk, Suffolk and Essex, martyr, lying at Bury in Suffolk. Make him in the habit royal of a peaceable King with a beard, an arrow in the right hand, a sceptre in the left hand and an open crown, his arms the field azure 3 crowns of gold.'

The painter was given a programme of figures, and the attributes correct for each figure; but the way in which he drew the figures and coloured them was not controlled by the programme, and constituted his design.

What controlled design far more than the imposed programme was the nature of the material and the methods which had to be used to prepare it. Glass is exceptional among media, though paralleled by true fresco, in that it leaves little room for second thoughts. Retouching is impossible and there is consequently a quality of spontaneity and immediacy. This goes hand in hand with the brilliance due to transparency, the unique fact that paintings on glass are viewed by transmitted light. The realisation of this remarkable quality goes back at the furthest to Early Christian times, and the first windows of coloured glass were probably mosaics made up of pieces forming geometrical patterns. The craft of painting so that the pigment could be permanently fired on in a kiln is relatively modern, to the extent that it may be called the characteristically mediaeval skill. There seems little doubt that the technique is derived from that of enamel, and owes its rise in western Europe to experiments subsequent to the arrival of Byzantine enamel-workers in the Rhineland in AD 972. They came in the train of the Princess Theophano (*c.* 956–991), daughter of the Byzantine Emperor Romanus II, at her marriage to the Roman (German) Emperor Otto II (955–983). Allowing some time for experiment, it is just possible that the early date claimed for some glass in Alsace – the second half of the eleventh century – may be correct. What

are generally regarded as the earliest stained glass panels in Europe are five figures of prophets in Augsburg Cathedral, of *c.* 1120–40. The oldest stained glass in France, probably some of that at St Denis and Chartres, and a Tree of Jesse panel at York in England, all date from near the middle of the twelfth century.

The story of glass windows is complicated by the problem of glass-making, itself an extremely ancient craft going back to the Near East. One suggested route by which the making of glassware vessels of high quality may have reached the West is by way of Corinth, where two glass factories dating back to the eleventh century, and possibly founded by Egyptians, have been discovered. In 1147 the Normans took Corinth and may have carried off the glass-workers. From whatever source, Normandy acquired the secrets of coloured glass and remained for the rest of the Middle Ages one of the main sources of supply. White glass suitable for plain windows and for the painting of faces, hands or backgrounds, was made in England early in the thirteenth century. It is said that the first of these glassmakers was from Normandy, Laurence ' *vitrearius* ', and that he set up a glass furnace near Chiddingfold in Surrey about 1225. Fifty years later the place-name ' le Ovenhusfeld ' shows where the furnace was. By the middle of the fourteenth century foreign workers from Germany, the other great centre of glassmaking, had come to Chiddingfold, and John de Alemaygne supplied glass in 1352 for St Stephen's Chapel and in 1355 for St George's Chapel in Windsor Castle. Meanwhile other glass furnaces, for making white glass only, had been set up in Cheshire and the Abbot of Vale Royal had a grant from Edward I for making glass in Delamere Forest.

The success of the stained glass window depended upon at least five main factors: the quality and colour of the glass itself; the methods of painting and firing; improved cutting, inlaying and grinding of glass; the lead cames for assembly of the pieces of glass into panels; an iron framework or arrangements of metal bars to which the panels could be secured rigidly in the windows. For the last of these the blacksmith was responsible; for the first, the foreign glassmakers of Normandy and the Empire (mainly in Hesse and Lorraine). The other three lay within the competence of the glaziers themselves. For the lead cames there was authority in the treatise of Theophilus, who described how lead strips of H-section might be cast in moulds of stone or wood. At St Remi at Rheims a chalk mould for casting cames, with some fragments of lead fitting in it, was actually discovered in a well. The change from cast to milled cames did not come until after the end of the Middle Ages. Improvements in the handling of glass were largely a development of the fourteenth century, when the period of greatest change was between 1330 and 1380. Glass was not cut with a diamond point, but the sheets cracked by touching with a hot soldering-iron and dropping cold water, then nibbled to shape with the grozing iron, a tool made for the purpose. (109)

M

Neater edges and more intricate shapes were achieved as time went on. Small holes too were drilled out of pieces of glass in order to lead in details of another colour. An alternative to this was the grinding away of the 'flashing' of ruby glass from the white base (solid red glass being opaque), leaving white patches; and these could be turned into a golden yellow or an orange red by the process of silver stain which, as we have seen, came into England by about 1310.

The coloured glass from foreign suppliers was sold by merchants. In 1307 glass for windows at Westminster Palace was bought from Sara de Salle, who supplied 11 seams (loads) of white glass at 7s. each; from Master William de Horkeslye the glazier, who was able to supply another 11 'seams' at the same price; and from John Russel, merchant, who sold 12 seams of red and 8 of green at 14s. the load, and 4 seams of 'Ind', i.e. deep blue, at the high price of 18s. The price had gone up considerably by 1354–55 when Westminster Abbey was getting glazing done. Two 'semes' of white glass cost £2; 4 'peys' of glass of divers colours cost 8s. at 2s. the piece; a piece called 'Safre', presumably sapphire blue, cost 3s. 4d. Another 3s. 4d was spent on buying and mending the instruments of the glaziers for the year; £1 10s. 4d went on the ironwork of the windows; £2 10s. 0d on the wages of the master glazier with his boy for 10 weeks at 5s. for the two, as well as livery for the master. Another glazier worked for four weeks at 2s. 6d a week. A more detailed reference to the ironwork is made in an account of 1340 for Westminster Palace. John de Walworth, glazier, was paid 9d for 9 small bars of iron called 'soudletts' (saddlebars) bought for holding the window glass.

The coloured glass came from abroad, but the pigments of the painted pattern had to be laid on in the glazier's shop. Furthermore, they had to be prepared by grinding as had other colours. In 1350 a brazen mortar with an iron pestle was bought at Westminster Palace for grinding 'geet' (black lead glass) and various other paints for colouring glass, for 7s.; and 18s. was spent on an iron plate with an iron grinder (*molour*) bought for grinding silver filings, 'geet' and gum arabic for painting glass. Later on, in the fifteenth century, the appearance of white glass was improved; it became smoother and whiter, more silvery in tone; but time has shown that this improvement in appearance was dearly bought since the glass contained an excess of alkali and was thus more liable to corrosion. It was in this period too that plain window-glass began to be fitted into the openings of private houses, previously filled with canvas and shuttered at night. In 1342–43 at Westminster Palace the windows of the Master Mason's tracing-house were fitted with 7 ells (8¾ yards) of canvas. Even if oiled to give translucency it is difficult to understand how the master, William Ramsey, could have seen to draw. By not later than 1419 glass had been fitted to the windows of a small, though moated, house at Great Canfield in Essex, 30 miles from London.

There were already many glaziers at work in the thirteenth century, but to obtain the services of outstanding masters it seems always to have been necessary either to bring the master to the site, or to send away for the glass. In 1275 Christ Church priory at Canterbury gave Master John the Glazier (*Vitrear*) 6s. 8d for his expenses homewards (*versus patriam suam*) before Lent. In 1290 the King's Glazier was John of Bristol (died *c*. 1294), paid £64 for windows in Westminster Abbey. At York the great glasspainter was Master Robert le Verreour, probably the Robert Ketelbarn free of the city as a 'verrour' in 1324. In 1327 he supplied coloured glass for the new chapel fitted up for the Queen in the Archbishop's Palace, and in 1333–35 he was paid £5 10s. 6d for making 19 glass windows with the King's arms and other windows, made at York and sent to the royal fortalice of Haywra for the chapel there. As Robert le Glasenwright he was assessed to the tax of 1327 on 20s. in the parish of St Wilfrid. But his great work was the west window of York Minster, for which he was paid 100 marks (£66 13s. 4d) by Archbishop Melton in February 1339.

In 1343 our friend John de Walworth, glazier of London, was ordered to take workers of glass in London and the region around it to glaze windows of the new chambers and the king's chapel in the palace of Westminster before the meeting of Parliament which had been summoned. Impressment on a much wider scale took place for the glazing of St Stephen's Chapel after 1352 under John de Chester. Some provincial glass shops supplied windows for buildings at a distance: Simon de Lenn (Lynn) made the window of the Duke of Lancaster for Ely Cathedral for £12 13s. 4d in 1356–58, when glass bought at Yarmouth, with carriage to Ely, came to £39 11s. od. Two 'glaschwrithes' had robes costing 11s. each and one painter had a robe value 8s. John Glasyer of Wells in 1415–16 was called to Bridgwater to mend the church windows, and in 1428–29 William Glasiar of Oxford was brought to glaze windows in the chancels at Hallow and Grimley for Worcester Cathedral priory. In other cases a local man was available, as at Wolvesey Palace in 1456–57, when Stephen Glasier of the City of Winchester was paid £1 2s. 2d for various windows including one with an image of the Blessed Virgin Mary containing 20 feet, charged at 11d the foot.

Besides paintings on walls and windows, integral with the building, there were also hangings which could be separated from it, some embroidered, others woven as tapestry. It is not possible to deal here with the details of these crafts or their many practitioners. As we have seen, some embroiderers were women, but after 1300 the main centre of the trade was London, where the shops of the great broderers were, such as Alexander le Seltere who in 1307 undertook to make a cope for the Archdeacon of Lichfield for £40 (114). The production of tapestry to a given design might be a long and complicated process, and it is worth concluding with the details of production of the great tapestry of St

Dunstan for the London Goldsmiths Company in 1530. It cost £6 to send their servant to Flanders for 11 weeks and a day. There he had to spend 10s. on getting the Life of St Dunstan translated into Dutch. Four artists were employed for 16 days at 1s. a day to make the design in black and white, and a boy was hired at 2d a day to sharpen their pencils. The cost, for 195 Flemish ells (about 148 yards), came to more than £250. On top of this it was necessary to pay 10s. for legal advice and the affixing of the Town Seal of Brussels to the transaction, and £3 in dues. A Spaniard had £2 for changing money; and when at last the Goldsmiths got their finished tapestry back to London, the English customs charged £10.

Chapter 13

Craftsmen of Enrichment (2) Metalwork

The goldsmiths, as we have seen, were themselves patrons of other crafts. By the nature of their trade they were in a better financial position to exercise patronage than any other group outside royalty, nobility and the higher clergy. Reference has also been made to the fact that goldsmiths, as early as the twelfth and thirteenth centuries, were concerned with other crafts in metal including bronze-founding, and that from the fourteenth to the sixteenth century some goldsmiths were also clockmakers. Salzman found that, in the first quarter of the sixteenth century, a London goldsmith was making engines and instruments for draining a deep mine near Truro. We can see from evidence of this kind that the mere appellation of 'goldsmith' is highly ambiguous: it may mean a banker, concerned with money and with jewels as money's worth; but it may also mean a trained metalworker with profound knowledge of machinery and engineering, a leading technologist of his time. It may be added that, apart from the early association of goldsmiths with the great monasteries, already mentioned, there is little to indicate that they tended to be clerical artists; on the contrary, most of the great goldsmiths known by name were laymen with wives and families.

It has been pointed out by Dr Joan Evans that the finer architectural monuments, such as that of Edmund Crouchback, Earl of Lancaster (died 1296) in Westminster Abbey, (123) are 'to be thought of in terms of enamelled gold'. The inspiration of some details may well be derived from the small-scale and filigree character of jewellery and reliquaries. On a vast scale the transept of York Minster, dating from c. 1225–50, seems to be an enlargement of a shrine; though it is by no means certain that it was not the architectural type of shrine that was posterior to, and presumably derived from, the mason's design for York. It is at any rate certain that there were close links between the stylistic developments in the goldsmiths' and the masons' trades. It is easy to see how this could come about, when there were leading families of hereditary goldsmiths constantly about the king's palace at Westminster and at monasteries such

as Ely and St Albans. Continuous personal contacts must account for much.

Goldsmiths were particularly well placed in regard to contact with the monarchs for whom they made, and probably designed, the coinage. There was direct personal intervention on the part of the king in some historical instances, notably that of Charles of Anjou, king of Naples (1266–1285), who rejected the first pattern for his *carlino d'oro* because the lettering was uncomfortably crowded and the obverse and reverse out of alignment. We may also assume that the personal taste of royalty was consulted over the making of crowns and of seals. The crowns were made by the king's goldsmiths, for example Thomas Frowick who made a gold crown for Queen Margaret in 1303 and Roger Frowick who made the crown for Edward II in 1315, an advance of 20 marks (£13 6s. 8d) being paid to Frowick by the king's own hands. In 1386 John Bottesham of London, goldsmith, received £25 17s. 4d for making a hunting knife and a hunting horn with tassels of green silk for Richard II, and in the latter part of that king's reign the inventories of jewellery and plate show almost incredible riches of gold, silver and enamel. In 1396 there was, among much else, a great plate of silver gilt and enamelled with a king riding on a white horse and a white hart lying in the middle of the plate upon a hill. The courts of Europe all had treasuries filled with pieces of this type, but very little now remains. The Lynn Cup of *c*. 1340, (132) the jewelled Crown made in England before 1399 and now in the Residence Treasury at Munich, and the amazing trinket of Parisian workmanship, *Das goldene Rösslin* of *c*. 1403, (115) now stand almost alone as specimens of the highest flights of the goldsmith's art.

What is surprising about the London goldsmiths is that they were a numerous body: in 1368 their guild ordinances were sworn to by 135 members, at a time when the total population of London (men, women and children) has been put at about 40,000. They were extremely select: in 1393 they were the first City Company to receive a Royal Charter (having already been incorporated in 1327), the premium to enter an apprenticeship of 7 years was 10 marks (£6 13s. 4d). In 1500 Venetian travellers to London counted 52 goldsmiths' shops in the Strand alone, filled with silver plate, and remarked that in all the shops of Milan, Rome, Venice and Florence put together there were not so many pieces of such magnificence. That there was a market for this large output is the amazing thing, for England was not a rich country between 1350 and 1500. On the other hand it was a great mercantile centre and attracted both craftsmen and dealers. In 1445 a safe-conduct was issued to two Greeks, Andronicus and Alexius Effomato, workers in Damascene gold from Constantinople, while they should remain in England, and in the next year ' James Cordis ' (presumably Jacques Coeur), Silversmith to the King of France, had a licence to sell goods to foreigners in London during 1447.

Goldsmiths were responsible for a good deal beyond plate, even with-

out considering their excursions into mechanism and engineering. They were generally the makers of seals from the twelfth century onwards, and many seal engravers listed by the late H. S. Kingsford were elsewhere named as goldsmiths. Nor were the seals they cut necessarily of precious metal: Adam de Thorp, a goldsmith of London, was in 1390 paid £1 13s. 4d for engraving a brass seal with the king's arms. On the other hand, John Domegode who made and engraved a metal seal in 1403, was described as a lapidary, a stonecutter or jeweller. A new seal for the Bishopric of Durham was made at York in 1333 by Hugh ' le Seler ', the same man as Hugh de Lillyng, ' seler ', who took up the freedom in 1327. William Seler, who was living in Bootham with his wife Dulcia in 1381 and died in 1402, was a goldsmith, and it is likely that seal-engravers were regarded as a subdivision of the trade.

Jewellery was for the most part within the province of the goldsmiths, and it was the London goldsmith John Palyng who in 1382 had 100 marks (£66 13s 4d) for providing for Queen Anne of Bohemia a worked fillet with a large ruby and two sapphires; three rings of pearls, each ring of four pearls and a great diamond placed in the middle of each. Even commoners' wives might have substantial collections, for we know from the will of Margaret, the widow of John de la Touk of London and sister-in-law of John Brampton, Master of the Glaziers Company in 1373 and King's Glazier from 1378, that her sister was to receive a fermail of gold made to represent the four points of the compass, a pair of paternosters of amber, a silk girdle with roses of silver, and a silver cup of Paris make. About the same period the royal expenditure covered the making of a set of chess of crystal and jasper ' with its family ' of pieces, and exquisitely fashioned pieces for games and pastimes, whether of stones, ivory or bone, would tend to be sold through the shops of the goldsmiths (117–18). The imagined picture of a mediaeval jeweller's shop is a fascinating one, and the fortunate apprentice to this luxury trade may be envied; yet not all were lucky, and there was a darker side to the business. The Goldsmiths' charter of 1393 had to provide that the Company must relieve ' those who by fire and the smoke of quicksilver have lost their sight '.

From the precious to the base metals is an easy transition, now that we know the truth of the mediaeval alchemist's premise, that lead can be transmuted into gold. Lead was one of the most useful substances and, even if not precious, commanded a high price. It was carried for great distances and seems commonly to have been bought at fairs. The treasurer of Christ Church priory at Canterbury in 1218–19 bought 6 cartloads of lead at Lynn Fair for £9 19s. 4½d, the cellarer had another 6 loads, and the Sacrist two loads; the price per load was £1 13s. 2½d. The same accounts sixty years later show that in 1277–78 Thomas the plumber went to London in connection with melting lead at a cost of 1s., William de Kent was given £2 14s. 10d to buy lead, and a plumber had 3s. 5d for another journey to London, as well as 2d for his horse. The tradition of

melting down old lead from roofs and recasting it with a proportion of new lead added, still in force today, was already practised at the Tower of London in 1339–40. Old lead from the tower above the outer gate towards London, to the amount of 9 carrats 1 wag' 22 cloves, was to be melted and cast by Richard de Cant' and Thomas atte Diche, plumbers of London, and laid anew. The carrat or cartload was the same as a fother; the 'wag'' or waye or wey was 182 lb and consisted of 26 cloves each of 7 lb. There were 12 weys in the carrat, which meant that the fother consisted only of 19½ avoirdupois hundredweights.

Most large buildings had their own 'plumbery' or lead-working shop, with arrangements for melting and casting lead into sheets. In 1436 William Rolles, a mason, was repairing the walls of Old St Paul's Cathedral, and also new making the 'Meltyngpette' in the Plumbery, for 8 days in October and 3 days later, taking 8½d a day. At Westbury-on-Trym in 1469–70 lead was bought for the roof of the Bishop of Worcester's chapel, 41 cwt and 25 lb price 5s. the hundredweight; and a plumber of Bristol cast the lead and covered the roof for a bill of £3 16s. 7d. Where the work was done by direct labour, and all the costs had to be found separately, there was also the fuel for melting the lead. About 1543 at Whitehall Palace John Evermyn of London, woodmonger, supplied 3000 of billets spent within the Plondy (Plumbery) at Charing Cross 'as in melting of leede cast for the coveryng of the said gallerie' for 16s. Minor objects of lead, such as the cames for glass windows and cast pilgrims' badges and pierced ventilators, have already been mentioned.

We are left with the large field of craftsmen whose work was in iron and steel (119–122). In modern times most blacksmiths have been farriers, simply shoeing horses, and this has tended to obscure the fact that the trade of blacksmith ran through a whole gamut of subdivisions, ranging from sheer utility up to fine art. The smith was also in great demand, not simply for making things, but for repairing tools and welding steel edges onto them and 'battering' or re-shaping tools such as those used by masons. A great deal of regular employment for smiths was thus on building sites. Reference must be made to an extremely misleading statement in *The History of Technology*, to the effect that 'in the Middle Ages cutting-edges were of iron', contrasting with the universal modern use of steel. This is quite untrue, as the numerous examples collected by Salzman abundantly show. Steel was imported as 'osmonds' from Sweden and also from Spain, at any rate from the thirteenth century; and the mediaeval Latin word *acer* (*asser*, *ascer*, etc.) is found from the middle of the twelfth. Because of its high price, steel was used sparingly for the tips of wedges, the edges of axes, points of picks and the like. In 1515 Rauff Robynett, smith, engaged on Wolsey's works at York Place in Westminster, charged 6d 'for sharping and laying wt. stele 3 mattoks'. His price 'for sharping of the masons' smalle tools', i.e. chisels, bolsters and the like, was 1d for ten tools. At Old St Paul's in 1381 the smith John

Helder was paid 7s. for the quarter from Michaelmas to Christmas for mending the tools of the masons. There was a smithy at the cathedral, for in 1394–95 carriage of 8d was paid on an anvil ('anefelt') bequeathed to the smithy of St Paul's and brought from Hackney.

It is impossible here to give any account of the specialised crafts of blade-smith and armourer, but the practitioners of both were numerous from the thirteenth century onwards (121–122). The production of mail de-manded many thousands of links and much labour in 'knitting' them together according to patterns. Plate had to be hammered flat by hand or by water-powered hammers when such had been brought into operation. Not only mail and plate-armour, swords, battle-axes and other weapons had to be made, but other necessaries such as stirrups and spurs. These last were needed in such large quantities as to have produced the separ-ate trade of spurrier. Arrowsmiths and riveters were also largely involved in preparations for war, though the use of bows and arrows for sport and for the taking of game for food must not be overlooked. Cutlers were largely devoted to the production of knives for peace. As an interesting parallel to the hallmarking of gold and silver plate, it is worthy of note that armour was stamped. Mr Claude Blair in his modern study of the subject has shown that there were three different kinds of mark: the mark of the individual armourer; the view mark of the town in which a piece was made, or in England the mark of the London Armourers' Company; and marks identifying the arsenals where armour was officially stored. (135)

The use of water-power for hammers is mainly evidenced rather late in the period. By 1408 the production of iron in blast-furnaces with water-powered blast had been introduced in Weardale and probably also in the Forest of Dean. In 1496 a great water-hammer was at work in Ashdown Forest in Sussex. Before such improvements were made the labour force must have been gigantic: in 1254 the Sheriff of Sussex was ordered to provide 30,000 horseshoes and 60,000 nails, and iron rods were bought in the Weald by the hundred for the use of the king's chief smith. From these bars all kinds of metal fittings had to be forged. In 1305 at Westminster candlesticks of iron for the King's Chamber and Little Chamber at York Place cost 2s. and 1s. 4d, made by Laurence the smith, who also provided bars for the new chimney in the chamber of the Queen's ladies in waiting for 3s. 6d. Master James of Lewisham, the king's chief smith from 1293, had to make iron saddlebars and win-dows for the Queen's chamber next her chapel. Adam the smith was paid 3s. for six iron bars with clasps for various doors, and an iron case-ment (*cassa*) for a window in the King's Little Chamber. Structural iron-work was being used extensively by the fourteenth century. In 1334 at St Stephen's Chapel Walter the smith was making 12 cramps called 'tiraunz' for strengthening the stones of tracerywork high up on the two towers next to the east gable, each 2 feet long and 2 inches square. Such mediaeval ironwork has usually lasted well, and this may have

been due to tempering in tallow, but also sometimes to waxing. In 1451–52 the bailiffs of Shrewsbury paid 1d for wax to blacken the iron hooks (*gumphos*) of the windows of a tower.

Even the plain products of the ordinary blacksmith had a supremely workmanlike quality. Simple grilles for window openings and the like often display great ingenuity in forging, and the designers had a notable gift for proportion. We are fortunate in that a multitude of examples of such ordinary ironwork survives, as well as a good deal of higher grade: hinges and other door furniture, wrought screens and railings round tombs. The variety is immense, and poses the problem of whether the artists were themselves smiths, or whether the blacksmith simply carried out work to designs made by masons or other masters in charge of works. There is perhaps a limited truth in this, but we shall see that the case of Thomas de Leighton implies that really outstanding smiths were the designers of the work they, or their shops, executed. Although many smiths are named in accounts, it is only in a small minority of cases that surviving ironwork can be positively linked to these documented personalities. A wide field for further research exists.

Routine work demanded an enormous output. The nailsmith in particular was kept busy on a scale which seems hardly conceivable. Every single nail had to be forged by hand, yet orders of many thousands could be filled at the great fairs or at the shops of the London builders' merchants. Canterbury Cathedral priory, for works in the city in 1273, bought at Wye Fair:

30,000	of nail called 'prig' (? sprig)	18s.	1½d
3,000	lednail	2	9
4,000	husem	3	4
700	plancheneil	3	1
2,000	doreneil	3	2
300	doreneil (larger)		10
1,000	gret doreneil	3	6
3,000	doreneil	6	3

In Westminster in 1305 two hinges with hooks, bought for the door of the chamber of the king's sons at York Place cost 4d, and the ceiling (and/or panelling, *celura*) of their great chamber required another selection of nails: 1,300 bordnail at 2d a hundred; spikyng nail in three sizes, 500 at 5d a hundred, 900 at 4d, 800 at 3d, and latnail (lath nails) also in three sizes, 14,000 at 7d the thousand, 17,000 at 6d and 12,000 at 5d. Other parts of the work at York Place needed further quantities of these nails, with prignail at 5d a thousand and white nails at 4d a hundred. These last were probably tinned nails: in 1469 the account for the building of Bodmin Church allowed 9d to William Southrey for tinning nails for the chancel door.

Prices went up after the Black Death and royal works accounts for 1363–64 and 1365–66 show about a dozen more or less standardised sorts of nails:

Nails with tinned heads	10s.	od per thousand
Spikyng with white tinned heads	7	0
Gross spikyng for windows & scaffolds	6	8
Middel spykyng (lesser spykyng)	5	0
Dornail	4	2
Lesser Dornail	3	8
Lednail for plumbing	3	4
Windonail	3	4
,,	2	6
Celingnail	1	8
Rofnail for lathing	1	6
Rofnail	1	4
Traunson (transom) nail	1	1
,, ,,	1	0
Sprigg nail	10	

When a storehouse was built at Westminster Abbey in 1393–94 a floor was laid with 250 elm boards costing 2s. 6d a hundred, fixed with nails at 6d a hundred, presumably ' middle spiking'. Still other types were used in building a barn at Harmondsworth, Middlesex, in 1426–27. The nails, bought from John Dersford, smith, and sent to Harmondsworth, included 250 spykenayll, 350 fyfstroknayll (five-stroke-nails), and other ironwork described as 2 gosefett (goosefeet), 2 wodecokbelez (woodcock-bills) and 12 gumphs (hooks or gudgeon-pins). The charge was based on 2d per lb for 200 lb of iron, and carriage cost 4s. A new door to the Bishop's Hall by Old St Paul's was made in 1387–88 and the same price of 2d a lb was charged for 2 iron bolts with a key etc., amounting to 22 lb; two locks for the door, with two keys came to 1s. 8d; two rings with a latch and catch cost 6d. There were also 12 hinges and 12 hooks amounting to 15 lb and costing 2s. 8d. The hinges were evidently of the type with a ring swinging on the hook or ' gumph' built into the jambs of the door. In addition, 300 small iron hooks called ' croket' were bought for hanging tapestry and cost 2s.

Hanging might be done by means of curtain rods. At Canterbury Cathedral about 1505 two iron rods with ' whyt tynnyd' roses were bought for 8d to hang curtains at the altar of the Blessed Virgin. At the same time a lock and key and a pair of ' crosscharnollis' (hinges) for the chest of the same new altar also cost 8d. Though some smiths specialised, the same man is at times called both smith, or blacksmith, and locksmith. In 1515 Rauff Robynett, as a smith, supplied for York Place a ' stoklok' and a close staple for the same for 1s., a new ' platelok' (4s.

4d) a key for the garden gate and 2 bolts (1s.), the price ' tynned ' being 2d the lb, total 5s. 4d. Described as a ' loksmyth ' he also provided 4 ' thymbles ' and 4 hooks for the great gate towards the street (Whitehall), weighing 15 lb charged at 1½d, and also two locks and a pair of hinges tinned for the great back gate into the Garden, 36 lb at 2d. Evidently tinning added ½d per lb to the cost at this period. At Anne Boleyn's Coronation in 1533 ironwork was provided by Henry Rummyng, some-times called a locksmith, at other times ' Blake Smythe '.

As has been said, it is hard to determine the artistic responsibility for the higher flights of the smith's craft. In England the earliest fine iron-work is the grille or ' pilgrims' gate ' in Winchester Cathedral, now re-stored to its ancient position at the entry to the south choir aisle. Its date was put by Starkie Gardner as *c.* 1093, but merely on the ground that this part of the Norman cathedral was then finished. The closest parallel, both in design and workmanship, is in the iron screens inserted by the Crusaders between the columns of the Dome of the Rock. The limiting dates for these screens are 1099–1187, between the capture of Jerusalem by the First Crusade and its recapture by Saladin; but the screens are not likely to have been made before the Templars took charge and strictly excluded the laity from the central sanctuary. This was in 1119 or later, and a date in the mid-twelfth century is the most likely both for the Templars' screen and for that at Winchester. Rather later developments of the same type of ironwork are centred mainly in the Ile de France around Paris, and in northern Spain, but so far as these can be dated they belong to the first half of the thirteenth century. One French ex-ample, at Le Puy, is believed to be substantially earlier, and in the context of the Templar screens at Jerusalem it is suggestive that the architecture of Le Puy is manifestly under strong Moorish influence.

English wrought iron in the thirteenth century was dominated by details produced with dies of steel or hardened iron. The special skill involved indicates interchange of ideas with the goldsmiths and with the moneyers who cut dies for the coinage. Every enrichment had to be struck while red-hot onto the appropriate die and demanded exceptional skill to pro-duce the accurate results which have survived. The general character is given by vine-scrolls and flowers, and it can be approximately dated from two works of the highest class. The first is the ironwork on the original western doors of St George's Chapel at Windsor, made when the original chapel of Henry III was completed about 1243–45. (141) The work includes several occurrences of the stamp inscribed: GILE-BERTVS, which one would expect to be that of the smith. No smith of that name is known and various suggestions have been made as to the Gilbert thus commemorated. There were three royal officers named Gil-bert concerned with the works at Windsor: Gilbert of Grange (de Grangia), one of the viewers of the accounts, 1243–47; Gilbert the Car-penter, *c.* 1254–73 and appointed King's Carpenter in Windsor Castle

in 1273; and Gilbert de Tegula, bailiff of Windsor, *c.* 1255–60. So far as date is concerned, only the first, Gilbert of Grange, fits the chronology of the chapel; he may well be the man remembered by the stamp, but it is uncertain if he was the designer of the ironwork.

Luckily the master responsible for the later phase is not in doubt. The splendid iron grille of the tomb of Queen Eleanor of Castile in Westminster Abbey was made by Master Thomas de Leighton for £12 with £1 for carriage and fixing (142). There are several places called Leighton in England, but only one is anywhere near London, Leighton Buzzard, and it is surely beyond coincidence that iron hinges of this same remarkable style occur also on the church door there, and at the churches of Eaton Bray and Turvey, also in western Bedfordshire. Leighton seems to have got the job because the king's chief smith, Henry of Lewes, had died on 18 October 1291. Within a few years of 1300 there was a great change in style, to geometrically interlaced bars, seen in the screens of the choir of Canterbury Cathedral of *c.* 1310 (137). The accounts for 1308–09 show that £4 6s. 6d was spent on 1,500 (i.e. 15 cwt) of iron of Spain for the work of the lord prior, that is Henry of Eastry, responsible for the transformation of the choir between 1304 and about 1314. Later in the fourteenth century another important iron screen was made in Canterbury Cathedral, around the chapel of St Mary in the Crypts. In 1378 and 1379 sums of £50 and £6 18s. were spent on it, and in 1380 another 3s. 4d for mending the new iron gate in the Crypts.

Lattice screenwork developed into the 'joiner's' style, of which the most important specimen is the grille of Henry v's Chantry in Westminster Abbey, made by Roger Johnson, a London smith, in *c.* 1425–31. Towards the end of the fifteenth century, and under the influence of Flemish architectural details, another revolution took place. The iron grille made for Edward iv's tomb at Windsor is of a quite different kind of joiner's work, its many pieces being actually jointed and pegged with cotter-pins almost as if they were made by a cabinet-maker (145). St John Hope commented that 'there are so many points of resemblance between . . . this iron monument and . . . the tabernacle work of the stalls as to suggest that the head smith and the chief carpenter were working near each other.' The smith was John Tresilian and the master carver in charge of the stalls was William Berkeley or Baker; each was paid at the very high rate of 1s. 4d a day or £24 5s. a year, while the master mason, Henry Janyns, received only £12. The works continued from 1477 to 1483, so that we have a precise date and the names of the master craftsmen, but the derivation of the design is not really fixed. What can be said is that the old attribution to Quintin Matsys, only eleven years old when the works were begun, is completely out of the question.

Although the engagement of highly paid specialists for unusual works formed an exception, the normal rule that it was the master mason who was responsible for design is reaffirmed, even in regard to ironwork. In

1496 the Abbot of Westminster accepted a tender from Symond Smyth of Westminster to make two ' ferments ' (i.e. *ferramenta*, iron grilles) for the two windows of the steeple for 1½d a lb, £5 being advanced at sealing of the contract. The transom bars were to be 4 ft 3 in. in length and in ' bignes ' according to a patron, and the standards and staybars also of such substance, as should be showed him by the warden of the Abbey masons. As we know, the duty of a warden of masons was to act as the deputy of the master, in this case Robert Stowell. Here it was the architect, Stowell, through his staff, who was responsible for the design and specification even of a simple and functional grille. But in another case we are again plunged into doubt. In 1484–85 decorative vanes (' faydes ') were made for the new north-west tower of York Minster. A large basin and two other pieces of basins were bought for making the vanes for 5s. 10d from Thomas Gray, apparently the York goldsmith of that name, free of the city in 1468 and chamberlain in 1481. Then John Colan made the vanes, a quarter of beaten gold for gilding them, iron staples to attach them were bought, and William Webbe paid for the gilding, all for 8s. 8d. Colan seems to have been the John de Culayn, goldsmith, who took up the freedom in 1449 and died in the summer of 1490. The master mason through the whole period from 1472 until 1505, when he died, was William Hyndeley. Who designed the vanes?

Epilogue

There is no true end to discussion: further problems always remain to be solved. We have seen that there are still serious questions to be answered, notably on the subject of design. The interrelation of masons, goldsmiths and painters, still has to be unravelled. These residual puzzles should not distract attention from the many older controversies which have been settled for good. Allowing only for minimal exceptions, it is possible to assert firmly that the typical craftsman of the Middle Ages was a small capitalist and an individualist rather than one of a herd. He was the man with an independent shop of his own, a workshop first and then a shop for the sale of the product, rather than an employee. Normally a layman with family ties and apt to be tied by inheritance to the trade practised by his forebears, he was likely to be succeeded in the business by his sons, who were also his pupils. Outside the family he would be associated, along with his wife, in some secular organisation reflecting the common interest of those with the same skill, and also in some religious body such as a parish or craft fraternity, tending towards the ultimate good of his soul.

The craftsman was almost always free by condition, untrammelled by restrictions on his movement; able to compete in the open market; and to travel to find other work or to set up his business in some other place. His skill, as a craftsman combining intelligence with handiwork, and as a man of business involved in keeping records and correspondence with clients and with suppliers of materials, implied that he was an educated man. This does mean a much higher standard of literacy than that of the general population, and agrees with the likelihood that he would have attended schools until the age of pupilage or apprenticeship to his craft, about 13 or 14. In England, attendance at primary school before 1350 necessarily implied a knowledge of French, then the language of instruction; and attendance at cathedral or monastic choir schools, or at grammar schools after the age of 9 or 10, automatically meant a substantial grounding in Latin. Competence in reading, writing, and especially in arithmetic

and elementary accountancy, was the norm rather than the exception among skilled craftsmen.

It is now possible to identify the craftsman as a specific kind of human being. It has been usual to regard the craftsman before the Industrial Revolution as the forerunner of the factory hand and therefore as a 'workman' or member of the 'labouring class'. We can see that any such identification is not just over-simplified but utterly untrue. The craftsman, in his contribution to society, was closely equivalent to the professional middle class, which is in fact (as shown by abundant genealogies) largely derived in blood from the skilled craftsmen of two, three and more centuries back. He was not a bourgeois even though he might be a burgess: his interests as a man of skill sharply differentiated him from the middleman trader and the merchant. We have seen that, towards the end of the fourteenth century and more explicitly in the fifteenth, it was the mercantile class of importers and middlemen that steadily depressed the status of the manufacturing crafts and their guilds. Money talked, and by the time that only money had any real say, the Middle Ages were over and had given place to the Renaissance, a half-way house towards modern industrialism.

The speed of change, from mediaevalism to industrialism, varied greatly between different crafts. Whereas the great leaders of mediaeval art in the trades of mason and carpenter had lost their leadership in the sixteenth century, clockmakers, horners, joiners and cabinet-makers, and saddlers continued their work with only slight modifications down to a time within living memory. The fundamental skills of the apothecary, the gardener and the working jeweller survive, as do some others. Yet it has to be said that the last glimpses of the mediaeval scene, and of mediaeval method, have nearly come to an end within our own time. The last great sailing ships have gone along with the last steam locomotives, both of them exemplifying in their individuality the same vital spark, continuing from the age of the craftsman. It would seem that humanity now faces a future of automatism in which the personal alliance between brain and hand progressively disappears. It may nevertheless be the case that individual skills, though of new kinds, will once more emerge.

Looking back on the crafts and human craftsmanship as a whole it is possible to detect a pattern related to the main periods of cultural productivity. Each culture has a life-span in which its art-forms and total style come into existence, flourish, develop and eventually decay. Within the culture particular crafts will make preponderant contributions, and each single skill has its own separate development. Though the craft with its secrets may have been introduced ready-made, it will still undergo changes in its new environment, and the end-product will not be identical with that of the same process in its country of immediate origin. Over and above such ancient crafts are those founded upon new inventions, or upon ancient inventions transferred over long distances and then redeveloped.

Examples of this last category are the great Chinese inventions such as silk-working machinery and printing. Any craft in any one cultural epoch goes through three main periods, the first of experiment, the second of bringing towards perfection, and the third in which that quasi-perfection becomes stereotyped. In certain cases there is no experimental stage because a perfected process or mechanism is transplanted whole, as the horizontal frame loom was when it reached Europe in the thirteenth century. (29)

The introduction of new processes and equipment, whether by direct importation or by the play of fresh invention upon a received idea, is a subject of which little is known. The mere fact of the occurrence and its approximate date are often the sum total of our knowledge. In spite of the lack of mediaeval correspondence, it seems probable that more light will eventually be thrown upon these questions. In many cases received opinions will be overturned, and one might hazard a guess that there will be a limited rehabilitation of mediaeval men of science: alchemists, astrologers, physicians and surgeons. For a long time prejudice has ruled and the baby has been thrown out with the bath water. Amid the mass of speculation in manuscripts relegated as alchemical, astrological, or herbal, will be found remains of serious chemical, astronomical, psychological, medical and botanical research. Signs of such rehabilitation appear in *The History of Technology*, which points out, for example, that the alchemist Thomas Norton of Bristol claimed to have invented a furnace for all purposes and that the cylindrical furnace with a damper of *c.* 1500 may have been due to him. Furthermore, the manuscript of Norton's 'Ordinal of Alchemy' of *c.* 1477 includes an illumination which first shows a balance inside a glazed case, an evident mark of quantitative accuracy in chemistry. In surgery there is already the acclaimed work of John Arderne (*fl.* 1349–1378), including serious observations on topographical botany of medicinal herbs. Before 1456 two Sicilians, the Brancas, father and son, were carrying out plastic facial surgery, and it must be remembered that throughout Europe the practise of surgery was an experimental craft, not an academic study.

In the thirteenth century in England, under the impulsion of Queen Eleanor of Provence and her son Edward I, comfort and improved hygiene invaded the English palace and the English house. Before 1300, as we have seen, strenuous efforts were made to provide piped supplies of drinking water, paved streets, civic amenities and better standards of health. In spite of unavoidable ignorance as to the exact causes of disease, the mediaeval apprehension that dirt was a source of infection was acute. Lydgate could write of King Priam's new Troy that it was drained by streams flowing through conduits which secretly cleansed away all filth.

N

Whereby the town was utterly assured
From engendering of all corruption,
From wicked air and from infection
That cause often by their violence
Mortality and great pestilence.

When Henry Yeveley was letting some of his property in Horsleydown, Southwark, in 1390 he inserted covenants that his tenants should not throw out filth or refuse so as to attract crows or other birds into the ditches; they might have reasonable use of the water for washing skins so long as this was done out of sight of the public going towards Horsleydown.

Precautions were taken too over the supply of fresh food. Refrigeration was unknown, but Salzman showed that the great catches of fish were brought back to port alive in a well in the holds of fishing vessels. For land transport they were packed in salt. The city of Norwich rendered to the Crown annually 24 pies made with the first herrings caught each season. each pie contained five herrings, cooked with ginger, pepper, cinnamon, cloves and spices. Land in East Carleton, five miles southwest of Norwich, was held by serjeanty of carrying these pies to the king; the carrier was given one of the pies for himself, and on arrival at court received liberal entertainment. Cooking was one of the more highly skilled crafts, though its products were not durable, and for banquets at least an aesthetic element was introduced. The first of the great English cookery books, *The Forme of Cury*, was compiled by 'the chief masters cooks of King Richard the Second . . . the which was accounted the best and royallest viander of all christen Kings', and we know the names of two of these master cooks. Master Thomas Beauchef, who in his time had cooked for the Black Prince, became an emeritus cook in 1383 because he was 'an old man and not able to labour as he used to do'; his fee, wages and robe were continued for life, with leave ' to go away for recreation and return when he pleases'. His successor was his junior John Goodrich, who had been in the royal kitchens from 1363 and went on until 1393. Beauchef was still alive in 1391 and Goodrich died in 1398.

Closely related to cookery was the garden in its functional guise. The craft of gardener was concerned primarily with fruit and vegetables for the table, but also with the herbs needed for salads, condiments and medicines. We have seen that gardeners were taking up the freedom of York in the fourteenth century, and even one ' herberour' who would have made and cared for the enclosed pleasure gardens or arbours found at royal palaces, the mansions of the nobility, and at monasteries and convents of nuns. It was the garden of the nuns at Romsey Abbey that leapt into historical fame about 1092, when King William Rufus and his courtiers visited it on the plea of examining the roses and flowering

herbs. The king's real aim of getting to see the Saxon heiress Edith-Matilda, later to become the wife of his younger brother Henry I, was foiled by the shrewdness of the mother abbess, but the incident left its mark upon horticultural and social history. Almost exactly a century later there is evidence of serious fruit culture at Chester Castle, when Ranulph, 6th Earl of Chester, granted to William, keeper of the garden and orchard, not only the residue of the apples after the yearly shaking down of the crop, but the 'restingtre' – shown by a continuing series of records to have been the stock tree of the orchard, from which grafts were taken.

Until the thirteenth century the best kinds of fruit came from France, but by the fourteenth English gardening must have become really skilful. The first serious problem arose over the introduction of rosemary, a rather tender shrub given to Queen Philippa by her mother in 1338. By 1400 its successful culture had been worked out and set down in writing, apparently the first English treatise on details of horticultural method. Somewhere about this time too there came the booklet on kitchen and herb gardening of Master John Gardener, mentioning nearly 100 kinds of plant and giving cultural hints. These were practical manuals based upon experience, utterly different from the theoretical Latin treatises supposedly based upon classical information and largely consisting of unscientific nonsense. The age of Edward III was one of continuing scientific progress and one of the king's physicians, John Bray (died 1381), produced an admirable glossary, alphabetically arranged, of the names of herbs in Latin, English and French. About 1400 copies of the surgical works of John Arderne began to be illustrated with lifelike, instead of merely conventional, drawings of the plants mentioned. The apothecary and the doctor were at last given real aids to the identification of the wild plants they needed.

Hardly anything has been said in this book of the impractical crafts of amusement. It might be held that the therapeutic qualities of music gave it practical value, and the playing of trumpets and beating of drums were essential parts of the military machine. The makers of church organs and of musical instruments have been mentioned, but we know little enough of the details. All that can be said is that the many carvings of mediaeval instruments, and the few actual examples – such as the Warwick Gittern – that survive, indicate that this is one of the skills that has altered least down the centuries. The minstrels able to sing and to play upon the instruments were always well rewarded by kings and nobles, but even though we can hear modern recitals of much of the music they played, we can form no real idea of their methods of playing or what changes in execution took place during or after our period. That there was a high standard of appreciation of serious musical recitals is shown by the gift in 1387–88 of £1 6s. 8d to a certain Nicholas who played the organ of Westminster Abbey, on the order of the prior. Such a sum

could not be worth less than £150 in the values of today. The great royal abbey seems to have catered also for more secular amusements, for in 1447–48 John Traunsham was paid 8d for mending ' le Westdore ' and another 8d for making the lodge for ' le Tenyspleyers '.

There is little enough direct evidence of mediaeval games, let alone of the craftsmen who must have made balls, rackets and bats. Tennis balls were probably made of leather by glovers, and bats and rackets by joiners. Nets could at any rate be provided by the netmakers whose normal output served for fishing. In 1543 the accounts for the king's works at Westminster include a payment to Richard Hattfeld of the parish of ' Sente Martense be syds Charyng Crosse, nettmaker ' for a drag net bought of him and delivered at the place called ' Petty Callesse wtin the parke '. All sorts of small items made of different kinds of leather would be made by the sheathers who were organised in London by 1375 and whose skills had been practised much earlier. Not only sheaths for knives, daggers and swords, but boxes, buckets, caskets and inkwells were made, often of *cuir boulli* (99, 100). In this process the leather was not actually boiled, though in one variant it may have been dipped in hot water before moulding. It seems to have been more usual to steep it in oil or wax to produce, after drying, the lasting toughness which was the great advantage of the material.

It has been explained that saddles, which we now think of as essentially leather goods, were considered a branch of the joiner's trade, and that the painters' guilds were originally concerned with the colouring of wooden saddles. Covering with leather did, however, become normal for ordinary qualities, though the best saddles for royal use substituted velvet. Among Richard II's stores in 1398 were:

> 1 saddle covered with red velvet worked in embroidery with pearls and silk and garnished with these letters R and Y and all the harness of silver gilt.
> 1 saddle covered with red velvet and garnished with crowns and great purses (*bursell'*) and all the harness of silver gilt.
> 1 saddle covered with blue velvet garnished with crowns and harts and all the harness of silver gilt.

The initial letters R and Y were those of King Richard and his second queen, the young Isabella (Ysabel) of France.

To the story of these complex interrelationships between the crafts there is no real end. Mediaeval art and workmanship were sophisticated and their skills were diverse. At the same time they were firmly based on the capacities of individual human beings who together formed the whole body of mediaeval craftsmen. Their numbers were very great. In York alone in 1381 there were some 850 independent masters engaged in their different trades, and with their skilled employees the number must have been a thousand at least. Some figures quoted by Salzman from royal

accounts and the rolls showing the payment of ulnage on cloth give us an idea of the almost incredible productivity of hand craftsmanship in the textile industry. In 1232 Wilton was able to supply, for a single order, 500 ells (625 yards) of linen for the king's tablecloths for Christmas, at 3d or 3½d the ell – roughly the wages of one man for a day. In 1336 the wardrobe of Edward III bought 9,693 ells of English linen, 237 ells from Paris, and 1,125 ells from Rheims. For 1395 there are figures relating the output of woollen cloth to the numbers of weavers: in the county of Suffolk 733 broadcloths had been made by about 120 persons. Narrow cloths, in which 12 yards counted as a 'dozen' and a whole cloth was 24 yards, amounted to 9,200 dozens from a total of 300 makers, of whom 15 had been able to make from 120 to 160 dozens each. If we put the figure at 1,500 yards in the year for each of these prolific weavers, and count 300 working days to the year, they wove 5 yards a day each; and some managed to weave well over 6 yards a day.

Out of all the immense output of these thousands of craftsmen, spread over five centuries, only a small portion remains, and what is left is diminished daily by the toll of war, fire, flood and sheer rapacity. All of the craftsmen have long disappeared from the scene: nearly as many years have now elapsed since the last of them passed to their rest as the whole time of their working. Some of them died young while still apprentices, others were snatched off in mid-career, it may be by the plague; but the greater number worked on steadily through a full tale of years until they could work no more. The luckiest were those who had either won their economic independence and made fortunate investments in property, or those who had served a generous master. The generosity of most of the mediaeval kings to their servants is one of the most pleasing traits of personal character to be found in history: it must have been rare indeed for a craftsman in the royal service to have to face 'the growing difficulties of age and poverty' (*crebrescentibus incommodis etatis et inopie*), in the sad phrase of a Winchester deed of 1283. On the contrary, we have seen the honourable and fully paid retirement accorded to Thomas Beauchef the master cook, and may note the handsome pensions given to two of the king's smiths about the same time. In 1371 Peter Bromley was granted £5 a year for his good service; and in 1375 Thomas de Eltham, already earning 6d a day at Queenborough Castle, had for his long service an additional 2d a day for life.

Generosity may have started at the top, but it leavened the whole of mediaeval society. In reading large numbers of mediaeval wills one is struck by the handsome bequests to servants and apprentices as well as to relatives, and by the wider charity of many of the arrangements made for masses. It is not uncommon to find such a clause as: 'Also I will that these things above bequeathed which tend to works of charity or piety for me and for my soul shall also accrue to the merits and benefit of others to whom I am in any way rightfully bound and that they

should share with me in all things which may be done for me and my soul as if they were personally expressed.' According to their means, craftsmen provided for masses and, if possible, left property charged with their permanent maintenance. Thus Henry le Masun (*cementarius*) of London and his wife Alice in 1281 bought land and houses in the parish of All Hallows ' Colemannecherch'; and when he died in 1288 he left his capital house and curtilage to his son Edmund, charged with maintaining 15 masses in the church. Some were anxious that the members of their guilds and fraternities should attend their funeral: in 1531 Humphrey Coke, chief carpenter to Henry VIII, desired ' that my crafte and occupacion of carpynters and all other brotherhoodes as I am of shalbe at my burying and every of them to be honestly rewardid for their labours after the discrescions of myn said executours.'

Other craftsmen of the wealthier sort prepared their own tombs while they were alive. So our old friend John Aylmer the freemason, dwelling in St Saviour's, Southwark, referred in his will of 1548 to his grave, where ' I have laid a marbull stone all redy for my burial with certain pictures', probably brasses. Incidentally, his household goods included pictures of a lord and a lady and many other pictures of men and women, perhaps kept by him as patterns for brasses or effigies which he might be called on to provide. Aylmer had very likely made monuments for many others in the course of his long career: he had been over 64 at the beginning of 1536 and so must have passed 76 when he died. Aylmer's gravestone has not survived; like those of so many others, in the words of John Stow, ' men of good worship, whose monuments are now for the most part utterly defaced'. Stow was making his notes before 1598 and could still find the London churches full of many remaining monuments which perished in the Fire of 1666, among them that in St Magnus to Henry Yeveley, ' freemason to Edward III, Richard II, and Henry IV, who deceased 1400 '. Not only in London, but in the whole country, monuments to mediaeval craftsmen are now rare indeed. Among the few is one of the most remarkable than can ever have been put up by a craftsman as a memorial of himself, the Bellfounders' window in the north nave aisle of York Minster, commemorating Richard Tunnoc, who died in 1330 (**156–8**). One of the wealthiest men in York, of which he had been a bailiff in 1320, Tunnoc was M.P. for the city in 1327 and probably had the window made in the following year, when he obtained licence to found a chantry at St Thomas's altar, endowed with 4 marks yearly out of his house in Stonegate. As a record of craft processes the window is unique in England, though paralleled by a number abroad.

For rich craftsmen or poor, the bells tolled, but more often for the rich, who could afford to leave sums to pay the bellringers for years afterwards to call them to mind on the anniversary of their death. In such records as the churchwarden's book of Louth, covering all receipts and payments for the twenty-five years 1500–1524, the fees for ringing the

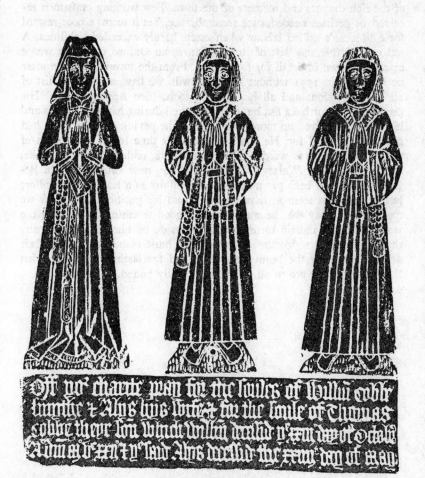

Sharnbrook, Bedfordshire: Brass of William Cobbe, smith, and his wife Alice, who both died in 1522, and their son Thomas Cobbe. 'Off yor charite pray for the soules of Willm Cobbe smythe & Alys hys wife & for the soule of Thomas Cobbe theyr son, which Willm decessid ye xxii day of Octobr' Anno Domini MVᶜ xxii & ye said Alys decessid the xxiiij day of May.

great bells appear as a substantial source of income. It was appropriate that men should, year after year, be reminded to pray for the souls of some of the rich drapers and mercers of the town. Few working craftsmen received, or perhaps needed, such remembrance. Yet it seems a poor reward for a lifetime's skilled labour when assets hardly exceeded liabilities. A sad case of this was that of Robert Carow, an Oxford carpenter whose career is known in detail for forty years. From the inventory, taken after he had died in 1531 without leaving a will, we have a complete list of all his possessions and all his working tools. (See Appendix VII.) His property was worth £2 8s., but debts incurred during his last sickness and his burial swallowed up more than £2, and the paving over his grave had not yet been paid for. He had worked in his time for at least seven of the colleges and was warden of the carpenters, under Humphrey Coke, at the building of Wolsey's Cardinal College, now Christ Church. Besides this he had been prominent in local affairs as a leading Councillor; but he does not seem to have profited from his position. Of Carow we may certainly say that he was a man of good worship. Considering the works that still remain to us from those made by him and by so many thousands of other worthy craftsmen, we must stand amazed at their achievement. For the beauty, the skill, and the lasting quality of what they wrought, we are to all of them rightfully bound.

Appendix of Illustrative Documents

I. A contract to repair the Gaol of York in 1377 (translated from the text printed by L. F. Salzman, *Building in England*, 1952/1967, pp. 453–4)

This indenture tripartite between Ralph de Hastinges sheriff of York of the one part and Richard de Thorne one of the canons of the church of St Peter of York of the other part, and Robert de Dounom and Stephen de Barneby carpenters of the third part witnesseth that it is thus agreed between them, that the foresaid Robert and Stephen have granted and undertaken to repair and mend certain defects of the Gaol and of the head of the mill pond of the aforesaid appearing to be so damaged and so dangerous that they should take down about the half of the great house of the Gaol aforesaid towards the east which is so weak and rotten that it may not stand nor be serviceable but seems rather about to fall suddenly and slay the prisoners below, and that part of the aforesaid house they shall well and sufficiently rebuild and repair as in its upper floor and in its walls and in its leaden gutters and in all other its necessaries; and the other part of the foresaid house they shall likewise repair both in floors and walls of this part as well as in two plaster chimneys that is one beneath in the chamber of the Gaoler and the other above in the foresaid part of this house and in all other its necessaries, and the whole of the foresaid house they shall cover anew with a single layer of 'Thakborde'; and also they shall cleanse a certain breach of a certain part of the foresaid mill pond nearest to the mills of the lord King there, and they shall raise the forepart of that damaged part with a great hewn beam (' houuetre ') and behind they shall take down an old timber pond-bay which is too weak and shall there rebuild a new bay sufficient enough, and in the midst of the foresaid breach they shall rebuild another new bay, which bays behind and in the midst together with the hewn beam in front, they shall strengthen and bind together crosswise with long and strong beams of timber and shall also fill up the foresaid breach thus repaired with great stones and clay and other suitable materials up to the top in the manner that it should be.

And for the completion of these works well and faithfully to the use and behoof of the said lord King the same Robert and Stephen shall provide and find timber planking ' thakborde ' iron nails lead plaster brick (' waltyghel ') and workmen and all other things competent and necessary to the aforesaid works. And also they shall begin those works with all the speed they may and shall profitably complete without delay. And upon these they have found pledges and surities that it to say Andrew Monemaker of York, John Hunter of York, Henry Plummer of York, Simon Warde of York, and William Bernard of Grimston.

For the making of these works as is aforesaid the same Sheriff by the consent and survey of the same Richard de Thorne shall give to the same Robert and Stephen of the money of the said lord King in all Thirty-nine pounds six shillings and eight pence. That is to say first and in hand eleven pounds, and when half done fourteen pounds three shillings and fourpence, and at the end of the whole of the foresaid work fourteen pounds three shillings and fourpence. And moreover the foresaid Robert and Stephen shall have for themselves outside their own covenant all that is taken out and remains over of the old rotten or weak timber 'thakborde' and planking of the foresaid house, so that it be of no value as timber but only for burning.

In witness of which all the parties aforesaid alternately have set their seals to this indenture tripartite. Given in the Castle of York on Sunday next after the feast of St Barnabas the Apostle (11 June) in the year of the reign of King Edward the third after the Conquest of England the fifty and first (Sunday 14 June 1377).

A little is known of some of the sureties: John Hunter was made free of York as a tewer (leatherdresser) in 1356; Andrew Monemaker, the Andrew of Florence, moneyer, who had been admitted in 1361, was living with his wife Marion in the parish of St Olave in 1381; Henry Plummer was of St Wilfrid's parish in 1381; and Simon Warde took up the freedom as a wright in 1380.

II. Indenture of bowyer's apprentice of York in 1371 (translated from the text printed by Maud Sellers in *York Memorandum Book*, part i, Surtees Society, CXX for 1911, 1912, pp. 54–5)

This indenture witnesseth that Nicholas son of John de Kyghlay shall serve well and faithfully in the manner of an apprentice John de Bradlay of York, bowyer, as his master, and with him shall dwell from the feast of St Peter ad Vincula AD 1371 to the end of seven years next following fully to be completed; and the foresaid Nicholas the precepts of his said master, far and near, shall willingly do, concealing his secrets, and shall keep his counsel. He shall not do him damage to the value of sixpence per annum or more, nor know of its being done without preventing it to the best of his power or warning his said master thereof forthwith; the goods of his said master he shall not waste nor lend them to anyone without his will and by his special precept; he shall not play at dice; he shall not be in the habit of frequenting taverns, gaming-houses (*scaccarium*) nor brothels; he shall not by any means commit adultery or fornication with the wife or daughter of his foresaid master under pain of doubling his aforesaid years (of servitude); he shall not contract marriage with any woman nor marry her during the term of the foresaid seven years unless it were with the will and consent of his said master; from the service of his foresaid master he shall not unlawfully withdraw nor absent himself by days or nights during the abovesaid term.

Within which term the foresaid John de Bradlay shall instruct and inform the foresaid Nicholas his apprentice in his craft which he uses of bowyercraft, and in buying and selling as belongeth to his foresaid craft, in the best manner that he know or may without any concealment, and for him of food and drink, linen and woollen cloths, bed, footwear and all other necessaries as becomes such an apprentice sufficiently shall provide and ordain for the whole of the aforesaid term. For which teaching faithfully to be given to the foresaid Nicholas in the foresaid form in his foresaid craft, Thomas de Kyghlay, chaplain, shall give to the said John de Bradlay six shillings and eightpence sterling for each of the three years next following the date of these presents; and for all the premisses on the part of the said John in the foresaid form faithfully to be fulfilled, William

del Clough of York, bowyer, constitutes himself pledge and surety for the same John. And to all the premisses on the part of the said apprentice and to the foresaid payments faithfully to be made in the foresaid form, the foresaid Thomas binds himself by these presents.

In witness of which the foresaid parties and beforenamed pledges have alternately set their seals to the parts of this indenture. With these witnesses: John Swerd, Robert Christendome, Roger Bower, Robert Garnet, Philip Bower and others. Given at York the feast and year abovesaid.

Of the boy Nicholas nothing further is known and he does not seem ever to have taken up the freedom of York. His father may have been the John de Kyghlay, glover, who was free in 1354 and died in 1389. Thomas de Kyghlay, chaplain, very likely John's brother, may have been the rector of 'Kyngston in Somersett' who desired to be buried at St Oswald, Nostell, and whose will was proved at York on 9 March 1395/6. The master, John Bradlay, had taken up the freedom as a bowyer in 1369; William del Clough his surety was free in 1366 and probably dead by 1381, when Thomas de Clogh, bowyer, and his wife Margaret were living in the parish of St John Ouse Bridge.

The witnesses also seem to have been men of the same trade. Philip 'Bower' is not otherwise recorded, but Roger Bower was living in the parish of All Saints Pavement in 1381, with his wife Emma and a servant John; Robert Christendome, bowyer, with Joan his wife and William a servant, was in St Michael's, Spurriergate, as was Robert Garnet, bowyer, free in 1354, with his wife Margaret. John Swerd became free as a bowyer in 1361 and was Chamberlain of the city in 1367.

III. Ordinance of the masons of York Minster, 1370 (modernised in spelling from the text printed by James Raine in *The Fabric Rolls of York Minster*, Surtees Society, XXXV for 1858, 1859, pp. 181–2. The northern dialect seems to have closely resembled modern Lowland Scots, so a few scoticisms have been preserved)

It is ordained by the Chapter of the kirk of Saint Peter of York that all the masons that shall work till the works of the same kirk of Saint Peter, shall fra Michaelmas day until the first Sunday of Lent, be ilka day at morn at their work in the lodge that is ordained to the masons at work inwith the close beside the foresaid kirk, as early as they may see skilfully by daylight for till work; and they shall stand there truly working at their work all the day after, as long as they may see skilfully for till work, if it be all workday; other else till it be high noon smitten by the clock, when holiday falls at noon, save that inwith that foresaid time betwixt Michaelmas and Lent; and in all other time of the year they may dine before noon if they will, and also eat at noon where them likes, so that they shall not dwell fra their works in the foresaid lodge no time of the year in dinner time, but so short time that no skilful man shall find default in their dwelling; and in time of meat, at noon, they shall no time of the year dwell fra the lodges, nor fra their work foresaid over the space of the time of an hour, and after noon they may drink in the lodge; and for their drinking time betwixt Michaelmas and Lent they shall not cease nor leave their work passing the time of half a mileway (10 minutes); and fra the first Sunday of Lent until Michaelmas they shall be in the foresaid lodge at their work at the sun rising, and stand there truly and busily working upon the foresaid work of the kirk all the day, until it be namore space than time of a mileway (20 minutes) before the sun set, if it be workday; other else until time of noon, as it is said before, save that they shall, betwixt the first Sunday of Lent and Michaelmas, dine and eat as is before said, and sleep and drink after noon in the foresaid lodge;

and they shall not cease nor leave their work in sleeping time passing the time of a mileway, nor in drinking time after noon passing the time of a mileway. And they shall not sleep after noon na time but between Saint Helenmas and Lammas; and if any man dwell fra the lodge and fra the work foresaid, other make default any time of the year against this foresaid ordinance, he shall be chastised with abating of his payment, at the looking and device of the master mason; and all their times and hours shall be ruled by a bell ordained therefor. And also it is ordained that no mason shall be received at work, to the work of the foresaid kirk, but he be first proved a week or more upon his well working; and, after that he is found sufficient of his work, be received of the common assent of the master and the keepers of the work, and of the master mason, and swear upon the book that he shall truly and busily at his power, for out any manner guile, feints or deceit, hold and keep holy all the points of this foresaid ordinance in all things that him touches or may touch, fra time that he be received till the foresaid work as lang as he shall dwell mason hired at work till that foresaid work of the kirk of Saint Peter, and not go away fra that foresaid work but the masters give him leave at part fra that foresaid work; and wha somever come against this ordinance and breaks it against the will of the foresaid Chapter have he God's malison and Saint Peter's.

This new ordinance must have been made shortly before 31 October 1370, when Master Robert de Patrington, the master mason of York Minster, with twelve other masons, came before the Chapter and swore to obey these rules, saying: 'Lords, if it be your wills, we grant for to stand at our works truly at our power,' etc. An earlier ordinance, recorded in Latin, and probably dating from 1352, referred both to the masons and to the carpenters, and ordered that an oath to obey them should be taken by the chief master and second master mason, by the carpenter of the fabric, and by the other masons, carpenters and workmen employed. Instead of a bell, the summons to work at that time was by the masters or one of them knocking on the door of the lodge; and in the evening they were to work on until the ringing of the bell of St Mary's Abbey called ' le Langebell '. The two master masons and the carpenter were made responsible for the due observance of the rules.

IV. A craftsman's calendar of holidays for 1337 (paid and unpaid holidays taken from an account for works at the Tower of London, P.R.O., E.101/470/1, as worked by Roger de Langele, a skilled carpenter paid at the top rate of 6d per day; and set against the calendar for the year 1337)

Wed	1	January	Circumcision	Unpaid
Mon	6	„	Epiphany	Paid
Sat	25	„	Conversion of St Paul	Unpaid
Sat	22	February	St Peter in Cathedra	Paid
Mon	24	„	St Matthias	Unpaid
Tue	25	March	Annunciation of B.V.M.	Paid
Fri	18	April	Good Friday	Unpaid
Sat	19	„	Eve of Easter	Paid
Mon	21	„		
Tue	22	„		
Wed	23	„	Week after Easter	Unpaid
Thu	24	„		
Fri	25	„		
Sat	26	„		
Thu	1	May	St Philip and St James	Paid

Sat	3 May	Invention of Holy Cross	Unpaid
Tue	6 „	St John at the Latin Gate	Paid
Thu	29 „	Ascension Day	Unpaid
Mon	9 June		
Tue	10 „		
Wed	11 „	Week after Whitsun	Unpaid
Thu	12 „		
Fri	13 „		
Sat	14 „		
Thu	19 „	Corpus Christi	Paid
Tue	24 „	Nativity of St John Baptist	Unpaid
Mon	7 July	Translation St Thomas	Paid
Tue	22 „	St Mary Magdalene	Unpaid
Fri	25 „	St James	Paid
Fri	1 August	St Peter ad Vincula (Lammas)	Unpaid
Fri	15 „	Assumption of B.V.M.	Paid
Fri	29 „	Decollation St John Baptist	Unpaid
Mon	8 September	Nativity of B.V.M.	Paid
Mon	29 „	St Michael	Unpaid
Sat	18 October	St Luke	Paid
Tue	28 „	St Simon and St Jude	Unpaid
Sat	1 November	All Saints	Paid
Tue	11 „	St Martin of Tours	Unpaid
Thu	20 „	St Edmund King and Martyr	Paid
Tue	25 „	St Katherine	Unpaid
Sat	6 December	St Nicholas	Paid
Mon	8 „	Conception of B.V.M.	Unpaid
Thu	25 „	Christmas Day	
Fri	26 „	St Stephen	Unpaid
Sat	27 „	St John the Evangelist	
Mon	29 „	St Thomas of Canterbury*	

* Taken instead of Sun 28 December, Holy Innocents

Other feasts which were kept as official holidays in some years, and for which some craftsmen in royal service received pay, were: 2 February, Purification of B.V.M.; 11 June, St Barnabas; 29 June, St Peter and St Paul; 10 August, St Lawrence; 24 August, St Bartholomew; 14 September, Exaltation of Holy Cross; 21 September, St Matthew; 2 November, All Souls; 30 November, St Andrew; 21 December, St Thomas Apostle. This list is not exhaustive, and there was a great deal of variation both at different dates and as between different grades of craftsmen.

V. A brickmaker's contract, 1534
(from the muniments of New College, Oxford; the spelling has been modernised and Arabic numerals substituted for Roman, but no other alterations have been made)

This indenture made the 24th day of November in the 26th year of the reign of King Henry the VIIIth between the Warden and Fellows of the College called Saint Mary College of Winchester in Oxford of the one party And Richard Whytby and Clement Peake of the parish of Saint Giles without Cripplegate beside the City of London Brickmakers of the other party Witnesseth that the said Richard Whytby and Clement Peake have promised covenanted and granted and by these presents promise covenant and grant to make and deliver unto the use of the said Warden and Fellows Eight hundred thousand of Bricks

after the largest assize of the Chamber of the said City of London well and substantially to be made and burned Whereof Five hundred thousand shall be made at Stanton St John in the County of Oxford in three clamps or kilns and the residue of the said Eight hundred thousand shall be made at Tingewick in the County of Buckingham in other three kilns or clamps. And the same Eight hundred thousand of Bricks to be made and delivered out of the Rows unto the said kilns or clamps and well and substantially to be burned on this side the Feast of Saint Michael the Archangel next coming after the date of these presents without further delay. For the which Eight hundred thousand of Bricks in manner and form abovesaid to be made delivered and burned The said Warden and Fellows promise and grant to pay unto the said Richard and Clement their Executors or Assigns Three score three pounds six shillings and eight pence of lawful money of England after the rate of 19d. for every 1000. Of the which sum of £63 6s. 8d the said Warden and Fellows promise to pay unto the said Richard and Clement their Executors or Assigns at such time as they shall begin to dig the earth for the said Bricks Six pounds; At such time as they shall begin to mould the bricks Four pounds; And every fortnight after that they have so begun to mould the said bricks (if their work diligently shall go forward) Three pounds six shillings and eight pence. And the residue of the said sum of £63 6s. 8d to be paid unto the said Richard and Clement their Executors or Assigns at such time as their said bargain shall be fully finished and performed. Moreover the said Richard and Clement Peake promise and grant by these presents to make and deliver to the use abovesaid out of the Rows unto the said kilns or clamps Ten thousand of Bricks over and beside the said 800,000 in recompense of the waste of the same 800,000 without any thing therefore to be demanded or paid. And furthermore it is agreed between the said parties, That the said Warden and Fellows shall find sufficient Sand Straw and Wood for the making of the same Bricks to be carried and laid at the moulding places where the said Bricks shall be made at all times convenient at the proper costs and charges of the said Warden and Fellows. And the said Richard and Clement their Executors or Assigns shall sustain and bear all manner charges whatsoever they shall be concerning the making and burning of the said Bricks at their proper costs and charges. In Witness whereof the parties abovesaid to these present Indentures interchangeably have set their Seals the day and year above specified.

(Two small, non-armorial seals are appended to the College copy.)

VI. Contracts for Norfolk church roofs, 1319–1330 (from the Borough Court Rolls of Great Yarmouth, C.4/42, m. 4; C.4/43, m. 1; C.4/53, m. 18v.; translations and abstracts from the originals in Anglo-French. The three contracts were all undertaken by the same family of Yarmouth carpenters, and the two first are of outstanding importance since they show the separate arrangements made by different clients, the rector for the chancel and parishioners for the nave, with the same builders; and because they indicate the precise date of 1319 for the building of the surviving church of Norton Subcourse, which was evidently designed as a single unity early in the fourteenth century. The roof at Holy Trinity (East) Caister, was a renewal set on an earlier nave.)

Memorandum that William de Gunton and Roger de Gunton of Great Yarmouth on Tuesday on the feast of the apostles Saint Philip and Saint James in the 12th year of the reign of King Edward son of King Edward (1 May 1319) before Roger Gavel bailiff of Great Yarmouth present in the same court of Great Yarmouth acknowledged an indented writing in which are contained these words:

These are the covenants made between Roger de Hales parson of the church of St Margaret of Norton next Haddiscoe (Subcourse) of the one part and William de Gunton and Roger de Gunton of Great Yarmouth of the other part, that is to say That the foresaid William and Roger de Gunton at their own costs shall work and must cause to be worked a roof for a chancel of the foresaid church of 25 couples of oak according to the width and the length of the patterns (*eschankelyons*) between the said parties to this made and ordained So that the said roof of the foresaid couples, with battens, with wallplate and as much as belongs and appertains in timber to the said roof, must be ready and framed well and suitably in all sorts of work belonging to carpentry ready for roofing and must be raised upon the walls of the foresaid chancel at the costs of the foresaid William and Roger de Gunton between the day of the making of these letters and St Michael the Archangel (29 September) next following. And if it should happen, which God forbid, that the foresaid William and Roger de Gunton should fail to do and perform the said work in the form aforesaid the foresaid William and Roger de Gunton grant and oblige themselves by these letters to be bound and obliged to the foresaid Roger de Hales parson of the aforesaid church in 20 marks (£13 6s. 8d) sterling to be paid in the foresaid town of Norton within three days after the said day of St Michael the Archangel next to come with no remission. And to this the aforesaid William and Roger de Gunton bind themselves them and their heirs and their executors by these letters, their goods and all their chattels and all their lands and tenements whatsoever.

(*Added*:) Afterwards that is to say the Thursday next after the feast of Saint Michael the Archangel in the year of the king King Edward son of King Edward the 13th (4 October 1319) came William Saleman, Roger de Gunton and acknowledge that the said covenants have been discharged accomplished and completed in all points.

Memorandum that the Thursday next after the feast of Saint Michael in the year of the reign of King Edward son of King Edward the 13th (4 October 1319) William Saleman of Norton next Haddiscoe with the one part of an indenture, Roger de Gunton and Margaret who was wife of William de Gunton and John de Gunton son of him the same William de Gunton of Great Yarmouth bearing the other part of the same indenture in the court of Great Yarmouth before John Perchrun bailiff, acknowledge the said indentures which they pray should be enrolled . . . :

These are the covenants made between William Swetman, Roger le Gris, William Saleman and William Hubert of Norton next Haddiscoe of the one part and Roger de Gunton and Margaret who was wife of William de Gunton and John de Gunton son of him the same William de Gunton of Great Yarmouth of the other part, that is to say That the aforesaid Roger Margaret and John . . . shall make . . . a roof for the church of St Margaret of Norton . . . of 32 rafters of oak . . . according to the price of 12s. 6d the rafter, of the width and length of the rafter made by them in the chancel of this the same church . . so that the said roof, with battens and all that belongs . . . in timber must be ready and framed for roofing and must be raised . . . between the day of the making of these letters and . . . (29 September 1320) . . . And if it happen, which God forbid, that the aforesaid . . . should fail . . . the foresaid . . . oblige themselves . . . to be bound . . . in £20 sterling to be paid . . . within three days . . . the said William, Roger, William and William shall find all the iron nails of which they shall have need and shall owe and pay to the foresaid Roger Margaret and John for making the said roof . . . £20 sterling if the work shall have so many rafters as is before said to be paid at certain terms that is to say on the day of the making of these letters 10 marks (£6 13s. 4d) which they have

been paid, and at Easter next following 6 marks (£4), and at the feast of St Peter's Chains (1 August) 6 marks, and within the third day after the feast of St Michael the Archangel next following the remainder of the money . . . and a coom (half a quarter) of wheat and a coom of malt and a bacon at the raising of the said roof . . . In witness . . . (they) have interchangeably set their seals . . .

Roger Bettes, Thomas Trig of Caister chaplains, William de Wabronne parishioners of Caister next Great Yarmouth and John de Gunton carpenter and burgess of Great Yarmouth and Robert de Gunton carpenter dwelling in the town of Great Yarmouth present in court of Great Yarmouth before Bartholomew de Thorp proffer certain indentures . . . :

Be known to all men this covenant made on Monday the morrow of the Close of Easter in the 4th year of the reign of King Edward the third after the Conquest (16 April 1330) between sir Roger Betes, sir Thomas Trig of Caister chaplains, John Heny, William de Wabronne and John Trig parishioners of the same town of the one part and John de Gunton carpenter and burgess of Great Yarmouth and Robert de Gunton carpenter dwelling in the said town of Yarmouth of the other part: That is to say that the aforesaid John and Robert shall take down the roof of the church of the Holy Trinity of Caister and shall frame and raise up another of 29 couples well and suitably made the whole roof of good timber and clean of heart of oak, each couple of the length of 25 of a man's feet and of the square measure according to the purport of a pattern (*eskauncellyn*) made between the said parties of a stick (*fusshel*) sealed under their seals and each couple shall be framed with tiebeams, collars, and ashlars cross-braced among the collars (*chescon cuple serra lye des soebemes wyndbemes & de asshelers croyses parmy le Wyndbemes*) . . . And to find and perform this work with all manner of timber and iron nails and all that belongs to the roofing and . . . to raise the said roof . . . between the day of making the covenant and the feast of the Nativity of Our Lady (8 September) next following at their costs And the foresaid John and Robert carpenters grant that they shall be held and bound . . . if anything of the aforesaid work shall remain unfinished . . . by their default. For which roof and work aforesaid the foresaid sir Roger, sir Thomas, John, William and John (have agreed that) the foresaid John and Robert carpenters shall have the timber of the old roof and 10 marks and 10 shillings (£7 3s. 4d) of silver that is to say on the day of the making of these writings 5 marks and 10 shillings and at the feast of Our Lady aforesaid the other 5 marks. . . . In witness of which to these writings indented the said parties interchangeably have set their seals. In presence of Geoffrey de Drayton, Walter del Sond, Bartholomew de Thorp, Stephen de Catefeld bailiffs of Great Yarmouth, Alexander Fastolf, Richard his brother, John Elys, Robert Elys of the same town Given at Great Yarmouth the day and year aforesaid.

(Thanks are due to Mr A. P. Baggs and to Mr Paul Rutledge for bringing these contracts to my notice, and to Mr Rutledge for additional information on the Gunton family. William de Gunton senior, carpenter, was party to a deed in 1303; on 11 January 1336/37 it appears from a plea that Robert de Gunton was son of William de Gunton, carpenter, and Margaret his wife. The will of John de Gunton, dated 9 May 1349 and proved 11 May is enrolled and shows that his wife Beatrix was already dead; he left only a daughter Isabella.)

VII. Inventory of the goods of Robert Carow, carpenter, 1531 (from the probate records of the court of the Archdeacon of Oxford, Series I, vol. 1 (1528–43), ff. 37–8; now in the Department of Western MSS, Bodleian Library, Oxford).

Latin words and phrases have been translated, spelling modernised, and Arabic numerals substituted for Roman. Robert Carow, a leading Oxford carpenter, is first heard of as working for Oriel College in 1491, and thereafter he was concerned with building at a number of other colleges. He was a main contractor for timberwork on the new Corpus Christi College in 1517–18, made to the design of the master carpenter Humphrey Coke. He was a Councillor of Oxford in 1518–1522 and again in 1529 when he was one of those who signed a motion to conclude the 'varyances betwene the Towne and th'unyversyte'. In spite of his busy career, culminating in the position of warden of the carpenters at the building of Wolsey's Cardinal College (Christ Church) from 1525, again under Humphrey Coke, Carow died a poor man. After payment of his debts and funeral expenses, his estate amounted to only 7s. 8d, without allowing anything for paving over his grave. (For his career in detail see J. Harvey, *English Mediaeval Architects*, 1954, 55.)

Inventory of Robert Carow of Oxford carpenter intestate deceased appraised by William Campynett and Richard Dere and other appraisors lawfully deputed:

Imprimis 5 chisels		10
Item a compass and 2 augers (10d) Item a gouge (10d)		
and an old chipping axe Item 2 drawing planes (11d)	2	7
Item 13 small planes (12d) Item 2 adzes (10d) a handsaw (3d)	2	1
Item a drawer and 7 small planes	1	6
Item a square (8d) Item a hammer and a wimble (4d)	1	0
Item 4 boxes (4d) Item 2 prickers a knife and a compass (4d)		8
Item 2 brazen pots broken (10d) Item a small pan and a kettle (6d)	1	4
Item 3 candlesticks (10d) Item a dropping pan and a frying pan (8d)	1	6
Item 4 porringers a platter and an old basin	1	6
Item 2 small pewter pots and 2 old salt-cellars	1	2
Item a pair tongs and a pot hanger		6
Item a strainer a chafingdish and 2 saucers		6
Item 2 stools (6d) and an old rope (14d)	1	8
Item 2 old mattresses and a pillow	1	0
Item 5 old blankets	2	6
Item 5 old sheets and 4 old table-cloths	3	8
Item 4 old towels (12d) Item 2 old doublets (2s)	3	0
Item a gown and a jacket and a frieze jacket	7	4
Item a bedstead and 2 coffers	2	8
Item an old tester and 2 painted cloths	1	0
Item a jack a coverlet and an old mantle	2	6
Item a hood for a woman (4d) Item a pair of bellows (6d)		10
Item an undercloth stuffed with flocks	1	4
Item 2 boards a form and a chair	1	0
Item a small grindstone	1	4
Item an ambry (dresser) with a board to set vessels upon	1	4
Item wood and old timber for fire	1	4
Item a plank and 2 old trestles		4
Appraised total of the goods aforesaid	£2 7	9
(The real total of the items set down is £2 8s. 0d)		

The Judge granted letters for collection to a certain Master Melchior Butler master of arts lest the goods of the deceased should be wasted etc. for the payment of the debts of the said deceased to be applied according to reasonable portions etc. with due notification to creditors beforehand in all parish churches

O

within the university of Oxford publicly in due form of law had and announced
Item 2 pieces of timber ————

An account of the said Master Melchior Butler collector of the goods of Robert
Carow deceased intestate as appears below:

Imprimis at his burial (7s 1d) Item at the month's mind (7s)	14	1
Item paid to Master Perotte collector of the rents of St Frideswide's	3	4
Item paid to Edward Stawnton for debt for meat and drink and other things	4	4
Item paid to Richard Atkynson tailor for debt	2	4
Item paid to William Campynett for debt	1	10
Item paid to Herry's wife for bread drink and victual	1	0
Item paid to Katherine alewife for victual	1	2
Item to Christian his servant for wages	1	0
Item to James late his servant for wages	3	6
Item paid to the proctors of Our Lady's Chapel in St Peter's church for his grave	6	8
Item to a poor woman for keeping him in his sickness		10
Item for paving of the grave ————		
Total of all the aforesaid payments	(£2 0	1)

From the taxation of 1524 we know that Carow (Robert Karewe) lived in the
parish of St Peter in the East, paying 5s., with 2s. for his servant James Lynche
and 4d for his servant Richard Sclatter. William Campenett was a neighbour,
paying 6s. to the tax, of which he was a sub-collector; Campenett also paid 1s.
for one Richard Atkynson his servant, possibly the tailor of 1531. Richard Dey
(? = Dere) also lived in the parish, paying 1s. 4d and 1s. for his servant John
Dobsyn.

Bibliography and Abbreviations

AASRP	Associated Architectural Societies' *Reports and Papers*
Adamson 1930	J. W. Adamson, 'The Extent of Literacy in England in the Fifteenth and Sixteenth Centuries', *The Library*, 4th Series, X (1930), 163–93
AJ	*Archaeological Journal* (Royal Archaeological Institute)
Amherst 1895	A. Amherst, *A History of Gardening in England* (1895, etc.)
Anderson 1935	M. D. Anderson, *The Medieval Carver* (1935)
Anglo 1969	S. Anglo, *Spectacle, Pageantry and early Tudor Policy* (1969)
ANJ	*The Antiquaries Journal* (Society of Antiquaries of London)
Atkins 1943	J. W. H. Atkins, *English Literary Criticism: the Mediaeval Phase* (1943)
B	*The Builder*
Baggallay 1885	F. T. Baggallay, 'The Use of Flint in Building . . .', *Transactions RIBA*, New Series, I, 105–24
Baillie 1929	G. H. Baillie, *Watches: their History, Decoration and Mechanism* (1929)
Barlow 1945	F. Barlow ed., *Durham annals and documents of the thirteenth century* (Surtees Society, CLV, 1945)
Bartlett 1953	N. Bartlett, *The Lay Poll Tax Returns for the City of York in 1381* (London and Hull, East Riding Antiquarian Society, 1953)
Bates 1891	C. J. Bates, *Border Holds of Northumberland* (1891)
Beeson 1971	C. F. C. Beeson, *English Church Clocks* (1971)
Beresford 1967	M. Beresford, *New Towns of the Middle Ages* (1967)
Bergen 1906	H. Bergen ed., *Lydgate's Troy Book* (EETS, ExS, XCVII, 1906)
Blair 1958	C. Blair, *European Armour* (1958)
Blore 1946	W. P. Blore, 'A Fourteenth-Century Account for Cathedral Organs', *Laudate*, XXIV no. 81, (June 1946), 38–41
BM	British Museum
Bodl	Bodleian Library, Oxford
Bond 1908	F. Bond, *Fonts and Font Covers* (1908)
Bond 1916	———, *The Chancel of English Churches* (1916)
Borradaile 1966	V. & R. Borradaile trans., *The Strasburg Manuscript – a medieval painter's handbook* (1966)

Borth Borthwick Institute, York

Brooks 1940 F. W. Brooks, ' A Medieval Brick-yard at Hull ', JBAA, 3rd Series, IV for 1939 (1940), 151–74

Butcher 1870 J. H. Butcher, *The Parish of Ashburton* (1870)

Cahen 1968 C. Cahen, *Pre-Ottoman Turkey* (trans. J. Jones-Williams, 1968)

Cal ClR *Calendar of Close Rolls*

Cal LibR *Calendar of Liberate Rolls*

Cal PatR *Calendar of Patent Rolls*

Carter 1925 T. F. Carter, *The Invention of Printing in China and its Spread westward* (New York, Columbia U.P., 1925; rev. ed., 1931)

Carus-Wilson 1954 E. M. Carus-Wilson, *Medieval Merchant-Venturers* (1954; 2nd ed., 1967)

Chapman 1907 F. R. Chapman, *Sacrist Rolls of Ely* (Cambridge, 2 vols., 1907)

Christie 1938 A. G. I. Christie, *English Mediaeval Embroidery* (1938)

Clay 1944 C. T. Clay, ' The Keepership of the Old Palace of Westminster ', EHR, LIX (1944), 1–21

Collins 1897 F. Collins, *Register of the Freemen of the City of York, i 1272–1558* (Surtees Society, XCVI for 1896, 1897)

Colombier 1953 P. du Colombier, *Les Chantiers des Cathédrales* (Paris, Picard, 1953; rev. ed., 1973)

Coulton 1928 G. G. Coulton, *Art and the Reformation* (1928)

CUL Cambridge University Library

Darlington 1945 R. R. Darlington ed., *The Cartulary of Darley Abbey* (Kendal, Derbyshire Archaeological Society, 2 vols., 1945)

Devon 1837 F. Devon, *Issues of the Exchequer, Henry III–Henry VII* (1837)

Dilks 1945 T. B. Dilks, *Bridgwater borough archives 1400–45* (Somerset Record Society, LVIII for 1943, 1945)

Dixon & Raine 1863 W. H. Dixon & J. Raine, *Fasti Eboracenses: Lives of the Archbishops of York*, I (1863)

Dobson 1971 R. B. Dobson, ' Guild ', *Encyclopaedia Britannica* (1971), X, 1013–16

Dobson 1973 ——, 'Admissions to the Freedom of the City of York in the later Middle Ages ', *Economic History Review*, 2nd Series, XXVI no. 1 (1973), 1–22

Dodwell 1961 C. R. Dodwell ed., *Theophilus: The Various Arts* (Oxford, 1961)

Drake 1912 M. Drake, *A History of English Glass Painting* (1912)

Drew 1939 J. S. Drew, *Compton near Winchester* (1939)

Dudding 1941 R. C. Dudding, *The First Churchwardens' Book of Louth 1500–1524* (Oxford, 1941)

EETS Early English Text Society

EHR *English Historical Review*

Eland 1949 G. Eland, *At the Courts of Great Canfield, Essex* (1949)

Englefield 1936 W. A. D. Englefield, *History of the Painter-Stainers Company of London* (1923; rev. ed., 1936)

Evans 1949 J. Evans, *English Art 1307–1461* (Oxford, 1949)

Ex S Extra Series

Fernández Montaña 1881 J. Fernández Montaña, *Lapidario del Rey D. Alfonso X: Codice Original* (Madrid, 1881)

Fowler 1911 R. C. Fowler ed., *Registrum Radulphi Baldok* etc. (Canterbury & York Society, VII, 1911)

Frankl 1960 P. Frankl, *The Gothic: Literary Sources and Interpretations through Eight Centuries* (Princeton, N.J., 1960)

Fry 1907 R. E. Fry, ' On a Fourteenth-century Sketchbook ', *Burlington Magazine*, X (1906–07), 31–8

Furnivall 1868 F. J. Furnivall, *Early English Meals and Manners – The Babees Book* (EETS, OS, 32, 1868)

Gardner 1927 J. S. Gardner, *Ironwork – Part I* (1892; rev. ed., 1927)

Gilyard-Beer 1970 R. Gilyard-Beer, *Fountains Abbey* (1970)

Gross 1908 C. Gross, *Select cases concerning the law merchant* (Selden Society, XXIII, 1908)

Groves 1894 T. B. Groves, ' Some Local Stone Marks ', *Proceedings of the Dorset Natural History and Archaeological Field Club*, XV (1894)

Hadfield 1969 M. Hadfield, *A History of British Gardening* (1969)

Hahnloser 1935 H. R. Hahnloser, *Villard de Honnecourt* (Vienna, 1935; rev. ed. Graz, 1972)

Harvey 1944A J. H. Harvey, ' The Western Entrance of the Tower ', *Transactions of the London & Middlesex Archaeological Society*, New Series, IX (1944), 20–35

Harvey 1944B ——, *Henry Yevele c. 1320–1400: the Life of an English Architect* (1944; rev. ed., 1946)

Harvey 1945A ——, ' Notes from the York Guildhall ', B, CLXIX (31 August 1945), 165–6

Harvey 1945B J. H. Harvey, ' The Building Works and Architects of Cardinal Wolsey ', JBAA, 3rd Series, VIII for 1943 (1945), 50–9

Harvey 1946 ——, ' Side-lights on Kenilworth Castle ', AJ, CI (1946), 91–107

Harvey 1947A ——, *Gothic England: a Survey of National Culture 1300–1550* (1947; rev. ed., 1948)

Harvey 1947B ——, ' Some Details and Mouldings used by Yevele ', ANJ, XXVII (1947), 51–60

Harvey 1947C ——, ' Some London Painters of the 14th and 15th Centuries ', *Burlington Magazine*, LXXXIX no. 536 (November 1947), 303–5

Harvey 1948 ——, *The Plantagenets 1154–1485* (1948; rev. ed., 1959, 1972)

Harvey 1949 ——, *Dublin: a Study in Environment* (1949; rev. ed,. 1972)

Harvey 1952 ——, ' Henry Yevele Reconsidered ', AJ, CVIII (1952), 100–08

Harvey 1954 ——, *English Mediaeval Architects: a Biographical Dictionary down to 1550* (1954)

Harvey 1956 ——, ' Hyde Abbey and Winchester College ', *Papers and Proceedings* of the Hampshire Field Club . . ., XX (1956), 48–55

Harvey 1957 ——, ' Great Milton, Oxfordshire, and Thorncroft, Surrey: the Building Accounts for two Manor-Houses of the late Fifteenth Century ', JBAA, 3rd Series, XVIII for 1955 (1957), 42–56

Harvey 1961	——, 'The Wilton Diptych – a Re-examination', *Archaeologia*, XCVIII (1961), 1–28
Harvey 1962	J. H. Harvey, 'The Origin of the Perpendicular Style', in *Studies in Building History*, ed. E. M. Jope ('1961'; 1962)
Harvey 1965	——, 'Winchester College', JBAA, 3rd Series, XXVIII (1965), 107–28
Harvey 1966	——, 'The Fire of York in 1137', YAJ, XLI part 163 (1966), 365–7
Harvey 1968	——, 'The Origins of Gothic Architecture: some further thoughts', ANJ, XLVIII (1968), 87–99
Harvey 1969	——, *William Worcestre: Itineraries* (Oxford, 1969)
Harvey 1971	—— 'Richard II and York', in F. R. H. Du Boulay & C. M. Barron ed., *The Reign of Richard II* (1971), 202–17
Harvey 1972A	——, *The Mediaeval Architect* (1972)
Harvey 1972B	——, *Conservation of Buildings* (1972)
Harvey 1972C	——, 'Mediaeval Plantsmanship in England: the Culture of Rosemary', *Garden History*, I no. 1 (September 1972), 14–21
Harvey & King 1971	J. H. Harvey & D. King, 'Winchester College Stained Glass', *Archaeologia*, CIII (1971), 149–77
Haskins 1924	C. H. Haskins, *Studies in the History of Mediaeval Science* (Harvard, 1924; rev. ed., New York, 1960)
Heaton 1948	N. Heaton, 'The Origin and Use of Silver Stain', JMG, X no. 1 (1947–48), 9–16
HMC	Historical Manuscripts Commission
Hocart 1936	A. M. Hocart, *Kings and Councillors* (1936; rev. ed., 1970)
Holland 1895	W. Holland, *Cratfield, Suffolk* (1895)
Holmyard 1928	E. J. Holmyard ed., *Ordinal of Alchemy* (1928)
Hope 1900	W. H. St J. Hope, *The Architectural History of the Cathedral Church and Monastery of St Andrew at Rochester* (1900)
Hope 1913	——, *Windsor Castle* (2 vols., 1913)
Hornell 1943	J. Hornell, 'The Fishing and Coastal Craft of Ceylon', *Mariner's Mirror*, XXIX no. 1 (January 1943), 40–53
HoT	*History of Technology*, ed. C. Singer, E. J. Holmyard, A. R. Hall & T. I. Williams (5 vols., 1954–58)
Howgrave-Graham 1961	R. P. Howgrave-Graham, 'The Earlier Royal Funeral Effigies', *Archaeologia*, XCVIII (1961), 159–69
Hussey 1881	R. C. Hussey, *Extracts relating to the Cathedral . . . of Canterbury* (1881)
JBAA	*Journal* of the British Archaeological Association
JMG	*Journal* of the British Society of Master Glass-Painters
Jope & Pantin 1968	E. M. Jope & W. A. Pantin, 'The Clarendon Hotel, Oxford', *Oxoniensia*, XXIII (1958), 1–129
JRIBA	*Journal* of the Royal Institute of British Architects
Kahl 1963	W. F. Kahl, introduction to Unwin 1963
Kerry 1883	C. Kerry, *A History of the . . . Church of St Lawrence, Reading* (Reading, 1883)
Kingsford 1941	H. S. Kingsford, 'Some English Mediaeval Seal-Engravers', AJ, XCVII for 1940 (1941), 154–80
Kirby 1888	T. F. Kirby, *Winchester Scholars* (1888)
Kirby 1892	——, *Annals of Winchester College* (1892)

Kirby 1899 ——, ed., *Wykeham's register* (Hampshire Record Society, XI, 2 vols., 1896–99)

Kirk 1892 R. E. G. Kirk, *Accounts of the obedientiars of Abingdon abbey* (Camden Society, New Series, LI, 1892)

Knoop & Jones 1933 D. Knoop & G. P. Jones, *The Mediaeval Mason* (Manchester, 1933; rev. ed., 1967)

Knowles 1936 J. A. Knowles, *Essays in the History of the York School of Glass-Painting* (1936)

Kramer 1917 S. Kramer, *The English Craft Gilds* (New York, Columbia U.P., 1917)

Lafond 1954 J. Lafond in *Bulletin de la Société Nationale des Antiquaires de France*, 8 dec. 1954, 94–5

Lasko & Morgan 1973 P. Lasko & N. J. Morgan, *Mediaeval Art in East Anglia 1300–1520* (Norwich, 1973)

Laurie 1930 A. P. Laurie, *The Painter's Methods and Materials* (1930)

Law 1891 E. Law, *History of Hampton Court Palace* (3 vols., 1885–91)

Le Couteur 1926 J. D. Le Couteur, *English Mediaeval Painted Glass* (1926; rev. ed., 1932)

Leggett 1972 J. I. Leggett, ' The 1377 Poll Tax Return for the City of York', YAJ, XLIII for 1971 (1972), 128–46

Lemmon 1962 K. Lemmon, *The Covered Garden* (1962)

Lethaby 1906 W. R. Lethaby, *Westminster Abbey and the King's Craftsmen* (1906)

Lloyd 1925 N. Lloyd, *A History of English Brickwork* (1925)

Lloyd 1958 H. A. Lloyd, *Some outstanding Clocks over Seven Hundred Years: 1250–1950* (1958)

Lodge & Somerville 1937 E. C. Lodge & R. Somerville ed., *John of Gaunt's Register 1379–83* (Camden 3rd Series, LVI, 1937)

Loftie 1883 W. J. Loftie, *History of London* (1883)

Lowe 1961 J. Lowe, ' The Medieval English Glazier ', JMG, XIII no. 2 (1960–61), 425–32 (and no. 3, 1961–62, 492–508)

Lowther 1951 A. W. G. Lowther, in *Papers and Proceedings* of the Hampshire Field Club XVII part 2 (1951), 130–2

MacCracken & Sherwood 1934 H. N. MacCracken & M. Sherwood, *The Minor Poems of John Lydgate*, ii (EETS, OS 192, 1934)

Marsh 1914 B. Marsh, *Records of the Worshipful Company of Carpenters*, II (1914)

Maskell 1911 A. Maskell, *Wood Sculpture* (1911)

Mortet & Deschamps 1929 V. Mortet & P. Deschamps, *Recueil de Textes relatifs à l'Histoire de L'Architecture* (Paris, 2 vols., 1911, 1929)

Needham 1954 J. Needham, *Science and Civilization in China*, I (1954)

Nelson 1913 P. Nelson, *Ancient Painted Glass in England 1170–1500* (1913)

Oman 1957 C. Oman, *English Church Plate 597–1830* (1957)

Orme 1973 N. Orme, *English Schools in the Middle Ages* (1973)

OS Original Series

Plenderleith & Maryon 1959 H. J. Plenderleith & H. Maryon, ' The Royal Bronze Effigies in Westminster Abbey ', ANJ, XXXIX (1959), 87–90

Postan 1939 M. M. Postan, 'The Fifteenth Century', *Economic History Review*, IX (1938–39), 160–67

Power 1910 D'A. Power, *Treatises of Fistula* (EETS, 139, 1910)

Power 1912 ——, *English Medicine and Surgery of the Fourteenth Century* (1912)

Prideaux 1896 W. S. Prideaux, *Memorials of the Goldsmiths' Company* (1896)

Pritchard 1967 V. Pritchard, *English Medieval Graffiti* (Cambridge, 1967)

PRO Public Record Office

Procter 1951 E. S. Procter, *Alfonso X of Castile* (1951)

Raine 1837 J. Raine ed., *Sanctuarium Dunelmense et sanctuarium Beverlacense* (Surtees Society, V, 1837)

Raine 1839 J. Raine, *Historiae Dunelmensis Scriptores tres* (Surtees Society, IX, 1839)

Raine 1859 ——, ed., *The Fabric Rolls of York Minster* (Surtees Society, XXXV, 1859)

RCHM Royal Commission on Historical Monuments (England)

Remnant 1965 M. Remnant, 'The Gittern in English Mediaeval Art', *Galpin Society Journal*, XVIII (1965), 104–09

RO Record Office.

Salmon 1943 J. Salmon, 'The Windmill in English Medieval Art', JBAA, 3rd Series, VI for 1941 (1943), 88–102

Salusbury 1948 G. T. Salusbury, *Street Life in Mediaeval England* (1948)

Salzman 1923 L. F. Salzman, *English Industries of the Middle Ages* (1923)

Salzman 1952 ——, *Building in England down to 1540: a documentary history* (1952; rev. ed., 1967)

Saunders 1932 O. E. Saunders, *A History of English Art in the Middle Ages* (1932)

Sellers 1912 M. Sellers ed., *York Memorandum Book*, part i (Surtees Society, CXX for 1911, 1912)

Sellers 1918 ——, *The York Mercers and Merchant Adventurers* (Surtees Society, CXXIX for 1917, 1918)

Sharpe 1889 R. R. Sharpe, *Calendar of Wills in the London Court of Husting* (2 vols., 1889)

Snell 1926 B. S. Snell, 'Some Ancient Building Terms', JRIBA (18 December 1926)

Snell 1928 ——, 'More Ancient Building Terms', JRIBA (22 December 1928)

Spencer 1968 B. W. Spencer, 'Medieval Pilgrim Badges', *Rotterdam Papers* ed. J. G. N. Renaud (Rotterdam, 1968), 137–53

Stow 1603 J. Stow, *Survey of London* ed. C. L. Kingsford (2 vols., 1908)

Taylor 1963 A. J. Taylor in *Genava* (Geneva), New Series, XI (1963), 289–315

Thomas 1929 A. H. Thomas, *Calendar of Plea and Memoranda Rolls of London, 1364–81* (1929)

Thompson 1916 A. H. Thompson, 'The Building Accounts of Kirby Muxloe Castle, 1480–4', *Transactions* of the Leicester Archaeological Society, XI (1915–16)

Thompson 1928 ——, *History and Architectural Description of the Priory of St Mary, Bolton-in-Wharfedale* (Thoresby Society, XXX for 1924, 1928)

Thompson 1933	D. V. Thompson jr., *The Craftsman's Handbook by Cenino d'Andrea Cennini* (New York, 1933)
Thompson 1936	——, *The Materials of Medieval Painting* (1936)
Thompson 1939	J. W. Thompson, *The Literacy of the Laity in the Middle Ages* (Berkeley, California, 1939)
Thomson 1930	W. G. Thomson, *A History of Tapestry* (1906; rev. ed., 1930)
Thorndike 1929	L. Thorndike, *Science and Thought in the Fifteenth Century* (New York, 1929)
Triggs 1896	O. L. Triggs ed., *Lydgate's The Assembly of Gods* (EETS, Ex S, LXIX, 1896)
Turner 1851	T. H. Turner, *Some Account of Domestic Architecture in England* (Oxford, 1851)
Unwin 1963	G. Unwin, *The Gilds and Companies of London* (4th ed., 1963)
VCH	*Victoria County Histories*
WAM	Westminster Abbey Muniments
WCM	Winchester College Muniments
Wight 1972	J. A. Wight, *Brick Building in England from the Middle Ages to 1550* (1972)
Wilkinson 1875	J. J. Wilkinson, ' Receipts and Expenses in the building of Bodmin church, A.D. 1469 to 1472 ' (Camden Society, New Series, XIV, 1875)
Willetts 1958	W. Willetts, *Chinese Art* (2 vols., 1958)
Williams 1907	L. Williams, *The Arts and Crafts of Older Spain* (3 vols., 1907)
Williams 1955	N J. Williams, *Kingston-upon-Thames Bridgewardens' Accounts 1526–1567* (Surrey Record Society, XXII, 1955)
Williams 1963	G. A. Williams, *Medieval London: from Commune to Capital* (1963)
Willis & Clark 1886	R. Willis & J. W. Clark, *Architectural History of the University of Cambridge* (3 vols., 1886)
Woodforde 1944	C. Woodforde, ' Some Medieval Lead Ventilating Panels at Wells and Glastonbury ', JMG, IX no. 2 (1944), 44–50
Woolley 1953	L. Woolley, *A Forgotten Kingdom* (1953)
Wright 1866	T. Wright ed., *Chronicle of Pierre de Langtoft* (Rolls Series, 2 vols., 1866–68)
YAJ	*Yorkshire Archaeological Journal* (Yorkshire Archaeological Society)
YASRS	Yorkshire Archaeological Society, Record Series
Young 1817	G. Young, *History of Whitby* (2 vols., 1817)

Notes to the Text

References are not given for biographical details of carpenters, carvers, engineers, joiners, marblers and masons to be found in J. H. Harvey, *English Mediaeval Architects* (1954).

Page
PREFACE

2 Architect – for the word see Harvey 1972A, 10–12, 17

4 Yeveley – Harvey 1944B, Harvey 1947B, Harvey 1952
York Guildhall – Harvey 1945A

INTRODUCTION

8 Hocart – Hocart 1936, 116, 119–21
9 Arthur's Hall – Kilhwch and Olwen in *The Mabinogion*
10 Tara – R. A. S. Macalister, *Tara* (Dublin, S. O.)
Precedence – Furnivall 1868, 187, 381
Plutarch – HoT, II, 604, quoting *Vitae parallelae: Marcellus*, xiv, 4
Secretaries – Hocart 1936, 126
Magistri – Frankl 1960, 111–12
11 Lydgate – *The Assembly of Gods*, lines 854–61 (Triggs 1896, 26); *Troy Book*, lines 552–60 (Bergen 1906, 160)
12 Inventions – HoT, II, 755, 766–7; cf. Thorndike 1929, 19; Lynn White jr. in *Speculum*, XV (1940), 141
Paper – HoT, II, 189; Carter 1925, 100
Alcohol – HoT, II, 141
Silk – HoT, II, 198
13 China – Needham 1954
14 Lapidario – Williams 1907, II, 225–7; Heaton 1948, 12; HoT, II, 12
Eversley – Proctor 1951, 130
Silver Stain – Lafond 1954, 94–5; PRO, E 372/197, rot. 47, year 24 Edward III
15 *Ecce* – Fernández Montaña 1881, 51 (f. 80v)
Clocks – Baillie 1929, 20–46; HoT, III, 648; Lloyd 1958, 5; Beeson 1971, 13 ff.
16 Langtoft – Wright 1866, 314
Chemistry – HoT, II, 347–82
17 Guilds – Kahl 1963, xxx; Salzman 1923, 257, 312
List – EHR, XVI, 501
Localisation – Unwin 1963, 32–4

CHAPTER I

20 Spinning wheel – HoT, II, 644
London crafts – Unwin 1963, 370–89
York – Sellers 1918, xl–xli; Bartlett 1953
Messager – York Minster Library, MS XVI A 2, ff. 36v, 38v
Craftsmen – Unwin 1963, 62–3
21 Merchant-venturers – Carus-Wilson 1954, esp. (ed. 1967), xvi
22 York 1377 tax – Leggett 1972

23 Richard II – Harvey 1971, 209–10
York freemen – Collins 1897; cf. Dobson 1973
24 Tinners – Salzman 1923, 79—80
Free masons – Harvey 1972A, 79, 137–8
26 Roger le Herberur – Amherst 1895, 31; PRO, C 47/3/31
Aliens – Kramer 1917, 206 and n. 123; Sellers 1918, xxviii—xxix
Coverlet weavers – Collins 1897, 77
Clockmaker – Bartlett 1953, 19
28 Downam — Harvey 1954, 87 (s. v. ' Donnom ')

CHAPTER II

31 Technology and science – HoT, II, 774
32 Guilds – for the whole subject see Dobson 1971
Feste du Pui – Unwin 1963, 98–9
St Paul's Fraternity – Ibid, 116–17
York Mercers – Sellers 1918, iv–vi, xiii
33 Near East – Cahen 1968, 193–200
Guildhouses – Harvey 1948, 25; Harvey 1949, 63
34 Ropley – Hampshire Record Office (formerly PRO), Eccl 2/159293
London Companies — Unwin 1963, 342
Amalgamated crafts – Kramer 1917, 1 ff.; cf. Unwin 1963, 86–7
35 Shops – PRO, E 101/473/15
Ordinances – Unwin 1963, 89
Strangers – Thomas 1929, lii
36 Pewterers – Unwin 1963, 164–5
Fishmongers, etc. – Ibid, 42
37 Hervey – Loftie 1883; Williams 1963, 227–9, 243–6
38 Decline – Postan 1939
Livery – Unwin 1963, 190–1, 226
40 Conspiracies – Harvey 1972A, 143–4; Unwin 1963, 161
Liveries – Unwin 1963, 191–2
Royal entries etc – Ibid, 272–3, 179–80, 196; Anglo 1969
41 Goldsmiths – Unwin 1963, 178
42 Lydgate – MacCracken & Sherwood 1934, 776–80

CHAPTER III

43 Literacy – Jenkinson 1927, 134–6; Adamson 1930; Thompson 1939; cf. Harvey 1947A, 21–2, 155–7; also Orme 1973, 43—50, not seen when this book was written.

44 Winchester — Kirby 1888

45 Apprenticeship – Harvey 1972A, 71; Salzman 1923, 340–1; Sellers 1912, 56

46 Articles of Masonry – Harvey 1972A, 200

47 St Stephen's Chapel – PRO, E 101/469/11
Westminster Abbey – WAM 19344
Peyntour – CUL, Add. MS 6392, ff. 396–7
Bell – Salzman 1952, 592–4

48 Apprentices – Sharpe 1889, I; Harvey 1954, 92; Knoop & Jones 1933, 166 and n. 2 (ed. 1967, 148 and n. 3)
Webb – Harvey 1947A, 99
Secrecy – Unwin 1963, 91

49 Thorncroft – Harvey 1957, 55
Repression – Unwin 1963, 91–2
Canterbury – Kramer 1917, 191 n. 27
Regensburg – Frankl 1960, 140–1; cf. Harvey 1972A, 148–9

50 Secrecy – Unwin 1963, 97–8; Salzman 1923, 141–2
Treatises – Dodwell 1961, xvi–xvii; Lowe 1961, 429–30

51 Cryptogram – C. J. Gadd & R. C. Thompson in *Iraq*, III (1936), 87–96; H. Moore, ibid, X (1948), 26–33; Woolley 1953, 93–5
Astrolabe – Haskins 1924, 113–19; cf. Harvey 1968, 92–3
Theophilus – Dodwell 1961, xix–xx, etc.

54 Strassburg MS – Borradaile 1966
Cennini – Thompson 1933

56 Tracing paper – Ibid, 13–14
Honnecourt – Hahnloser 1935

57 Carpenters – Marsh 1914, 18, 56, 154, 228
Servants, Ibid, 20; 76, 98, 102, 125, 154, 160, 173, 174, 214, 234

CHAPTER IV

58 Greenhouse – Lemmon 1962, 14—15
Working hours – Salzman 1923, 317–18

59 Tower of London – PRO, E 101/474/13
Nightwork etc – Kramer 1917, 26 n. 11; cf. Atkins 1943, 195
Overtime – Knoop & Jones 1933, 208–9 (ed. 1967, 186–7)
Chertsey – PRO, E 101/459/22

60 Norwich – Cathedral Muniments, rolls 17, 28
Holidays – Salzman 1923, 319; cf. Knoop & Jones 1933, 118–21 (ed. 1967, 106–8)
Thomas Painter – PRO, E 101/468/16; BM, Cotton MS. Nero C.VIII, f. 31v
Custom – PRO, E 101/467/7(1)

61 Lambhith – E 101/472/8
Sunday – Salzman 1923, 321

62 Pilgrimage – Harvey 1954, 58, 90, 204; 122; and Exeter Cathedral fabric rolls 2683, 2684 per Dr D. F. Findlay
Journeys — C. Desimoni, *Atti Liguri di Storia Patria*, XIII (1877–84) 537–698; Unwin 1963, 2

63 Fleming PRO, E 101/468/11
Waleden – BM, Cotton MS. Nero C.VIII, f. 57v

Burnham – Somerset RO (formerly PRO), Eccl 2/134/131912/3/6
Conway – S. Toy in *Archaeologia*, LXXXVI (1937), 163
Wolvesey – Hampshire RO (formerly PRO), Eccl 2/2/155831
Herebright – Harvey & King 1971, 150–2

64 Scissors – E. M. Jope in HoT, II, 100
Plough – Ibid, II, 89
Plane – HoT, II, 243
Needles – Ibid, II, 75
Instruments – Ibid, III, 582
Scarborough – PRO, E 101/482/8
Lincoln – Lincs. Archives Office, Amc. 5/Misc/1 per Mrs. D. M. Owen
London – Guildhall Library, Commissary Court of London, 323 More
Drawing boards etc – PRO, E 101/469/8, 9, 11; Harvey 1962, 164
Abingdon – Kirk 1892, 48
St Stephen's – PRO, E 101/468/6(28.)

65 Wharf — E 101/471/11
Shrewsbury – Corporation Bailiffs' Accounts, box xviii, 881
York Place – PRO, E 101/474/7
Chalk line – Salzman 1952, 344; Bodl, MS. Eng. hist. b. 192, f. 27 ff.
Sieve — Hants. RO (formerly PRO), Eccl 2/159375
Picks – PRO, E 101/468/5
Tower of London – PRO, E 101/470/1
Pevensey – PRO, DL 29/728/11977
Lead – Worcs. RO (formerly PRO), Eccl 2/128/92473
Weights etc. – H. Doursther, *Dictionnaire Universel des Poi's et Mesures* (1840; Amsterdam, Meridian, 1965)
Thurrock – Essex RO, D/DP A.22
Coals, Plaster – Bodl, MS. Eng. hist. b. 192, f. 27 ff.

66 Acres – PRO, C. 78/5 (no. 14), m. 8
Boxley – Salzman 1952, 449
Marks – Salzman 1923, 175, 325–6
Tanning – Salzman 1923, 248

67 Bytham – Gross 1908, 103
Swynnerton – William Salt Archaeological Society, New Series VI part i (1903), 112
London – Salzman 1923, 113
Medicine – Unwin 1963, 173
Painters – Ibid, 354
Masons – Harvey 1972A, 200–01
Co-operation – Unwin 1963, 354

68 Strike PRO, E 101/469/11
Wages – Salzman 1923, 317
St Stephen's – PRO, E 101/472/4
Silkstead — Drew 1939, 40
Lodgings – Salzman 1923, 116

69 New College – Archives, first Hall Book
Earl of Warwick – Warwick Corporation Archives, Household Accounts; cf. Harvey 1947A, 84, 93, 173–8
Dodyngton — Willis & Clark 1886, II, 440n.
Merton College – Record 4054 per Professor E. M. Jope
St Stephen's – PRO, E 101/469/12
Ormesby – *History Teacher's Miscellany*, IV, 176

York Place – PRO, E 101/474/7
Norwich – Cathedral Muniments, rolls
226, 1136
Yeveley – PRO, E 101/654 per Dr A. J.
Taylor
Medilton – E 159/175 Easter, rot. 16
70 Durham – Barlow 1945, 183; Raine
1839, ccclxxiii
Hoggekyns – Cal PatR 1416-22, 379;
cf. Lowther 1951
Beke – Salzman 1952, 590–1
Croxton – R. R. Sharpe, *Calendar of
Letter-Book ' K ',* 314

CHAPTER V
71 Cluny – Harvey 1972A, 243
Coutances – Ibid, 59
York – Raine 1859, 200
Windsor – Salzman 1923, 115–16
72 Westminster – WAM 17656
Yeveley – PRO, SC 6/917/11; E 101/
473/1, 4
Coventry – HMC, 15th Report, App.
part x (1899), 144
74 Masons – Harvey 1954
Towns – cf. Jope & Pantin 1958, 5–7
75 Felstede – Salzman 1952, 433–4
St Paul's – Ibid, 441—3; 478–82
Southwark – Ibid, 446–8
Tothill – WAM 17545, 17517
Burton – Sharpe 1889, II, 113
Lyndys – Norwich Corporation Muni-
ments, Court Roll no. 19.B, m. 6
76 Godard – Ibid, no. 15, m. 19
Darley – Darlington 1945, I, 200
York – PRO, E 135/25/1, m. 2; York
City Archives, C. 60, m. 5/23, 6/23,
1/23, 2/23
77 Journeymen – Salzman 1923, 255–6
Glass – Harvey & King 1971, 149 ff.
Chichester – Harvey 1954, 58
St Stephen's – PRO, E 101/468/6(2.)
Osekin – Ibid, 468/21, f. 116v
Ely – CUL, Add. MS. 2956, f. 158
Dunster – AJ, XXXVIII (1881), 77
York Place – PRO, E 101/474/7
78 Bradshaw – Ibid, 474/19
York – Raine 1859, 17–19
Lodge – Harvey 1972A, 114–16, 207–8
79 Kenilworth – Harvey 1946, 97, 101
80 Purlin – Salzman 1952, 212; cf. Snell
1926, Snell 1928
Rafter — Salzman 1952, 214, 352, 516
81 Constitutions – Harvey 1972A, 140–6,
191–207

CHAPTER VI
84 Pattern-weaving – Willetts 1958, I, 225–
53
85 Monk and mason – Anderson 1935, 145
Design – Harvey 1972A, 21–43
Swinburne Pyx – *English Medieval
Silver* (London, Victoria & Albert
Museum, 1952), 3–4; Lasko & Morgan
1973, 13
86 Goldsmiths — Oman 1957, 5–8; Salzman
1923, 128
87 Secrecy – Harvey 1972A, 102–4

88 Architects – Colombier 1953, 59 (ed.
1973, 68–9)
Scriveners – Thompson 1928, 98; WCM
22090, 22097, 22100, 22086
89 Rochester – Hope 1900, 126
Canterbury — Blore 1946, 38–40; Lam-
beth Palace Library, MS. 243, ff. 40–1
Farnham – Hants. RO (formerly PRO),
Eccl 2/159210, m. 5
Wills – Guildhall Library, Commissary
Court of London, 354 Broun; 374, 390
More
Farringdon – Salzman 1923, 135
90 Bellfounders – Ibid, 145, 150–5; HoT,
II, 64
Ramsey – *Fenland Notes and Queries,*
V, 313
Tuning – Salzman 1923, 148
Westminster – PRO, E 101/471/11
St Paul's – Cathedral Library, B.95.10
91 Effigies – H. Maryon in HoT, II,
478–9; Plenderleith & Maryon 1959; cf.
Howgrave-Graham 1961
Tothe – Borth, York Wills, Reg. 3, f.
112v
92 Moulds – Spencer 1968; cf. Woodforde
1944
Pewterers – Salzman 1923, 140—3
93 Paytefeyn – YASRS, LXXIV (1929),
166
Brass – Bodl, MS. Eng. hist. b. 192, f.
27 ff.
Clocks – H. A. Lloyd in HoT, III, 648;
cf. Lloyd 1958; Beeson 1971
94 Westminster – WAM 19858
Froissart – *Poésies,* ed. A. Scheler
(Brussels, Académie royale de Belgique,
3 vols., 1870–72), I, 53 ff.
Queenborough – PRO, E 101/483/29
95 Nuremberg – Lloyd in HoT, III, fig.
386
Lynn – Kings Lynn, Chamberlains' Ac-
counts, E.a.41
Exeter – Cathedral fabric rolls 1424–5,
1444–5, per Dr D. F. Findlay
Shrewsbury – Corporation Bailiff's
Accounts, box viii, 379
Gloucester – Cathedral Register 4, f.
242
Whitehall – WAM 12257
Clockmakers – Kramer 1917, 189 n.
21

CHAPTER VII
96 Invention – HoT, II, 640, 651
Vitruvius – Harvey 1972A, 19–21, 53,
95, 174
Vegetius – Ibid, 19, 208–9, 215–16
97 Water Supply – R. Willis in *Proceed-
ings of the Archaeological Institute at
Winchester, 1845,* 186; HoT, II, 691;
Harvey 1949, 105; Stow 1603
Highclere – Hants. RO (formerly
PRO), Eccl 2/159382, per the late Rev.
J. H. Bloom
Mills — HoT, II, 216, 610—11; Salz-
man 1923, 221
99 Sawyers – Young 1817, II, 927; WCM
11753; WAM 33291, f. 24v

Stone saws – Salzman 1952, 336; Harvey 1945B, 52

Bromsgrove – Worcester Cathedral, Cellarer's roll C. 71

Iron-mills – HoT, II, 69

100 Bologna – Ibid, II, 206

Windmills – R. Wailes in HoT, II, 617, 623; Salmon 1943

Lathe – HoT, II, 206

Spinning Wheel – Salzman 1923, 214n.; HoT, II, 203–4

Wheelbarrow – HoT, II, 642; Salzman 1952, 353; PRO, E 101/479/23; BM, Add. Ch. 34724

101 Hoists – Salzman 1952, 324–7

Treadwheels – Kirk 1892, 30; Raine 1859, 88–9

Westminster – PRO, E 101/469/8, 11

Highclere – Hants. RO (formerly PRO), Eccl 2/159388

Xanten – Coulton 1928

102 Canterbury – Lambeth Palace Library, MS. 242, f. 274; cf. (Southampton), HMC, 11th Report part 3 (1887), 135–6

Bodmin – Wilkinson 1875, 16, 18

Screws – HoT, II, 646–7

Drawbridge – Harvey 1944A; cf. PRO, E 101/472/5

Font-covers – Bond 1908, 301

Rams – Salzman 1952, 86, 328

103 Hire of plant – PRO, E 101/467/9; 468/11

Turf – E 101/468/11

104 Centres – PRO, E 101/467/7(4.), m. 2

Scaffolds – E 101/468/6(91.); 547/18; 469/8; 469/11; 461/6

Helicoidal scaffold – Taylor 1963, 309

105 Worcester – Cathedral, Cellarer's roll, C. 88

York Place – PRO, E 101/474/7

Centres – E 101/467/10; 469/8; Wilkinson 1875, 17–18

Hereford – *Calendar of Papal Letters 1305–42*, 196

Cambridge – Salzman 1952, 451–2

Kirby Muxloe – Thompson 1916

106 Building season – Kirby 1892, 511; Harvey 1962, 154 n. 10

Thatching – PRO, E 101/470/15; 470/10

107 Winchester – E 101/491/13

Ashill – E 101/458/3

Bishops Hull – *Somerset and Dorset Notes and Queries*, VII (1901), 264

Westminster – WAM 19344

Highclere – Hants. RO (formerly PRO), Eccl 2/159380; 159382; 159375

109 York Place – PRO, E 101/468/11

Piles – Cal LibR 1226–40, 394; PRO, C 47/3/47

CHAPTER VIII

111 Cambridge – PRO, E 101/459/15

Patterns – E 101/468/6(9.); 469/8; 469/11

Herkeling – 468/6(91.)

Caen – 469/3

112 Rochester – Bodl, MS. Top. gen. C. 20, pp. 29, 45

Eastminster – PRO, SC 6/1258/1

Battersea – WAM 19358

Quarries – PRO, E 101/491/13; Merton College record 4054 per Professor E. M. Jope; WAM 23497; Dudding 1941, and cf. J. H. Harvey, *The Inhabitants of Louth, Lincs, in 1500–25* (typescript, copies in BM, Society of Genealogists, Lincoln Public Library); Cal PatR 1361–4, 482

York Place – PRO E 101/468/10; 474/7

113 Tower – 471/11

Ashlar – WAM 18855

Winchester – Kirby 1899, ii, 127

Highclere – Hants. RO (formerly PRO), Eccl 2/159380

Miners – PRO, Deputy Keeper, 48th Report, 394; HoT, II, 68

Lime – Salzman 1923, 3–4; Cal LibR 1226–40, 466; ibid, 1245–51, 4

114 Chalk – PRO, E 101/474/7

Cement – 469/2

Canterbury – Dean and Chapter Muniments, Chartae Antiquae Z.176 per the late W. P. Blore

115 Timber – J. H. Harvey, *Country Life*, CVI no. 2759 (2 Dec. 1949), 1677–8

Abingdon – Salzman 1952, 244–5

Ely – Chapman 1907, II, 33; Harvey 1954, 203–4

York – Raine 1859, 170–1

116 Forest of Dean – *Rotuli Litterarum Clausarum 1204–24*, I (1833), 537

Wargrave – Hants. RO (formerly PRO), Eccl 2/159457

117 Lincoln – Cathedral, Chapter Acts, A.2/34, f. 6v

Morer – PRO, E 101/474/7; Williams 1955

Towns – Beresford 1967, 3

118 Beauneveu – Fry 1907, 37

St Stephen's – PRO, E 101/468/6(62.)

Exeter – Cathedral fabric roll no. 2649, per Dr D. F. Findlay

Durham – Bond 1916, 69

119 Shrewsbury – HMC, 15th Report part x (1899), 31

Pepysian sketchbook – Walpole Society, XIII (1925), 1–17

120 Templates – R. H. G. Thomson in HoT, II, 385

Worcestre – Harvey 1969, 315–16

Westminster – WAM 23533, 23566, 23568, 23596

York Place PRO, E 101/474/7

Weldon – Fowler 1911, 91–3

121 Highclere – Hants. RO (formerly PRO), Eccl 2/159403

Westminster – WAM 23552

Auxerre – Mortet & Deschamps 1929, II, 204

Walton – PRO, DL 28/4/4

Ely – CUL, Add. MS. 2956, f. 158 ff.

St Paul's – PRO, SC 6/917/18

Bergholt – PRO, Early Chancery Proceedings 789/43 per the late L. F. Salzman

Reading – Kerry 1883, 68

Leverton – *Archaeologia*, XLI, 333

Tirry – PRO, SP 1/101, ff. 205–8

CHAPTER IX

123 Langland – C text, xiv, 158—62; cf. B text, xi, 338–41
124 Woodstock – PRO, E 101/497/12
125 Marks – A. J. Dunkin ed., *Report of the Proceedings at Canterbury in 1844* (1845), 258n.
126 Poole – *Ars Quatuor Coronatorum*, XLIV for 1931 (1936), 236
127 Portland – Groves 1894
 Merstham – *Surrey Archaeological Collections*, XLVIII (1943), 154
 Sible Hedingham – Pritchard 1967, 77–9
 Repairs – Harvey 1965, 112n.; Exeter Cathedral fabric roll 1350–51; PRO, E 101/473/4
 Worcester – Harvey 1972B, 162–3
128 Gloucester – Cal PatR 1441–6, 134
 Strangers – Thomas 1929, lii; Cal PatR 1485–94, 221; Kramer 1917, 196
129 Bryan – BM, Arundel MS. 68, f. 17v
 Lambert – VCH, *Durham*, I, 334
130 Marblers – Salzman 1923, 93–4; Lambeth Palace Library, MS. 242, f. 114v; Exeter Cathedral fabric rolls per Mrs M. E. Clegg; *Ars Quatuor Coronatorum*, XLII for 1929 (1931), 95
 Dytton – Guildhall Library, Archdeaconry Court of London, reg. I, f. 298
 Bonevyle – Canterbury Cathedral, Prior's Account Rolls, xvii. 11 and roll of William Selling
 Bourde – BM, Add. MS. 28564, f. 263
131 Lorymere – Essex RO, D/D Pr 139 per Professor L. Stone
 Ely – VCH, *Cambridgeshire*, IV, 73 n. 31
 Flintwork – Baggallay 1885
 Slates – PRO, E 101/497/18; Salzman 1923, 89; E 101/461/11; 470/7; 542/6
 Winscombe – Somerset RO (formerly PRO), Eccl 2/134/131910/6/15
 Bodmin – Wilkinson 1875, 20, 23–4
132 Paving – Salusbury 1948; HoT, II, 526, 532–3
133 York – Cal ClR 1296–1302, 218; Cal PatR 1317–21, 395; 1327–30, 457; 1334–8, 162; York Minster, Chamberlain's Roll, E 1 (10); City Archives, Memorandum Book B/Y, ff. 48–48v
 Thornbury – WAM 22909
 Hawkhurst – *Archaeologia Cantiana*, V, 55–86
 St Stephen's – PRO, E 101/468/6(35.)
 Exeter – Cathedral fabric roll 1312–13 per Mrs M. E. Clegg; roll 1321–22 per Dr D. F. Findlay
 Chaucombe – Lethaby 1906, 250
134 Cannon balls – PRO, E 101/486/13; E 364/30.E.
 London Bridge – Corporation Records, Bridge-Masters' roll 12, m. 8

CHAPTER X

137 Potter – Salzman 1923, 171—2
 Spain – HoT, II, 357
 Tabriz – E. M. Jope in HoT, II, 302
 Tiles – J. S. Gardner and E. Eames, JBAA, 3rd Series, XVII, 24–42; E.

138 Eames, ibid, XX–XXI, 95–106
 Fountains – Gilyard-Beer 1970, 36
 Alicatado – C. Cid, *Los Azulejos* (Barcelona, Argos, 1950)
 Position Marks – E. Eames, JBAA, 3rd Series, XXVI, 40–50; XXXV, 71–6
 Clarendon – E. Eames, JBAA, 3rd Series, XX–XXI, 96; ibid, XXVIII, 73
 Halesowen – E. Eames, ibid, XVII, 38
139 Tilemakers – Salzman 1952, 146
 Meaux – J. C. Cox, *Transactions* of the East Riding Antiquarian Society, II (1894), 1–6
 Tileworks – Salzman 1923, 176–80; P. Mayes, JBAA, 3rd Series, XXVIII, 86–106
140 York – Selden Society, LVI (1937), 333
 Fires – Turner 1851, 279; Harvey 1966
 Norwich – Salzman 1923, 174
 London – PRO, E 101/4/10; 468/10
 York Place – 468/11
 Highclere – Hants. RO, Eccl 2/159375, 159380
141 Uxbridge – PRO, SC 6/1261/6
 Havering – E 101/464/27
 Abingdon – Kirk 1892, 27
 Portchester – PRO, E 101/479/23, 24
 Hull – Brooks 1940
 York – Minster Library, Vicars Choral deeds, 239, 397, 398, 401
 Lynn – Corporation Archives, Trinity Gild, G.d.58
 Kingston – Corporation Records, C.I. 3–4
142 Pachesham – A. W. G. Lowther, *Proceedings* of the Leatherhead & District Local History Society, I No. 1 (1947), 8–9; No. 2 (1948), 7–8; No. 3 (1949), 6
 Ramsey – BM, Add. MS. 33448
 Worcester – Cathedral, roll C.211; C.195, 200, 200A
 Dover – PRO, E 101/462/23
 Waltham – Hants. RO (formerly PRO), Eccl 2/159437, m. 11d
 Canterbury – Cathedral Library, Fabric Drawer XX, per the late W. P. Blore
 Westminster – WAM 16470
143 Saxham – Salzman 1952, 144
 Tewkesbury – Worcs. RO (formerly PRO), Eccl 2/128/92485
 Limehouse – Bodl. MS. Eng. hist. b.192, f. 27 ff.
 Brick – Lloyd 1925; Wight 1972
144 York – RCHM, *York*, II (1972), 19, 139–40, 174
 York Guild – Minster Library, Y I b.
145 Wall-tile – T. W. French in RCHM, *York*, III (1972), lxxi; Salzman 1952, 230
 Canterbury – Lambeth Palace Library, MS. 242, f. 47v
 York Place – PRO, E 101/468/10, 11
 Westminster – 470/10
146 St Paul's – 473/4
 York – R. B. Cook in AASRP, XXXIII part ii (1916), 476–7
 North Curry – Somerset RO (formerly PRO), Eccl 2/134/131908/5/12
 Wolvesey – Hants. RO (formerly PRO), Eccl 2/2/155827
 Ashburton – Butcher 1870

CHAPTER XI

147 Woodworking – HoT, II, 237
Plane, Ibid, 641

148 Westminster – Clay 1944
Hyde – Harvey 1956, 51–2; BM, Harleian MS. 1761, ff. 106–7

149 Lichfield – Bodl. MS. Ashmole 794, f. 120
London – Guildhall Library, Commissary Court of London, 47, 172 More
St Stephen's – PRO, E 101/468/3
Farnham – Cal ClR 1392–6, 352

150 Wethersfield – PRO, DL 29/42/822
Enfield – Bodl. MS. Eng. hist. b.192, f. 27 ff.
Ormesby – *The History Teacher's Miscellany*, IV, 176
Worcester Inn – Worcs. RO (formerly PRO), Eccl 2/128/92475

151 Canterbury – Royal Museum, Bundle LVI.A(7) per the late Mrs D. Gardiner
Goleigh – WCM 11753
Wormley – PRO, C 1/1010/18

152 Capel – C 47/80/4, no. 106
Person – Raine 1837, no. x
Briggs – York Minster Library, L 2 (4), f. 6v
Cotyngham – Ibid, ff. 285v, 290v

153 Denton – Borth, York Wills, reg. 5, f. 230
St Paul's – PRO, E 101/473/9

154 Ashwell – Guildhall Library (formerly PRO), Eccl 2/137/171463/4/9
Wheels – E. M. Jope in HoT, II, 548–52
Chariots – Devon 1837, 263, 276, 296
Shipbuilding – T. C. Lethbridge in HoT, II, 581–3; F. Marryat, *The King's Own* (1830), chap. xlix

155 Brid – PRO, E 101/402/10, f. 36v
Joinery – HoT, II, 242; Unwin 1963, 86
Salamon – PRO, E 101/467/6(6.)
Hambledon – Hants. RO (formerly PRO), Eccl 2/159444
Lee - Guildhall Library, Commissary Court of London, 347 Wilde
Panelling – HoT, II, 243–5

156 Waltham – Hants. RO, Eccl. 2/3/155836
Canterbury – *Archaeologia Cantiana*, XXXII, 213
York — Borth, York Wills, reg. 2, f. 652; reg. 3, f, 347v
Turners – HoT, II, 251
Whitehall – Bodl. MS. Eng. hist. b.192, f. 6v
Basket-work – HoT, II, 237
Banbury – Westminster Public Library, Peculiar Court, 163 Bracy
Chip-carving – HoT, II, 247

157 Ormskirk – Maskell 1911, 310
Westminster – Howgrave-Graham 1961
Canterbury – Bodl. MS. Top. Kent C.3, ff. 146, 149

158 Melrose – *Archaeologia*, XX1 (1846), 346–9
Alnwick – Bates 1891, 21
Bristol – Worcs. RO (formerly PRO), Eccl 2/128/92484
Modbury – PRO, Deputy Keeper's 48th Report, 350

CHAPTER XII

160 Patrington – York Minster Library, L 1 2, p. 56 col. 4
Brasses – C. K. Jenkins in *Apollo*, August 1946, XLIV no. 258, 34

162 Painting – HoT, II, 248–9; Englefield 1936

163 Glass-painting – Knowles 1936, 230–1; C. Woodforde in *Proceedings* of the British Academy, XXV (1939), 29
Westminster – PRO, E 101/503/12

164 Media – Thompson 1936; Laurie 1930
Alban – York Minster Library, L 2 (4), ff. 33v, 36
Westminster – Bodl. MS. Eng. hist. b.192, f. 2

165 Colours – Harvey 1947C, 304; cf. Thompson 1936, 98
Caister – BM, Add. Roll 17231
St Stephen's – PRO, E 37/197, rot. 47
Worcester – Cathedral, Obedientiary roll C.414
Thetford – CUL, Add. MS. 6969, f. 221
Windsor – Cal LibR 1245–51, 172, 187, 255
William – W. R. Lethaby in *Proceedings* of the British Academy, 1927, 133
Nigel – Cal LibR 1240–45, 26
Thomas – Cal ClR 1237–42, 333
Woodstock – Salzman 1952, 162
Exeter – Cathedral fabric roll 1279–80 per Mrs M. E. Clegg

166 London – Unwin 1963, 86
York Place – PRO, E 101/468/11
Hugh of St Albans – Harvey 1947C
Wilton Diptych – Harvey 1961, 6–7; Harvey 1947C, 304
Adam – PRO E 101/468/21, f. 106
Mettingham – BM, Add. MS. 33985, ff. 79v, 97v

167 St Paul's – Lodge & Somerville 1937, no. 231
Cratfield – Holland 1895, 24
Kessingland – Norwich Wills, 118 Typpes per the late Rev. C. Chitty
Banwell – *Proceedings* of the Somerset Archaeological and Natural History Society, LI for 1905 (1906)
Canterbury – Cathedral MS. C.11 per the late W. P. Blore
Hampton Court – Law 1891, I, 360
Whitehall – Bodl. MS. Eng. hist. b.192, ff. 27 ff.
Whitewashing – Cal LibR 1226–40, 457; Raine 1859, 48; WAM 22995

168 Glaziers – Nelson 1913, 2; Lowe 1961
Greenwich – Le Couteur 1926, 11
Glassmaking – Salzman 1923, 183–4; HoT, II, 326

169 Vale Royal – Salzman 1923, 186
Chalk mould – H. Deneux (*Bulletin Monumental*, LXXXVII, 1929) in JMG, III no. 2 (Oct. 1929), 81–4
Techniques – Drake 1912, 17–18, 21, 24

170 Westminster – PRO, E 101/468/21, f. 20v
Abbey – WAM 19623
Saddlebars – PRO, E 101/470/10
Mortar — E 372/197
Glass – Drake 1912, 39–41

Canvas – PRO, E 372/189
Canfield – Eland 1949, 56
171 Canterbury – Lambeth Palace Library, MS. 242, f. 21v
John of Bristol – Lethaby 1906, 172, 299
York, Haywra – PRO, E 101/501/8; 544/18; YASRS, LXXIV, 165; York Minster Library, L 1 2, p. 56; Dixon & Raine 1863, 434
Walworth – Cal PatR 1343–5, 24
Ely – CUL, Add. MS. 6383, 11
Bridgwater – Dilks 1945, no. 576
Worcester – Cathedral, Obedientiary roll C.85.A
Wolvesey – Hants. RO (formerly PRO), Eccl 2/2/155827
Embroidery – Saunders 1932, 226; cf. Christie 1938
Tapestry – Thomson 1930; Unwin 1963, 179; Prideaux 1896, I, 45

CHAPTER XIII
173 Goldsmiths – Salzman 1923, 72
Monuments – Evans 1949, 6
174 Coins – P. Grierson in HoT, II, 491
Crowns – Salzman 1923, 130; Devon 1837, 128
Bottesham – Devon 1837, 231
Plate – PRO, E 101/403/10, f. 53
London – Salzman 1923, 134, 137
Greeks etc. – PRO, Deputy Keeper's 48th Report, 364, 373
175 Seals — Kingsford 1941
Thorp, Domegode – Devon 1837, 242, 297
Seler – Salzman 1923, 132
Palyng – Devon 1837, 221
Touk – Sharpe 1889, II, 214
Chessmen — PRO, E 364/30 E.
Blindness – Unwin 1963, 160
Canterbury – Treasurer's accounts, per the late W. P. Blore; Lambeth Palace Library, MS. 242, f. 43v
176 Tower of London – PRO, E 101/470/9
St Paul's – PRO, SC 6/917/18
Westbury – Worcs. RO (formerly PRO), Eccl 2/128/92473
Whitehall – Bodl, MS. Eng. hist. b.192, f. 27 ff.
Steel – R. H. G. Thomson in HoT, II, 384; Salzman 1952, 288, 330–1
York Place – PRO, E 101/474/7
St Paul's – 473/1, 9
177 Armour – Blair 1958; HoT, II, 721
Sussex – Salzman 1923, 25, 28, 32

York Place – PRO, E 101/468/10, 11
St Stephen's – 470/15
178 Shrewsbury – Corporation Records, Bailiffs' accounts box xviii, 881
Nails – Lambeth Palace Library, MS. 242, f. 16v; PRO, E 101/468/10, 11; 472/12, 17; Wilkinson 1875, 18; WAM 19879; WCM 22104
179 St Paul's – PRO, E 101/473/4
Canterbury – Cathedral, MS. C.11, f. 47, per the late W. P. Blore
York Place — PRO, E 101/474/7
180 Rummyng – Bodl, MS. Rawlinson D.775, f. 172 ff.
Ironwork – Gardner 1927
Die-cutting – P. Grierson in HoT, II, 485–92
181 Canterbury – Hussey 1881, 12
Windsor – Hope 1913, II, 378, 399, 403, 406, 429
182 Westminster — WAM 31804
York – Raine 1859, 88

EPILOGUE
185 Experiment etc. – cf. Hornell 1943, 40
Loom – HoT, II, 212
Norton – HoT, II, 741; cf. Holmyard 1928
Surgery – Power 1910; Power 1912; Thorndike 1929, 22–3
186 Yeveley – Oxford, Magdalen College deeds, Surrey 86
Fish – Salzman 1923, 260–3
Cookery — Harvey 1947A, 92, 154
Gardening – Amherst 1895; Hadfield 1969; City of Chester Records, CR 63/2
187 Rosemary – Harvey 1972C
Bray – BM, Sloane MS. 282, ff. 167v–173v
Gittern – Remnant 1965
Westminster – WAM 19875; 23513
188 Nets – Bodl, MS. Eng. hist. b.192
Leather – London Museum, *Medieval Catalogue* (1940), 185–99
Saddles – PRO, E 361/5, rot. 8
189 Linen – Salzman 1923, 226, 239
Pensions – Harvey 1956, 55; Lethaby 1906, 306: Cal PatR 1364–7, 329; 1374–7, 105
190 Henry le Mason – London Corporation Records, Hustings Roll 12 (115); will, Roll 18 (64)
Aylmer – *Masonic Record*, XVI no. 189 (August 1936), 204–5
Louth – Dudding 1941

Index

Artists and craftsmen who worked in England are listed separately after the main index. There are collected entries for: Building Terms, Metals, Stones, Timber, Tools, and Trades and Occupations. Numerals in *italics* are principal references; those in **heavy type** refer to the figure numbers of the illustrations on the plates or (with p.) to the pages on which line-blocks occur.

Index of Artists and Craftsmen

Ilkeley, Gilbert, de, gardener, 25

James, nailsmith, 25
Janyns, Henry, mason, 181
John, carver, 69
—— glazier, 171
—— tilemaker, 140
Johnson, Roger, smith, 181
Jolif, John, limeburner, 114
Jongnur, Salamon le, joiner, 155
Jon, William, carpenter, 157
Jordan, Henry, bellfounder, 92

Karver, Kerver, Geoffrey, carver, 158
—— Thomas, joiner, 119
Kent, Richard – see above, Cant'
—— Thomas, painter, 154
Ketelbarn, Robert, glazier, 171
Killer, Leonard, ? bricklayer, 151
Kirkeby, Nicholas, brickmaker, 143
Kyghlay, John de, glover, 194-5
—— Nicholas de, bowyer, 194-5
Kymer, Gilbert, physician, 67

Lakensnyder, Arnald, 27
—— Henry, 27
—— Katherine, 27
Lambert, marbler, 129
Landric, ? carpenter, 148
Langele, Roger de, carpenter, 196-7
Langford, John, carpenter, 150
Laurence, glassmaker, 169
—— smith, 177
Lee, William, joiner, 155
Leighton, Thomas de, smith, 178, 181; 140, 142
Lenn, Simon de, glazier, 171
Lesyngham, Robert, mason, 118
Leveland, Geoffrey de, engineer, 148
—— Wimund de, ? engineer, 148
Levesham, William de, spicer, 28
Lewes, Henry of, smith, 181
Lewisham, James of, smith, 177
Leyer, John, paviour, 77
Leyt, Thomas de, quarryman, 112
Lililowe, Nicholas, tilemaker, 140
Lillyng, Hugh de, seal-engraver, 175
Limoges, John of, enameller, 89
Lincoln, John of, clockmaker, 94
Litlyngton, Thomas, painter, 166
Lodowycus, lutemaker, 89
Lorymere, Henry, marbler, 131

Loveday, Thomas, blacksmith, 95
Lovell, John, clockmaker, 26
Lyde, John, carpenter, 105
Lyghtfote, Katherine, builder's merchant, 139
Lyllyngstone, Thomas, carpenter, 99
Lyndys, William, mason, 75
Lyngwode, William, carpenter, 157; 67

Mady, Richard, mason, 64
Mallinge, Walter de, paviour, 140
Malmesbyry, Richard de, painter, 165
Malton, Elias de, plasterer, 145
—— Thomas de, cook, 27
Mansell, John, cook, 27
Mapleton, John, marbler, 130
Marberer, John, marbler, 72
Marbler, Adam the – see above, Corfe, Adam of
Mason, Alexander le, mason, 75
—— John le, 76
—— John son of John, 76
—— Peter, mason, 77
—— Richard, mason, 64
—— Ronold, slater, 131-2
Massingham, John, carver, 48, 158
Mathie, Adam, mason, 105
Matthew, carver, 158
Mauncy, Thomas, carpenter, 57
Mayhew, John, marbler, 130
Medilton, John, physician, 69
Melbourn, Robert de, mason, 134
Meppushal, John, mason, 105
Mere, John de, carpenter, 63
Merton, Richard, clockmaker, 94
Meryman, Richard, mason, 77
Mineur, Gerard le, engineer, 107
Moldemaker, Gilbert le, porter, 92
Montacute, William de, carver, 133; 88
Morer, William, builder's merchant, 117
Moreton, Roger de, mercer, 27
Morton, William de, latoner, 93
Musket, Nicholas, latoner, 25, 93
Mymmes, John de, imagemaker, 133-4
Mynnois, mason, 133

Nedeham, James, carpenter, 57
Neve, William, glazier, 112
Newby, Robert, bricklayer, 144
Newcastle, Gilbert of, painter, 164
Newton, William de, bellfounder, 92

Nicholas, carpenter, 149
—— organist, 187-8
Nicolyne, John, carpenter, 105
Nigel the chaplain, painter, 165
Norman, John, wheelwright, 154
Norton, Thomas, alchemist, 185
Notingham, Ralph de, wiredrawer, 25

Ocle, Robert, painter, 166
Offington, John de, mason, 128
Orchard, William, mason, 112
Ordsale, William de, pewterer, 92
Organier, Janyn le, organbuilder, 89
Orgar, John, mason, 112
Orlogeer, John, clockmaker, 94
—— William, clockmaker, 94
Osekin, Robert, carpenter, 77
Oswestre, David, carpenter, 72
Otto, goldsmith, 86
Oxenforth, Oxford, Adam de, bookbinder, 25, 28
Oxford, Thomas of (Glasyer), glasspainter, 69, 77, 164

Page, Thomas, carpenter, 115
Palterton, John, mason, 62
Palyng, John, goldsmith, 175
Partrik, John, tiler, 128, 144
Patrington, Robert de, mason, 160-2, 196
Pavier, Peter the, tilemaker, 139
Pawmer, Richard, bricklayer, 151
Pay, Thomas, cook, 28
Payntour, Martin le, ? carver, 64
Paytefyn, Adam, latoner, 93
Peake, Clement, brickmaker, 143, 197-8
Peires, William, carter, 150
Penythorne, Richard, carpenter, 57
Peperton, R., mason, 121
Perish, William, slater, 131
Person, Robert, carpenter, 152
Peter, mason, 76
Peyntour, Hugh le, tilemaker, 139
—— Thomas le, marbler, 48
—— Thomas, mason, 47
Plasterer, Roger, plasterer, 146
Plastrour, Stephen le, plasterer, 145
—— Thomas le, plasterer, 145
Plumer, Plummer, Bartholomew, plumber, 121
—— Henry le, plumber, 25
—— Henry, plumber, 193-4
Popilton, William, goldbeater, 25
Poter, John le, founder, 90
Powle, James, brickmaker, 142
Poynton, Robert, tilemaker, 141-2